LIBRARIES, ARCHIVES, ...
IN TRANSITION

In this anthology, top scholars researching libraries, archives, and museums (LAM) issues in Scandinavia explore pressing issues for contemporary LAMs.

In recent decades, relations between libraries, archives, and museums have changed rapidly: collections have been digitized; books, documents, and objects have been mixed in new ways; and LAMs have picked up new tasks in response to external changes. Libraries now host makerspaces and literary workshops, archives fight climate change and support indigenous people, and museums are used as instruments for economic growth and urban planning. At first glance, the described changes may appear as a divergent development, where the LAMs are growing apart. However, this book demonstrates that the present transformation of LAMs is primarily a convergent development.

Libraries, Archives, and Museums in Transition will be essential reading for students, scholars, and practitioners seeking to get on top of the LAM literature or the particularities of Scandinavian LAMs.

Casper Hvenegaard Rasmussen is Associate Professor in the Department of Communication, Section for Galleries, Libraries, Archives and Museums (GLAM) at the University of Copenhagen. His long-term research interest involves library studies and cultural policy studies. Currently his research is focusing on the relations between libraries, archives, and museums.

Kerstin Rydbeck is Professor of Information Studies at Uppsala University and holds a doctoral degree in literature. Her research has focused on the sociology of literature – particularly on readers, reading patterns and social reading activities, and on the history of popular education and public libraries.

Håkon Larsen is Professor of Library and Information Science at Oslo Metropolitan University. His main areas of interest are cultural sociology, cultural policy studies, and library studies. He has published extensively on the topic of cultural organizations and legitimacy. He holds a PhD in sociology.

LIBRARIES, ARCHIVES, AND MUSEUMS IN TRANSITION

Changes, Challenges, and Convergence in a Scandinavian Perspective

Edited by
Casper Hvenegaard Rasmussen
Kerstin Rydbeck
Håkon Larsen

Routledge
Taylor & Francis Group

LONDON AND NEW YORK

First published 2023
by Routledge
4 Park Square, Milton Park, Abingdon, Oxon OX14 4RN

and by Routledge
605 Third Avenue, New York, NY 10158

Routledge is an imprint of the Taylor & Francis Group, an informa business

British Library Cataloguing-in-Publication Data
A catalogue record for this book is available from the British Library

ISBN: 978-1-032-03752-3 (hbk)
ISBN: 978-1-032-03364-8 (pbk)
ISBN: 978-1-003-18883-4 (ebk)

DOI: 10.4324/9781003188834

Typeset in Bembo
by codeMantra

CONTENTS

FIGURES AND TABLES

Figures

Tables

CONTRIBUTORS

Ragnar Audunson is Professor Emeritus in the Department of Archivistics, Library and Information Science at Oslo Metropolitan University.

Leiv Bjelland is Assistant Professor in the Department of Archivistics, Library and Information Science at Oslo Metropolitan University.

Roger Blomgren is Professor in the Swedish School of Library and Information Science at the University of Borås.

Brita Brenna is Professor in the Department of Culture Studies and Oriental Languages at the University of Oslo.

Hans Dam Christensen is Professor in the Section of Galleries, Libraries, Archives and Museums (GLAM), Department of Communication, University of Copenhagen.

Terje Colbjørnsen is Associate Professor in the Department of Archivistics, Library and Information Science at Oslo Metropolitan University.

Johanna Rivano Eckerdal is Associate Professor in the Section of Archives, Libraries, Museums and Digital Cultures, Department of Arts and Cultural Sciences, Lund University.

Samuel Edquist is Professor in the Department of Humanities and Social Sciences at Mid Sweden University.

Lars-Erik Hansen is Associate Professor in the Department of Archivistics, Library and Information Science at Oslo Metropolitan University.

Isto Huvila is Professor in the Department of ALM at Uppsala University.

Ole Marius Hylland is Research Professor at Telemark Research Institute.

Henrik Jochumsen is Associate Professor in the Section of Galleries, Libraries, Archives and Museums (GLAM), Department of Communication, University of Copenhagen.

Jamie Johnston is Associate Professor in the Department of Archivistics, Library and Information Science at Oslo Metropolitan University.

Nanna Kann-Rasmussen is Associate Professor in the Section of Galleries, Libraries, Archives and Museums (GLAM), Department of Communication, University of Copenhagen.

Ulrika Kjellman is Associate Professor in the Department of ALM at Uppsala University.

Håkon Larsen is Professor in the Department of Archivistics, Library and Information Science at Oslo Metropolitan University.

Casper Hvenegaard Rasmussen is Associate Professor in the Section of Galleries, Libraries, Archives and Museums (GLAM), Department of Communication, University of Copenhagen.

Henriette Roued-Cunliffe is Associate Professor in the Section of Galleries, Libraries, Archives and Museums (GLAM), Department of Communication, University of Copenhagen.

Kerstin Rydbeck is Professor in the Department of ALM at Uppsala University.

Björn Magnusson Staaf is Associate Professor in the Section of Archives, Libraries, Museums and Digital Cultures, Department of Arts and Cultural Sciences, Lund University.

Bjarki Valtysson is Associate Professor in the Department of Arts and Cultural Studies at the University of Copenhagen.

Andreas Vårheim is Professor in the Department of Language and Culture at UiT – The Arctic University of Norway.

PREFACE

During the last decades, common research and practice fields for libraries, archives, and museums (LAMs) have emerged. In the Scandinavian countries of Denmark, Norway, and Sweden, the education of LAM professionals is being conducted in cross-sectoral LAM departments at several universities, and sometimes even in joint LAM programs. With this anthology, we have gathered top scholars researching LAM issues in Scandinavia, where each contributes their expertise in discussing pressing issues for contemporary LAMs. The book will be essential reading for advanced undergraduate and graduate students in LAM-related programs, as well as scholars seeking to get on top of the LAM literature or the particularities of Scandinavian LAMs.

The anthology springs out of a workshop grant in 2018 from The Joint Committee for Nordic Research Councils in the Humanities and Social Sciences (NOS-HS), which funded the project *Libraries, Archives, and Museums: Changes, Challenges, and Collaboration* (LAMC3). One of the main goals of the project was to establish collaboration between Scandinavian researchers across the LAM fields. The point of departure for the collaboration was three workshops in Copenhagen, Uppsala, and Oslo. At the second workshop in Uppsala, the idea of an anthology was discussed and developed. Several participants pointed to the need for an anthology for Scandinavian graduate and advanced undergraduate students covering pressing issues for LAMs. At the third workshop in Oslo, we were discussing chapter drafts for this book.

Preceding the LAMC3 project, many of the authors of this anthology participated in the research project *The ALM-field, Digitalization, and the Public Sphere* (ALMPUB), funded by the Norwegian Research Council. Through the ALMPUB and LAMC3 projects a network of LAM scholars has been established. Although the anthology is the end-product of this particular collaboration, many of the authors have ongoing collaborations on studies of LAM issues within and

beyond Scandinavia. The book is centered around Scandinavian LAMs, but the issues discussed are by no means particular to Scandinavia. As such, the book will also be of interest for scholars and students studying LAM issues around the globe.

<div align="right">

Casper Hvenegaard Rasmussen
Kerstin Rydbeck
Håkon Larsen

</div>

1

INTRODUCTION

Libraries, archives, and museums in transition

Casper Hvenegaard Rasmussen, Kerstin Rydbeck, and Håkon Larsen

Libraries, archives, and museums (LAMs) have a long, interrelated history and, since the turn of the century, growing relations between LAMs have become more apparent. Internationally, the number of collaborative projects and partnerships has increased and the incidence of libraries, archives, or museums sharing premises or even merging has grown. Many of the collaborations follow trends in digitalization, which can be seen in the development of shared digital cultural heritage platforms and content sharing. Accordingly, digital convergence among LAMs is a growing field of research. The number of cross-sectoral textbooks and other publications is slowly increasing and collaborations between sector-specific educational environments are discussed in tertiary education. Collectively, this indicates that a common LAM perspective is in the process of becoming an established phenomenon (Hvenegaard Rasmussen and Hjørland 2021).

Scandinavia (Denmark, Norway, and Sweden) offers a fruitful region for LAM research for several reasons. First, Scandinavian LAM institutions are relatively well funded and developed compared to the situation in other parts of the world. Second, LAMs in Scandinavia are governed by a cultural policy rooted in the welfare states' values of enlightenment, community building, and participatory democracy. Third, some of the tertiary education of the respective LAM professionals in Scandinavia is in cross-sectoral departments, or so-called "LAM departments." In Sweden and Denmark, some departments offer programs and specializations in library and information science, archival science, and museum studies, and in Norway there are programs in library and information science and archival science in joint departments. In this book, we will address all three sectors. The book encompasses a common LAM perspective and addresses issues related to LAM institutions' environment, collections, and challenges.

DOI: 10.4324/9781003188834-1

Even though educational convergence may appear most apparent in Scandinavia, institutional mergers between LAMs are widespread in Australia (Robinson 2019) and research on digital convergence has been initiated in North America (Marty 2014). The described challenges and the transition of LAMs are thus an international trend. Although we adopt a Scandinavian perspective in this book, we deal with tendencies and issues discussed internationally within library and information science, archival science, and museum studies.

Relations between LAMs

The borders between libraries, archives, and museums have always been complex and ever-changing. On the one hand, LAMs are cognate fields with different tasks. Basic definitions of LAMs generally highlight collections: Libraries have books, archives have documents, and museums have artifacts. Therefore, it makes sense to talk about librarians working at libraries, archivists working at archives, and curators working at museums. On the other hand, the borders between LAMs are not as clear and well defined as they may initially appear. The definitions of libraries, archives, and museums have changed over time and the division of collections between books, documents, and artifacts has become increasingly blurred. National libraries frequently exhibit artifacts and normally own special collections of documents. Archives display artifacts and some even maintain libraries. Museums often have archives and sometimes also libraries.

Noticeable changes in the relations between LAMs have taken place in recent decades. As collections have been digitized, books, documents, and objects have been mixed in new ways. The respective institutions have all responded to external pressures, such as increased demands for demonstrating relevance. Libraries host makerspaces and literary workshops, archives fight climate change and support the culture and rights of indigenous peoples, and museums are used as instruments for economic growth and urban planning. At first glance, these changes may appear to be divergent developments. However, the observed changes in LAMs should mainly be seen as a convergence for several reasons that are discussed below.

A common historical ancestry

The birth of libraries is normally dated back to Mesopotamia 2500 BC. Those early libraries consisted of clay tablets, some of them with literary text but more often with different types of legal and financial contracts, administrative texts, and letters – or what we today should define as archives of documents (Pedersén 2005). The Library of Alexandria is another frequently used example showing the blurred borders between LAMs. Here originals or copies of much of the known text in the world were stored in the form of papyrus rolls, a huge archive in the present understanding. It also had cultural artifacts and even a zoological garden. The Library of Alexandria was a place for researchers and therefore it was called

the "Mouseion," or the "Temple of the Muses." Mouseion is the etymological precursor to the museum as we know it today (Dilevko and Gottlieb 2003; Marcum 2014). Another precursor to the museum was the "cabinet of curiosities," which could contain any notable object. It could be artwork, books, natural items, etc. For the premodern collector there was no distinct border between objects, documents, and books. The collectors were generally royalty, scientists, or wealthy individuals, and many of their collections became the foundation for a modern collecting institution. One of the most energetic collectors was the Irish physician Hans Sloane. He collected more than 71,000 items, and after his death in 1753, his collection became an important part of the British Museum, with some of it being channeled later into the Natural History Museum and the British Library, as they grew out of the British Museum. The British Museum served as the national library in Great Britain until the British Library was established in 1973 (Delbourgo 2017; Høiback 2020, 51–55). The overlapping borders between libraries, archives, and museums have a long history.

Intersecting cultural policy aims

LAMs have been described as "memory institutions" collecting cultural heritage in different ways (Dempsey 1999). In a Scandinavian context, many LAMs are subsumed under the culture sector. Therefore, LAMs are part of the national cultural policy serving certain shared political purposes such as supporting enlightenment and national identity (Brown and Davis-Brown 1998; Vestheim 1997). Furthermore, LAMs form an important part of the infrastructure of the public sphere, through supporting access to knowledge, freedom of speech, and deliberative activities (Audunson et al. 2019; Larsen 2018). Finally, together with other cultural institutions that receive public funds, LAMs are influenced by dominant trends in cultural policy. Mangset et al. (2008) highlight some of these and point to the following as the two most important: (1) Scandinavian cultural policy tries to promote equal access to culture and to reduce structurally based inequalities in cultural life; (2) since the 1970s, Scandinavian cultural policies have taken a distinct sociocultural turn where diversity and broadening of the concept of culture have been at the forefront of cultural policy. With this in mind, it is not surprising that a Swedish survey has documented only small variations between professionals' visions in LAMs (Huvila 2014).

From collection-driven towards user-driven

"From collection to connection" has been a buzzword in the public library field for two decades. The slogan indicates that a library is more than a collection. It is not only a quiet place with public access to published documents, it should also be a vibrant and social place supporting the aims of public libraries in new ways such as makerspaces or reading groups (Jochumsen, Hvenegaard Rasmussen, and Skot-Hansen 2012). Likewise, museums have been transformed from

being about something to being for somebody (Weil 1999). Just like libraries, museums have moved from being collection-driven towards a more user-driven approach (Anderson 2012). The same tendency can be identified among archives. According to Cook (2013), the archivist has been transformed over the past 150 years from passive curator to community facilitator. Thus, on a general level, LAMs have gone through the same transformation. The collections are still an important part of LAMs, but the users have been given greater priority over the last 50 years. This increased user orientation has been put into practice in different ways, such as considering diversity, focusing on user surveys, or co-creating content with users.

Proximity in government agencies

As mentioned above, the relations between LAMs are ever-changing, but this is not synonymous with an increasing convergent development. During the twentieth century, the institutionalization and professionalization of libraries, archives, and museums expanded with the result that borders between the three fields became sharper (Given and Mctavish 2010; Tanackovic and Badurina 2009). However, LAMs have been placed together in different government agencies. In Chile, that happened back in 1929, when the Dirección de Bibliotecas, Archivos y Museos was created. In the US, the Institute of Museum and Library Services was formed in 1996. It is a federal agency with the mission that museums and libraries work together in order to transform the lives of individuals and communities (Pastore 2009). Library and Archives Canada, formed in 2004, is a merger of the National Library of Canada and the National Archives of Canada (Bak and Armstrong 2008). Previously, Norway had the Norwegian Archive, Library and Museum Authority and England the Council for Museums, Archives and Libraries. They have both closed down now, although not due to a lack of relevance: The English LAM authority was abolished due to public budget cutbacks (Hooper-Greenhill 2004), and the Norwegian closure was the result of a power struggle between the National Library and the LAM authority (Hylland 2019; Skare, Stokstad, and Vårheim 2019).

Collaboration between LAMs

The main argument for establishing LAM authorities was the new digital possibilities in the wake of the Internet. According to Marty (2014), Rayward's (1998) book chapter "Electronic Information and the Functional Integration of Libraries, Museums, and Archives" was the starting point for a new research agenda on the topic of digital convergence. Rayward's point of departure was that the separation of books, documents, and objects in libraries, archives, and museums did not make sense in a digital environment. Since the new millennium, there have been many examples of digital convergence from small collaborations between local institutions to the supranational level. One example

of the latter is Europeana, the European Union's digital platform for cultural heritage, to which more than 3,000 institutions across Europe have contributed. These institutions range from major international names like the Rijksmuseum in Amsterdam, the British Library, and the Louvre to regional archives and local museums from every member state (Valtysson 2012). However, digitalization is not the only driver for collaboration. According to Kann-Rasmussen (2019), the collaboration between cultural institutions itself is a quality in the present society. In this, the ability to create connections between fields is of considerable value. The most valuable links are those that connect different fields or cross boundaries. Hvenegaard Rasmussen (2019) argues that this is exactly what digital convergence is all about: Collaboration between different fields.

Cultural imperatives and shared professional practices

Working in a library, archive, or museum is based on different professional practices. Furthermore, being employed in a metropolitan art museum or a small museum of local history is not the same thing. However, LAMs, along with other cultural institutions, have been influenced by several trends or imperatives over the past few decades. An imperative is an authoritative command or call for action that is perceived as being universal and self-explanatory, and those who criticize the basic idea of the imperative runs the risk of being perceived as irresponsible, foolish, or morally corrupted (Henningsen and Larsen 2020, 53). We have already touched upon some imperatives in the culture sector, such as user orientation, collaboration, and digitalization. In addition, new public management, the experience economy, and participation can be viewed as imperatives. The content of the various imperatives is not so important in this context, as the crucial aspect of the highlighted imperatives is their push towards a convergent professional practice in LAMs. Compared to the twentieth century, it is more common in the twenty-first century for all kinds of LAM professionals to carry out user surveys, to work in a project-oriented manner, to design experiences, to digitize collections, to use social media for marketing, and to co-create content with the users.

The historical roots of LAMs

A basic assumption in this book is that institutions such as libraries, archives, and museums do not develop in a vacuum. On the contrary, the development of an institution is an interplay between internal and external forces. An internal driver for change could be power struggles between professionals within a field, while external forces could be changes in legal requirements, a certain zeitgeist or social, cultural, or technological changes pushing for adaptation within organizations. In this section, we will discuss four key forces of social change that have influenced the emergence and development of libraries, archives, and museums, as well as the rest of society. These are enlightenment, nation state,

modernity, and democracy. In reality, these are inextricably linked with each other. For pedagogical reasons, we have nevertheless divided these into separate sections in our discussion on drivers for the formation of modern libraries, archives, and museums.

Enlightenment

In European history, the period between the seventeenth and eighteenth centuries is often entitled the "Age of Enlightenment." More specifically, it was an intellectual movement driven by the bourgeoisie arguing for new ideas such as liberty, progress, constitutional government, and separation of the Church and state. The historical background for the Age of Enlightenment was the established privileges for the Church, the king, and aristocracy (Zafirovski 2010). For adherents of enlightenment, absolute monarchy and religious power should be replaced by science and reason. The destiny for each person should be taken from God and king and handed over to the individual. If the individual is to have a fair chance of proving successful in life, enlightenment is an important precondition. One of the most influential enlightenment thinkers was the German philosopher Immanuel Kant, who in 1784 replied to the question "What is enlightenment?" in a Berlin journal:

> Enlightenment is man's emergence from his self-imposed nonage. Nonage is the inability to use one's own understanding without another's guidance. This nonage is self-imposed if its cause lies not in lack of understanding but in indecision and lack of courage to use one's own mind without another's guidance. Dare to know! (Sapere aude.) "Have the courage to use your own understanding" is therefore the motto of the enlightenment.
>
> *(Kant 1996, 58)*

Courage and reason are indispensable ingredients for Kant if the individual is to be enlightened. However, without access to knowledge, the enlightenment of the people would fail. Thus, LAMs were vital sources of knowledge. From the middle of the seventeenth century and onwards, highbrow art was increasingly perceived as an expression of the highest condition of mankind and granting public access to art museums was seen to a greater extent as a duty of the state (Duncan and Wallach 1980). Furthermore, other kinds of museums were also imposed a didactic burden as compared to earlier collections that were more concerned about creating surprise or provoking wonder (Bennett 1995, 2). Free public access to knowledge is the foundation for the public library movement, which originated in the US and UK, and later spread to the Scandinavian countries (Frisvold 2015; Torstensson 1993). According to Emerek (2001), the formation of Danish public libraries was based on Anglo-American inspiration regarding rational operation and organization, and the Age of Enlightenment when it comes to the value base for establishing public libraries. Finally, the Age

of Enlightenment plays an important role in public access to archives. In the wake of the French Revolution, a legal act from 1794 underlined for the first time the citizens' right to access public archives in France. In the time that followed, this right to civic access to archives was increasingly recognized in other parts of Europe (Duchein 1992).

Nation state

Since the eighteenth century, the nation state has gradually replaced kingdoms, empires, and city states as the dominant way of ruling over geographic territories. A nation state is a state in which the great majority identify themselves as a nation. Ideally, the cultural boundaries match up with political boundaries in a nation state. In reality, all nation states consist of people with different ethnic and cultural backgrounds. Thus, nation building has been an ongoing task for maintaining the legitimacy of a nation. LAM institutions have played a conspicuous role in nation building. According to Berger (2013), national archives have supported the construction of national master narratives in Europe. A major task assigned to historians was to legitimate the history of the nation state, and archives adopted an important position in nation building. For example, after Norway achieved independence from Denmark in 1814, the Norwegian national archive was established in 1817. The national master narratives are also embedded in the museums' chronological exhibitions, which became more widespread in the wake of the Enlightenment. After the French Revolution, the Louvre was reorganized in a chronological way that allowed visitors to decode the nation states' history of development. Roughly speaking, the chronological national master narrative begins in an "oppressed" or "uncivilized" past and ends with an "independent" and "civilized" present nation state (Mordhorst and Wagner Nielsen 1997). Furthermore, throughout Europe, the values of national cohesion were manifested in the architecture of the national archives, libraries, and museums, all situated in the most prestigious parts of the nations – the capitals (Aronsson 2015). Sometimes, the alliance between the nation state and cultural heritage was expressed in the national institutions' ornamentation. One example is the three busts outside the German national library. Here are Gutenberg and Goethe located together with Bismarck, who masterminded the unification of Germany and served as its first chancellor. Finally, according to Duncan and Wallach (1980), the Louvre changed from celebrating the glory of the king to becoming a symbol of France's superiority as a nation state.

In summary, the Louvre embodies the state and the ideology of the state. It presents the state not directly but, as it were, disguised in the spiritual forms of artistic genius. Artistic genius attests to the state's highest value – individualism and nationalism. It demonstrates the nation's destiny and the state's benevolence (Duncan and Wallach 1980, 463).

The citation above refers to an embedded conflict in modern LAMs, namely the tension between individualism and nationalism. On the one hand, LAMs

pay tribute to such values as accountability and neutrality, growing out of the Enlightenment and making up important prerequisites for individual formation of opinion. On the other hand, LAMs, and especially the big national institutions, are potentially an integrated part of the value-based national master narratives.

Modernity

Seen from a sociological perspective, enlightenment and the formation of nation states are part of the modernization of society: The transformation from a feudal or premodern society to a modern society (Giddens 1990). One of the most predominate characteristics of modernity is social change and the awareness of change as a condition for living in a modern world. According to Bennett (1995, 10), museums in the late nineteenth century were referred to as "machines for progress" because many (chronological) exhibitions allowed visitors to follow a path of evolutionary development that led from simple to more complex forms of living. Furthermore, the systematic and institutionalized way of collecting is modern. For the French philosopher Michel Foucault, LAM institutions are emblematic of modernity:

> The idea of accumulating everything, of establishing a sort of general archive, the will to enclose in one place all times, all epochs, all forms, all tastes, the idea of constituting a place of all times that is itself outside of time and inaccessible to its ravages, the project of organizing in this way a sort of perpetual and indefinite accumulation of time in an immobile place, this whole idea belongs to our modernity.
>
> *(Foucault 1986, 26)*

In addition to change, other significant characteristics of modernity are rationality and differentiation of society into different relatively independent expert systems. The formation of modern libraries, archives, and museums is an obvious example of such relatively independent expert systems. Consequently, modernity has been a driver for a divergent development of libraries, archives, and museums, whereas a feature of a postmodern society is de-differentiation (Smith 2001, 225), which is also manifest in the move towards convergence in LAMs. As mentioned above, Hans Sloane's huge collection of many different items got divided into a library, an archive, and a museum. In each of these institutions, experts managed the collections. Many libraries used Dewey's universal decimal classification system, and according to Hvenegaard Rasmussen and Jochumsen (2007), the use of the universal decimal classification is more than a functional tool for storing and retrieval, it is a symbol of modern society's endeavors toward differentiation and putting everything in its rightful place. The same endeavors can easily be identified in the modern museum because science became the guiding light for knowledge organization. Museums were divided into different types of museums such as art museums and botanical museums. In art museums,

works of art were arranged chronologically into periods defined by art history, while botanical specimens were arranged taxonomically according to Linnaean classification (Roppola 2012, 14–16). In the introduction to *Archives and the Public Good: Accountability and Records in the Modern Society*, Cox and Wallace (2002) discuss the significant roles that records play in accountability. For instance, when our personal data are records in archives or records are used as evidence in court proceedings, "accountability" is an unavoidable term. In the same way, accountability is vital to all modern LAM institutions because the legitimacy of these institutions is related to accountability.

Democracy

The French Enlightenment philosopher Voltaire advocated freedom of speech and freedom of religion but did not believe in democracy – he preferred an enlightened absolute monarch. However, it is nearly impossible to imagine the Scandinavian democracies without the Age of Enlightenment. In a democracy, it is not only the monarch who needs to be enlightened; all citizens need enlightenment to participate in democracy. The Danish public library pioneer Andreas Schack Steenberg clearly points that out:

> It is important to consider the position that "common man" holds today compared with his position only a hundred years ago. The right to vote, eligibility, and the impact on the corporate world through unions have given the masses a responsibility as never before. The people's horizon is broadened and thereby their need for knowledge and critical thinking. The huge power average people have obtained today underlines the increasing need for "society to enlighten its master."
>
> *(Steenberg 1900, 14)*

It is not surprising that Steenberg recommends that libraries should solve the task of enlightening the entire population. Retrospectively, public libraries have ensured free access to knowledge in the Scandinavian countries. However, throughout the twentieth century, there were extensive disagreements about the content within the library field. Steenberg argued for highbrow literature and nonfiction as defined by experts in the library field, while other actors within the field preferred literature in accordance with the literary preferences of the "common man." National cultural policies in the Scandinavian countries reflect this conflict, under the labels of "democratization of culture" and "cultural democracy" (Mangset et al. 2008). Democratization of culture was the point of departure for national cultural policies in the postwar era. In this strategy, the culture sector supports democracy by giving access to highbrow art and culture as a part of the publicly funded enlightenment. As a supplement or alternative to the democratization of culture, cultural democracy gained speed in the 1970s. It is a strategy supporting democracy by ensuring that cultural diversity flourishes,

among other things by supporting amateur cultural activities. According to this strategy, all kinds of cultural preferences should be present in publicly funded cultural life. Today, freedom of speech is an important value in cultural policy. These strategies have also influenced LAM institutions. Supporting democracy is perceived as an important task for LAMs, but disagreement will potentially occur when the question of how to best support democracy is raised.

The structure of the book

Finally, in this chapter, we will present the main themes of the book: The history and policy of libraries, archives, and museums in Scandinavia; LAMs and their collections; and challenges for LAMs in the twenty-first century. Part I consists of four chapters, dealing with the development of libraries, archives, museums, and cultural policy in a Scandinavian context. All chapters have a societal perspective, focusing on how enlightenment, nation building, modernity, and democracy have shaped the LAMs. Furthermore, all the chapters pinpoint different types of libraries, archives, and museums. The first three chapters end their discussions at the turn of the millennium. The last chapter in this section describes the development of cultural policies in Denmark, Norway, and Sweden, mainly focusing on the period from the 1960s to the present. As already mentioned in the paragraph on democracy, the guiding light for Scandinavian cultural policy is the access to information and art (democratization of culture) and the support of diverse cultural expressions (cultural democracy).

Collection is the point of departure for the second theme of the book. It is a common feature of all kinds of LAMs that they collect, maintain, and develop their collections. Part II consists of three chapters concentrating on different aspects of LAM collections. In the first chapter, the authors describe and discuss the collection status for LAMs. If the above-mentioned slogan "From collection to connection" is a reality, are LAMs still constituted by their collections? The authors of the next chapter focus on the selection, maintenance, and exhibition of collections. Despite curation primarily being connected to museums, the concept is in this chapter used for discussing selection, maintenance, and exhibition in all kinds of LAMs – how has the selection of content changed over time? All collections entail a need for knowledge organization, which is the topic for the last chapter in this part of the book. The aim of the chapter is to describe and discuss differences and similarities between knowledge organization in libraries, archives, and museums.

The last theme of the book is eight common challenges for LAMs. Part III starts with two chapters discussing the impact of digitalization on LAMs. The first chapter is dedicated to the challenges that digitalization represents for LAMs, their professionals, and users. The next chapter is focusing on the use of digital communication in LAMs. The main aim of the chapter is to explore the current state of digital communication across and between LAMs. The third

chapter in the section deals with literacy and the education of LAM users. In the chapter, the authors present how LAMs have shifted from being enablers of mainly informal learning to increasingly becoming places for formal learning as well. The fourth common challenge is participation. The entire cultural field is witnessing a "participatory turn," and among LAMs, "participation" has been the most prominent buzzword for more than a decade. The authors of the chapter describe and discuss different types of participation, including crowdsourcing, co-creation, and the facilitation of shared experiences in terms of culture and art. The fifth challenge is the increased pressure to demonstrate the worth of one's work to a broad public, and the need for managers of culture organizations to engage in continuous legitimation work. This chapter contains discussions on a range of issues related to ongoing legitimation work in Scandinavian LAMs. Due to the increased need for legitimation, LAMs need to develop and strengthen ties to their local communities. In the sixth chapter, authors describe and discuss how the institutions are anchoring themselves in their communities and connecting with various user groups. Special attention is paid to services to immigrants, the use of volunteers, and collaboration with local partners. Traditionally, LAMs have been perceived as neutral institutions, but this alleged neutrality has been questioned over the past two decades, and different kinds of activism have emerged. This growing LAM activism is the topic for the seventh chapter in this part of the book. In the last chapter, the authors address how LAMs support some of the challenges that the Scandinavian societies face in the twenty-first century. The point of departure is the United Nations Member States Agenda for Sustainable Development Goals, of which the chapter discusses two of the goals, as related to LAMs: First, how LAMs are advancing environmental responsibility; second, how they promote social equity related to diversity and equality.

The anthology is completed with a concluding chapter, where the described differences and similarities between libraries, archives, and museums are discussed and future common challenges are outlined.

References

Anderson, Gail. 2012. *Reinventing the Museum, the Evolving Conversation on the Paradigm Shift*. Lanham: AltaMira Press.

Aronsson, Peter. 2015. "National Museums as Cultural Constitutions." In *National Museums and Nation-Building in Europe 1750–2010: Mobilization and Legitimacy, Continuity and Change*, edited by Peter Aronsson and Gabriella Elgenius, 167–199. London: Routledge. https://doi.org/10.4324/9781315737133.

Audunson, Ragnar, Svanhild Aabø, Roger Blomgren, Hans-Christoph Hobohm, Henrik Jochumsen, Mahmood Khosrowjerdi, Rudolf Mumenthaler et al. 2019. "Public Libraries as Public Sphere Institutions: A Comparative Study of Perceptions of the Public Library's Role in Six European Countries." *Journal of Documentation* 75, no. 6: 1396–1415. https://doi.org/10.1108/JD-02-2019-0015.

Bak, Greg and Pam Armstrong. 2008. "Points of Convergence: Seamless Long-Term Access to Digital Publications and Archival Records at Library and Archives Canada." *Archival Science* 8, no. 4: 279–293.

Bennett, Tony 1995. *The Birth of the Museum: History, Theory, Politics*. London: Routledge.

Berger, Stefan. 2013. "The Role of National Archives in Constructing National Master Narratives in Europe." *Archival Science* 13, no. 1: 1–22.

Brown, Richard Harvey and Beth Davis-Brown. 1998. "The Making of Memory: The Politics of Archives, Libraries and Museums in the Construction of National Consciousness." *History of the Human Sciences* 11, no. 4: 17–32.

Cook, Terry. 2013. "Evidence, Memory, Identity, and Community: Four Shifting Archival Paradigms." *Archival Science* 13, no. 2: 95–120.

Cox, Richard J. and David A. Wallace. 2002. "Introduction." In *Archives and the Public Good: Accountability and Records in Modern Society*, edited by Richard J. Cox and David A. Wallace, 1–18. Westport: Quorum Book.

Delbourgo, James. 2017. *Collecting the World: The Life and Curiosity of Hans Sloane*. London: Penguin UK.

Dempsey, Lorcan. 1999. "Scientific, Industrial, and Cultural Heritage: A Shared Approach." *Ariadne*, Issue 22.

Dilevko, Juris and Lisa Gottlieb. 2003. "Resurrecting a Neglected Idea: The Reintroduction of Library-Museum Hybrids." *The Library Quarterly* 73, no. 2: 160–198.

Duchein, Michel. (1992) "The History of European Archives and the Development of the Archival Profession in Europe." *The American Archivist* 55, no. 1: 14–25.

Duncan, Carol and Alan Wallach. 1980. "The Universal Survey Museum." *Art History* 3, no. 4: 448–469.

Emerek, Leif. 2001. "At skrive bibliotekshistorie: Om grundlæggelsen af det moderne folkebibliotek i Danmark". In *Det siviliserte informasjonssamfunn: Folkebibliotekenes rolle ved inngangen til en digital tid*, edited by Ragnar Audunson and Niels Windfeld Lund, 88–118. Bergen: Fagbokforlaget.

Foucault, Michel. 1986. "Of Other Spaces." *Diacritics* 16, no. 1: 22–27.

Frisvold, Øyvind. 2015. "Da 'biblioteksrevolusjonen' kom til Norge." In *Samle, formidle, dele. 75 år med bibliotekarutdanning*, edited by Ragnar Audunson, 73–89. Oslo: ABM-media.

Giddens, Anthony. 1990. *The Consequences of Modernity*. Stanford, CA: Stanford University Press.

Given, Lisa M. and Lianne McTavish. 2010. "What's Old Is New Again: The Reconvergence of Libraries, Archives, and Museums in the Digital Age." *The Library Quarterly* 80, no. 1: 7–32.

Henningsen, Erik and Håkon Larsen. 2020. "The Digitalization Imperative: Sacralization of Technology in LAM Policies." In *Libraries, Archives and Museums as Democratic Spaces in a Digital Age*, edited by Ragnar Audunson, Herbjørn Andersen, Cicilie Fagerlid, Erik Henningsen, Hans-Christoph Hobohm, Henrik Jochumsen, Håkon Larsen and Tonje Vold, 53–72. Berlin: De Gruyter Saur. https://doi.org/10.1515/9783110636628-003.

Høiback, Harald. 2020. *Kunnskap og begeistring. En innføring i museenes historie, hensikt og virkemåte*. Oslo: Cappelen Damm Akademisk.

Hooper-Greenhill, Eilean. 2004. "Measuring Learning Outcomes in Museums, Archives and Libraries: The Learning Impact Research Project (LIRP)." *International Journal of Heritage Studies* 10, no. 2: 151–174. https://doi.org/10.1080/13527250410001692877.

Huvila, Isto. 2014. "Archives, Libraries and Museums in the Contemporary Society: Perspectives of the Professionals." In *IConference 2014 Proceedings*, 45–64. https://doi.org/10.9776/14032.

Hvenegaard Rasmussen, Casper. 2019. "Is Digitalization the Only Driver of Convergence? Theorizing Relations Between Libraries, Archives, and Museums." *Journal of Documentation* 75, no. 6: 1258–1273. https://doi.org/10.1108/JD-02-2019-0025.

Hvenegaard Rasmussen, Casper and Birger Hjørland. 2021. "Libraries, Archives and Museums (LAM): Conceptual Issues with Focus on their Convergence." *Encyclopedia of Knowledge Organization.*

Hvenegaard Rasmussen, Casper and Henrik Jochumsen. 2007. "Problems and Possibilities: The Public Library in the Borderline between Modernity and Late Modernity." *The Library Quarterly* 77, no. 1: 45–59.

Hylland, Ole Marius. 2019. "ABM-utviklings vekst og fall." *Nordisk kulturpolitisk tidsskrift* 22, no. 2: 257–276. https://doi.org/10.18261/issn.2000-8325/-2019-02-04.

Jochumsen, Henrik, Casper Hvenegaard Rasmussen and Dorte Skot-Hansen. 2012. "The Four Spaces: A New Model for the Public Library." *New Library World* 113, no. 11/12: 586–597. https://doi.org/10.1108/03074801211282948.

Kann-Rasmussen, Nanna. (2019). "The Collaborating Cultural Organization: Legitimation through Partnerships." *The Journal of Arts Management, Law, and Society* 49, no. 5: 307–323.

Kant, Immanuel. (1996). "An Answer to the Question: What Is Enlightenment?" In *What Is Enlightenment? Eighteenth-century Answers and Twentieth-century Questions,* edited by J. Schmidt, 58–64. Berkeley: University of California Press.

Larsen, Håkon. 2018. "Archives, Libraries and Museums in the Nordic Model of the Public Sphere." *Journal of Documentation* 74, no. 1: 187–194. https://doi.org/10.1108/JD-12-2016-0148.

Mangset, Per, Anita Kangas, Dorte Skot-Hansen and Geir Vestheim. 2008. "Nordic Cultural Policy." *International Journal of Cultural Policy* 14, no. 1: 1–5. https://doi.org/10.1080/10286630701856435.

Marcum, Deanna. 2014. "Archives, Libraries, Museums: Coming Back Together?" *Information & Culture: A Journal of History* 49, no. 1: 74–89.

Marty, Paul F. 2014. "Digital Convergence and the Information Profession in Cultural Heritage Organizations: Reconciling Internal and External Demands." *Library Trends* 62, no. 3: 613–627.

Mordhorst, Camilla and Kitte Wagner Nielsen. 1997. "Formens semantik: En teori om den kulturhistoriske udstilling." *Nordisk Museologi,* no. 1: 3–18.

Pastore, Erica. 2009. *The Future of Museums and Libraries: A Discussion Guide.* Washington, DC: Institute of Museum and Library Services.

Pedersén, Olof. 2005. "De äldsta biblioteken – lertavlor med kilskriftstext." *Tvärsnitt* 3: 2–6.

Rayward, W. Boyd. 1998. "Electronic Information and the Functional Integration of Libraries, Museums, and Archives." In *History and Electronic Artefacts,* edited by E. Higgs, 207–226. Oxford: Clarendon Press.

Robinson, Helena. 2019. *Interpreting Objects in the Hybrid Museum: Convergence, Collections and Cultural Policy.* London: Routledge.

Roppola, Tiina. 2012. *Designing for the Museum Visitor Experience.* London: Routledge.

Skare, Roswitha, Sigrid Stokstad and Andreas Vårheim. 2019. "ABM-utvikling og avvikling: Institusjonell konvergens og divergens i kulturpolitikken." *Nordisk Kulturpolitisk Tidsskrift* 22, no. 2: 231–256. https://doi.org/10.18261/issn.2000-8325/-2019-02-03.

Smith, Philip 2001. *Cultural Theory: An Introduction.* Malden, MA: Blackwell.

Steenberg, Andreas Schack. 1900. *Folkebogssamlinger: Deres Historie og Indretning.* Aarhus: Jysk Forlagsforretning.

Tanackovic, Sanjica Faletar and Boris Badurina. 2009. "Collaboration of Croatian Cultural Heritage Institutions: Experiences from Museums." *Museum Management and Curatorship* 24, no. 4: 299–321. https://doi.org/10.1080/09647770903314696.

Torstensson, Magnus. 1993. "Is There a Nordic Public Library Model?" *Libraries & Culture* 28, no. 1: 59–76.

Valtysson, Bjarki. 2012. "EUROPEANA: The Digital Construction of Europe's Collective Memory." *Information, Communication & Society* 15, no. 2: 151–170. https://doi.org/10.1080/1369118X.2011.586433.

Vestheim, Geir. 1997. *Fornuft, kultur og velferd: Ein historisk-sosiologisk studie av norsk folkebibliotekpolitikk.* Oslo: Det Norske Samlaget.

Weil, Stephen. 1999. "From Being about Something to Being for Somebody: The Ongoing Transformation of the American Museum. (What Is Emerging Is a More Entrepreneurial Institution)." *Daedalus* 128, no. 3: 229–258.

Zafirovski, Milan. 2010. *The Enlightenment and Its Effects on Modern Society.* Berlin: Springer Science & Business Media.

Libraries, Archives, and Museums in Scandinavia

History and Policy

2

LIBRARY HISTORY OF THE SCANDINAVIAN COUNTRIES

Ragnar Audunson, Henrik Jochumsen, and Kerstin Rydbeck

Introduction

Scandinavian libraries have been shaped and formed by social, political, professional, and technological trends over the past 200 years. Some of these trends represent profound developments affecting all societies and all social fields, for example, the Age of Enlightenment and the growth of scientific thinking and modern universities from the eighteenth century and onwards. Other examples include industrialization, technological developments – from the printing press and the steam engine to social media and the Internet – and finally globalization with its migration and growth of global culture.

Some trends have a Scandinavian character, for example, the growth of the Scandinavian social democratic welfare state during the twentieth century (Engelstad, Larsen, and Rogstad 2017; Larsen 2018), whereas others are of a more national character, for example, the historical coincidence that the public library reform in Norway was implemented at the turn of the twentieth century at the same time as Norway was struggling for full independence for the first time in more than 400 years.

Some trends, finally, are related to the professional field of librarianship, for example, the decisive influence that German university libraries after the Humboldtian university reforms had on academic libraries and the profound impact of the Anglo-American public library model on public library developments.

In this chapter, we analyze the history of Scandinavian libraries and librarianship in relation to such developmental trends. Important questions include how the different formative eras referred to above have left their traces on libraries and whether we can identify a Scandinavian library model.

DOI: 10.4324/9781003188834-3

1800–1900: The birth of modern libraries

Although Denmark and Sweden had universities and university libraries going back to the fifteenth century and national libraries were established in the middle of the seventeenth century, it seems fair to link the birth of modern libraries to the Age of Enlightenment and the growth of a bourgeois public sphere. In the three Scandinavian countries, these developments were triggered at the end of the eighteenth and the beginning of the nineteenth century (Josephson, Karlsohn, and Östling 2014). This period saw the establishment of the Humboldtian university model where knowledge and the scientific search for knowledge was the ultimate value. This ideal started to permeate the Nordic universities – the universities in Uppsala and Lund in Sweden, Copenhagen in Denmark, and, from 1811, the university in Kristiania, later Oslo, in Norway. The growth of modern national libraries based on legal deposit laws and with the mandate of documenting the national literature, not the censorship needs of an absolute ruler, can also be traced back to the Age of Enlightenment (Henden 2017).

A scientific community presupposed access to research. Research-based literature and universalistic university libraries striving to cover all scientific fields and give access to the latest achievements in research were established in all the Scandinavian countries, very much based on the German library model developed at the University of Göttingen in the last half of the eighteenth century (Frisvold 2021). Universal acquisition to cover the research needs of the university professors was a central part of this model. University librarians were supposed to have professional backgrounds from scientific disciplines taught and researched at the university the library served. This model structured the development of the university libraries throughout the nineteenth and the greater part of the twentieth century. From the very few and very small university libraries of the nineteenth century with only a handful of employees to the more numerous and larger libraries towards the middle of the twentieth century, a clear continuity can be identified stemming from this model.

One important dimension in the Age of Enlightenment was the growth of a bourgeois public sphere with a deliberating public discussing cultural, political, and scientific issues. Reading societies, which provided their members with books and where the informed citizenry met and discussed, existed in all the Scandinavian countries.

Educating the lower classes was also an integrated part of enlightenment, and libraries providing the peasants with useful books, e.g., new and modern modes of production, were established by utilitaristic clergymen in the first few decades of the nineteenth century. From the 1830s, parish libraries with the underprivileged classes as their target groups became more numerous. They had a paternalistic profile and were often financed by altruistic organizations such as the Royal Norwegian Society for Development, the Swedish Society for Diffusion of Useful Knowledge, and the Society for the Proper Use of the Liberty of the Press in Denmark. Toward the end of the nineteenth century, a close connection

between these parish libraries and elementary schools developed. At least half of all the parishes in Denmark, Sweden, and Norway had libraries around 1870 (Torstensson 1993).

The last decades of the nineteenth century also saw the development of an organized and increasingly self-conscious labor movement. Trade unions, which would come to play a decisive role in the Nordic model, grew rapidly. Also, other mass movements, such as the temperance movement, became important. Many of them prioritized enlightenment and cultural initiatives in the form of libraries established and run by the movements and, as time went on, study circles (Rydbeck 1995).

By the end of the nineteenth century, then, the situation could be summarized as follows:

- University libraries firmly based on a model, which would structure these libraries well into the last half of the twentieth century, were established in all the countries.
- A national library function based on legal deposit legislation and producing national bibliographic tools was established in all three countries.
- Libraries for common and underprivileged people, often with a paternalistic profile, with very limited resources and without professional staff, were to be found in the majority of municipalities. In a short time, these libraries would be overrun by the public library revolution.
- Popular social movements, first and foremost the labor movement, which regarded access to culture, knowledge, and literature as vital in their project of liberating ordinary people and elevating them socially, started to enter the scene.

1900–1945: Modernization, mass culture, and democracy

The decades from 1900 until 1940 were a period of revolutionary change politically, socially, and technologically. Voting rights were expanded to include all adults. In the Scandinavian countries, implementing voting rights for all was concluded in 1913 (Norway), 1915 (Denmark), and 1921 (Sweden). Mass organizations and movements in sports, working life, and culture with the capacity to mobilize hundreds of thousands of citizens and channel their interests and points of view from the grassroots level to the decision-making echelons in society were established during this period. Commercial mass culture and means of mass communication such as broadcasting, the movie and music industry, and newspapers with a mass circulation were developed. Industrialization exploded. In the Scandinavian countries, the labor movement, with the social democratic parties as its political wing, became dominant and came into government in all three countries between 1930 and 1940, signaling the start of the process toward a welfare state – a people's home – encompassing all social strata, going beyond the concept of a working class-based democracy (Friberg 2014).

This concept made the idea of public librarianship, also focused upon the public as a whole and not specific classes or groups, very relevant. It was a time when rationality, engineering, and scientific approaches started to permeate all fields of life from family planning via urban planning and scientifically based industrial and agricultural production to social engineering, sometimes in perverted forms as exemplified by the influence that eugenics had in broad circles. The extension of democracy was paralleled by authoritarian and oppressive fascist, Nazist, and Stalinist regimes in other parts of Europe, giving a new vitality to the democratic role of libraries (Harris 1978). Within this context of technological, social, and cultural change, modern librarianship developed.

Modernization and the growing role of science and academic libraries

The rapid and profound modernization process, which took place after the turn of the century, presupposed advanced knowledge and research. Universities expanded and new institutions at university level were established, often in professional sciences. The number of students, which at the turn of the century was not very much more than 1,000 at the major universities in the three countries, grew by several hundred percent in the decades leading up to World War II. Nevertheless, only a very small margin – from 1% to 2% – of each yearly cohort would reach that educational level. However, initiatives were taken to open up education to gifted young people from more modest backgrounds.

As universities expanded, so did university libraries. Collections, staff, and the number of users grew. New buildings were inaugurated. The academic libraries, however, expanded and developed within the German university library tradition of the late eighteenth and early nineteenth century. Librarians were recruited from among university graduates who went through an internal apprenticeship. Stacks were closed. Services were targeted towards the needs of the university professors, and the proximity between librarians and the professors they should serve was very close – a trait that today is regarded as modern and innovative (embedded librarianship).

The early institutionalization of public libraries 1900–1940

While the academic libraries expanded and developed within a professional framework established more than 100 years earlier, the public library revolution implemented around the turn of the century in all three countries meant a break with earlier models of libraries for the general public.

The Anglo-American public library model was implemented and institutionalized in the three Scandinavian countries more or less simultaneously and in very parallel ways, albeit with some national differences. In all the Scandinavian countries, the so-called "library" revolution is linked to entrepreneurial personalities who played vital roles in triggering the development:

Haakon Nyhuus in Norway, Andreas Schack Steenberg in Denmark, and Valfrid Palmgren in Sweden (Torstensson 1993; Dahlkild and Bille Larsen, I 2021; Frisvold 2021).

The public library movement was built on the following basic principles:

1 Libraries were for the general public, not for specific groups, e.g., the poorer classes.
2 The principle of free borrowing was established as a mainstay in the professional ideology.
3 From early on, services to children were integrated into the public library model.
4 The collections were presented and made accessible on open shelves.
5 Active mediation and outreach initiatives were taken.
6 Although education and enlightenment were the primary purposes of public libraries, the role and importance of entertainment and leisure time reading was recognized – if not as a goal in its own right, as an instrument to promote educational literature.
7 Promoting social mobility and self-development was an important goal.

The public library revolution was vital in establishing librarianship as a professional, political, and administrative field, and it was vital in promoting a reading public due to the immense growth in the number of users and the lending figures it led to compared to earlier libraries for common people. While the development of academic libraries represented continuity from the previous century, the Anglo-American public library model represented a completely new paradigm and a break with former traditions.

In the course of the first two decades, in all three countries, important milestones such as the establishment of earmarked state grants to public libraries, professional journals, national professional library meetings, and library associations were passed. Denmark deviated from the other two in adopting a library law and establishing a state directorate for public libraries as early as in 1920. Norway got its first library law in 1935 but Sweden had to wait until the end of the century – 1997.

Dahlkild and Bille Larsen describe the development of Danish public libraries after the adoption of the library law in 1920 and up to 1940 as dynamic: The state directorate was given a relatively strong mandate. A number of new library buildings were erected, public libraries were to be found in most municipalities by the end of the period, and a library education was established. They conclude that at the outbreak of World War II, Denmark had a fully developed public library system lying at the forefront internationally (Dahlkild and Bille Larsen, II 2021).

One particular trait in Sweden during this period was the growth and importance of study circle libraries, linked primarily to the temperance and the labor movement's free educational work. In the late 1930s, there were more than 5,500

such study circle libraries in the country, mostly in rural and smaller urban areas (Berg and Edquist 2017, 98–99). Toward the end of the 1940s, more than a third of the Swedish municipalities still did not have a municipal public library, and a study circle library then generally ran the public library service (Frenander 2012, 28–41). Gradually, however, the study circle libraries merged with the libraries run by the municipalities.

At the outbreak of World War II, then, the foundations for a political, administrative, and professional library field were laid in all three countries and library schools were established. Of the three countries, Denmark had the most strongly institutionalized public library network.

The era of the welfare state and libraries: 1945–1975

Expansion of universities and changing roles of academic libraries

Equalizing access to higher education was a major goal for the social democratic governments that were in power in all the Scandinavian countries after 1945. Simultaneously, this was also a period valuing rationality and engineering, and thus education, in all walks of life. Initiatives to give young people coming from a working-class or agricultural background access to education, e.g., the establishment of the Norwegian State Educational Loan Fund in 1947 offering state-provided loans to students, were taken. Denmark and Sweden followed some years later. Free hands, however, were needed in the reconstruction and industrialization of the countries. Directing resources to solve the acute housing problems that people experienced in the late 1940s and the 1950s took priority over using the same resources to build new university and college campuses or, for that matter, libraries. The number of students was relatively stable between 1945 and 1960. University libraries were still institutions first and foremost serving the needs of the professors in addition to this thin layer of students.

However, the educational system below university level, including upper secondary education, expanded. At the beginning of the 1960s, this implied a growth in the number of young people who met university enrollment requirements. In the decade between 1960 and 1970, the number of university students exploded by between 300% and 400% in all of the countries. In addition, the process of integrating hitherto vocational education areas, e.g., nursing, social work, teacher training, and librarianship, into the system of academic education added to the explosion. The universities and colleges thus changed from being for the elite into mass universities, which in the course of a relatively few years had hundreds of thousands of students.

The development of higher education also changed the roles and usage of academic libraries. New universities and colleges were created, which meant that the number of academic libraries increased – and thereby also the need for new, competent library staff. It was too resource-intensive and time-consuming for the academic libraries to train their own staff in this new situation. And

last but not least, the competence needs changed at the academic libraries as a consequence of the transformation from elite to mass universities. Practically simultaneously, around 1970, the library education in the three countries established educational programs for academic librarians. Simultaneously with the growth in the number of students came a demand for the abolition of professor rule and changes in teaching following the youth rebellion. This development meant that both lending and staffing in the research libraries increased fivefold from 1945 to 1970 (Dahlkild and Bille Larsen, II 2021, 196–216).

These developments and the consequences they had for academic librarianship meant a qualitative change in academic libraries and a departure from the 200-year-old Göttingen model, which can be paralleled to the public library revolution that took place in the other branch of librarianship some 60 years before.

Cultural democracy and the expansion of public libraries

As stated above, reconstructing the economy after five years of occupation was the main priority in Denmark and Norway in the period immediately after the end of World War II. The situation in Sweden, which had succeeded in staying neutral during the war and in keeping its economic capacity intact, was somewhat different. Although priority had been given to reconstruction and developing the industrial capacity, promoting democratic access to culture in all three countries was seen as vital in developing the welfare state, democracy, and ordinary people's quality of life – a common vision in all three Scandinavian countries. The task was seen as giving common people access to high culture. Institutions serving such needs in the different cultural fields – theater, music, art, and movies – were established in all the countries, and policy documents for a democratic cultural policy were formulated immediately after the war, e.g., the Letter of Culture (Kulturbrevet) in Norway, a document elaborated by broad segments within the cultural field, and the pamphlet Democracy's Demands to Libraries in Denmark (Dahlkild and Bille Larsen, II 2021; Frisvold 2021).

The development of public libraries must be seen in this context of a policy for cultural democracy. Public libraries were an integral part of this policy of cultural democracy. The pamphlet Democracy's Demands to Libraries explicitly saw the democratic role of libraries as vital and deeply intertwined with the restoration of democracy. The document even called for citizen participation in the governance of libraries through so-called "users' councils" – an approach regarded today as innovative and modern (Dahlkild and Bille Larsen, II 2021).

Public libraries in Denmark, Norway, and Sweden embarked upon the postwar period from different positions. In Denmark, a solid platform had been established in the interwar period following the adoption of the library law in 2020. That platform remained relatively intact during the war. Norwegian libraries were harder hit. Fifty libraries, mainly in the northernmost parts of the country, were destroyed (Frisvold 2021). The library office in the responsible ministry

estimated that reorganization would take years. Sweden succeeded in staying out of the war and was consequently less affected.

In all of the Scandinavian countries, public libraries were owned, financed, and run by the local governments. The Danish library from 1920 and the new Norwegian law adopted in 1947 made it compulsory for local governments to have a public library and also defined minimum grants to be allocated to the local libraries. Both countries established a state directorate to coordinate central library policies and to see to it that the law was complied with by the municipalities. Sweden had neither a library law nor a state directorate. At state level in Sweden, public library work was regarded primarily as part of the work for public enlightenment. Consequently, the National Board of Education (Skolöverstyrelsen) handled the public library issues. In the early 1970s, however, this changed as a consequence of the new cultural policy. From now on, public libraries (including school libraries) were first and foremost considered as cultural institutions, and the national responsibility was handed over to the new Swedish Arts Council. In 2010, it changed again, and since then the Royal library has been responsible for the whole library sector, but still with the Ministry of Culture as responsible for the national library policy (Thomas 2009; Rydbeck 2022).

In spite of the differences between Sweden and the two other countries as far as legislation and a state directorate were concerned, all the countries had a system with earmarked state grants in the first few decades after 1945.

In all three countries, the municipalities responsible for libraries in general were very small and had limited resources. However, during these years, there were several mergers of municipalities. In Norway, a wave of mergers took place in the last half of the 1960s. In Denmark, the most important reform was implemented in 1970. In Sweden, the most important reforms took place in 1952 and in 1971. In Denmark and Sweden, but not so much in Norway, these reforms made the remaining municipalities larger and financially stronger, and increased their opportunities to develop the public library services. Consequently, the collections grew, the number of professionally trained staff increased, new library buildings were built, new branches opened, and outreach activities began to develop. Norway deviated somewhat from Denmark and Sweden, and still has a very high number of very small municipalities and thus a much higher proportion of very small libraries with short opening hours and a part-time librarian without professional education.

Around 1950, all the Scandinavian countries had a two-layer system with municipal libraries and a network of county libraries. The role of the county libraries was partly professional counseling, partly to supplement local collections, and partly to facilitate cooperation and inter-library lending. In addition, Denmark and Norway had a national level in the state directorates. The state level in all the countries, however, actively stimulated local libraries via earmarked grants and organizational initiatives, e.g., three national lending centers that were created in the 1960s by the Swedish state in different parts of the country, as the last link in the public libraries' media supply (Thomas 2009).

Although ambitious library plans were developed in Denmark and Norway immediately after World War II, as stated above, other needs did not give very much room for costly library initiatives. That was a bit different in Sweden, and 75% of Swedish municipalities received new library buildings between 1947 and 1963 (Torstensson 1993, 59). The economic growth in the late 1950s and early 1960s, however, created new openings for a similar development in Denmark and Norway. The modernization and investment in public libraries in the Scandinavian countries during the 1960s provided inspiration for the library development in the United Kingdom (Black 2011).

Of particular importance was the Danish library law from 1964. In addition to preserving the principle of making libraries a mandatory municipal institution, the principle of free borrowing on a national level, meaning that everyone living in the country can lend freely at any library, was explicitly stated in the law. The law required all larger municipalities to have a library-trained leader. The law also contained financial provisions where municipal grants to public libraries generated state grants, thus stimulating local authorities to increase allocations to libraries; it also expanded the mission of public libraries beyond the promotion of books and reading, opening up for other media and the promotion of cultural activities in a broader sense.

Norway limped a bit after Denmark and Sweden. The law triggering the modernization of Norwegian public libraries was adopted by the parliament in 1971, and implemented in 1972. The Danish law of 1964 heavily influenced this law. The purpose of libraries was practically identical, opening up for other media than printed ones and a broader perspective on cultural activities, indicating the close links in Scandinavian librarianship. Requirements regarding professional education were formulated. In order to receive earmarked state grants for libraries, local governments had to comply with regulations specified by the state directorate regarding, for example, the standard of the library premises. Although Norway throughout the period has been lagging somewhat behind its Scandinavian neighbors as far as running costs per capita for public libraries and figures for lending and library use are concerned, there can be no doubt that the 1971 law initiated a significant development in Norwegian public libraries.

The expansion of the public libraries in the Scandinavian countries must be seen in close connection with the so-called "new cultural policy" in the 1960s and 1970s. In Denmark, the establishment of the Danish Ministry of Culture in 1961 was a milestone. In Norway, the governmental white paper from the early 1970s and the development of municipal cultural administrations following in its wake represented a similar milestone. In Sweden, the new cultural policy was approved by the parliament in 1974. These policies were based on a strategy to democratize culture by making it accessible to the entire population regardless of social background or geographical location (Nilsson 2003, 231–255). This welfare-oriented cultural policy vision was not only expressed in the expansion of the number of new libraries but also in the growth of new media, such as gramophone records in the collections and in a wide range of cultural activities

in the libraries in the form of, for example, children's theater, film screenings, and exhibitions (Ørom 2005; Jochumsen and Hvenegaard Rasmussen 2006; Hedemark 2009). This development caused librarians to add new and more popular cultural media to the libraries' collections and to prioritize the representation of more marginalized cultural forms such as women's culture and workers' culture in the libraries.

Another feature toward the end of this period was the changing relationship between the state and local governments. During the first few decades after 1945, all three countries had a system with earmarked grants, giving the state opportunities to guide and shape local library policies directly. Comply, or we take away the grants! Gradually earmarked grants were supplanted by block grants, which the local government could use according to its own priorities. Sweden was first, with this switch taking place there in 1965.

One interesting feature that is particular for Scandinavia is the library's role as a tool for supporting a national production of literature in these relatively small language communities. Both Norway and Sweden have arrangements where the state buys a certain number of copies of published books deemed to be of a satisfactory quality and distributes them for free to the public libraries. All the countries have arrangements where authors are compensated for the use of their works in libraries.

Three trends were central in the period 1945–1975:

1 An expansion of libraries within a political context aimed at democratizing access to cultural experiences, from the middle of the 1960s supplemented with a policy for cultural democracy meaning broadening cultural forms, activities, and media to be integrated (Vestheim 1997).
2 A professionalization of the field. The role of professionally educated librarians increased (Audunson 2015).
3 The start of a development, first in Sweden, from a state intervening and steering directly via earmarked grants to a state relying on indicative and indirect guidance via the change from earmarked grants to block grants.

The comeback of the market, digitization, and libraries: 1975–2000

At the beginning of the 1980s, the financial boom that was a significant factor in the Scandinavian expansion of the welfare state in previous decades was replaced by a financial crisis. In the late 1970s and early 1980s, Sweden, followed by Denmark and Norway, respectively, got new right-wing governments, whose goal was to reform, modernize, and rationalize and to some extent privatize the welfare state. This had to be done through decentralization, market management, and increased efficiency – or in other words: new public management. For the public libraries, this meant staff reductions, restrictions on opening hours, closures of branches, and cuts in the material budget.

When the first library law was finally accepted by the Swedish parliament in 1996, it was a consequence of the deteriorating economic situation of the municipalities. Combined with the neoliberal spirit, ideas arose among both municipal and national politicians about privatizing public library activities and introducing fees on book loans. One municipality tried to outsource the public library services, but the experiment ended in disaster: After only one year, the company went bankrupt and the municipality had to take back the responsibility. This first attempt, however, was followed in some other municipalities during the 1990s, with better results (Hansson and Heedman 2004, 4; Hedemark 2009, 101–105; Lindberg 2015, 3–4).

The development made the government and the parliament finally realize the need for legislation. The new library act, implemented in 1997, focused mainly on the public libraries (SFS 1996:1596). It established that there had to be public libraries in all municipalities where the inhabitants could borrow books free of charge, and that the responsibility for this lay with the municipality. The public libraries would also provide computerized information and pay special attention to the needs of certain specified groups such as children and young people, the disabled, and immigrants. The library law established the right to library services, but did not say how to meet the requirements. And there was nothing about staffing or the competence of the staff.

But the law also focused to some extent on the research libraries. It was stated that there should be libraries at all universities and colleges, and that this was the responsibility of the state. There were also demands for collaboration between public and research libraries. The act stated that research libraries had to make literature from their collections available to the public libraries free of charge, and to assist them in their efforts to provide users with a good library service. The Library Act very much regarded public and research libraries as one joint national library resource.

Up until 1983, the Danish state had reimbursed the municipalities half of their expenses for public libraries. Thereafter the libraries became part of the municipal block grants, and as such, they had to live with the uncertainty associated with being dependent on municipal priorities. Norway introduced the same system in connection with a revision of the law on public libraries in 1985. As previously mentioned, Sweden had already introduced block grants in 1965.

The public libraries' response to this development was, among other things, to move in new directions. One of these was to make different approaches to the private business sector by establishing information services and business services in the libraries. The attention paid to the business community could also be seen as a sign that a generally more market-oriented way of thinking began to gain a foothold in public libraries. This was reflected by the fact that librarians now often referred to the library's users as "customers," just as the choice of material became more demand-oriented.

At the same time, the public libraries were positioning themselves as important institutions when it came to counteracting the risk of a division of the

population into an information technology A and B team, which at the time received great political attention. The libraries were also implementing their potential concerning the increasing number of ethnic minorities who became part of the population. The main traits of the library model proved resilient in its meeting of neoliberalism challenges in the 1980s and 1990s, questioning the principle of free services and library services as a universal and publicly financed welfare arrangement.

Conclusion

The different formative eras from the Enlightenment to the Internet, globalization, and social media have definitely all left their traces on Scandinavian librarianship. Studying libraries is like doing an archeological study uncovering still existing layers reflecting all these periods. Two trends have, however, proved to be particularly profound and resilient: The traditions from the early nineteenth century, which have structured academic librarianship, and the ideas of the public library revolution of the early twentieth century. In spite of many predictions (e.g., Nicholas 2012) that libraries will become irrelevant and obsolete, libraries seem to have succeeded in adapting to political, social, and technological changes based on their traditional platform, remain relevant, and survive as libraries recognizable as such.

Throughout the twentieth century, there has been a marked dualism in librarianship between academic libraries and public libraries. During the last few decades of that century, there seems to have been a process of convergence: The development of universities from elite institutions to mass institutions has led university libraries to adopt working methods similar to those found in public libraries, e.g., as meeting places and arenas for public debate.

In the twentieth century, both public libraries and academic libraries developed within the framework of the Scandinavian social democratic welfare state based on equal access to basic services such as education, health, housing, and culture. One can talk of a Scandinavian or Nordic library model (Torstensson 2009). Neoliberalism challenged that model and, to varying degrees in the three countries, led to elements of privatization and market solutions in all the traditional fields of welfare. One can, however, maintain that the Scandinavian model has survived within the field of librarianship.

References

Audunson, Ragnar. 2015. "Bibliotekarene – en profesjon under press? Institusjonalisering, de-institusjonalisering og re-institusjonalisering av et profesjonelt felt." In *Samle, formidle, dele: 75 år med bibliotekarutdanning*, edited by Ragnar Audunson, 47–71. Oslo: ABM-media.

Berg, Anne and Samuel Edquist. 2017. *The Capitalist State and the Construction of Civil Society: Public Funding and the Regulations of Popular Education in Sweden, 1870–1991*. Palgrave Macmillan. https://doi.org/10.1007/978-3-319-52455-9.

Black, Alistair. 2011. "'New Beauties': The Design of British Public Library Buildings in the 1960s." *Library Trends* 60, no. 1: 71–111.

Dahlkild, Nan and Steen Bille Larsen, eds. 2021. *Dansk bibliotekshistorie.* I: *Biblioteker for de få: tiden før 1920* and II: *Biblioteker for alle: tiden efter 1920.* Aarhus: Aarhus universitetsforlag.

Engelstad, Fredrik, Håkon Larsen and Jon Rogstad. 2017. "The Public Sphere in the Nordic Model." In *Institutional Change in the Public Sphere: Views on the Nordic Model,* edited by Fredrik Engelstad, Håkon Larsen, Jon Rogstad, and Kari Steen-Johnsen, 46–70. DeGruyter Open. https://doi.org/10.1515/9783110546330-004.

Frenander, Anders. 2012. "Statens förhållande till folkbiblioteken, 1912–2012." In *Styra eller stödja? Svensk folkbibliotekspolitik under hundra år,* edited by Anders Frenander and Jenny Lindberg, 15–88. Borås: Borås University.

Friberg, Anna. 2014. "Folkhemmets demokrati – en analys av den svenska socialdemokratins språkbruk kring demokratiska deltagandeformer." In: *Slagmark – Tidsskrift for idéhistorie,* no. 69: 89–104. https://doi.org/10.7146/sl.v0i69.104324.

Frisvold, Øivind. 2021. *Kunnskap er makt: norsk bibliotekshistorie – kultur, politikk og samfunn.* Oslo: ABM-media.

Hansson, Johanna and Julia Heedman. 2004. *Privatisering av folkbibliotek – skildrat i politiska dokument under 1990-talet.* Borås: Borås University.

Harris, Michael H. 1978. "The Purpose of the American Public Library: A Revisionist Interpretation of History." In *Public Library Purpose,* edited by Barry Totterdell, 39–51. London: Bingley.

Hedemark, Åse. 2009. "Det föreställda folkbiblioteket: en diskursanalytisk studie av biblioteksdebatter i svenska medier 1970–2006." PhD diss., Uppsala: Uppsala University.

Henden, Johan. 2017. "Det er ikke alene et Universitets-, men også et Nationalbibliothek: Axel Charlot Drolsum i universitetsbiblioteket 1870–1922." PhD diss., Trondheim: NTNU, Norwegian University for Science and Technology.

Jochumsen, Henrik and Casper Hvenegaard Rasmussen. 2006. *Folkebiblioteket under forandring: Modernitet, felt og diskurs.* Copenhagen: Danmarks bibliotekforening and Danmarks bibliotekskole.

Josephson, Peter, Thomas Karlsohn, and Johan Östling. 2014. "Introduction: The Humboldtian Tradition and its Transformation." In *The Humboldtian Tradition: Origins and Legacies,* edited by Peter Josephson, Thomas Karlsohn and Johan Östling, 1–18. Leiden/Boston: Brill Academic Publishers.

Larsen, Håkon. 2018. "Archives, Libraries and Museums in the Nordic Model of the Public Sphere." *Journal of Documentation* 74, no. 1: 187–194.

Lindberg, Annica. 2015. "'Vi har ju vår yrkesstolthet': folkbibliotekariers föreställningar om samt upplevelser av folkbibliotek på entreprenad." MA thesis, Borås: Borås University.

Nicholas, Davis. 2012. "Disintermediated, decoupled and down." *CILIP Update* 29–31.

Nilsson, Sven. 2003. *Kulturens nya vägar: kultur, kulturpolitik och kulturutveckling i Sverige.* Malmö: Polyvalent.

Ørom, Anders. 2005. "Folkebiblioteket i samfundet: Et rids af 100 års historie." In *Det stærke folkebibliotek – 100 år med Danmarks Biblioteksforening,* edited by Martin Dyrbye, Jørgen Svane-Mikkelsen, Leif Lørring, and Anders Ørom, 9–37. Copenhagen: Danmarks Biblioteksforening.

Rydbeck, Kerstin. 1995. "Nykter läsning: den svenska godtemplarrörelsen och litteraturen 1896–1925." PhD diss., Uppsala: Uppsala University.

Rydbeck, Kerstin. 2022. "Lagstiftning och styrdokument för de offentliga biblioteken." In *Biblioteksgeografin: en antologi om svenskt biblioteksväsende och om biblioteksforskning,*

edited by Roger Blomgren, Katarina Michnik och Johan Sundeen, 49–83. Lund: Studentlitteratur.

SFS. 1996:1596. *Bibliotekslag.*

Thomas, Barbro. 2009. *Bibliotekslagstiftning: perspektiv och exempel.* Stockholm: Svensk biblioteksförening.

Torstensson, Magnus. 1993. Is there a Nordic Public Library Model? *Libraries and Culture,* 28, no. 1: 59–76.

Torstensson, Magnus. 2009. "Library Spirit in the Baltic-Nordic Region: Comparative Analysis." In *Library Spirit in the Nordic and Baltic Countries: Historical Perspectives,* edited by Martin Dyrbye, Ilkka Mäkinen, Tiiu Reimo, and Magnus Torstensson, 183–186. Tampere: Hibolire.

Vestheim, Geir. 1997. *Fornuft, kultur og velferd: ein historisk-sosiologisk studie av norsk folkebibliotekpolitikk.* Oslo: Norske samlaget.

3

THE HISTORY OF ARCHIVES IN SCANDINAVIA

Samuel Edquist, Leiv Bjelland, and Lars-Erik Hansen

Introduction

"Archives were not drawn up in the interest or for the information of posterity."
Even if not entirely true, this famous quote by English archivist Hilary Jenkinson
(1922, 11) points out that archival documents – records – are normally created as a
byproduct, and for the benefit, of an organization's administrative functions, not
for the assistance of some historian or genealogist 150 years later. Nonetheless,
the latter "secondary" uses of archives are what springs to mind when the gen-
eral public think about archives. As sites of cultural heritage, archives are aligned
with libraries and museums. But to fully appreciate archives as heritage, we also
need to understand that records more often than not are created and preserved
for the benefit of the original creator.

To a large degree, the development of Scandinavian archives resembles that in
the rest of Europe. Many of the tendencies are similar, which is why it is also nat-
ural to present the different Scandinavian archival histories in one piece, while
highlighting the differences that are still found.

In the following historical overview of Scandinavian archives, the main focus
will lie on the modern state institutions, since they have until now dominated
the archival landscape. Until the end of the twentieth century, the state sector in
Denmark had a near monopoly on organized archival institutions (Bundsgaard
and Gelting 1992). In Norway and Sweden, the state sector has also been domi-
nant, and both archival policy and the profession have largely been shaped in the
mold of state archives. Archival legislation has mainly concerned state archives.
However, since the nineteenth century and particularly in recent decades, the
archival sector in municipalities and the private archival sector have been thriv-
ing. We will therefore treat them separately after the general chronological sur-
vey to which we now turn.

DOI: 10.4324/9781003188834-4

Medieval and early-modern Scandinavian archives

If we exclude prehistoric rock carvings and runestones, which may be seen as documentary evidence, the dawn of Scandinavian archives occurred in the thirteenth and fourteenth centuries. Initially, they were records of the king, often moving from castle to castle. Archiving before the nineteenth century was almost exclusively an integrated part of the administrative and legal functions of states, cities, religious organizations, or aristocratic families. Some records, documenting e.g. land ownership, debt, and treaties, could be relevant over the passage of many generations (Duchein 1992; Jørgensen 1968).

In Sweden and Denmark, central state archival institutions were established in the seventeenth century as parts of the growing early-modern state apparatuses. The uses of archives were still mainly for legal and administrative reasons, but they were also utilized in the proto-nationalist historiography of the early-modern states. In Denmark, a separate institution was established in 1663 for records of a legal and long-lasting nature, not crucial for the daily matter of affairs, which had been kept separately since the fourteenth century from more temporary records. These historical archives came to be known as the "Secret Archive" and developed into a resource for historical research during the eighteenth century (Kjölstad 2012; Paasch 2018). In Sweden, the predecessor of the National Archives was established in 1618 as a function within the Royal Chancellery. Internal regulations ensured that records were kept and archived in an orderly way (Smedberg 2012). In Norway, a royal archival repository was located at Akershus fortress from around 1300 AD. For about 400 years until 1814, Norway was subordinated to Denmark, and Akershus fortress became an archive for the Danish king's representative in Norway. Many records on Norwegian affairs were also transferred to Copenhagen (Jørgensen 1968, 175–176).

The historical turn and nation building

If the legal and administrative aspect of archives had dominated until the eighteenth century, a new role rose to prominence with the modern era. While the records creators' primary interests remained crucial and still are today, external agents' interests in archives became more prominent, in two ways: First, what we now call "freedom of information" interests – famously put in effect with the French Revolution, when access to public archives was proclaimed a general civic right (Duchein 1992, 17); secondly, the generally growing interest in history within societies at large also affected archives: They were largely transformed into tools of academic historiography, and archives became part of nation building and similar forms of identity politics during the nineteenth century (Berger 2013; Cook 2013). At the same time, state archives in Europe, including Scandinavia, increased in organizational size and complexity, and emerged as independent institutions. They also increasingly became more accessible to external users – primarily historians.

Simultaneously, a modern archivist profession emerged, largely recruited from historians, and the two groups maintained close bonds long into the twentieth century in all Scandinavian countries, just as in other Western countries (Ridener 2009).

In Sweden, the National Archives developed into a central archival repository of the state, especially from the 1830s. The new and more historical dimension of the National Archives was increasingly emphasized, in line with traditional administrative functions. There was an increase in the number of employees, and efforts were made to arrange and describe old records that had remained disordered from a long time before, as well as to transcribe and print historical records. The National Archives gradually obtained more storage facilities in Stockholm, although there was a constant need for more, and subsequently there was an increase in the inclusion of records that had until then been stored at individual state agencies (Norberg 2007).

In Denmark, a similar development began in the second half of the nineteenth century. A peculiar outcome of the transformation in Denmark was that for some decades, there were two parallel national archival authorities. The old Secret Archive remained a separate body, although it transferred to a new ministry for the Church and education service, and from the 1850s, it received state records that had been created until 1750; this relieved a state administration that was in dire need of more space. However, noncurrent records created after 1750 were transferred for preservation in a new institution, the Kingdom's Archives (*Kongerigets arkiver*), established in the 1860s (Kjölstad 2012; Paasch 2018). After a couple of decades, the two were united into a single National Archive.

While the Danish and Swedish National Archives trace a direct continuity from medieval and early-modern state archives, things were different in Norway. Norway became independent of Denmark in 1814, entering instead a personal union with Sweden, yet with its own constitution and a large degree of autonomy apart from in foreign and military affairs. The National Archives was established shortly afterwards, initially as an office under the Ministry of Finance and handled by the ministry's ordinary staff until the 1830s when the first designated archivist was employed. Initially, the National Archives was first and foremost a repository that was to secure records necessary for the government apparatus, both from the old repository at Akershus fortress and from the new administration. Toward the mid-nineteenth century, the National Archives emerged as an independent organization that also had a cultural heritage role, and the employment of romantic poet Henrik Wergeland may be regarded as symbolic (Svendsen 2017).

Initially, an important task for the Norwegian National Archives was transferring material relevant for Norway from the Danish state. Some guidelines had been set out in the Kiel Treaty, and after negotiations, the first transfers took place in 1820. Initially, the focus was on records of administrative value; only later did records primarily of historical value become the focus for subsequent negotiations and transfers. Control over the archives documenting the governing

of Norway remained for a long time a diplomatic tangle between the countries; it was not finally resolved until 1990 (Svendsen 2017).

Early archival legislation

The general development of the Scandinavian national archives followed a similar path: They crystallized as independent institutions within the government apparatus, with an increased number of employees. In the 1840s, they were transferred to the ministries for Church and education in all countries, and in the 1870s and 1880s, the national archives as independent agencies were established. The late nineteenth and early twentieth century gave ample proof of an extensive institutional development of the state archives in all countries, as well as increased legal regulation.

In Sweden, there was no separate law on archives until 1991. Instead, public sector archives had been indirectly regulated by the freedom of information legislation, which from 1766 had stipulated that citizens have a general right of access to the state's (and later also municipal bodies') written records (unless they were designated as secret). This led to a wide notion of "archives" in Sweden; generally records are considered archived at an early stage, when they are still kept by the original creator. A similar wide notion has been prevalent in Norway, while the Danish definition of archives has largely excluded contemporary records.

From as early as the seventeenth century, there were rules regarding the orderly formation of record categories such as registries, concepts, and incoming letters within the Swedish Royal Chancellery. From the late nineteenth century, a series of new regulations concerning the state archives was issued, specifying the obligations and organization of the National Archives, as well as basic rules regarding archival care. There were also general regulations about appraisal – which was seen as an increasingly unavoidable task – making it clear that all destruction of records must be sanctioned by the National Archives (Norberg 2007; Smedberg 2012).

As in Sweden, the first archival law in Norway came late (1992), but other forms of regulation were in place earlier. The creation of records in state bodies and municipalities had been rudimentarily regulated since the eighteenth and nineteenth centuries (Valderhaug 2011). The tasks of the National Archives were described, at its foundation, in a governmental resolution as safeguarding "qualified documents" from Akershus fortress. In the early twentieth century, this was elaborated in a royal resolution, which established a national archival agency led by the National Archivist as the leader for all state archival institutions (Marthinsen 1983).

Denmark saw its first Archives Act in 1889, which was short and largely regulated the tasks of the new National Archives. In addition, there were circulars and other internal regulations, e.g., on the transfer of records (Eriksen 1993; Kjölstad 2012, 175).

A network of state archival institutions

A common theme is that the history began with archival institutions for the central government in the capital. During the last half of the nineteenth century, regional state archives outside the capitals developed in all countries. Norway was first, with institutions in Trondheim (1850) and Bergen (1885) – both at first duly submitted to the regional authorities but integrated in the National Archives in the early twentieth century. During the 1900s, six additional regional archives (soon labeled "state archives," *statsarkiver*) were established. Until an organizational restructuring in 2016, the state archives had total responsibility for archives from their area (Svendsen 2017).

The new Danish Archive law from 1889 stipulated the establishment of three regional state archives (in Copenhagen, Odense, and Viborg), soon known as "county archives" (*landsarkiver*). The county archives (a fourth was established in Aabenraa in the 1930s) were part of the unified state archival agency. A similar development occurred in Sweden, where regional state archives (*landsarkiv*) were established from 1899 until 1935 at seven locations (Vadstena, Lund, Uppsala, Visby, Gothenburg, Östersund, and Härnösand).

In the past few decades, there has been a tendency towards organizational centralization of the state-level archives in Scandinavia. In Sweden, the so-called "War Archives" was discontinued as a separate government agency under the Ministry of Defense, and became a section of the National Archives in the 1990s; the same happened to the regional state archives in 2010. In Denmark, the central-state archival agency incorporated, in 1993, the Danish Data Archive in Odense, which primarily stores quantitative research data from various disciplines (Clausen and Marker 2000). Norway has seen several mergers of private institutions with the National Archives from the 1980s onwards, such as the Norwegian Private Archive Institute, the Norwegian Historical Source Institute, and the Sámi Archives (Svendsen 2017). During the 2010s, the National Archives of all countries were reorganized and based upon functions rather than geography.

Crystallizing out a separate archival theory

Around the turn of the twentieth century, a distinct archival theory became dominant all over Europe. The principle of provenance, *respect des fonds* in French, served a dual purpose: A pragmatic solution for the transfer of records from creators to archival institutions – they did not have to be reorganized more than necessary – but it also reflected the interests and theoretical views of academic historiography. For historians, archives ought to be as "neutral" and "authentic" as possible, and that was regarded as being accomplished only when the archives were seen as "organically" born out of the transactions of the original creators. These views became almost universally adopted by the European archivists during this time (see Chapter 8, this volume).

In Sweden, the principle of provenance was complemented by the idea that the "original order" within the archive should be kept, sometimes called "the structure principle." In Sweden, this was soon the official archival policy from the National Archives in the early twentieth century, with the aim of ordering the archives that still remained within the creating bodies. With a particularly Swedish model for archival description introduced at the same time, most government agencies had to arrange their archives in series within certain categories, such as minutes and copies of sent letters. This model remained in state archives until the 2010s and was also almost entirely followed by municipal and private archives.

In Denmark, the principle of provenance was formally adopted in 1903, but this occurred slightly later in Norway, in 1913. Arguably as a consequence of the disagreement with Denmark over archives from the Denmark-Norway era, Norway defended a principle of "territorial provenance," i.e., that records related to a specific area were to be controlled by whoever controlled the area, even if that meant removing records from the archives of previous powers (Svendsen 2017).

Archival expansion in the welfare states

In the twentieth century, there was a general growth in archives altogether, due to various and mutually influencing factors. Most importantly, there was a general rise in the state bureaucracy and organization with the evolving welfare state, and also a technological development that made record creating easier, such as the typewriter and copying techniques. Increasingly, new formats were introduced in the archives, where photographs and audiovisual recordings came to supplement written papers. This led to new challenges with methods of preservation, as well as a need to reformulate the classical notion of records, which had for a long time been based on textual documents.

The growth of archives put new questions on the agenda for Scandinavian as well as international archives – not least the planning of archiving from the start, and the need for appraisal. In many respects, the development of the twentieth century forced the archival functions to somewhat go back a couple of steps toward the more bureaucratic-administrative end of the axis. For example, in Sweden, the National Archives increasingly functioned in a role of, so to speak, controlling the documentation all over the state sector, to decrease the overproduction of archives, and not least to assist with appraisal.

In all Scandinavian countries, the destruction of records became an increasingly important part of archival work from the mid-twentieth century to the present day. Common to all countries has been a certain pragmatism, led more by economic incentives than by international appraisal theory. In order to find a path between total retention and total destruction, various forms of sampling have been used (where, e.g., records concerning persons born on certain dates

have been kept), as well as initiatives to increase efficiency, such as the Danish innovation of arranging current records according to decimal-based classification systems ("journalplaner"); one advantage was that this could make large-scale destruction of records concerning topics without long-term value easier than chronological ordering, where appraisal would have to be on the item level. Methods like the ones described here have occasionally been controversial for archivists that find them too schematic. On a legal level, the Danish Archival Act of 1992 emphasizes the destruction of records as a key task for state archives, more so than in Norway and Sweden, and the level of destruction seems to have been higher in Denmark (Bloch and Larsen 2006; Bringslid et al. 2009; Edquist 2019; Marthinsen 1983; Paasch 2018).

Digitalization and the complex contemporary archival landscape

From the 1960s onwards, records creation has continued to accelerate in volume and complexity, not least because of the introduction of digital technologies. Digital records were introduced in the 1950s and 1960s in major administrative systems and similar centralized functions. Their preservation was discussed from the beginning but became a paramount issue in the 1990s, when the vast majority of all new documents became digital.

Adding to the complexity is the reorganization of the public sector, not least from the 1980s when neoliberal doctrines became prevalent. Many former state and municipal bodies have been privatized, sometimes leading to disruptions of the archives and reduced access. New organizational models, temporary projects, etc. flourish, which also challenges records and archives management.

Since the 1960s and 1970s, new use patterns and new techniques for making archives accessible have also emerged (e.g., see Chapters 6, 7, and 9 in this volume). Simultaneously, an opposite development is also visible: Many professionals consider themselves as records managers rather than as working in the field of culture, mainly managing current information and evidence in fragile and fluid digital media.

In all Scandinavian countries, the National Archives have introduced functions and requirements for the transfer of digital records. Government agencies are expected to follow certain guidelines for their electronic records, and Norway has had, since the late 1990s, a national standard for digital records, the NOARK 4, later NOARK 5 (Geijer, Lenberg, and Lövblad 2013, 110–116; Kjellberg and Hall-Andersen 2017; NOU 2019:9). However, the challenges of long-time preservation and management of digital archives are still a matter of discussion and sometimes dispute. Some archivists fear that the care of born-digital archives tends to be underfinanced, and that the "outside world" (those responsible for government funding, or the top managements of various organizations) generally underestimates the economic and, even more so, the organizational requirements of digital preservation of archives.

Beyond the government: Municipal and private archives

Municipal record keeping has tended to be weaker than that of the state, even though early municipal legislation from the mid-nineteenth century in all countries included some rules on archiving. Typically, only larger cities and towns had separate archival institutions. Measures to improve municipal archives were taken during the twentieth century. Since the 1940s, the Norwegian National Archivist has been mandated to supervise municipal archives. In Sweden, beginning in the 1930s, the National Archives issued advisory regulations for municipalities, e.g., on appraisal. In the 1980s, these regulations were formalized with a special archival council jointly run by the National Archives and the cooperation organizations of municipalities and county councils (since 2020 called "regions", *regioner*), and from 1991, municipalities followed the same archival legislation as the state. Since then, most municipalities have established formal archival functions with employed archival personnel. In Denmark, municipal archives were traditionally tended by the National Archives. Since 1992, municipalities may choose to be liable to the National Archives or establish a local archival institution. Municipal archives must follow the same archival legislation as state archives, in terms of, for example, appraisal and accessibility (Edquist 2019; Furdal 1993; Valderhaug 2011).

All countries, especially smaller municipalities, lack sufficient resources for archiving. In Norway, cooperation between municipalities in so-called "IKAs" (*interkommunale arkiv*, inter-municipal archives) has been on the rise since the 1970s (Bering 2017). Inter-municipal cooperation is less widespread in Denmark and Sweden, even though legislation permits it (Furdal 1993). However, the challenges of digital archiving have forced some smaller municipalities in Sweden to cooperate.

Municipal archival institutions, especially in larger cities and towns, have since the 1980s often embraced a more "cultural" approach. In Bergen, the city archive was given the task of guiding the municipality's employees and acting as a repository, but also of promoting the use of the archives and collecting private material from the municipality. Oslo City Archive soon followed a similar path, and even some IKAs have developed public programs for active outreach. The City Archives in Stockholm has pursued many activities with the aim of reaching a larger audience, e.g., in the project "Stockholm Sources" *(Stockholmskällan)*, a digitized historical database that is run in collaboration with the City Museum (Bering 2017; www.stockholmskallan.se).

Private archives have tended to be even less regulated. Larger businesses and organizations created and kept archives to the extent that they needed them. There were also some acquisitions of nationally significant private archives, from major noble families and the like, by the National Archives.

Separate institutions for private archives emerged from the early twentieth century. In all three countries, the labor movement established archival institutions in the early twentieth century. Over time, additional private archival

institutions have emerged, such as for business archives, archives for popular movements that are typical for Sweden, and local history archives that are abundant in Denmark. However, until now, vast amounts of private archives have been kept in public institutions – state or municipal archives, libraries, and museums – in all three countries. Generally, there have been more natural "libraries, archives, and museums" (LAM) connections in the private archives sector. For example, the institutions for labor movement archives are also libraries in all countries. And since private archives often have close relations with museums and libraries, they are also at the forefront in setting up exhibitions, archival pedagogics, and other public programs. Private archives have been discussed in policy debates on archives in Scandinavia as examples of a wider documentary heritage than that which public archives offer (Bundsgaard and Gelting 1992; NOU 2019:9; SOU 2019:58).

Archival politics: Democracy, transparency, and heritage

In all Scandinavian countries, the legal frameworks have changed in recent decades. In 1991 and 1992, Sweden, Denmark, and Norway all received new laws for archives throughout the public sector (that had already applied to Denmark since 1976). The laws, normally complemented by more detailed ordinances and regulations, include various rules on the proper care of archives, rules on transfer from agencies to archival institutions, and the responsibilities of the National Archives as the archival authority. Among national differences, the Norwegian law also contains some passages on private archives, and the National Archives may put some restrictions on particularly valuable private archives. As previously mentioned, Danish legislation puts a larger explicit emphasis on the destruction of records, while Swedish legislation since 1991 has put some emphasis on heritage and nonacademic users of archives.

If we define archival politics as all those political measures that affect the functioning of archives, we cannot restrict ourselves to only discussing legislation and other forms of explicit regulatory interventions. Another crucial aspect is economics: The actual funding from public bodies to both public and private archives. Without sufficient personnel and resources, it may be difficult to always fulfill the sometimes strict rules on proper archival care. Many previous studies have shown that archival realities often differ from what is considered desirable in legislation and policy documents (e.g., see: Edquist 2019; Eriksen 1993; Thorhauge, Heide Petersen, and Mølbak Andersen 2018).

Very sketchily, archivists have transformed from being guardians of public secrets to a contemporary professional identity where openness and transparency are hailed. Before the nineteenth century, access to state archives was generally difficult. During the nineteenth century, steps toward opening them to the general public were taken, even though the vast majority were historians. Reading facilities, etc. were established, but visiting an archival depot required time and skill (Norberg 2007; Thomsen 1976). Today, records and

archives are key elements of citizens' rights to control the doings of public authorities.

Records are important for transparency in all Scandinavian countries, but there has always been a tension between openness and secrecy. In Sweden, the rules of secrecy were transferred to a separate law on secrecy in the 1930s, which until this day regulates access to public sector archives, regardless of whether they are kept by the original creator or an archival institution. Thus, there is no separate regulation of access in the specific archival legislation.

Also in Norway, freedom of information rules are found in other legislation than that explicitly concerning archives, but just as in Sweden, the freedom of information legislation directly concerns archives, since both countries have a wide definition of the term: Archives also include very new and "living" records. In Denmark, archives are more separated from contemporary records. The Danish Archives Act has its own access provisions: Public records are usually released after 20 years, but if they contain personal information, they are released after 75 years (Thorhauge, Heide Petersen, and Mølbak Andersen 2018, 1222). Other legislation also has access provisions. Access can thus be granted in accordance with either the Archives Act or the Public Access to Information Act. This may sound liberal, but what the practical consequences are may be disputed. It has been argued that countries that have access rules both in freedom of information laws and archive laws (e.g., Denmark, Iceland, the UK, Germany, and France) may have less of a culture of openness in administration, and have therefore found it necessary to regulate access to disposed archives specifically. On the other hand, countries that only regulate access to public records in a Public Access to Information Act, like Sweden and Norway, may rely on this regulation alone because their administrations embrace a culture of openness (Noack 1993). However, in Sweden, the opposite argument has been made: That the principle of openness in legislation has led to a culture of avoiding documentation, with open but empty archives as a result (National Archives of Sweden 2004).

Concluding remarks: Archivists and archives today

Until the late twentieth century, there were no academic programs for Scandinavian archivists, who were typically employed on the basis of a degree in history or a similar discipline, and trained "in-house" (e.g., see: Svendsen 2017).

From the 1970s in Sweden, the 1990s in Norway, and slightly later in Denmark, several universities established programs in archival science. Some, like the programs at the University of Aalborg, Oslo Metropolitan University, and Mid Sweden University (which also includes PhD-level training), stress contemporary records management and draw on information sciences more than on history (Sundqvist 2020). This development from practical in-house training to a more theoretical education is partly due to transformations in the profession, and partly to the general academization of education.

Today, archivists are faced with an increasing specialization within the profession, where new technologies bring both new opportunities and challenges. On the one hand, records managers work as information specialists in digital environments, managing records created in the present for usage in a near or distant future. The reshaping of public administration from classic bureaucracy to less hierarchical and less stable organizations has put many archivists in new positions where they have to argue for archival concerns that may clash with other interests.

On the other hand, archival institutions are still heritage and memory institutions. More traditional archivists at archival institutions that predominantly store records that are several decades or centuries old largely work with service, provision, and mediation for the benefit of external users.

In the late twentieth century, many waited for the archival profession with digitalization to split into at least two professions. However, to date, there have been no signs of any definite split. On the contrary, there is a widespread view that archivists must be experts in *both* the contemporary creation and management of "living" archives, *as well as* having a longer perspective of time, whether they mainly work with old or contemporary archives.

Archives are double-edged, keeping records from a more or less distant past that serves history writing and historical knowledge, as well as being contemporary and future-looking: Evidence of activities for the records creators themselves, but also for the general public, as "accountability agencies" (Eastwood 2002, 70) or as reservoirs for historical knowledge. Archival institutions are thus only partially siblings of museums and libraries in storing information from the past, although the historical dimension of archives is probably the one with which most people associate. Nonetheless, an important part of the archival sphere will continue to acknowledge that there is a demand in society for archives as reservoirs of memory and heritage. That part of archives increasingly also aims to further increase the outreach of archives and to attract even more users.

References

Berger, Stefan. 2013. "The Role of National Archives in Constructing National Master Narratives in Europe." *Archival Science* 13, no. 1: 1–22. https://doi.org/10.1007/s10502-012-9188-z.

Bering, Bjørn. 2017. "Veien fram går først tilbake: Utviklingen av det kommunale arkivlandskapet." In *Han e' søkkane go'! Et festskrift til byarkivar Arne Skivenes*, edited by Ragnhild Botheim, Ine Merete Baadsvik, Gudmund Valderhaug, and Aslak Wiig, 121–134. Oslo: ABM-media.

Bloch, Elisabeth, and Christian Larsen, eds. 2006. *At vogte kulturarven eller at slette alle spor: Om arbejdet med den danske bevaringsstrategi*. København: Arkivforeningen.

Bringslid, Synøve, Ivar Oftedal, Maria Press, and Torkel Thime. 2009. *"Ti der var papir overalt": Bevaring og kassasjon av arkiver i norsk lokalforvaltning på 18- og 1900-tallet*. Oslo: Riksarkivaren.

Bundsgaard, Inge, and Michael H. Gelting. 1992. "What to Be or Not to Be? Evolving Identities for State and Grassroots Archives in Denmark." *The American Archivist* 55, no. 1: 46–57. https://doi.org/10.17723/aarc.55.1.5r77m1126454mh0q.

Clausen, Nanna Floor, and Hans Jørgen Marker. 2000. "Denmark: The Danish Data Archive." In *Handbook of International Historical Microdata for Population Research*, edited by Patricia Kelly Hall, Robert McCaa, and Gunnar Thorvaldsen, 79–92. Minnesota Population Center.

Cook, Terry. 2013. "Evidence, Memory, Identity, and Community: Four Shifting Archival Paradigms." *Archival Science* 13, no. 2–3: 95–120. https://doi.org/10.1007/s10502-012-9180-7.

Duchein, Michel. 1992. "The History of European Archives and the Development of the Archival Profession in Europe." *The American Archivist* 55, no. 1: 14–25. https://doi.org/10.17723/aarc.55.1.k17n44g856577888.

Eastwood, Terry. 2002. "Reflections on the Goal of Archival Appraisal in Democratic Societies." *Archivaria* 54: 59–71.

Edquist, Samuel. 2019. *Att spara eller inte spara: De svenska arkiven och kulturarvet 1970–2010*. Uppsala: Institutionen för ABM, Uppsala universitet.

Eriksen, August Wiemann. 1993. "Arkivbekendtgørelsen af 1992." *Arkiv: Tidsskrift for arkivforskning* 14, no. 3: 171–179.

Furdal, Kim. 1993. "Arkivloven og kommunerne: Nogle betragtninger." *Arkiv: Tidsskrift for arkivforskning* 14, no. 3: 180–199.

Geijer, Ulrika, Eva Lenberg, and Håkan Lövblad. 2013. *Arkivlagen: En kommentar*. Stockholm: Norstedt juridik.

Jenkinson, Hilary. 1922. *A Manual of Archive Administration: Including the Problems of War Archives and Archive Making*. Oxford: Clarendon Press.

Jørgensen, Harald. 1968. *Nordiske arkiver*. København: Arkivforeningen.

Kjellberg, Jette Holmstrøm, and Mette Hall-Andersen. 2017. "Kvalitetssikring – i hvilken grad bør arkiverne styre myndighedernes digitale sagsdannelse?" In *Dokumentation i en digital tid – ESDH, arkiver og god forvaltningsskik*, edited by Elisabeth Bloch, Peter Damgaard, Else Hansen, and Lise Qwist Nielsen, 45–58. København: Arkivforeningen.

Kjölstad, Torbjörn. 2012. "Danmark." In *Det globala minnet: Nedslag i den internationella arkivhistorien*, edited by Lars Jörvall, Louise Lönnroth, Gunilla Nordström, Alain Droguet and Per Forsberg, 163–186. Stockholm: Riksarkivet.

Marthinsen, Jørgen H., ed. 1983. *Norske arkivbestemmelser 1817–1983*. Oslo: Forbruker- og administrasjonsdepartementet.

National Archives of Sweden. 2004. *Handlingsoffentlighet utan handlingar? Rapport från ett seminarium i Stockholm den 7 mars 2003*. Stockholm: Riksarkivet.

Noack, Johan Peter. 1993. "Arkivlovens tilgængelighedsbestemmelser." *Arkiv: Tidsskrift for arkivforskning* 14, no. 3: 157–170.

Norberg, Erik. 2007. *Mellan tiden och evigheten: Riksarkivet 1846–1991*. Stockholm: Riksarkivet.

NOU. 2019:9. *Fra Kalveskinn til datasjø: Ny lov om samfunnsdokumentasjon og arkiver*. Oslo: Kulturdepartementet.

Paasch, Marianne. 2018. "Gemt eller glemt? En undersøgelse af recordsbegrebets betydning for fremtidens informationsforvaltnings- og arkivpraksisser." PhD diss., Aalborg: Aalborg Universitetsforlag. https://doi.org/10.5278/vbn.phd.socsci.00083.

Ridener, John. 2009. *From Polders to Postmodernism: A Concise History of Archival Theory*. Duluth, MN: Litwin Books.

Smedberg, Staffan. 2012. "Sverige." In *Det globala minnet: Nedslag i den internationella arkivhistorien*, 231–260. Stockholm: Riksarkivet.

SOU. 2019:58. *Härifrån till evigheten: En långsiktig arkivpolitik för förvaltning och kulturarv*. Stockholm: Kulturdepartementet.

Sundqvist, Anneli. 2020. "Archival Science: A Nordic Research Paradigm?" In *Rød mix: Ragnar Audunson som forsker og nettverksbygger*, edited by Sunniva Evjen, Heidi Kristin Olsen and Åse Kristine Tveit, 81–119. Oslo: ABM-Media.

Svendsen, Åsmund. 2017. *Arkivet – en beretning om det norske riksarkivet 1817–2017*. Oslo: Press forlag.

Thomsen, Hans Kaargaard. 1976. "Omkring Geheimearkivets syn på arkivbenyttelse, arkivordning og registrering i det 19. århundrede (1820–1882)." *Arkiv: Tidsskrift for arkivforskning* 6, no. 2: 108–131.

Thorhauge, Jens, Jakob Heide Petersen, and Ole Magnus Mølbak Andersen. 2018. "Denmark: Libraries, Archives, and Museums." In *Encyclopedia of Library and Information Sciences, Fourth Edition*, edited by John D. McDonald, and Michael Levine-Clark, 1215–1228. Boca Raton, London and New York: CRC Press. https://doi.org/10.1081/E-ELIS4.

Valderhaug, Gudmund. 2011. *Fotnote eller tekst? Arkiv og arkivarer i det 21. hundreåret*. Oslo: ABM-media.

4

A CONCISE HISTORY OF MUSEUMS IN SCANDINAVIA

Hans Dam Christensen, Brita Brenna, and Björn Magnusson Staaf

Introduction

The joint establishment of new types of museums and collections across the Scandinavian countries from the mid-seventeenth century to the end of the twentieth century will be the primary focus in the following. These commonalities will loosely be paralleled with societal changes. The use of key concepts such as "type," "collection," "museum," and "societal changes" will be rooted in common sense, that is, pragmatically and without further theoretical reflections. This approach distills a "Scandinavian" history of museums in the singular, which puts focus on clusters of identical museum types – both local and nationwide, small and large – originating within delimited time spans. As the Scandinavian countries are in many ways entangled historically, such an overall and long-time perspective on the development in this part of Europe contributes to a more multifaceted understanding of the history of museums. At the end, we draw some tentative conclusions at a generic level about new museum types and societal changes.

Collecting the whole wide world

Universities and scholarly environments played a crucial role when the foundations for the modern Scandinavian museums were laid. Uppsala University and the University of Copenhagen were founded at the end of the 1470s, and Lund University was founded in 1666 (Magnusson Staaf and Tersmeden 2016). In particular, the act of collecting was associated with the endeavors of individual professors. Thus, one of the first well-documented collections was that of Ole Worm in Copenhagen. As a professor at the university, Worm (1588–1654) collected *naturalia* and man-made objects from the 1620s onwards. His collection was

DOI: 10.4324/9781003188834-5

organized like many other cabinets of curiosities of the time, although Worm expressed an overt ambition to establish what he – in a modern sense – "considered to be optimal conditions for other people's learning of nature by facilitating object lessons and hands-on activities" (Tarp 2018).

At the universities of Lund and Uppsala, various collections in the eighteenth century were open to scholars and students. As with Worm, collections were associated with individuals and not the university as an organization, although some of these assemblages of artifacts were later donated to the university. The Stobaean collection at the Lund University Historical Museum, donated to the university by Kilian Stobaeus (1690–1742) in 1735, is an example of this (Stjernquist 2005). However, the most prominent professor-collector in Sweden in this period was a former student of Stobaeus, Carl Linnaeus (1707–1778) in Uppsala. The most striking aspect of Linnaeus's collecting practices was his methods. The collections were structured on the basis of specifically defined empirical criteria. Linnaeus's methods regarding the structuration of collections were to have an impact on the way collectors and museums organized both their collections and displays from the mid-eighteenth century onwards in areas outside the field of natural history (Broberg 2019).

As part of the Danish-Norwegian "twin kingdom" up to 1814, Norway did not have its own university until 1811. However, the oldest scholarly institution in the country, the Royal Norwegian Society of Sciences and Letters, was established in 1760 in Trondheim as the Trondheim Society by, among others, the Bishop of Nidaros, Johan Ernst Gunnerus (1718–1773). Gunnerus is yet another representative of a strong leaning towards the collecting and describing of *naturalia*, who in 1759 started building his collection of mainly natural objects, but also antiquities and instruments (Brenna 2011). After his death, the collection was auctioned. Large parts were acquired by the Society and became much later part of the regional university museum (Andersen et al. 2009). Similarly, many of these early collections can be traced in the natural history museums founded in the following centuries such as the Swedish *Naturhistoriska riksmuseet* and the Danish *Statens naturhistoriske museum*.

In Scandinavia, as in the rest of Europe, those who compiled the collections can be grouped in three: Scholars and institutions of higher learning, aristocrats and royals, and members of the bourgeoisie (MacGregor 2007). The relative weight of these groups and their intertwinement made for differences in the Scandinavian countries. Since there was no university on Norwegian soil – and very limited aristocracy or royals – most collectors in this early period were clergymen, whereas Sweden and Denmark were furnished with collectors connected to universities and academies, a wealthy bourgeoisie, and royal and aristocratic collections.

The world through the nation's prism

Museum Wormianum was not donated to the University of Copenhagen. In 1655, the Danish King Frederik III bought the collection and included large parts

in his *Kunstkammer* (Mordhorst 2009). This collection had been established a few years before, simultaneously with the *Kunstkammern* in Stockholm and at Gottorp Castle in the Duchy of Schleswig-Holstein-Gottorp.

The Copenhagen *Kunstkammer*, together with the Royal Library, moved into a new building in 1673, arguably the first larger building in the Nordic countries "designed for the purpose of housing classified collections" (Ekman 2018). This *Kunstkammer* existed officially until 1825, and the dispersal of these collections gives a condensed history of the specialization of museums, connected to the establishment of different disciplines in the first half of the nineteenth century. As early as in 1827, the Danish Royal Collection of Paintings became publicly accessible, and stepwise a number of other collections encompassing, among others, *naturalia*, ethnographica, antiquities, and artistic handicrafts came to be accessible as separate "museums" until the nearly 10,000 artifacts officially turned into newly instituted collections such as the Zoological Museum (1862), the National Museum (1892), and the National Gallery (1896) (Gundestrup 2005). Christian Jürgensen-Thomsen (1788–1865), who is credited as the originator of the "Three-Age System" of European antiquity in 1837, managed the assembling of these collections. He classified the artifacts chronologically by seeing which artifacts occurred with which other artifacts in closed finds while organizing the collections; this evidence-based division of prehistory into discrete periods has been reverberated in an abundance of displays (Gräslund 1987).

Royal collections also played an important role in relation to the first public museums in Sweden. Gustav III's Museum of Antiquities, which opened in the royal palace in Stockholm in 1794, is generally considered the oldest public museum in Sweden (Landgren and Östenberg 1996). However, it was during the second half of the nineteenth century that museums had a breakthrough in Sweden. The opening of *Nationalmuseum* in Stockholm in 1866 was a central event in this context. The Swedish parliament had already decided in 1845 that a new museum, housing parts of the royal art collections as well as national archaeological collections, was to be created. This parliamentary decision became one of the largest investments in buildings made for civil purposes in this period (Bjurström 1992).

In Norway, the National Gallery opened in 1842 (Lange 1998). While Sweden and Denmark established a number of "national" museums, in Norway only this museum would have that designation. The discussion about establishing a national museum surfaced on various points in the nineteenth century. However, in the end, responsibility for archaeological heritage was given to regional museums by law in 1905, a division that still underlies the Norwegian museum landscape where the university museums, e.g., the one in Trondheim, are responsible for the natural heritage, ethnography, and archaeology (Jørgensen 2020). Thus, this museum type has a particular significance in contrast to both the typical university museum worldwide and the majority of Norwegian museums.

Experiencing the past

The collecting of cultural heritage in Scandinavia flourished in the second half of the eighteenth century. In all three countries, the *grand* national collections and, not least, the increasing public access to these collections went alongside the bourgeoning idea of the modern nation state, as establishing museums and registering and documenting art, nature, and cultural heritage became an obligatory part of being a nation.

Societal and cultural developments had an impact on the continuation of these narratives. On the one hand, the number of regional and local museums increased considerably in Scandinavia during the second half of the nineteenth century and the beginning of the twentieth century. These museums often covered wide fields of topics ranging from archaeology to ethnological natural history and arts – countless with a regional focus, and a few with a universal collection ambition (Eriksen 2009). They were to a certain degree built on the initiatives of the populace in the rural districts and indicated changing power relations between center and periphery. On the other hand, larger nationwide initiatives also saw the light of day. In 1891, *Skansen*, typically considered the world's oldest open-air museum, opened on the outskirts of central Stockholm (Bäckström 2012). A distinctive Scandinavian feature of the history of museums might be this development of the "open-air museum," which spread widely. Several decades later, it became an inspiration for the eco-museum movement from the 1970s (Hubert 1985). In the Scandinavian context, the establishment of the still vibrant *Skansen* became the first case of this museum type, soon followed by a similar Danish museum, *Frilandsmuseet*, in 1897. The founder of *Skansen* was inspired by King Oscar's Collection in Oslo, which from 1881 included four historic farm buildings and a stave church, transferred to the royal manor at Bygdøy near Oslo (then Christiania) for public viewing (Rentzog 2007). As a forerunner to the open-air museums, the establishment of *Nordiska Museet* (1873) in Stockholm, *Dansk Folkemuseum* (1879), and *Norsk Folkemuseum* (1894) is notable in documenting life before the industrial era. In general, close collaboration between Scandinavian museum professionals was significant for the development of museum practice in this period (Bäckström 2012).

The new museum types represented a new view on museum learning. Put simply, the existing museums offered visitors the combination of a scientifically determined narrative and the possibility of comparing identical or related types of objects from flint arrowheads to silver cauldrons. At the new museums, the main idea was to present historical settings for the visitors. It should be possible to enter or look into more or less historically and geographically authentic buildings, rooms, environments, or *tableaux vivants*, possibly encountering mannequins or living persons dressed in period-specific clothes, in order to experience a corporeal "history" (Bäckström 2012). Notably, in the Danish context, the *Dansk Folkemuseum* was located from 1885 in the same building in Copenhagen as *Skandinavisk Panoptikon*, a popular wax cabinet, both using

similar display techniques and both initiated by the upcoming founder of the above-mentioned *Frilandsmuseet*, who was also former director of the *Tivoli* amusement park (Sandberg 2002). Increasingly at the beginning of the twentieth century, this connection to popular culture was downplayed in favor of more scientifically oriented displays.

Museum industry – or a dialectic of collections?

Alongside the development of the industrial society, a strong labor movement, including national trade union confederations and a network of political, educational, and recreational organizations, also emerged in the three Scandinavian countries. This movement played a crucial role in both the success of the social democratic parties, which started to gain governmental power during the 1920s, and, in combination with this, the development of a welfare state from the 1930s to the 1970s. Notably the goal of eight hours' labor, eight hours' recreation, and eight hours' rest had already been settled around 1920. This settlement made room for spending more time on education and culture. The states increasingly launched cultural political initiatives from public libraries to modern art museums in order to fund, but also regulate, education and recreation. Thus, a growing large-scale public financing of museums became a shared trait in Scandinavia. Museums were to be considered a common good, a form of "cultural public service" dedicated to a secular understanding of knowledge that all citizens were to have access to; for example, from the early twentieth century, museums were increasingly presented as places where schoolchildren could be taught.

The societal changes following the birth of the industrial era gave rise to a musealized focus on peasant people's lives, culture, and buildings, as mentioned above. Alongside this focus, the emerging agricultural museums started a complementary documentation of the preindustrial profession. Following the Nordic exhibition of Industry, Agriculture, and Art of 1888 in Copenhagen, the *Dansk Landbrugsmuseum* opened the following year (Søndergaard and Bavnshøj 2004), and in Norway, the Royal Norwegian Society for Development started a systematic collecting of agricultural implements and machinery in 1891 (Øverland 1909). In 1894, the Society was allowed to build a museum close to the above-mentioned royal manor at Bygdøy, which merged with the *Norsk Folkemuseum* in 1922. In Sweden, the collections of the Royal Swedish Academy of Agriculture opened as a museum for agriculture and fishery in 1907 (Jansson 2014).

Simultaneously, a new museum type mainly documenting the excellence of historical and contemporary artistic manual work arose in order to inspire artisans and manufacturers. Stimulated by the recurrent Nordic and world's fairs, a number of museums for applied arts and decorative arts, starting with the Norwegian *Kunstindustrimuseet*, Oslo, in 1876 and the *Vesterlandske Kunstindustrimuseum* in 1887, followed by the Danish *Kunstindustrimuseet* in 1890, the Norwegian *Nordenfjeldske Kunstindustrimuseum* in 1893, and the Swedish *Röhsska Museet* in 1904, saw the light of day within three decades (Glambek 2010). This type

of museum was followed by yet another new type predominantly addressing technological history and, not least, technological developments and innovation in the flourishing industrial society. The *Danmarks Tekniske Museum* was founded in 1911, the *Norsk Teknisk Museum* in 1914, and the Swedish *Tekniska Museet* in 1923 (Althin 1974; Skyggebjerg 2009; Gjølme Andersen and Hamran 2014).

Generally, a close collaboration between politicians, industrialists and scholars took place in initiating and developing these museums; for example, the foundation of *Norsk Teknisk Museum* followed the popular 100 years anniversary exhibition of the free *Eidsvoll* constitution of 1814, which, among other things, showed Norway's development from agrarian society to industrial society (Gjølme Andersen and Hamran 2014). In Denmark, the *Kunstindustrimuseet* was initiated by the Association of Industry and was located for three decades next to the Association's premises on City Hall Square in Copenhagen. In Sweden, associations related to technology, engineering, and industry founded the *Tekniska museet*; until 1936, the Royal Swedish Academy of Engineering housed the museum (Althin 1974).

In line with this promotion of new ideas by way of collections and museums in the industrial era, the emerging of school museums from the 1860s onwards to 1900 is also noticeable. In Gothenburg, the second-largest city in Sweden, a collection was established in the new city museum in the early 1860s after the founder's visit to *The International Exhibition* in London in 1862. The idea was not to document the history of schools, but to showcase modern pedagogical tools, instruments, etc., including atlases, handicrafts, chemistry flasks, desks, and chairs; in 1909, the collection opened as *Göteborgs skolmuseum* (Karlsson 2009). In 1887, a similar collection, *Dansk Skolemuseum*, was established by the Danish Union of Teachers (Larsen 2016), and at the beginning of the twentieth century, after representatives from Christiania public schools took part in another world's fair, the *Exposition Universelle* in Paris in 1900, the *Kristiania Folkeskolers Museum* was initiated (OBL 2020).

Other museum types reflecting the progress of the industrial society in combination with the infrastructural developments of the nation should also be included in this period, for example, the civil service museums (*"etatsmuseer"*). The state railway museums in Norway, Sweden, and Denmark were founded in 1895, 1915, and 1918/19, respectively (Kolding 2016). A closer look at the initiating activities shows that an important driver for the groundwork was employees, who wanted to document the "past" that was disappearing due to new organizational and technological developments within a field that was heavily regulated by the state (Kolding 2016). Other similar museums of infrastructural importance that also emerged in this period include Scandinavian postal museums in 1907, 1913, and 1947, respectively.

The oldest Scandinavian museum closely connected to industry is probably the Norway Fisheries Museum, founded in 1879 in Bergen, the second-largest city in Norway. This museum was founded by the Society for the Promotion of Norwegian Fisheries as part of the efforts to modernize the profession (Skreien

2009). In Denmark, a similar museum followed in 1899 (Rasmussen 1979), and in Sweden, a museum commemorating the past of the professions of agriculture and fishery (see above) opened in 1907.

This duality between progress and commemoration is important to note, because it is often taken for granted that museums are historically oriented. As the prior examples demonstrate, many museums were established as much as places to get new knowledge about techniques, technologies, and science as places to conserve history – model museums as much as history museums (Eriksen 2009).

The meaning of art in the welfare states

A number of industrialists, merchants, and financiers in the early and modern capitalist society accumulated fortunes to an extent that was comparable to aristocratic life in previous centuries. This expanded the amount of a familiar type of collections. Private collections of decorative arts, antiques, fine arts, and, in particular, contemporary art, owned and displayed by wealthy citizens, became manifest around 1900. In Denmark, not least the founder of the Carlsberg brewery in 1847 and his son were both enthusiastic art collectors on a grand scale. In 1888, the son, Carl Jacobsen (1942–1914), and his wife, Ottilia (1854–1903), donated their collections of modern French and Danish art to the state and the city of Copenhagen on the condition that a suitable building was provided; this museum, *Ny Carlsberg Glyptotek*, opened in 1897 (Glamann 1996). Notably, the Swedish *Thielska galleriet* opened in 1926, located in Ernest Thiel's (1859–1947) former residence in the exclusive Djurgården park area just outside Stockholm. The art collection of Pontus (1827–1902) and Göthilda (1837–1901) Fürstenberg, the first private art gallery in Sweden that was open to the public (from 1885 one day a week), was donated to Gothenburg Museum after the couple's demise and is today a distinct part of the Gothenburg Museum of Art (Nordström 2015).

Many private art collections were gradually opened to visitors. However, public access to the collections located in privately built galleries did not mean openness for people of all classes (Bennett 1995). From 1918, *Ordrupgaard*, an affluent owner's private home north of Copenhagen displaying a collection of modern French and Danish paintings, was open one or two days per week, typically for people with a special interest, before it turned into a state museum in 1953 and became accessible for all (Rostrup 1981). Initially, Thiel's collection was open to friends and acquaintances "and to others by previous request by telephone, as made explicit in newspapers and the most authoritative guide book on Sweden at the time" (Kjærboe 2016). Obviously, the bulk of the workforce needed by the industrialist-capitalist machinery to accumulate fortunes could not access these collections easily. In general, workers' families had neither the proper aesthetic education or the right contacts, nor the required time to prioritize elite art collections – and telephones were certainly not part of their everyday life. Even at the state museums, access could be limited. Although,

for example, access to the National Gallery in Copenhagen was free of charge, opening hours were restricted due to the lack of electric light in the galleries (Houlberg Rung 2013).

In the post–World War II period, combined recreational and educational museums saw the light of day. Notably, the Danish *Louisiana Museum of Modern Art* and the Swedish *Moderna Museet* both opened in 1958, and in Norway, the *Munch Museet* emerged five years later in a brand-new modernist building, and, in yet another new building, the *Henie Onstad Kunstsenter* was established in 1968. To varying degrees, these museums had a strong desire for modern art to have a wide audience in contrast to the dominant trends in the traditional art museum world. The former and the latter were in the vein of the early twentieth-century art collection initiatives by industrialists, financiers, etc. Former champion figure skater Sonja Henie (1912–1969) and her husband, shipping magnate Niels Onstad (1909–1978), founded the *Henie Onstad Kunstsenter* (Hellandsjo 2009), and in terms of *Louisiana*, a wealthy cheese merchant converted his country house to a museum for modern Danish art. Soon he encountered modern art on an international scale, and with a series of extensions, the museum gradually turned into a collection of predominantly international art (Handberg 2017). In contrast, the bulk of the collection of *Munch Museet* consists of Edvard Munch's bequest, which was donated to the city of Oslo in 1940 and exhibited from 1963. The *Moderna Museet* emanated from the art collection of *Nationalmuseum*, but the museum formed within a few years, followed by *Louisiana*, a significant international profile. Not least, the head of the museum from 1960, Pontus Hultén (1924–2006), who later became founding director of the *Centre Georges Pompidou*, was responsible for this development (Tellgren 2017).

In particular, *Louisiana* and *Moderna Museet* augured new tendencies in terms of learning and recreation that would become widely accepted museum practice over time. The folk museums and open-air museums introduced visitor-involving events in order to let people experience the past. In the post-war years, the shaping of citizens in the welfare society was important. At *Louisiana*, the founder used the expression "space of togetherness" ("samværsmiljø") to frame the mission of the museum, and addressed cultural policy as a basic spiritual necessity for the modern democratic state (Vest Hansen 2020). These views could easily be tailored to the egalitarian Scandinavian societies and supported by the states. Within a few decades, activities around, for example, changing exhibitions, recreational spaces and cafés, targeted outreach to children and young people, and user participation were well-integrated in the various cultural policies of Scandinavia without regard to the ruling government's ideological color.

In the wake of welfare

In terms of this chapter's focus on new museum types related to broad societal changes in Scandinavia, a few things are noteworthy around the 1980s. The Labor movement and the social democratic parties lost momentum in the 1970–1980s.

The industrial society was gradually being replaced or supplemented by, depending on the perspective, the information or knowledge society, the service society, neoliberalism, or plain hypercapitalism. Hence, a new type of museum emerged, namely museums documenting workers' life. In Denmark, the Workers Museum opened in 1983, the Norwegian Industrial Workers Museum was founded in 1983 and opened in 1988, and the Museum of Work in Sweden saw the light of day in 1991. The former is located in the original Workers Assembly Building in central Copenhagen, whereas the Norwegian and the Swedish museums are located in former industrial areas (Nye 1988; Ågotnes 2007).

Alongside this development, new trends in cultural and social history affected the spread of museums in Scandinavia. In the period 1913–1921, women in the three countries were granted universal suffrage. However, women still had several obstacles in their way preventing them from reaching full equality, and in the 1960s and 1970s in particular, various left-wing organizations fighting for equal rights were founded. In Denmark, the Red Stocking Movement led to the initiative of the *Kvindemuseet* in 1982 in Aarhus, the second-largest Danish city, with the purpose of adding new dimensions to the narratives of the traditional cultural history museums (Ipsen and Sandahl 1990). In Norway, the *Kvinnemuseet* was established, with a similar purpose, in the early 1990s, outside Oslo in the family house of a famous woman pianist and author (Jacobsen 1994, 1995). Although the Swedish *Kvinnohistoriskt arkiv*, an archive for women's literature and archival documents, was established in 1958, and *DEA – Föreningen för et kvinnohistoriskt museum* – was founded in 1994, the first women's museum was not opened until 2014 in Umeå, and the next, *Stockholms kvinnohistoriska*, followed in 2019. Neither institution is a traditional museum as they do not possess collections, but rather organize exhibitions and, again, collect documentation about women's history (Thomsgård and Pousette 2020).

Another critical addendum to the narrative of the welfare society is the history of minority and indigenous museums. Scandinavian countries used to portray themselves as consisting of homogeneous populations, and museums had been important for forging common national identities. Various ethnographic collections displayed the others, the non-Western world, often as a result of Scandinavians exploring the world. However, indigenous people and religious minorities within the Scandinavian realms have been present all the way. For example, Danish museums had been collecting Greenlandic cultural and natural objects since Ole Worm's days. Although the idea of a Museum of Greenland in Copenhagen was under consideration in the early 1930s, this museum was never realized (Ries 2003). Instead, the National Museum in Greenland, established in the mid-1960s as the country's first museum, received 35,000 items from the National Museum of Denmark between 1984 and 2001 following a repatriation agreement in 1982. Nevertheless, the museum in Copenhagen contains by far the vastest collection of artifacts from Greenland (Gabriel 2009).

The largest group of minority museums in the countries is the Sámi museums. Sámi culture has also been collected and displayed by national and majority

museums from an early date, but there were no museums dedicated to, and run by, the Sámi population before the establishment of the Sámi collections in the Norwegian municipality of Karasjok in 1972 based on a range of collection and grassroots' initiatives throughout the preceding decade. Since then, museums have been established in different Sámi regions and they are now consolidated in six *Siidas* (organizational units) with responsibility for different Sámi groups. In Sweden, there is only one similar museum, Ájtte – the Swedish Mountain and Sámi Museum – which opened in 1989 (Hirvonen 2008).

As an indigenous population, Sámi started claiming ownership of land and culture. Other minority museums followed suit. Partly in line with an international trend, the Jewish Museum in Copenhagen was founded in 1985 and the museum was opened in 2004. During this period, the commemoration of Jewish history and culture, and of the Holocaust and World War II, led to the establishment of museums celebrating Jewish culture as well as museums and institutions remembering genocide. The Stockholm Jewish Museum was opened in 1987, and two Jewish museums were established in Norway, the Trondheim Jewish Museum (opened 1997) and the Oslo Jewish Museum (established in 2004) (Pataricza et al. 2021).

Conclusion

In this chapter, we have primarily been looking for similarities across the three Scandinavian countries. If space allowed, other clusters of museum types within limited time spans could have been added to our list, for example, criminal and police museums, maritime museums, Scandinavian-American migration museums, and forestry museums. In line with the critical approach to women's history, museums of nursing history from the 1980s are also notable. However, differences are also easy to identify, for example, the *ABBA museum* in Sweden, the *Oljemuseet* in Norway, and the *H.C. Andersen museet* in Denmark; and the locations of these museums are easy to justify. On closer inspection, the structures for public financing of museums and the administration and organization of the national museum landscapes also vary between the Scandinavian countries. An account of these matters falls outside the present narrative.

Nevertheless, despite our vague definitions of "type," "collection," "museum," and "societal changes," the comprehensive number of clusters of common museum types across the countries – in some cases just the two of them – make us infer that some sort of relation between new museum types and societal changes can be mapped, although not explained in an unambiguous way. At the macro level, one might assume that museums have more often been sociopolitical instruments for these changes than the reverse. At the micro level, there is not just one explanation for parallels between new types and societal changes. For example, close collaboration between individuals within a specific field or general trends from the outside of Scandinavia might have been reasonable influences. The purposes of the new museum type would also differ, for example, in the dialectic between

model museums (often inspired by visits to Nordic and world's fairs) and history museums (documenting a fading past). In both cases, important drivers could be technology and industrialization. But another driver has been wealth, both the wealth of individuals and the prosperity of the welfare state, and, in both historical and modern times, the quest for knowledge, education, and learning has been there all the way, although the means to communicate have had varying expressions. Notwithstanding all these explanations, which have only been indicated in the previous, quite a number of corresponding waves between new museum types and societal changes can be identified.

Two further observations, which might seem too obvious, should be noted because of the comparative material presented. Characteristically, the clusters of museum types above are framed by national distinctions and regulations. We are yet to see a joint museum run in collaboration by two or three Scandinavian countries, although the countries are similar in many ways and the identical museum types typically tell the same story at a generic level. Thus, the national framing *is* imperative. However, although the significance of this is clear, museums are not just about promoting or reflecting national identities. As our last observation, we note that a community on a smaller scale than the nation is typically at the core of the new museum type, be it industrialists and/or workers within a common field, employees at the state railways, art lovers, a group of people reacting towards societal amnesia, etc. A variety of museum types – both local and nationwide, small and large – signifies a manifoldness of identities.

References

Ågotnes, Hans-Jakob. 2007. "Eit industrisamfunn ser tilbake. Monument og forteljing i industristadmuseet." *Tidsskrift for kulturforskning* 6, no. 1–2: 79–93.

Althin, Torsten. 1974. "Ett tekniskt museum. Svenska Teknologiföreningens jubileumstanke år 1911." In *Dædalus: Tekniska museets årsbok 1974,* edited by Sigvard Strandh, 11–22. Stockholm: Tekniska Museet.

Andersen, H.W., Brita Brenna, Magne Njåstad and Astrid Wale, eds. 2009: *Æmula Lauri. The Royal Scientific Society of Sciences and Letters 1760–2010.* Sagamore Beach, MA: Science History Publications, 2009.

Bäckström, Mattias. 2012. *Hjärtats härdar: Folkliv, folkmuseer och minnesmärken i Skandinavien, 1808–1907.* Stockholm: Gidlunds förlag.

Bennett, Tony. 1995. *The Birth of the Museum: History, Theory, Politics.* London: Routledge.

Brenna, Brita. 2011. "Clergymen Abiding in the Fields: The Making of the Naturalist Observer in Eighteenth-Century Norwegian Natural History." *Science in Context* 24, no. 2: 143–166. https://doi.org/10.1017/S0269889711000044.

Bjurström, Per. 1992. *Nationalmuseum 1792–1992.* Höganäs: Bra Böcker.

Broberg, Gunnar. 2019. *Mannen som ordnade naturen: En biografi över Carl von Linné.* Stockholm: Natur & Kultur.

Ekman, Mattias. 2018. "The Birth of the Museum in the Nordic Countries. *Kunstkammer,* Museology and Museography." *Nordic Museology* 1: 5–26. https://doi.org/10.5617/nm.6395.

Eriksen, Anne 2009. *Museum: En kulturhistorie.* Oslo: Pax forlag.

Gabriel, Mille. 2009. "The Return of Cultural Heritage from Denmark to Greenland." *Museum International* 61, no. 1–2: 30–36. https://doi.org/10.1111/j.1468-0033.2009.01664.x.

Gjølme Andersen, K., and Olav Hamran. 2014. *Teknikk på museum: Norsk teknisk museum 1914–2014.* Oslo: Pax Forlag.

Glamann, Kristian. 1996. *Beer and Marble: Carl Jacobsen of the New Carlsberg.* Copenhagen: Gyldendal.

Glambek, Ingeborg. 2010. "Kunstindustrimuseer og den kunstindustrielle bevegelse." In *Samling og museum: Kapitler av museenes historie, praksis og ideologi*, edited by Bjarne Rogan and Arne Bugge Amundsen, 95–110. Oslo: Novus Forlag.

Gräslund, Bo. 1987. *The Birth of Prehistoric Chronology: Dating Methods and Dating Systems in Nineteenth-century Scandinavian Archeology.* Cambridge: Cambridge University Press.

Gundestrup, Bente. 2005. "Kunstkammeret 1650–1825 og dets betydning for dannelsen af det nationale museumsvæsen i Danmark." In *Ny dansk museologi*, edited by Bruno Ingemann and Ane Hejlskov Larsen, 13–36. Aarhus: Aarhus Universitetsforlag.

Handberg, Kristian. 2017. "The Shock of the Contemporary: Documenta II and the Louisiana Museum." *OnCurating* 33: 34–43.

Hellandsjo, Karin, ed. 2009. *The Art of Tomorrow Today: The Heine Onstand Art Centre.* Høvikodden: Skira Editore.

Hirvonen, Vuokko. 2008. "Sámi Museums and Cultural Heritage." In *Scandinavian Museums and Cultural Diversity*, edited by Kathrine Goodnow and Haci Akman, 23–29. New York: Berghahn Books.

Houlberg Rung, M. 2013. "Negotiating Experiences: Visiting Statens Museum for Kunst." PhD diss., University of Leicester.

Hubert, François. 1985. "Ecomuseums in France: Contradictions and Distortions." *Museum International* 37, no. 4: 186–190.

Ipsen, Merete, and Jette Sandahl. 1990. "The Women's Museum in Denmark." *Journal of Women's History* 2, no. 2: 168–170.

Jacobsen, Kari Sommerseth 1994. "Kvinnemuseet på Rolighed." *Nytt om kvinneforskning* 1: 31–34.

Jacobsen, Kari Sommerseth 1995. "Rolighed åpner dørene." *Kvinnejournalen* 2/3: 22.

Jansson, Ulf. 2014. "Akademiens roll förändras." *Skogs- och lantbrukshistoriska meddelanden* 68: 65–73.

Jørgensen, Guri. 2020. "Saker som beveger: NTNU Vitenskapsmuseet: Et universitetsmuseum som kategori, arbeidssted og formidlingssted." PhD diss., Norges teknisk-naturvitenskapelige universitet – NTNU.

Karlsson, Pernille. 2009. "Göteborgs skolmuseum och dess grundare." In *Hundra år i skolans tjänst: Nedslag i Göteborgs skolhistoria*, edited by Pernille Karlsson and Margaretha Sahlin, 11–34. Partille: Warne Förlag.

Kjærboe, Rasmus. 2016. "Collecting the Modern: Ordrupgaard and the Collection Museums of Modern Art." PhD diss., Aarhus University.

Kolding, Fredrik Birkholt. 2016. ""Alle 'Væsener' har deres eget Musæum." Begyndelsen til Danmarks jernbanemuseum 1906–1931." *Jernbanehistorie: Jernbanernes teknologi- og kulturhistorie 2016.* Årsskrift for Danmarks jernbanemuseum: 82–97.

Landgren, Lena, and Ida Östenberg. 1996. *Monument och manuskript: Antikvetenskapens historia till 1800-talets mitt.* Lund: Studentlitteratur.

Lange, Marit, ed. 1998. *Nasjonalgalleriets første 25 år 1837–1862.* Oslo: Nasjonalgalleriet.

Larsen, Christian. 2016. "Institutter, selskaber, museer og foreninger." *Uddannelseshistorier: Årbog 2016* fra Selskabet fra Skole- og Uddannelseshistorie: 11–31.

MacGregor, Arthur. 2007. *Curiosity and Enlightenment: Collectors and Collections from the Sixteenth to the Nineteenth Century.* New Haven, CT: Yale University Press.

Magnusson Staaf, Björn, and Frederik Tersmeden. 2016. *Lunds universitet under 350 år – Historia och historier.* Lund: Lund University.

Mordhorst, Camilla. 2009. *Genstandsfortællinger: Fra Museum Wormianum til de moderne museer.* Copenhagen: Museum Tusculanum Forlag.

Nordström, Charlotta. 2015. *Up the Stylish Staircase: Situating the Fürstenberg Gallery and Art Collecting in a Late-Nineteenth-century Swedish Art World.* Stockholm: Makadam Förlag.

Nye, David E. 1988. "The Workers' Museum in Copenhagen." *Technology and Culture* 29, no. 4: 909–912.

OBL 2020. *Oslo Byleksikon.* Accessed 25 February 2022. https://oslobyleksikon.no/side/Oslo_Skolemuseum.

Øverland, Ole Andreas 1909. *Det Kgl. Selskap for Norges Vels Historie Gjennem Hundre Aar 1809–1909.* Oslo: Kongelige Selskab for Norges Vel.

Pataricza, Dóra, Simo Muir, Sofie Lene Bak, Bjarke Følner, Vibeke Kieding Banik, and Pontus Rudberg. 2021. "Jewish Archives and Sources in the Nordic Countries: The Current State of Affairs and Future Perspectives." *Nordisk judaistik: Scandinavian Jewish Studies* 32, no. 2: 54–80. https://doi.org/10.30752/nj.111889.

Rasmussen. Holger. 1979. *Dansk Museumshistorie: De kulturhistoriske museer.* Copenhagen: Dansk kulturhistorisk forening.

Rentzog, Sten. 2007. *Open Air Museums: The History and Future of a Visionary Idea.* Kristianstad: Jamtli Förlag & Carlsson Bokförlag.

Ries, Christopher Jacob. 2003. *Retten, magten og æren: Lauge Koch sagen: En strid om Grønlands geologiske udforskning.* Copenhagen: Lindhardt and Ringhof.

Rostrup, Harvard. 1981. *Histoire du Musée d'Ordrupgaard 1918–1978.* Copenhagen: Ordrupgaard.

Sandberg, Mark B. 2002. *Living Pictures, Missing Persons: Mannequins, Museums, and Modernity.* Princeton, NJ: Princeton University Press.

Skreien, Norvall. 2009. "Norges Fiskerimuseum." In *Bergen byleksikon*, edited by Norvall Skreien and Gunnar Hagen Hartvedt, 344. Oslo: Kunnskapsforlaget.

Skyggebjerg, Louise Karlskov. 2009. *Danmarks tekniske museum: En appetitvækker til en rig samling.* Helsingør: Danmarks Tekniske Museum.

Stjernquist, Berta. 2005. *The Historical Museum and Archaeological Research at Lund University 1805–2005.* Lund: Historical Museum at Lund Univeristy.

Søndergaard, Jens Aage and Peter Bavnshøj. 2004. "De danske landbrugsmuseer – deres historie og fremtidsudsigter." *Landbohistorisk tidsskrift* 2: 9–32.

Tarp, Lisbet. 2018. "Museum Wormianum: Collecting and Learning in Seventeenth-century Denmark." In *Museums at the Forefront of the History and Philosophy of Geology*, edited by Gary D. Rosenberg and Renee M. Clary, 1–9. Geological Society of America, Volume 535. https://doi.org/10.1130/2018.2535(06).

Tellgren, Anna, ed. 2017. *Puntus Hultén och Moderna Museet. De formative åren.* Stockholm: Moderna Museet.

Thomsgård, Lina, and Helene Larsson Pousette. 2020. "Förord." In Karin Carlson, *Kvinnosaker. Ett sekel av kvinnohistoria genom 50 föremål*, 7–9. Stockholm: Bonnier Fakta.

Vest Hansen, Malene. 2020. "Mellem Slaraffenland og Utopia. Louisiana som velfærds-samfundets nye oplevelsesmuseum". In *Dansk museumsformidling i 400 år: I krydsfeltet oplysning-oplevelse*, edited by Lars Bisgaard, Hans Dam Christensen and Anette Warring, 233–260. Odense: Syddansk Universitetsforlag.

5

LAMS AS OBJECTS OF KNOWLEDGE AND CULTURAL POLICY

Developing synergies

Ole Marius Hylland, Nanna Kann-Rasmussen, and Andreas Vårheim

Introduction

Libraries, archives, and museums (LAMs) have an intertwined history, and these institutions play a pivotal role in the development of modern nation states. For all three institutions, it is fair to say that they became nationalized in the nineteenth century. The emphasis on establishing or developing libraries, archives, and museums with a national scope became evident during the 1800s in all Scandinavian countries. In accordance with this emphasis, LAMs took on another role. Archives can serve as an example. From being institutions for documenting rules, regulations, and power, they became institutions for developing national history and/or identity (Cook 2013). Put differently, they became part of politics and policy; they became a matter for the government and governance. Furthermore, they became part of culture and knowledge policy. However, the administrative organization and legislative framework have varied considerably, both between the three countries and across time.

In the latter part of the 1990s and at the beginning of the 2000s, an idea of synergy between libraries, archives, and museums gained momentum. The idea of convergence between LAMs was promoted in Europe, the United States, and Australia during the 1990s (Robinson 2012). This became a key idea partly because the metaphor of the LAMs as *memory institutions* could be related to the new possibilities that the Internet, databases, and seamless digital connections seemed to provide (ibid.). From an alternative perspective, and with the merged Library and Archives Canada as an example, Lisa Given and Lianne McTavish describe such processes rather as *reconvergence*, in the sense that libraries, archives, and museums thereby returned to an epistemological basis that they originally had in common (Given and McTavish 2010; see also Hvenegaard Rasmussen 2019).

DOI: 10.4324/9781003188834-6

In the Scandinavian countries, similar ideas on LAM synergies also became apparent during the same period, as we will describe in this chapter. We aim to identify and describe how Scandinavian LAM policies have evolved. How did the libraries, archives, and museums come to gravitate toward one another within national cultural and knowledge policies? And, as we are accustomed to treating Scandinavian and Nordic cultural policy as representative of a common *Nordic model*, we are also interested in looking at possible *differences* in the three national policies at stake in this chapter. We base the analysis on a close reading of policy documents from all three countries.

As indicated by the title of this chapter, we position the development of LAM policies within both culture *and* knowledge policies. There is an analytical as well as an empirical point to this. The empirical one is that policies of libraries, archives, and museums in the past few decades have been the responsibility of more than one ministry – both those dealing with arts and culture and those dealing with education, research, and enlightenment. The analytical point to be discussed is that the combination of knowledge and cultural policy captures an inherent tension in LAM institutions as being providers of historical knowledge, learning, research, cultural heritage, arts, and culture simultaneously. In our understanding, knowledge policy denotes the public policy from governmental, regional, or municipal authorities with explicit reference to education, learning, and research. Similarly, we understand cultural policy as the explicit public policy to finance, organize, regulate, and legitimate the production of culture, including cultural heritage (cf. Mangset and Hylland 2017).

The main part of the chapter is a decade- and nation-wise analysis of pivotal points in LAM policies during the past 60 years. After this section, we discuss the main questions of the article and identify traits and changes across six decades of LAM policies.

1960s and 1970s

The 1960s and the 1970s were decades for an expanded legitimation of national cultural policies. Going back to the nineteenth century, the initial phase of the history of cultural policy was based, generally speaking, on a combination of national identity formation, public enlightenment, and scientific development (cf. Dahl and Helseth 2006). For the Scandinavian nation states, the pride in having national cultural institutions, a national history, and national-minded authors, composers, and painters could legitimate governmental interest. At the same time, a nation and its prospects could also be judged by the *Bildung* of its citizens, hence the interest in educating the general public. Furthermore, new ideas on how to write history, especially the idea of *historicism*,[1] came to influence how the importance of institutions like museums, archives, and libraries was understood. These were, in other words, institutions of memory, education, knowledge, and identity.

When the Danish Ministry for Culture was established in 1961, the first Minister for Culture, Julius Bomholt, declared that the new ministry had two main responsibilities: First, to support the creation of art and culture; and second, to ensure that the individual citizen had access to art and culture through the creation of real cultural opportunities (Fihl Jeppesen 2002). From the beginning, the Danish Ministry of Culture focused on what Duelund (2003) and others have called "democratization of culture."

For public libraries, this strategy manifested itself clearly in a new library act from 1964. The act states that every municipality in Denmark must establish a public library. Furthermore, a new purpose clause (of which the main part is still in use today) stated that the objective of a public library is to promote enlightenment, education, and cultural activity by making books and other suitable materials available free of charge. After 1964, libraries extended their services to include children's libraries and extensive programming. This meant that libraries now hosted author talks and other programs. Furthermore, the 1964 legislation opened up for new lending materials such as music and artwork (Jochumsen and Hvenegaard Rasmussen 2006).

In the 1960s and 1970s, Danish cultural policy emphasized the institutions' efforts to mediate and promote arts and culture for the education of the people. Gradually, foci on equality and social justice became cornerstones of cultural policy, and the notion of "good culture" could be expanded. Museums were criticized by the Ministry of Culture for being boring and not meeting visitors at entry level (Warring 2020). As a result, the 1969 Museum Act specified that both history museums and art museums could apply for additional funding if they arranged presentations of cultural movies, music, or literary readings (Krogh Jensen 2019, 93). Even though museums were criticized for *not* being able to reach users, a report from 1975 rejected the notion that the number of visitors would be a suitable measure of the quality of museums (Warring 2020, 331). In the 1980s and 1990s, this would change drastically.

In 1961, the Ministry of Education and Religion in Sweden established LAMs as a specific domain within the budget for culture (SOU 2009:16-I, 137). During the 1960s and 1970s, a new cultural policy was developed and presented in several government reports and policy documents. The government bill on cultural policy from 1974 (Regeringens proposition 1974:28) kept the social-democratic ideals of democratizing culture, and to some extent emphasized values of popular culture, popular creativity and participation, and leisure activities (Frenander 2013).

The Swedish cultural policy goals of 1974 (Regeringens proposition 1974:28, 295, 300), relevant for the LAMs, are at the basis of cultural policy even in 2022, e.g., freedom of expression, the integration of diverse groups, and the conservation and presentation of cultural heritage. For the LAMs, the new cultural policy of 1974 was primarily a museums policy. The 1974 bill held that collections must be "researched and documented. Knowledge acquired through the research activity

must be disseminated through activities, mainly exhibitions" (Regeringens proposition 1974:28, 339; see also SOU 1973:5, 15–16). Furthermore, museums should be arenas for public debate, relevant to current societal debates, and cooperate with voluntary organizations. The idea of museums as general cultural centers was adapted to the Swedish context of municipal and county museums (SOU 1973:5, 232–33). The 1970s cultural policy also meant structural reforms in the museums' sector; the museum landscape established then mainly still exists – with national museums specializing in different types of collections and county cultural history museums (SOU 1973:5). Public libraries are described as the main municipal cultural institution and a hub for activities creating social interaction and emphasizing services for disadvantaged and vulnerable groups, including immigrants (Regeringens proposition 1974:28, 359; SOU 1972:66, 282–85). Archive policy is only summarily discussed in the policy documents of the 1970s.

In Norway, the legislation on public libraries used the phrase "increase public enlightenment" (*auka folkeopplysning*) as an overarching goal until 1971. In line with a general development toward ideals of cultural democracy, this was changed in the revised legislation this year, where libraries were described as more general cultural institutions, with an ambition to be more actively involved in the cultural activities of the ordinary citizen (Frisvold 2021, 128). A similar vision was put forward in the same period for the Norwegian museums, expressed, for example, by the parliamentary standing committee on education and church affairs. They stated that museums should be included in the general goal of cultural policy, "to expand people's ability to experience and their sense of quality, and to stimulate creative enterprise in the individual as well as activities in local communities" (Innst. S. nr. 175 (1972–1973), 460).[2] The first governmental white paper on cultural policy, in 1973, also underlined this kind of ambition for the museums. Archives, on the other hand, were not a very visible part of this new cultural policy, or, for that matter, for cultural policy as such. This was to change, but in the Norwegian context, the cultural policy documents and strategies of the 1970s (e.g., the key documents of the white papers on cultural policy) make almost no mention of archives.

Summing up, the 1960s and 1970s saw some new ideas and updated political legitimation of governmental expenditure on culture, which also encompassed the policies for LAM institutions. In short, this development is often captured by the twin concepts of *democratization of culture* and *cultural democracy* (Fihl Jeppesen 2002; Duelund 2003). Democratization of culture denotes the idea that quality culture and knowledge needed to be made available to the general public, to the uneducated or rural classes, in short, to the *folk*. Albeit a nineteenth-century idea, this grand thought was given new political relevance in the 1960s through different schemes to distribute arts and culture to all regions. "Cultural democracy" describes, on the other hand, a genuine expansion of the cultural policy portfolio to include amateur cultural activities, voluntary cultural work, and regional culture in general. In a number of European countries, this was explicitly referred

to in the 1970s as a new cultural policy (Mangset and Hylland 2017, 59–62). This also affected the political ambitions for the LAM institutions – especially for libraries at first, but followed shortly or simultaneously by museums. These institutions were envisaged to have roles as more general cultural institutions.

1980s and 1990s

The next two decades of Scandinavian LAM policies saw a continuation of some of the ideas from the previous decades, especially regarding the importance of what came to be referred to as *users*. In addition, we also see a few genuinely new ideas, on the importance of new technology, on public management, and on the potential in coordinating, both within libraries, archives, and museums and across them.

The two main Norwegian cultural policy white papers in the 1980s and 1990s emphasize the role of LAM institutions as general cultural institutions, being more than repositories for passive knowledge in the shape of books, documents, and objects. Museums are envisaged to work more actively towards different audiences. Archives are given more cultural policy attention, including the mentioning of archives actually having a general audience that they needed to communicate more actively with: "The ministry sees it as important to strengthen the audience function and make the archives more accessible" (St.meld. nr. 23 (1981–1982), 141). Libraries were also seen as not having realized their potential as general institutions of culture and participation. The 1981 white paper also pointed to the need to have a focus on *immigrants* as a target group for the work of libraries. Eleven years later, the emphasis on users in general had strengthened: "It will be important to develop operational models in the library sector with the *user* at its core" (St.meld. nr. 61 (1991–1992), 213). Children and young people were especially pinpointed as an important target audience.

By the start of the 1980s, it had already become evident for public policy that LAMs needed to respond to the development of new media. Archives needed to preserve source material on new technological platforms, libraries needed to include new media in their collections, and all LAMs had powerful new tools for their work on documentation and systematization information. This was also part of the argument put forward in 1992 on the potential of LAM coordination: "[T]hey all work on collecting, systemizing, organizing, preserving, and communicating knowledge" (St.meld. nr. 61 (1991–1992), 219). Information management and electronic data processing were two of the common features emphasized.

In addition to this rather cautiously phrased point on LAM convergence, there were explicitly stated aims to coordinate *within* the individual sectors. There should be a closer cooperation between research libraries and public libraries, the 1981 white paper stated. And in 1992, both new legislation on archives and a new public agency for museums were instigated to enhance the coordination within these two sectors.

In Denmark, there was a slightly different focus. In the 1980s and 1990s, ideas on new public management became visible in Danish cultural policy. LAMs were measured according to specific performance indicators via cultural statistics and performance contracts (Kann-Christensen 2009; Balling and Kann-Christensen 2013). These documents emphasized performance goals related to both increased use and to certain shifting goals such as diversity, digitalization, or collaboration. In the 1980s and 1990s, digital representation of collections in museums was considered to be especially important. In the libraries and archives, digitalization was primarily coupled to work processes and born-digital materials.

Trine Bille writes in a chapter on Danish cultural policy that "[t]he focus on instrumental objectives began in the 1980s where especially the municipalities began to argue for public support for the arts and culture" (Bille 2022, 24). On a local policy level, new libraries and museums were legitimized by focusing on economic impact. The idea was that these new houses of culture would attract resourceful families to the municipality, and thereby increase tax revenues as well as consumption.

In 1996, the Swedish government formally created a cultural heritage policy that included LAMs, and a cultural heritage department was established in the Ministry of Culture (Regeringens proposition 1996/97:3, 27). To exploit the LAMs' potential for historical insight and give cultural heritage a more visible identity as part of cultural policy, there was a stated need for a coordinated policy within this field (ibid., 129). This policy stressed the "preservation, use, and development" of cultural heritage (Regeringens proposition 2009/10:3, 30). Museum policy developed further as a public-oriented cultural heritage policy, stressing user engagement, citizen participation, and community orientation. The focus on museum research and curation was overtaken by the new heritage policy goals (Grinell and Högberg 2020). Despite being included in cultural heritage policy, archives policy and policy for public libraries were still treated as technical and sector-specific issues. University libraries and the National Library were, as in 1974, left to research and higher education policy. The parliament passed legislation creating a library law encompassing all public libraries and university libraries (SFS. 1996:1596; Regeringens proposition 1996/97:3, 9). The law confirmed year-long practices, e.g., every municipality should have its public library.

There are differences as well as similarities in the development of LAM policies in Scandinavia in the 1980s and 1990s. In Norway, ideas on LAM integration and coordination were put forward, partly legitimated with reference to the development of digital technology. In Denmark, LAM institutions were met with new ways of measuring their contribution to society. In Sweden, administrative changes signaled a general cultural heritage policy for the LAM sector. Across the three national policies, we see that there was a policy development toward looking at LAMs as institutions for audiences, communities, and participation. This is an important cornerstone for how common tasks for LAMs have come to be understood today, being seen as general, outward-oriented institutions.

2000s and 2010s

After the turn of the millennium, the importance of digitalization and its relevance for cultural policy became evident. Even if there were already precursors of digital ambitions from the 1980s and 1990s, the digital ambitions on behalf of LAMs were raised to a new level after 2000. In Norway, the Ministry of Culture and Church Affairs presented a pivotal white paper on LAMs, along with a whole new policy on the common goals and aims of these institutions (St.meld. nr. 22 (1999–2000)). The policy and the paper built on previous arguments, especially regarding the digital opportunities and challenges that were shared by the three institutions. This led to the establishment of the public body *ABM-utvikling* (literally "LAM development") in 2002, which was responsible for realizing the full potential of LAM coordination and convergence (Hylland 2019; Vårheim, Skare, and Stokstad 2020). *ABM-utvikling* was given the main task of developing the Norwegian LAM policy and worked on doing so until the entity was dissolved in 2010. This included an attempt to coordinate digitization in the three different sectors through standards for digitizing procedures, the publishing of a series of reports and strategies, supporting a variety of projects instigated by LAM institutions, and through establishing different projects for digital access to cultural heritage (ibid.; see also Henningsen and Larsen 2020). One of the fundamental ideas was captured in the title of a digitization strategy published in 2006: "Cultural heritage for everyone" (*Kulturarven til alle*) (ABM-utvikling 2006). There was an explicit and implicit notion that digitization equaled democratization (cf. Hylland 2014). This was a notion that in no way was unique to the Norwegian policy development.

The focus on LAMs as important digital institutions was maintained in several governmental white papers from the same period. In the course of one parliamentary year, the Norwegian Ministry of Culture published three white papers on LAMs, all emphasizing this aspect: On museums (St.meld. nr. 49 (2008–2009), on the digitization of cultural heritage (St.meld. nr. 24 (2008–2009)), and on libraries (St.meld. nr. 23 (2008–2009)). A statement from the white paper on digitization can serve to exemplify the ambitions for digital cultural heritage:

> The white paper is meant to contribute to the development of a digital society. It especially emphasizes the need for research and education, and that every individual needs knowledge to be able to influence their own existence as well as the development of society.
>
> *(St.meld. nr. 24 (2008–2009), 12)*

In the revised Public Library Act from 2014, the role of libraries also included the responsibility to offer "other media" to the general population, thereby including digital and digitized culture (LOV-2013-06-21-95). More important in this revised legislation, however, was the explicit goal for public libraries to be "independent meeting places and arenas for public discourse" (ibid., our translation).

Danish policy documents from the same period had a different focus. In the first decade of the new millennium, several policy documents on the so-called "experience economy" were published in Denmark. Examples include "Denmark's Creative Potential" (Ervervsministeriet and Kulturministeriet 2000) and "Denmark in the Cultural and Experience Economy – 5 New Steps on the Road" (Danish Government 2003). The focus on the experience economy challenged the museums in particular. According to Skot-Hansen (2008), they felt the competition from the many new experience attractions, which have learned to use experience as a strategic tool. At the same time, policymakers wanted to include museums as a competitive parameter in the economic development of cities and regions.

Another important policy document from the 2000s is the digitalization strategy (Digitaliseringsstyrelsen 2002). In this strategy, the government presents an ambitious plan to digitalize the public administration, so that the contact between citizens and administration (e.g., regarding taxes or scheduling of appointments with public authorities) would be digital. One concrete instrument was the establishment of citizen service centers. In practice, many municipalities decided that the public library would house these. In this way, a new societal task, to educate Danish citizens so they could meet expectations of digital public self-service, was given to the public libraries.

The current Danish library legislation stems from 2000. This act emphasizes digitalization and new media. In 2010, an influential report called "The Public Libraries in the Knowledge Society" (*Folkebibliotekerne i videnssamfundet*) was published by the Danish Agency for Libraries and Media. This report viewed libraries not only as providers of knowledge and culture, but also as central players in the development of the society at large. The library was still being characterized as a provider of enlightenment, education, and cultural activity (the keywords from 1964). However, the report characterizes library services as a way to support the development of the Danish society in an increasingly challenging competitive globalization (Styrelsen for Bibliotek og Medier 2010).

This can be seen as an example of instrumental cultural policy. Today, it makes more sense to see it as an early example of how cultural policy even today frames LAMs as active agents in the solving of society's agendas and problems. In Denmark today, cultural policy is not debated very much in the media (Hvenegaard Rasmussen 2018), and it is difficult to see what policy goals are present, even in different governments' cultural policy. Public funders expect LAMs to display strategic capacities and continuously show that they are capable of setting their own goals and contribute to solving problems they define themselves (Kann-Rasmussen and Hvenegaard Rasmussen 2021). Many Danish LAMs (more or less) willingly couple themselves to the agendas present in local and national contexts, e.g., by engaging in the climate debate or local health initiatives.

In Sweden, the 2009 government bill on culture introduced the most significant reform of the Swedish library system since 1912 (Frenander 2012, 7).

The National Library was given the responsibility for a national library policy from 2009 (SFS 2008:1421). It was to have a "national overview, promote collaboration, and drive development in the library sector, and, in consultation with the county libraries, continuously monitor the libraries' work" (Regeringens proposition 2009/10:3, 41). The regional state authority archives are stripped of their autonomous status as agencies and merged with the National Archives (Regeringens proposition 2009/10:3, 97–98). The 14 national museums (ten government agencies and four foundations) are expected to coordinate and develop cooperation among themselves and with the remaining museum sector, consisting of regional and local museums and partners outside the museum sector.

The 2017 government bill on cultural heritage policy introduces a new museum law and policy, emphasizing three main priorities: to make the common cultural heritage relevant for everybody; to widen and deepen public discourse; and to promote citizen co-creation and engagement, as well as museum research (Regeringens proposition 2016/17:116, 69). One prominent idea is that cultural heritage institutions are not primarily to represent social identities and diversity – they are public arenas for stimulating the participation of most people. The bill describes the process of digitizing heritage documents as an ongoing critical joint endeavor that still requires close attention and cooperation. From 2017, the Swedish National Heritage Board ("Riksantikvarieämbetet") was given an extended responsibility for museum issues: "To gather the responsibility for museum issues at the National Heritage Board" (Regeringens proposition 2016/17:116, 116). Though dominated by museum questions, Swedish cultural heritage policies aim to create better prospects for cultural heritage services within libraries and archives (Regeringens proposition 2016/17:116, 168). Digitization is a common issue, and enhanced coordination between LAM institutions is necessary for efficiency and user accessibility (ibid.). Also, in 2017, the National Heritage Board received the responsibility for coordinating cultural heritage digitalization policies. Formerly (from 2011), the National Archives had this role. A proposed update of the archives law is to complement the democratic infrastructure, cultural heritage, and digitalization policy frameworks, built through the library (Regeringens proposition 2009/10:3) and museum legislative processes (Regeringens proposition 2016/17:116).

Although the LAM policies in the Scandinavian countries have differed over the past two decades, they have one thing in common. The ambitions on behalf of the LAM institutions have expanded considerably. Whether as contributors to an experience economy, as in Denmark, or as digital and/or democratic beacons, LAMs have steadily been given greater and more general tasks as societal institutions. Albeit not the singular driver of convergence between LAMs (cf. Hvenegaard Rasmussen 2019), digitalization has been central both as a goal in itself for all three institutions and as a tool for reaching the goals of democratization and participation.

Sixty years of LAM policies: Discussion and concluding remarks

The gradual convergence between LAMs has not been of equal strength and character in the three Scandinavian countries. In Norway, *ABM-utvikling* was the institutionalization and the epitome of the idea of synergy between libraries, archives, and museums. The organization represented a meeting between different ways of understanding cultural material: As cultural heritage, as art, as information, and as documentation. The operational terms in the authoritative definitions of libraries, archives, and museums from IFLA, ICA, and ICOM are *information, documentation*, and *heritage*, which represents three different perspectives on knowledge and the function of knowledge: "remembering things differently" (Robinson 2012). The overall ambition behind *ABM-utvikling* was to connect these perspectives through digitization, accessibility, and dissemination. There was, however, a policy imbalance between the three sectors from the beginning: It was the cultural heritage and cultural preservation perspective, in other words the museum perspective, that dominated, which the other two sectors should learn from (Hylland 2019). The archives and libraries, in contrast to the museums, have statutory administrative tasks, in addition to the tasks as mediators of cultural heritage and cultural expression. The National Archives and the National Library represent long-standing government institutions, professions, and interests, making collaboration, institutional integration, and reform processes difficult. Institutional differences, conflicting institutional interests, the organization of change processes, and a lack of political interest may help explain the challenges that the institution *ABM-utvikling* faced.

In the case of Denmark, there has been no official coordination and synergy between LAMs, besides the fact that many public libraries house the local history archive. However, LAMs face similar challenges and expectations from society and policymakers, which arguably makes them more similar.

Swedish government policies for LAMs have evolved along two trajectories. The first line of development is towards more powerful institutions keeping their primary identities as libraries, archives, and museums. The second is LAM cooperation and LAM integration, as, for example, operationalized by the administrative coordination of responsibility, as described above. The Swedish museum sector has been consolidated and placed under the Swedish National Heritage Board. The National Library has been strengthened by adding public library policy to its portfolio. Also, the National Archive has kept its independent status. In the 2010s, museums formerly not regulated in legislation received such legislation (2017), and the library legislation of 1996 was revised and expanded. A new Archives law was proposed in the Government Inquiry of 2017 (SOU 2019:58).

On the other hand, the umbrellas of cultural heritage policy and heritage digitalization policy invite LAM cooperation. Both digitalization and cultural heritage policy are ultimately the responsibility of the National Heritage Board. The combination of roles strengthens the Board's position within the LAM

policy area and underlines its dominance in the cultural heritage sector. The clear division of potential LAM tasks, also through legislation, reinforces the traditional separate LAM institutional identities. Furthermore, the system of independent government agencies weakens the position of the ministries and parliament relative to the government agencies (Molander, Nilsson, and Schick 2002). Even more so during the last 30 years, this has been driven by EU integration and public management reform (Jacobsson and Sundström 2007), which adds to the general difficulties of institutional reform, policy change, and policy implementation. Nevertheless, "soft" institutional convergence between LAMs through collaboration relating to specific common issues is increasingly occurring in Sweden.

The widening of responsibilities, relevant for all three institutions, might explain other characteristics of the development of LAM policies in Scandinavia. Firstly, expanded responsibilities create institutions that are the object of both knowledge and cultural policies. On the one hand, they should serve the public through being institutions for heritage, identity, entertainment, and experience. On the other hand, they have kept their ambitions as institutions for education, learning, research, and general enlightenment. Inextricably linked or not, the combination of cultural and knowledge policies is evident in the continued dual (or triple) ministerial anchoring in respective ministries in the different countries. Secondly, the expanded responsibilities also increase the relevance of LAM synergy and convergence (cf. Hvenegaard Rasmussen 2019; Skare, Stokstad, and Vårheim 2019; Vårheim, Skare, and Lenstra 2019). When tasks and goals are becoming more general, and when all three institutions face a similar challenge in digitalization, there is an opportunity for gradual policy gravitation between the LAMs. The development of LAM policies in the Scandinavian countries might also be explained by the four proposed drivers of LAM convergence put forward by Hvenegaard Rasmussen (2019): A participatory turn, a user orientation, a new spirit of capitalism, and a digitalization imperative.

If we look at six decades of LAM policies in Scandinavia from a bird's-eye view, one evident point is that the idea of what libraries, archives, and museums might contribute to society has changed. The ambitions for their part are larger, their roles are more numerous, and their tasks more general. Both libraries and museums widened their scope to become more general cultural institutions. To date, there is little evidence to suggest that the policy on archives is moving in exactly the same direction, although they are clearly expected to have a more outward-, audience-, and public service-oriented role than before.

Notes

1 "Historicism" in the sense that a linear course of history explains cultural and social phenomena.
2 All quotes from political documents from Norway, Denmark, and Sweden are translated by the authors.

References

ABM-utvikling. 2006. *Kulturarven til alle.* Oslo: ABM-utvikling.

Balling, Gitte, and Nanna Kann-Christensen. 2013. "What Is a Non-User? An Analysis of Danish Surveys on Cultural Habits and Participation." *Cultural Trends* 22, no. 2: 67–76. https://doi.org/10.1080/09548963.2013.783159.

Bille, Trine. 2022. "Where Do We Stand Today? An Essay on Cultural Policy in Denmark." *Cultural Policy in the Nordic Welfare States*, edited by Sakarias Sokka, 20–40. Nordic Council of Ministers.

Cook, Terry. 2013. "Evidence, Memory, Identity, and Community: Four Shifting Archival Paradigms." *Archival Science* 23: 95–120. https://doi.org/10.1007/s10502-012-9180-7.

Dahl, Hans F., and Tore Helseth. 2006. *To knurrende løver. Kulturpolitikkens historie 1814–2014.* Oslo: Universitetsforlaget.

Danish Government. 2003. *Denmark in the Cultural and Experience Economy – 5 New Steps.* Copenhagen: Danish Government.

Digitaliseringsstyrelsen. 2002. *På vej mod den digitale forvaltning – vision og strategi for den offentlige sektor.* Copenhagen: Digitaliseringsstyrelsen.

Duelund, Peter. 2003. *The Nordic Cultural Model.* Copenhagen: Nordic Cultural Institute.

Ervervsministeriet, and Kulturministeriet. 2000. *Danmarks Kreative Potentiale: Kultur- og erhvervspolitisk redegørelse 2000.* Copenhagen: Ervervsministeriet and Kulturministeriet.

Fihl Jeppesen, Mia. 2002. *Kulturen, Kunsten og Kronerne: Kulturpolitik i Danmark 1961–2001.* Copenhagen: Akademisk.

Frenander, Anders. 2012. "A Hundred Years of Swedish Library Policy?" Paper presented at *International Conference on Cultural Policy Research* 2012, July 9–12, Barcelona.

Frenander, Anders. 2013. *Kulturen som kulturpolitikens stora problem: diskussion om svensk kulturpolitik under 1900-talet.* Hedemora: Gidlund.

Frisvold, Øivind. 2021. *Kunnskap er makt: norsk bibliotekhistorie – kultur, politikk og samfunn.* Oslo: ABM-media.

Given, Lisa M., and Lianne McTavish. 2010. "What's Old Is New Again: The Reconvergence of Libraries, Archives, and Museums in the Digital Age." *The Library Quarterly* 80, no. 1: 7–32. https://doi.org/10.1086/648461.

Grinell, Klas, and Anders Högberg. 2020. "Lagstadgad kunskap: om svensk museipolitik och forskning." *Nordic Museology* 29, no. 2: 41–49. https://doi.org/10.5617/nm.8449.

Henningsen, Erik, and Håkon Larsen. 2020. "The Mystification of Digital Technology in Norwegian Policies on Archives, Libraries and Museums: Digitalization as Policy Imperative." *Culture Unbound* 12, no. 2: 332–350. https://doi.org/10.3384/cu.2000.1525.20200504b.

Hvenegaard Rasmussen, Casper. 2018. "Der er ingen stemmer i kulturpolitik. En Bourdieu inspireret analyse af det offentligt støttede kulturlivs status i Danmark." *Nordisk kulturpolitisk tidsskrift* 21, no. 2: 226–245. https://doi.org/10.18261/ISSN2000-8325-2018-02-06.

Hvenegaard Rasmussen, Casper. 2019. "Is Digitalization the Only Driver of Convergence? Theorizing Relations between Libraries, Archives, and Museums." *Journal of Documentation* 75, no. 6: 1258–1273. https://doi.org/10.1108/JD-02-2019-0025.

Hylland, Ole Marius. 2014. "#Mangletre: Om makt og ideologi i den digitale kulturarvens politikk." *Nordisk kulturpolitisk tidsskrift* 17, no. 2: 253–274. https://doi.org/10.18261/ISSN2000-8325-2014-02-06.

Hylland, Ole Marius. 2019. "ABM-utviklings vekst og fall. Historien om hvordan en kulturpolitisk institusjon ble født og døde." *Nordisk kulturpolitisk tidsskrift* 22, no. 2: 257–276.

Innst. S. nr. 175 (1972–1973). *Om museumssaken.* Oslo: Stortinget.

Jacobsson, Bengt, and Göran Sundström. 2007. *Governing State Agencies: Transformations in the Swedish Administrative Model.* Stockholm: SCORE.

Jochumsen, Henrik, and Casper Hvenegaard Rasmussen. 2006. *Folkebiblioteket under forandring, modernitet, felt og diskurs.* Copenhagen: Danmarks Biblioteksforenings Forlag.

Kann-Christensen, Nanna. 2009. "Institutionelle logikker i biblioteksvæsenet og dets omverden. NPM vs. Bibliotekarisk praksis." *Dansk Biblioteksforskning* 5, no. 1: 17–28. https://doi.org/10.7146/danbibfor.v5i1.97468.

Kann-Rasmussen, Nanna, and Casper Hvenegaard Rasmussen. 2021. "Paradoxical Autonomy in Cultural Organisations: An Analysis of Changing Relations between Cultural Organisations and Their Institutional Environment, with Examples from Libraries, Archives and Museums." *International Journal of Cultural Policy* 27, no. 5: 636–649. https://doi.org/10.1080/10286632.2020.1823976.

Krogh Jensen, Susanne. 2019. "From Generalist to Specialist: The Professionalization of the Danish Museum Occupation 1985–2018." PhD diss. Copenhagen: University of Copenhagen.

LOV-2013-06-21-95. Lov om folkebibliotek (folkebibliotekloven).

Mangset, Per, and Ole Marius Hylland. 2017. *Kulturpolitikk. Organisering, legitimering og praksis.* Oslo: Universitetsforlaget.

Molander, Per, Jan-Eric Nilsson, and Allen Schick. 2002. *Does Anyone Govern? The Relationship between the Government Office and the Agencies in Sweden.* Stockholm: Center for Business and Policy Studies (SNS).

Regeringens proposition 1974:28. *Kungl. Maj:ts proposition angående den statliga kulturpolitiken.* Stockholm: Utbildningsdepartementet.

Regeringens proposition 1996/97:3. *Kulturpolitik.* Stockholm: Kulturpolitik.

Regeringens proposition 2009/10:3. *Tid för kultur.* Stockholm: Kulturdepartementet.

Regeringens proposition 2016/17:116. *Kulturarvspolitik.* Stockholm: Kulturdepartementet.

Robinson, Helena. 2012. "Remembering Things Differently: Museums, Libraries and Archives as Memory Institutions and the Implications for Convergence." *Museum Management and Curatorship* 27, no. 4: 413–429. https://doi.org/10.1080/09647775.2012.720188.

SFS. 1996:1596. *Bibliotekslag.*

SFS 2008:1421. Förordning (2008:1421) med Instruktion för Kungl. biblioteket.

Skare, Roswitha, Sigrid Stokstad, and Andreas Vårheim. 2019. "ABM-utvikling og avvikling: institusjonell konvergens og divergens i kulturpolitikken." *Nordisk kulturpolitisk tidsskrift* 22, no. 2: 231–256. https://doi.org/10.18261/issn.2000-8325/-2019-02-03.

Skot-Hansen, Dorte. 2008. *Museerne i den danske oplevelsesøkonomi.* Frederiksberg: Samfundslitteratur.

SOU 1972:66. *Ny kulturpolitik.* Stockholm: Kulturdepartementet.

SOU 1973:5. *Museerna.* Stockholm: Kulturdepartementet.

SOU 2009:16-I. *Betänkande av Kulturutredningen – grundanalys.* Stockholm: Kulturdepartementet.

SOU 2019:58. *Härifrån till evigheten: en långsiktig arkivpolitik för förvaltning och kulturarv : betänkande av Arkivutredningen.* Stockholm: Kulturdepartementet.

St.meld. nr. 23 (1981–1982). *Kulturpolitikk for 1980-åra.* Oslo: Kyrkje- og undervisningsdepartementet.

St.meld. nr. 61 (1991–1992). *Kultur i tiden.* Oslo: Kulturdepartementet.

St.meld. nr. 22 (1999–2000). *Kjelder til kunnskap og oppleving. Om arkiv, bibliotek og museum i ei IKT-tid og om bygningsmessige rammevilkår på kulturområdet.* Oslo: Kultur- og kirkedepartementet.

St.meld. nr. 49 (2008–2009). *Framtidas museum – Forvaltning, forskning, formidling, fornying.* Oslo: Kultur- og kirkedepartementet.

St.meld. nr. 24 (2008–2009). *Nasjonal strategi for digital bevaring og formidling av kulturarv.* Oslo: Kultur- og kirkedepartementet.

St.meld. nr. 23 (2008–2009). *Bibliotek – Kunnskapsallmenning, møtestad og kulturarena i e digital tid.* Oslo: Kultur- og kirkedepartementet.

Styrelsen for Bibliotek og Medier. 2010. *Folkebibliotekerne i vidensamfundet : rapport fra Udvalget om folkebibliotekerne i vidensamfundet.* Copenhagen: Styrelsen for Bibliotek og Medier.

Vårheim, Andreas, Roswitha Skare, and Noah Lenstra. 2019. "Institutional Convergence in the Libraries, Archives and Museums Sector: A Contribution towards a Conceptual Framework." *Information Research* 24, no. 4: 1–10.

Vårheim, Andreas, Roswitha Skare, and Sigrid Stokstad. 2020. "Institutional Convergence and Divergence in Norwegian Cultural Policy: Central Government LAM Organization 1999–2019." In *Libraries, Archives and Museums as Democratic Spaces in a Digital Age,* edited by Ragnar Audunson, Herbjørn Andresen, Cicilie Fagerlid, Erik Henningsen, Hans-Christoph Hobohm, Henrik Jochumsen, Håkon Larsen, and Tonje Vold, 133–162. Berlin/Boston, MA: De Gruyter Saur. https://doi.org/10.1515/9783110636628-007.

Warring, Anette. 2020. "Museumsformidling for fremtiden: Brug af museumshistorie i lovforberedende betænkninger." In *Dansk Museumsformidling i 400 År,* edited by Lars Bisgaard, Hans Dam Christensen, and Anette Warring, 317–343. Odense: Syddansk Universitetsforlag.

PART II
LAMs and Collections

6

DO COLLECTIONS STILL CONSTITUTE LIBRARIES, ARCHIVES, AND MUSEUMS?

Samuel Edquist, Ragnar Audunson, and Isto Huvila

Introduction

Libraries, archives, and museums (LAMs) maintain collections of various kinds, which are stored, developed, and made available in various ways to people outside these institutions. In this chapter, we will discuss the contemporary status of collections within LAM institutions. Because of partly interrelated technological changes and new paradigms in cultural policy from the late twentieth century and onward, it is no longer as evident as it (perhaps) was before that collections function as the very constitution of LAM institutions. Digital collections are by their nature volatile while analog collections are physically fixed, and contemporary dominant narratives question the perceived narrow and inward-looking traditional LAM institutions where experts and professionals choose what parts of collections should be served to passive users. Instead, other targets are put forward for these institutions that are – or at least are intended to be – more or less independent of collections. For example, they are increasingly positioned as user-oriented centers for cultural and social activities, experiences, and learning, and for navigating in information that is not necessarily stored at the respective institutions. It is therefore worth asking: *Do collections still constitute LAM institutions?* In the following, we will not present definitive answers but rather explore and map relevant tendencies and areas of conflict, as well as differences and similarities within the LAM sector as a whole on this topic, and within the individual arenas of libraries, archives, and museums.

Collections in this chapter are defined as those holdings of artifacts, books, media, documents, and other materials that, at least traditionally, have defined the three institutions. In regard to archives, that means we speak of "collections" in a more generic sense than what is common within the archival community, where a distinction is often made between "archives" (or "fonds"), which are

DOI: 10.4324/9781003188834-8

the sum of records amassed by a specific creator as the by-product of its activities and "artificial collections," which are typically brought together on the basis of a particular topic or media format (Johnston and Robinson 2002).

The forms of collections

Libraries, archives, and museums have historically been more or less determined by their respective collections. In the pre-digital age, museums were institutions with collections of artifacts (typically physical objects), while library collections consisted of books and other printed publications, and archives comprised mainly written records. From early on and up to the present day, it has not been unusual for collections to cross the LAM boundaries. For example, archival institutions and museums have had libraries, while artifacts and contemporary documentation collections can be found at archival institutions, and some archival collections (often manuscript collections and personal archives) are stored at libraries or museums. Nevertheless, collections have been regarded as the key component and raison d'être of LAM institutions. Larger LAM institutions were typically hosted by professional experts responsible for the respective collections, curating them (see Chapter 7, this volume), and organizing their items and finding aids (see Chapter 8, this volume). Not least, these professionals have traditionally decided what to collect (besides inheriting originally private collections) and what to make available to the general public (when such decisions were not made at higher levels, such as in legislation). The nature of mediation has differed among the fields. Typically, museums have made (small) parts of their collections available through public exhibitions, libraries have let users themselves choose what to read or borrow, and the same goes for archives. Many archival records, though, are largely not open to the general public at all (because of secrecy regulations and the like).

However, with technological development, the forms of LAM collections have become more diversified. The first waves of photographs and audiovisual recordings did not substantially change the overall hegemony of collections. However, digitalization, and especially the Internet, has led to a general challenge to the norm. Since the 1990s, digital collections have typically not been stored in particular places but have rather been shared and available online. Digitalization has meant new opportunities and challenges for LAM institutions and their collections. Nondigital collections have been increasingly digitized, that is, manifolded into digital surrogates with a view to increasing the availability of traditional artifacts, publications, and records, and in some cases also for preservation purposes. Digitization and the use of digital technologies in a broader sense have generally been favored in cultural policy in order to increase availability and introduce new forms of user-friendly interactions. A significant contributing factor is the certain status of digital technology as an end in itself that signifies such dominating values in contemporary society as progress, hybridity, renewal, and fluidity (Wormbs 2010; Henningsen and Larsen 2020).

Contemporary LAM institutions also have a rapidly increasing number of born-digital collections. The development has been perhaps the most dramatic in the archival sphere, since most contemporary records are digital from the very beginning. Also, museums gather, for example, social media content, and libraries are increasingly engaging in mediating born-digital publications. As we discuss in the next section, digitalization has partially led to new forms of ownership and responsibilities. The Internet and social media have facilitated interactions between users and institutions, which generally panders to the general trend for an increased user orientation.

In the early days of the Internet, there were those – mainly outside LAM institutions – that foresaw a future where traditional libraries, archives, and museums would no longer be needed, where everything would be available online for anyone to obtain anytime (see Jochumsen, Hvenegaard Rasmussen, and Skot-Hansen 2012, 587–588). Such narratives are heard less frequently today, but rather, LAM institutions have increasingly been regarded as meeting or access points where users can obtain some of the information or objects that are available but not necessarily stored in the institutions' collections.

Ownership and responsibilities of collections

In certain aspects, the traditional characteristic of LAM institutions, that of largely being dependent on "their own" collections, is becoming increasingly relaxed, due to both technological and social developments. LAM institutions increasingly function as "points of access" for digital collections that other institutions keep or are responsible for. E-books, e-journals, and databases with digitized newspapers, stored in national or international digital repositories, are typically freely available at libraries (as an alternative for users paying to gain access at home). Many archival institutions offer similar services. It is true that such point of access functions existed long before digitalization: Users have had opportunities to access analog books or records through systems of inter-institutional lending. However, with digitalization, these modes of accessing collections have shifted from the margin to the center of how LAM institutions operate.

Another trend that weakens the traditional connection between LAM institutions and their collections is underpinned by the general tendency in the Nordic cultural policy to shift from the notion of national homogeneity towards an open emphasis on cultural pluralism (see Chapter 14, this volume). This has had consequences regarding the ownership of collections (cf. Callison, Roy, and LeCheminant 2016). Artifacts and records concerning the Sámi population that have been made part of Norwegian and Swedish national archives and museums, often as a result of abuse and nationalist and racist policies, are increasingly becoming a matter of debate and repatriation demands. Similar questions have been raised concerning collections emanating from Danish colonialism in Greenland and the West Indies (Agostinho 2019).

Collections and/or user-oriented missions

In recent decades, a lively narrative has emphasized that the traditional roles of collections as the constituent force of LAM institutions have diminished. In academia, in cultural policy, and within professions, a strong opinion has developed arguing that collections as the self-evident raison d´être of LAM institutions belong to an older form of society with strict hierarchies between experts and users, and with a unilinear conception of relations between institutions and the outside world. In the past, users visited institutions and were passively presented with collections that experts had created and/or curated for exhibition. However, with new technology and new conceptions of the societal missions of LAM institutions, this older paradigm is being transformed, often summarized in catchphrases such as "from collection to connection."

There are different views of these matters among LAM institutions, professions, and academic scholarship. One is largely affirmative, taking as a starting point that society has changed in the post- or late-modern era. Old hierarchies have been dismantled in the current flexible, fluid, multicultural, and nonhierarchical world where information, knowledge, and experience, rather than industrial production, are the engines of societal change and development. In such a world, the choices of individual citizens are held in higher esteem. Proponents of such ideas tend to suggest that LAM institutions need to change in order to help them to adapt to evident societal changes. The traditional role of expert-curated collections is regarded as a remnant of an older, pre-digital society – a role that needs to be curtailed and replaced by a new and more externally oriented one. The binary opposition between active professionals and passive users is replaced by a vision of co-creation, where the needs and creative potentials of users are put at the center, as are generally the external functions of the institutions, such as offering arenas for social interaction and education.

In a typical expression of this narrative, museums are said to be in need of "reinvention." Traditional museums are labeled "elitist," "exclusive," "ethnocentric," and "collection driven," while the reinvented ones are "equitable," "inclusive," "multicultural," and "audience focused." Furthermore, the reinvented museum strives to achieve "exchange of knowledge" rather than being a "keeper of knowledge," and it is also "relevant and forward looking," not "focused on past." Consequently, the collections are moved from their primary position to a supporting role that "advances the educational impact of the museum." It is also stressed that the public has a growing impact; the museum must be regarded as "both customer and guest," and in order to achieve "visitor satisfaction" museums must engage in "market research" (Anderson 2004). Also, in the Nordic context, LAM institutions are increasingly discussed as having broader roles to play in society, not least as a part of the cultural economy. In order to foster "creativity and innovation," the so-called "four-space model" has been proposed for Nordic libraries as a way of stipulating their new role as spaces for meeting, performativity, inspiration, and learning (Jochumsen,

Hvenegaard Rasmussen, and Skot-Hansen 2012). In Malmö in southern Sweden, a traditionally industrial city that has officially aimed to redefine itself as post-industrial since the 1990s (see Holgersen 2014), the city library branded itself as a "darling library," pointing to a new library paradigm distinct from the "old" one characterized by hierarchies, passivity, and custodianship of collections. Instead of being a hierarchical collection-based institution, the library was to be a local cultural center open to citizens and a part of the story of the city's transformation to embrace the new economy (Carlsson 2013; see also Jochumsen, Hvenegaard Rasmussen, and Skot-Hansen 2012). Generally, cultural policy has shifted in recent decades in most European countries to increasingly emphasize culture and cultural heritage as part of the economy. LAM institutions are subjected to market and New Public Management logics that emphasize engaging as many visitors as possible, and taking part in efforts to make cities and regions economically attractive (Marling 2010; Svensson and Tomson 2016; cf. Kann-Rasmussen and Hvenegaard Rasmussen 2021) rather than maintaining and developing collections.

Another stance is more openly skeptical. In various ways, the away-from-collections narrative has been criticized or regarded as an effect of (nonbenevolent) external influence. Speaking of libraries, Scherlen and McAllister argue that the idea that libraries should stop focusing on collections is a dominant narrative, fueled by official cultural policy, that ought to be questioned. They claim that leaders of institutions tend to focus on what is considered new and modern, such as new technologies and various forms of user-oriented activities (Scherlen and McAllister 2019). Interviews with professionals indicate that the narrative of new, digital, and user-oriented activities is favored by administrators, the former sensing that their traditional collection-oriented work is perceived as antiquated and clinging to the past (Nicholson 2019, 143; see also Kann-Rasmussen and Balling 2015). An image of a general conflict of interests arises, where parts of the LAM sector reject the aims of some LAM institutions to foster user orientation according to overall trends in economic policies that also color cultural policy. This applies not least to the experience economy (Pine and Gilmore 2019), which positions cultural heritage as one of many sites for nurturing experiences (e.g., see: Marling 2010; Hvidtfeldt Madsen 2014). Contemporary LAM studies point at conflicting interests or rationales, where aspirations of further democratization coincide with an economic rationale (Jochumsen, Skot-Hansen, and Hvenegaard Rasmussen 2017). Libraries that focus on the needs of their communities and community building are not only, or even mainly, preoccupied with traditional library collections. In their world, the lending of tools, seeds, toys, and sports equipment is just as natural an activity as the lending of books. Söderholm has coined the term "X-lending library" to describe this loosening of ties between libraries and traditional collections (Söderholm 2018).

Regardless of the position one takes in these debates, and no matter what role collections *should* have in LAM institutions, it is not controversial to claim that collections – both analog and digital – still have a central role in vast parts of the

LAM landscape. The past dominance of the old collection-oriented missions perpetuates them and keeps LAM institutions working according to them (Dempsey and Malpas 2018). Another reason why LAM institutions continue to stress the curation of collections is that they have a legal duty to do so in all Scandinavian countries. As Grøn and Gram (2019, 315) note, there is a "catch 22 of cultural policy" between the continued collection-oriented legal mission and the parallel imperative of increased user orientation. They argue that there is a "paradox of participation," claiming that when the role of collections is greatly reduced, the institution also loses the possibility of attracting users, since the collections often remain the main objects of interest within the institutions that appeal to users (Grøn and Gram 2019, 320–322).

The future of collections in the LAM sectors

Around the turn of the millennium and for some time after, there was a widespread belief that digitalization would lead to major convergences between L, A, and M institutions, an idea that has partly overlapped with the collection-to-connection discourse. The actual bits and data of digital collections look the same, regardless of whether they represent museal objects, library e-books, or digital records. In the digital world, all LAM institutions share the same challenges and possibilities of digital preservation, curation of metadata structures, etc. (cf. Duff et al. 2013). In Scandinavia, most notably in Norway, there have been multiple projects for practical LAM integration (Vårheim, Skare, and Stokstad 2020), which has evidently also deepened a kind of theoretical convergence between the sectors even if the success of these initiatives has been debated. Archivists, librarians, and museum professionals also increasingly look at the other sectors for inspiration. Moreover, the overall user-oriented paradigm is typical of the entire LAM sector. However, as the following closer look at sectoral discussions shows, the status of collections at LAM institutions is a good example demonstrating that in spite of partial convergence, there are still foundational differences between the L, A, and M sectors.

Do collections still constitute museums?

Even if the idea of a museum without collections still raises debate, an increasing number of museum theorists and practitioners are toning down the role of collections as an irrevocable constituent of a museum (Brown and Mairesse 2018). Hooper-Greenhill's (2000) notion of post-museum crystallizes much of the criticism of the Western Enlightenment paradigm of museums as encyclopedic institutions. Similar criticism has stemmed from non-European traditions (e.g., Morishita 2019). There is an increasing number of institutions around the world identifying themselves as museums despite having no collections. These include Fotografiska, a Stockholm-based gallery of photography with branches around the world, and the Fisksätra museum, a museum and cultural center located in a Stockholm suburb of the same name. Also, mobile and virtual sites

and places rather than collection-based museums (Schweibenz 2019; Driver, Nesbitt, and Cornish 2021) diversify museums' relation to collections. The decentering of collections was also visible in the debate on the proposal by the International Committee for Museology (ICOFOM) of the International Council of Museums (ICOM) for a revised definition of "museum" in the late 2010s (Brown and Mairesse 2018). In this sense, the argument that a museum without collections calling itself a museum is not a proper museum is conspicuously losing its relevance.

At the same time, even if a museum without collections were no longer an oxymoron, collections are still valuable in different ways as building blocks, resources, records, and assemblies of knowledge, experiences, creativity, research, and cultural memory (Newell, Robin, and Wehner 2017). Moreover, a collection-less museum needs collections even if they would not be held for long-term preservation at that specific institution and the modus operandi of the museum would go beyond displaying its own collection of objects to utilize artifacts in a more diverse sense. The recent museology discourse is increasingly underlining the role of collections not only as evidence of the past but more and more as a resource for negotiating the present and envisioning the future (Newell, Robin, and Wehner 2017; Brown and Mairesse 2018). Their contemporary versus historical significations and the past and current perceptions of the legitimacy of their origins are raising questions about collections originating from foreign countries, and indigenous and vulnerable communities (Turnbull 2010; Savoy 2017). This has led to repatriation of collections – in Scandinavia especially from national to indigenous Sámi institutions, but also to other regions of the world.

The digitization of collections is frequently referred to as an opportunity not only for repatriation but also for management and sharing of museum collections in the future. Many museums are struggling with managing, preserving, and putting to use large historic collections and representing contemporary life where digitization and digital management of collection-related information unfold many opportunities (Cameron 2009). However, similarly to how Boast and Enote (2013) criticize virtual (i.e., digital) repatriation of being no real repatriation, digital collections and digitization is not a straightforward way of substituting physical collections. Interaction with digital artifacts satisfies many needs but not the actual presence of a physical object, similarly to how a physical copy is only sometimes equivalent to a physical original. Nevertheless, on the whole, there is hardly any doubt that the diversity of museums and their rapport with collections and collecting are continuing to increase, not only due to the opportunities presented by digital collections, collecting, and sharing but also through the (re)production of physical artifacts through digital documents.

Do collections still constitute libraries?

One of the authors of this chapter has defined libraries as institutions initiating social processes related to knowledge sharing, learning, and cultural experiences on the basis of organized collections of documents – physical as well as

digital (Audunson 2018). This definition, which has also found its way into the Norwegian Wikipedia (Wikipedia, n.d.), sees collections as a definitional characteristic of libraries. An institution not relying on collections as the fundamental tool for realizing its social mission related to knowledge sharing, learning, and cultural experiences is not a library. There are, however, developments that challenge this notion of a library.

The advent of e-books has changed the relationship between libraries and vendors and the relationship between libraries and collections, particularly the libraries' control over their collections. Collection development is frequently outsourced to commercial firms, which do the selection and acquisition, and thus, to a large extent, control the collections. Libraries increasingly serve as points of access for digital collections owned by commercial enterprises such as academic journals and book depositories. Paradoxically, one effect of this is that the traditional resource sharing among libraries in the form of interlibrary lending – a form of knowledge sharing that one should believe digitization facilitates – has become more difficult due to the commercial control and ownership of their collections.

There is no doubt that the concept of what libraries are has changed and expanded from the notion of framing them as institutions giving access to collections of books and other printed material. As previously mentioned, giving access to other kinds of material such as tools, toys, and seeds is seen as increasingly natural in a public library context. Some library theorists argue for a revised librarianship, whose role of fostering knowledge in the community can function without collections altogether (e.g., Lankes 2011). We can well foresee a future where the librarian does not manage a library collection but, as a member of a research or project group, is responsible for giving the project members access to adequate and timely information and knowledge sources available across the World Wide Web. We already have purely digital libraries without collections in the traditional sense – for example, the Health Library (Helsebiblioteket.no) in Norway.

In parallel to such trends, however, the traditional role of libraries related to managing collections of books and other traditional media is still among the most important reasons that legitimize that societal resources are used on libraries among the general public and library professionals (Audunson et al. 2019; Audunson, Hobohm, and Tóth 2020). When the library director in Malmö in the period 2010–2012 set out to develop the above-discussed new city library concept that fundamentally deviated from the traditional and collection-oriented one, it led to severe local conflicts and to the director resigning from her position (Carlsson 2013).

Do collections still constitute archives?

The development from collection to user orientation, both as an objective fact and as normative discourse, is not as far-reaching within archives as in the

library and museum sectors. The proper care of record collections is still widely regarded as the foundational mission for archives. While libraries and museums are predominantly outward-oriented institutions, archival institutions are that only to a limited extent, simultaneously retaining their "inward-looking" role as administrative and bureaucratic functions.

According to the still hegemonic principle of provenance, archival fonds are supposed to be amassed from the activities within creating bodies, with the dual mission of securing evidence and information that are crucial for the creators themselves, as well as for external users. The purpose of keeping records for "contemporary" reasons connected to administrative functions, legal security, etc. also continues to uphold a view that archives *are* collections of records, and that the interests of external users are sometimes regarded as secondary. Many archives are not supposed to be open to external users at all – for example, military records and medical records.

In archival scholarship, there are divided opinions on where to put the emphasis regarding the creation and appraisal of archives, where traditionally three agents are involved: creators, archivists, and users (Cox 2002). The varying opinions among archivists and archival scholars are spread along the overall memory vs. evidence axis that Cook (2013) has identified as a major difference of perspectives. Many contemporary archival theorists argue for a stronger emphasis on "evidence," that is, archival records as traces and witnesses of the occurrences that created the records in the first place. The argument goes that in the digital world, the care of records becomes more complicated, and all possible efforts must be put into securing digital records – which will become records of historical value in the future – that are as authentic as possible. With digitalization, the very demarcation of archival collections becomes more fluid, and a more holistic view of records from their birth and onwards becomes necessary (Upward 1996). However, such reasoning redefines collections rather than ruling them out.

At the other end of the spectrum, there has been, at least since the 1960s and 1970s, a more radical and activist notion of what archives should be. According to this view, archiving should to a larger degree be planned as a true documentation of society, which should cover especially sectors of society that hitherto have been under- or misrepresented in archives. Such a perspective is closely connected to the idea of the need to actively document contemporary society in the museum sector. Instead of archives keeping to their passive role of only receiving records, archivists ought to actively collect records according to specific schemes of planned documentation (e.g., Samuels 1986, 110–112). Such endeavors are normally constituent of the so-called "community archives" following the principle that archives should be actively created in order to strengthen the documentary heritage of particular, often subordinated, groups (Sheffield 2017).

As we have seen, archivists who stress the evidential value of contemporary born-digital records, and those who rather address the role of archives in memory and identity politics, both regard collections as the very reason for the existence,

and the mark, of archives. They serve historical research and the interests of memory and heritage, but also such contemporary aspirations as the freedom of information and keeping track of agreements, business transactions, legal verdicts, social welfare measures, and education.

Accordingly, there are few "archives without archival collections," if we brush aside the wider and sometimes metaphorical conceptions of "archives" that have gained prominence with the so-called "archival turn" (e.g., see: Ketelaar 2017). In the past few decades, there has also been a parallel development where archival institutions follow suit with museums and libraries in various ways of renegotiating the traditional top-down relation between professionals and users. There are numerous examples of crowdsourcing activities and so-called "participatory archives" (Huvila 2008) – a recent example being the project *Collecting Social Photography* where archives and museums in the Nordic countries aim to create new collections of individuals' digital photos (Boogh et al. 2020). Not least in the less legally regulated private sector, there is a growing interest in emphasizing the aspects of archives that border on museums or libraries, namely increased user contact and interaction, as well as transmission and mediation of archival collections to a wider audience. The focus is on access and heritage, and the digitization of analog archives tends to be emphasized as an important means of reaching out, not least to provide access online (e.g. see: Caswell 2014a). However, collections are the basis of such user-oriented archival orientations.

With the widening of the field of archival studies, a broader conception of archives has been put forward – not least in postcolonial and indigenous studies – that questions the materiality of archives and the traditional ideas of institutional ownership of archival records (Iacovino 2010; Fraser and Todd 2016). There, immaterial traces of memory and recollecting are also seen as "archives" (e.g., Faulkhead 2009; Caswell 2014b), e.g., proposing such new notions as "impossible archival imaginaries and imagined records" (Gilliland and Caswell 2016). These critical perspectives also often have a marked tendency to question the traditional role of archivists as professional guardians of collections, and instead to favor user involvement and co-creation of archives (e.g., Caswell 2014a). Even if the discussions on ownership and control as well as the (re-)conceptualization of collections of, for instance, Sámi- and Inuit-related archives are still dawning in Scandinavia, they are likely to continue and expand (cf. Maliniemi 2009). What is apparent, however, is that they are strongly connected to the understanding and framing of the notion of collections and that the emphasis is on other forms rather than on the traditional material and expert-organized ones.

Conclusion

There have been many discussions in recent decades about technological change and new social and cultural conjunctures radically transforming the traditional LAM institutions. They are often described as evolving from largely separated sectors, predominantly defined by their collections, into more user-oriented and

less hierarchical institutions, where old divisions among the LAM spheres are also withering away. The institutions have also seen many real changes in these directions, most visibly in libraries and museums, which are more predominantly oriented toward external users than are archives. The care and mediation of collections often becomes one of many missions, and in some cases is pushed into the background. However, in spite of these discursive and objective changes, there are many elements of continuity from the past. Moreover, pronounced user-oriented missions often depend on existing collections, and furthermore, many critics argue that the narratives of renewal and democratization connected to further user orientation sometimes coincide with contemporary doctrines in which information, culture, and heritage are increasingly regarded as important elements of the market economy.

The different institutional spheres of libraries, archives, and museums seem to have survived since they have – at least partly – different aims and missions. These are, to a degree, manifested in legislation, which particularly governs the institutions in the public sector, but institutional and professional identities are another aspect that fosters continuity. LAM institutions have historically developed with their respective notions of collections as the distinctive feature. To some extent, digitalization has loosened the boundaries between library publications, museum artifacts, and archival records, as well as enabling new opportunities for user involvement and mediation. Nevertheless, in the digital world, the notion persists that libraries, archives, and museums deal with conceptually different kinds of collections.

References

Agostinho, Daniela. 2019. "Archival Encounters: Rethinking Access and Care in Digital Colonial Archives." *Archival Science* 19, no. 2: 141–165. https://doi.org/10.1007/s10502-019-09312-0.

Anderson, Gail. 2004. "Introduction: Reinventing the Museum." In *Reinventing the Museum: Historical and Contemporary Perspectives on the Paradigm Shift*, edited by Gail Anderson, 1–7. Walnut Creek, CA: AltaMira Press.

Audunson, Ragnar. 2018. "Do We Need a New Approach to Library and Information Science?" *Bibliothek Forschung und Praxis*, 42, no. 2: 357–362. https://doi.org/10.1515/bfp-2018-0040.

Audunson, Ragnar, Svanhild Aabø, Roger Blomgren, Hans-Christoph Hobohm, Henrik Jochumsen, Mahmood Khosrowjerdi, Rudolf Mumenthaler, Karsten Schuldt, Casper Hvenegaard Rasmussen, Kerstin Rydbeck, Máté Tóth, and Andreas Vårheim. 2019. "Public Libraries as Public Sphere Institutions: A Comparative Study of Perceptions of the Public Library's Role in Six European Countries." *Journal of Documentation* 75, no. 6: 1396–1415. https://doi.org/10.1108/JD-02-2019-0015.

Audunson, Ragnar, Hans-Christoph Hobohm, and Máté Tóth. 2020. "LAM Professionals and the Public Sphere: How Do Librarians, Archivists and Museum Professionals Conceive the Respective Roles of their Institutions in the Public Sphere?" In *Libraries, Archives and Museums as Democratic Spaces in a Digital Age*, edited by Ragnar Audunson, Herbjørn Andresen, Cicilie Fagerlid, Erik Henningsen, Hans-Christoph Hobohm,

Henrik Jochumsen, Håkon Larsen, and Tonje Vold, 165–184. Berlin: De Gruyter Saur. https://doi.org/10.1515/9783110636628-008.

Boast, Robin, and Jim Enote. 2013. "Virtual Repatriation: It's Virtual, But It's Not Repatriation." In *Heritage in Context of Globalization: Europe and the Americas*, edited by Peter F. Biehl and Christopher Prescott, 103–113. New York: Springer. https://doi.org/10.1007/978-1-4614-6077-0_13.

Boogh, Elisabeth, Kajsa Hartig, Bente Jensen, Paula Uimonen, and Anni Wallenius, eds. 2020. *Connect to Collect: Approaches to Collecting Social Digital Photography in Museums and Archives*. Stockholm: Nordiska museets förlag.

Brown, Karen, and François Mairesse. 2018. "The Definition of the Museum through its Social Role." *Curator* 61, no. 4: 525–539. https://doi.org/10.1111/cura.12276.

Callison, Camille, Loriene Roy, and Gretchen Alice LeCheminant, eds. 2016. *Indigenous Notions of Ownership and Libraries, Archives and Museums*. Berlin: De Gruyter Saur.

Cameron, Fiona. 2009. "Museum Collections, Documentation, and Shifting Knowledge Paradigms." In *Museums in the Digital Age*, edited by Ross Parry, 80–95. London: Routledge.

Carlsson, Hanna. 2013. "Den nya stadens bibliotek: Om teknik, förnuft och känsla i gestaltningen av kunskaps- och upplevelsestadens folkbibliotek." PhD diss., Lund: Lund University.

Caswell, Michelle. 2014a. "Inventing New Archival Imaginaries: Theoretical Foundations for Identity-Based Community Archives." In *Identity Palimpsests: Archiving Ethnicity in the U.S. and Canada*, edited by Dominique Daniel and Amalia Levi, 35–55. Sacramento, CA: Litwin Books.

Caswell, Michelle. 2014b. "Toward a Survivor-centered Approach to Records Documenting Human Rights Abuse: Lessons from Community Archives." *Archival Science* 14, no. 3: 307–322. https://doi.org/10.1007/s10502-014-9220-6.

Cook, Terry. 2013. "Evidence, Memory, Identity, and Community: Four Shifting Archival Paradigms." *Archival Science* 13, no. 2–3: 95–120. https://doi.org/10.1007/s10502-012-9180-7.

Cox, Richard J. 2002. "The End of Collecting: Towards a New Purpose for Archival Appraisal." *Archival Science* 2, no. 3–4: 287–309. https://doi.org/10.1007/BF02435626.

Dempsey, Lorcan, and Constance Malpas. 2018. "Academic Library Futures in a Diversified University System." In *Higher Education in the Era of the Fourth Industrial Revolution*, edited by Nancy W. Gleason, 65–89. Singapore: Palgrave Macmillan.

Driver, Felix, Mark Nesbitt, and Caroline Cornish. 2021. *Mobile Museums: Collections in Circulation*. London: UCL Press.

Duff, Wendy M., Jennifer Carter, Joan M. Cherry, Heather MacNeil, and Lynne C. Howarth. 2013. "From Coexistence to Convergence: Studying Partnerships and Collaboration among Libraries, Archives and Museums." *Information Research* 18, no. 3. http://www.informationr.net/ir/18-3/paper585.html.

Faulkhead, Shannon. 2009. "Connecting through Records: Narratives of Koorie Victoria." *Archives & Manuscripts* 37, no. 2: 60–88.

Fraser, Crystal and Zoe Todd. 2016. "Decolonial Sensibilities: Indigenous Research and Engaging with Archives in Contemporary Colonial Canada." *Internationale Online*. http://www.internationaleonline.org/research/decolonising_practices/54_decolonial_sensibilities_indigenous_research_and_engaging_with_archives_in_contemporary_colonial_canada.

Gilliland, Anne J., and Michelle Caswell. 2016. "Records and Their Imaginaries: Imagining the Impossible, Making Possible the Imagined." *Archival Science* 16, no. 1: 53–75. https://doi.org/ 10.1007/s10502-015-9259-z.

Grøn, Rasmus, and Louise Kloster Gram. 2019. "Deltagelsens paradoks: Samlingens rolle i den brugerinddragende formidling." *Nordisk Kulturpolitisk Tidskrift* 22, no. 2: 312–331. https://doi.org/10.18261/issn.2000-8325/-2019-02-07.

Henningsen, Erik and Håkon Larsen. 2020. "The Digitalization Imperative: Sacralization of Technology in LAM Policies." In *Libraries, Archives and Museums as Democratic Spaces in a Digital Age*, edited by Ragnar Audunson, Herbjørn Andresen, Cicilie Fagerlid, Erik Henningsen, Hans-Christoph Hobohm, Henrik Jochumsen, Håkon Larsen, and Tonje Vold, 53–71. Berlin: De Gruyter Saur. https://doi.org/10.1515/9783110636628.

Holgersen, Ståle. 2014. "The Rise (and Fall?) of Post-Industrial Malmö: Investigations of City-crisis Dialectics." PhD Diss. Lund: Lund University.

Hooper-Greenhill, Eilean. 2000. *Museums and the Interpretation of Visual Culture*. London: Routledge.

Huvila, Isto. 2008. "Participatory Archive: Towards Decentralised Curation, Radical User Orientation, and Broader Contextualisation of Records Management." *Archival Science* 8, no. 1: 15–36. https://doi.org/10.1007/s10502-008-9071-0.

Hvidtfeldt Madsen, Karen. 2014. "Med historien i byen: Kulturarv som smartphone apps." *K&K – Kultur Og Klasse* 42, no. 117: 25–38. https://doi.org/10.7146/kok.v42i117.17557.

Iacovino, Livia. 2010. "Rethinking Archival, Ethical and Legal Frameworks for Records of Indigenous Australian Communities: A Participant Relationship Model of Rights and Responsibilities." *Archival Science* 10, no. 4: 353–372. https://doi.org/10.1007/s10502-010-9120-3.

Jochumsen, Henrik, Casper Hvenegaard Rasmussen, and Dorte Skot-Hansen. 2012. "The Four Spaces – A New Model for the Public Library." *New Library World* 113, no. 11/12: 586–597. https://doi.org/10.1108/03074801211282948.

Jochumsen, Henrik, Dorte Skot-Hansen, and Casper Hvenegaard Rasmussen. 2017. "Towards Culture 3.0: Performative Space in the Public Library." *International Journal of Cultural Policy* 23, no. 4: 512–524. https://doi.org/10.1080/10286632.2015.1043291.

Johnston, Pete, and Bridget Robinson. 2002. "Collections and Collection Description." The United Kingdom Office for Library and Information Networking: Collection Description Focus Briefing Paper 1. http://www.ukoln.ac.uk/cd-focus/briefings/bp1/bp1.pdf.

Kann-Rasmussen, Nanna, and Casper Hvenegaard Rasmussen. 2021. "Paradoxical Autonomy in Cultural Organisations: An Analysis of Changing Relations between Cultural Organisations and Their Institutional Environment, with Examples from Libraries, Archives and Museums." *International Journal of Cultural Policy* 27, no. 5: 636–649. https://doi.org/10.1080/10286632.2020.1823976.

Kann-Rasmussen, Nanna, and Gitte Balling. 2015. "Every Reader His Book – Every Book Its Reader? Notions on Readers' Advisory and Audience Development in Danish Public Libraries." *Journal of Librarianship and Information Science* 47, no. 3: 242–253. https://doi.org/10.1177/0961000614532486.

Ketelaar, Eric. 2017. "Archival Turns and Returns: Studies of the Archive." In *Research in the Archival Multiverse*, edited by Anne J. Gilliland, Sue McKemmish and Andrew J. Lau, 228–268. Clayton, Victoria: Monash University Publishing.

Lankes, David. 2011. *The Atlas of New Librarianship*. Cambridge, MA: MIT Press.

Maliniemi, Kaisa. 2009. "Public Records and Minorities: Problems and Possibilities for Sámi and Kven." *Archival Science* 9, no. 1–2: 15–27. https://doi.org/10.1007/s10502-009-9104-3.

Marling, Gitte. 2010. "Den kulturelle podning af danske byer – Performativ arkitektur og mangfoldig bykultur." *K&K – Kultur Og Klasse* 38, no. 109: 72–83. https://doi.org/10.7146/kok.v38i109.15792.

Morishita, Masaaki. 2019. *The Empty Museum: Western Cultures and the Artistic Field in Modern Japan*. E-book edition. London: Routledge. https://doi.org/10.4324/9781315616056.

Newell, Jennifer, Libby Robin, and Kirsten Wehner. 2017. "Introduction: Curating Connections in a Climate-Changed World." In *Curating the Future: Museums, Communities and Climate Change*, edited by Jennifer Newell, Libby Robin, and Kirsten Wehner, 1–16. London: Routledge. https://doi.org/10.4324/9781315620770.

Nicholson, Karen P. 2019. "'Being in Time': New Public Management, Academic Librarians, and the Temporal Labor of Pink-Collar Public Service Work." *Library Trends* 68, no. 2: 130–152. https://doi.org/10.1353/lib.2019.0034.

Pine, B. Joseph and James H. Gilmore. 2019. *The Experience Economy: Competing for Customer Time, Attention, and Money*. Revised ed. Boston: Harvard Business Review Press.

Samuels, Helen W. 1986. "Who Controls the Past?" *The American Archivist* 49, no. 2: 109–124. https://www.jstor.org/stable/40292980.

Savoy, Bénédicte. 2017. *Objets du désir, désir d'objets: Leçon inaugurale prononcée le jeudi 30 mars 2017*. Paris: College de France. https://doi.org/10.4000/books.cdf.5021.

Scherlen, Allan, and Alex D. McAllister. 2019. "Voices Versus Visions: A Commentary on Academic Library Collections and New Directions." *Collection Management* 44, no. 2–4: 389–395. https://doi.org/10.1080/01462679.2018.1547999.

Schweibenz, Werner. 2019. "The Virtual Museum: An Overview of its Origins, Concepts, and Terminology." *The Museum Review* 4, no. 1: 1–29.

Sheffield, Rebecka. 2017. "Community Archives." In *Currents of Archival Thinking* [2nd ed.], edited by Terry Eastwood and Heather MacNeil, 351–376. Santa Barbara: Libraries Unlimited.

Söderholm, Jonas. 2018. "Borrowing and Lending Tools: The Materiality of X-Lending Libraries." PhD diss., Borås: University of Borås.

Svensson, Jenny, and Klara Tomson. 2016. "Kampen om kulturen: idéer och förändring på det kulturpolitiska fältet." In *Kampen om kulturen: idéer och förändring på det kulturpolitiska fältet*, edited by Jenny Svensson and Klara Tomson, 9–25. Lund: Studentlitteratur.

Turnbull, Paul. 2010. "Introduction." In *The Long Way Home: The Meaning and Values of Repatriation*, edited by Paul Turnbull and Michael Pickering, 1–12. New York: Berghahn Books.

Upward, Frank. 1996. "Structuring the Records Continuum Part One: Post-Custodial Principles and Properties." *Archives & Manuscripts* 24, no. 2: 268–285.

Vårheim, Andreas, Roswitha Skare and Sigrid Stokstad. 2020. "Institutional Convergence and Divergence in Norwegian Cultural Policy: Central Government LAM Organization 1999–2019." In *Libraries, Archives and Museums as Democratic Spaces in a Digital Age*, edited by Ragnar Audunson, Herbjørn Andresen, Cicilie Fagerlid, Erik Henningsen, Hans-Christoph Hobohm, Henrik Jochumsen, Håkon Larsen, and Tonje Vold, 133–162. Berlin: De Gruyter Saur. https://doi.org/10.1515/9783110636628.

Wikipedia. n.d. "Bibliotek." Accessed May 25, 2022. https://no.wikipedia.org/wiki/Bibliotek.

Wormbs, Nina. 2010. "Det digitala imperativet." In *Efter the Pirate Bay*, edited by Jonas Andersson and Pelle Snickars, 140–150. Stockholm: Kungliga biblioteket.

7

CURATING COLLECTIONS IN LAMS

Terje Colbjørnsen, Brita Brenna, and Samuel Edquist

Introduction

As the previous chapter in this anthology established (see Chapter 6, this volume), collections still form a part of the rationale for libraries, archives, and museums. This chapter, broadly speaking, is about what LAM professionals *do* with the collections as they acquire, manage, develop, preserve, safeguard, document, appraise, interpret, and display them in various ways. All these practices can be discussed under the notion of *curating collections*.

While curation as a practice spans across LAMs, the concept of the curator is more frequently used in museums (particularly art museums) than in libraries and archives. Thus, as we will get back to in our concluding argument, while LAMs have much in common as holders of collections, as "memory institutions" (De Kosnik 2016, 26), the curatorial practices reveal differences in professional organization, historical roles, and mandates. All the while, the rise of the digital, and pressures to open up collections and allow contributions from the general public, has shifted priorities in LAMs (Andresen, Huvila, and Stokstad 2020; Vårheim et al. 2020). Expert curators now share the stage with algorithms and amateurs.

We start this chapter with a short section on how to understand curation and the role of the curator before beginning to explore what it has meant and what it means to curate collections for professionals in LAMs, starting with museums. As we bring this discussion into the present, we discuss how digitalization and the so-called "participatory turn" have changed and challenged curation practices.

Curation and the curator

Curation as a concept has a long and complicated backstory, with diverging usages in different disciplines. Derived from the Anglo-Norman *curatour*, the

DOI: 10.4324/9781003188834-9

common understanding is connected to the latin *cura*, meaning "to take care of" (also found in the modern term "to cure"). While the object and nature of this caretaking have shifted over the centuries since the first usages in the twelfth century (Oxford English Dictionary 2021a, 2021b), the objective remains similar: Someone is tasked with taking care of something. In our context, this something is typically a collection of artifacts or media (historical objects, works of art, documents, books, etc.), a comparatively modern notion dating back to the fifteenth century. An older, historical sense includes caretaking of "minors and lunatics" (George 2015, 2), as well as the priestly care "of souls" (Oxford English Dictionary 2021a).[1] A contemporary and broad definition of curation is offered by Bhaskar: "Acts of selecting, refining and arranging to add value" (Bhaskar 2016, loc. 146).

The person who takes care of collections will sometimes, but certainly not always, be called a "curator." "Curator" can be a job title but is also used more colloquially to describe functions carried out in relation to a collection. The contemporary understanding of the curator is carried over from how curation was redefined in the 1990s, primarily in the context of art galleries and art museums. Throughout the 1990s and 2000s, curators were elevated to the status of creators, even rising to become superstars on a par with high-profile contemporary artists (Altshuler 1994; O'Neill 2012).

As curators in the art world were assigned authority and power to identify and define art (Acord 2018), they also took significant positions in the field at large. O'Neill (2012) states that "the figure of the curator has moved from being a caretaker of collections – a behind-the-scenes organizer and arbiter of taste – to an independently motivated practitioner with a more centralized position within the contemporary art world and its parallel commentaries" (O'Neill 2012, 1–2). This independent curator is not responsible for the collection of any single institution but brings together works and artifacts from different collections for the purpose of exhibiting them. In a Scandinavian context, Solhjell (2006) has claimed that curators became the dominant force of art policy in Norway from the 1980s, taking over from the "art policy regimes" of academic and union representatives. The emergence of the "free art curator" in the 1990s, according to Røssaak (2018), brought a new paradigm: "In the art field, a new type of curator emerged at the end of the 20th century, one whose duties did not include functions such as purchasing and looking after collections" (Røssaak 2018, 128).

As the concepts of "curation" and "curator" have become buzzwords, the usage has been extended to new domains. Neologisms such as "wine curator" and "data curator" hint at extensions to new contexts, both professional and amateur. In the words of Bhaskar, "[c]uration is ubiquitous [and] we're all curators now" (2016, loc. 82). New uses of the curation concept also include individual and private curatorial practices, such as maintaining networks on social media or filtering content streams on digital platforms (Davis 2017; Merten 2020). The amateur work to document and preserve culture in digital format is increasingly

recognized as a way for individuals to wrestle power and authority away from the institutions and the state (De Kosnik 2016).

Under the notion of digital curation, we also find the concepts of "algorithmic curation" and "curation by code," deployed to describe how automated programs in online services filter content streams (Bandy and Diakopoulos 2021; Davis 2017; Morris 2015). While automated filtering processes are not typically seen to possess authority and expertise in and of themselves, algorithms and other "engines of order" (Rieder 2020) essentially sort, rank, recommend, and present items from a database, similarly to human curators.

What can we take from this multifaceted notion? We find it useful in this context to parse out *curation* along two strands (for a similar argument, see Smith 2012). On the one hand, curation, as evidenced by its historical and etymological origins, is connected to caretaking, preservation, custodianship, and acquisition. Simultaneously, curation, especially in the modern sense, implies selection from a larger collection for the purpose of exhibitions or similar. For the sake of brevity, we will refer to the former sense as the *caretaker curator* and the latter sense as the *exhibition curator*. To be clear, these are not job descriptions or mutually exclusive categories but should rather be seen as typologies (or Weberian "ideal types"). While the latter sense is probably the most widely used today, we also wish to highlight the relevance of the *caretaker curator*, as it remains vital for LAMs. We will return to these two understandings in the following section where curation and curating are discussed with specific attention to museums, libraries, and archives.

Curating LAM collections

Curating in museums

Museums employ curators to take care of, and to interpret, collections, thus invoking both our broad senses of curation. In the anglophone world, *curator* is a job title. As we mentioned earlier, the title is tied to care for collections, but has also gained traction as a designation for those curating temporary art exhibitions in recent decades. For non-English-speaking countries, there are a host of different job titles that are translated into English as "curator," in Danish "museumsinspektør" (museum inspector), in Norwegian "konservator" (conservator), and in Swedish "intendent" (keeper). Increasingly, however, versions of "curator" are also used as job titles in other countries. In a German introduction to museology, the author states that "Curator" is the English term for those taking care of collections, but also that the term is used more and more in German museums to designate employees that have expert knowledge connected to specific collections (Flügel 2005, 71). A curator is thus not only one who takes care of collections but also someone with specific knowledge of the collection in question.

Museums are defined by the nature of their collections, and those who care for the collections can have a wide variety of fields of expertise – as anthropologists, paleontologists, art historians, etc. In an introduction to a *Museum History Journal* special issue on "Cultures of Curating," Sarah Longair writes that "intellectual authority – the command over knowledge – might appear to be a fundamental component of curatorship" (Longair 2015, 1). Traditionally, much of the training for museum jobs has been done on-site, i.e., the specific skills required to take care of collections have been learned in a museum. The many training programs that have emerged worldwide since the mid-twentieth century have provided basic training for museum work, and for very many different functions in the museum. In most countries, no such training is required for getting a museum job, but curators are mostly hired for their knowledge of the field within which the museum collection is situated. However, there is a considerable difference between large and specialized museums and museums with a wide range of objects in their collections and few employees.

Taking care of a collection involves, among other things, preservation, safe-guarding, and documentation. When the first large museum boom took place in the second part of the nineteenth century, a collection and the presentation of the collection would often be the same thing. The collection *was* the exhibition. Exhibitions and museums have different stories of origin (Heesen 2012). As museums began organizing collections in storage rooms and keeping only part of the museum open for public view, curating would involve a set of tasks directed at the public, not least curating exhibitions and giving public lectures and tours (Bäckström 2016). Today, many curators have little access to their collections, as the objects are housed in remote or limited-access storage facilities. Knowledge about the collection is based on the digital version of the objects and the printed or digital information connected to them. Museums were among the early users of digital collection management systems and were trying out digital ways of organizing the collections from the 1960s (Olsrud 2019; Parry 2010). Thus, dig-itization had an impact on curatorial work from an early stage, but basically on the "behind-the-scenes" work of the museum, only later to become an impor-tant tool for presenting and organizing collections for public view on the Internet and on social media.

The last decades of the twentieth century witnessed sustained criticism of museums from several directions. Artists were challenging the authority of the museum through interventions and institutional critique. The eco-museum movement, starting in France, developed radical ideas directed at conven-tional museums, claiming that museums belonged to the community, being a storehouse for memories as well as a laboratory for community experiments. Museums for ethnography were heavily criticized as much for displaying looted objects as for spreading racist ideas. And more generally, museums were described as disciplinary institutions that were instruments for control of the population (Bennett 1995). In the wake of these criticisms, museum workers have redefined what curating might mean. In the 1990s, letting the public in to

curate their own exhibitions, bringing their own objects, was one experiment meant to challenge the power relation between curator and visitor. The idea was to let go of the curatorial authority and invite people to participate on an equal footing. Participation as such was far from new, but sharing authority was (Pierroux et al. 2020). Participation became even more pronounced as a curatorial ideal in the 2000s, with Nina Simon's *The Participatory Museum* (2010) as a culmination. Curating in museums today is as much about inviting, organizing, and empowering people as it is about objects.

Curating has thus acquired a much wider meaning, as we outlined at the beginning of this chapter. In the art world, curators take care of collections, but curating is mainly connected to making exhibitions. Curatorship has even been seen as being akin to artistic praxis (O'Neill 2012). However, in the larger museum world, the word "curating" does important work, carrying notions of novelty and innovation into the museum sector and becoming something of a catchword for new museum ideals. Titles such as *Curating the Future: Museums, Communities and Climate Change* point to the role that curating has acquired as a way of making the museum socially relevant and future-oriented (Newell, Robin, and Wehner 2016). The traditional museum was a place where the curator exerted authority based on knowledge and control of the objects. Today, curating signals a distance from the traditional curator, and gives promises of change.

At the turn of the century, there was a widespread fear that digital technologies would render museums obsolete, that people would rather visit exhibitions online, and that authentic objects would lose their attraction (e.g., Conn 2010). This has hardly been the case, and museums take part in large efforts to make their objects accessible, both in-house and digitally. In Sweden and Norway, DigitaltMuseum has made millions of objects accessible online. The large database Europeana hosts museum objects from around Europe, and the text that greets you on their homepage is "Curate your own gallery." Museums seem to have embraced digital solutions as a means to become more accessible and to share curatorial authority via digital substitutes (Cameron 2021). Thus, caretaking is still a central part of the curator's role, but the collection can also be handled, curated, and displayed by and with a larger public.

Curating in libraries

Library collections have traditionally consisted of books and other published documents, but developments in media technologies and new roles of libraries have changed their historical mandates. The so-called transition "from collections to connections" (Mathiasson and Jochumsen 2020; Söderholm and Nolin 2015) has seemingly shifted attention from what libraries contain to what they can enable in terms of services, events, meetings, and other public gatherings. Thus, the role of the librarian as caretaker curator for the (book) collection persists but is supplemented with other duties and demands. All the while, the Scandinavian

library sectors, consisting of public libraries, academic libraries, school libraries, special libraries, and the vast collections of national library institutions, have become more specialized, going in slightly different directions.

The modern public library is a creature of the late nineteenth and early twentieth centuries. Inspired by the free public library movement in the USA (Frisvold 2021; Torstensson 1993, 2012), Scandinavian librarians opened up their libraries' collections and invited new groups, especially children, through the doors. To quote a Danish history of libraries, they changed from being for the few to being for everyone (Dahlkild and Bille Larsen 2021). Where previously libraries had restricted access to books and manuscripts, now the collections were brought up from the vaults and into the light where patrons could browse for themselves. This also involved a shift in the librarian's role, reducing some of the gatekeeping power that comes with the privilege of exclusive access. However, the professionals in public libraries still held significant power in their right to decide on acquisitions and, not least, by recommending books to library users. In both these capacities, librarians and library management could make selections and recommendations based on criteria such as quality and appropriateness. A patron could be persuaded to borrow a different book appropriate for age or reading skills, or instructed to include a nonfiction book with the lending of a fiction book (Frisvold 2021). As pointed out in a Swedish history of libraries, there is an element of paternalism in the social mission of public libraries to educate and enlighten (Frenander and Lindberg 2012). The paternalistic strand is also evident in libraries' attitudes to popular culture. In practice, in Scandinavia, it took until the mid-1960s and 1970s before libraries were open to include popular cultural media like cartoons, genre fiction (e.g., romance and crime fiction), films, and pop music (Dahlkild and Bille Larsen 2021; Frisvold 2021).

The situation was different in the libraries connected to universities and other organizations and corporations that had the resources to house separate libraries. In these, patrons were more likely to be able to suggest and even dictate what the collections should hold (Johnson 2018). Now, the digital development has shifted the roles of academic librarians from acquirers and caretakers of items in a collection to maintaining subscriptions and negotiating license terms for bundles of ebooks and online journals provided by international publishing houses – at steep prices (Suber 2012). As a result, enabling open-access publishing is one responsibility that has been added to the academic librarian's to-do list (Jurchen 2020).

Despite the turn in the past couple of decades toward events and services (Audunson and Aabø 2013), collections (physical and digital) still form important parts of libraries' offerings (see Chapter 6, this volume). Librarians are tasked with taking care of these collections, from analyzing the needs and wants of patrons to selecting, acquiring, maintaining, and weeding content and promoting this to the public. While these are practices that fall quite neatly within our definition of curation, they are rarely referred to as such (although there are differences here between the Scandinavian countries). Tellingly, when librarians

from a number of European countries were surveyed about professional groups with which they identify, "museum curators" came bottom of the list (Johnston et al. 2021). The common term for the caretaking aspect in English is "collection development," or "collection management" (e.g., see: Johnson 2018; Saponaro and Evans 2019). When Scandinavian librarians are creating displays, exhibitions, or events to promote items from the collection to the public, the common term used is "formidling," a difficult term to translate into English, but parallel to German *Vermittlung* (Pharo and Tallerås 2017; Ridderstrøm and Vold 2015, 16–17).

One of the instances where libraries and librarians *do* refer to curation is in the more specialized circumstances where highly skilled librarians are responsible for collections of rare and historical books or other rare artifacts. While the position of "collection manager" would seem to consign a certain amount of power over acquisitions, etc., responsibilities for collection management or curation are typically more of a collective nature in libraries than what is the case for the curator in the art world. Furthermore, the ideal for modern librarians is to be aware of what patrons and users desire and expect from their library (Saponaro and Evans 2019). Public libraries are seen as houses to be filled with the activities of the public, not as the sole domain of controlling librarians.

The turn toward digital collections and services has also seen library practices converge with practices in the media sector. While libraries are institutionally different from commercial media companies and public service broadcasters (Tallerås et al. 2020), they share a common mandate or remit to reach out and recommend items to the public. Thus, algorithmic curation practices are also relevant for libraries, and many institutions develop platforms and services that help them maintain collections as well as presenting them to the public (see Chapter 10, this volume). An example of the former is the Danish Lyngsøe Intelligent Material Management System, which uses data on historical lending to help "manage an item's life cycle from purchase to end of life."[2] An example of the user-facing aspect of algorithmic collection management is the system used by the Deichman public library in Oslo to provide automated recommendations similar to those systems that govern the presentation of items in services like Netflix and Amazon (Pharo and Tallerås 2015, 2017).

In essence, curation in the modern library is undertaken by a combination of humans and computer-assisted systems. Librarians engage in both caretaking and exhibition-related activities. The shift toward digital resources has nonetheless meant a reduction in the ability of libraries to control and uphold their collections (Perzanowski and Schultz 2016).

Curating in archives

In the archival world, curation is a core activity predominantly in our *caretaker* sense. Traditionally, the act of gathering documents into archives or fonds was performed by records creators themselves. The principle of provenance originally

defined archives as holdings created or received by the respective creating body, and subsequently kept by them until handed over to archival institutions. However, various legal regulations have made the process of shaping archival holdings into something beyond the control of creators only. Appraisal – selecting what records should be kept or disposed – has become a necessity because of the accelerating growth of records over the last century. The actual appraisal decisions have been made by professional archivists in some cases, when not already inscribed in regulations, or made by nonarchivists within original creating bodies (see Chapter 3, this volume).

A more active role in acquisition is common in the private sector, since it is generally not regulated by law. Institutions that handle private archives often resemble museums: Professionals reach out to the public, crowdsourcing has become popular, and for long they have collected records either themselves or indirectly by urging individuals or organizations to hand in their archives (e.g., in the city archives in Oslo and Malmö; cf. Huvila 2008).

The caretaker aspect of curating archives – arranging, describing, and safeguarding – is traditionally called "custody" in archival terminology. However, in recent decades, it has been argued that we have transferred into a "post-custodial" age. The arguments are both technologically and theoretically motivated. First, digitalization has been said to make older models obsolete. Traditionally, it was conceived that records have a linear life cycle, from "active" (regularly used within the creating body), through "semi-active" (typically some years old, kept by the creator since they might be useful at short notice) to "definite" archives, when handed over to archival institutions for the benefit of others. Custodianship was regarded as a central archival ethos in safeguarding records, especially in the final stage of the life cycle. With digitalization, the old life cycle model became problematic. Proponents of the so-called "records continuum model" have argued that in digital environments, there are no clear divisions between new active records and old finished ones – you do not just move papers between rooms anymore, and digital records may always change (McKemmish 2001).

The post-custodial discourse was originally shaped in the context of radical archival ideas from the 1960s and 1970s, which stressed that traditional archives mainly reflected the dominant layers of both state and society: Archivists must increasingly be active, indeed activist, leaving behind the traditional passive role of custodians of biased archives (Ham 1981). In the 1990s, poststructuralist adaptations gained influence within archival theory. Frank Upward, one of the main architects of the records continuum model, stressed that the model was both postmodernist and post-custodial (Upward 1996). In a similar vein, Terry Cook stressed that modernist "paper minds" must adapt to a new postmodern reality where archivists "can no longer afford to be, nor be perceived to be, custodians in an electronic world" (Cook 1994, 301). Cook emphasized that the new realities led away from custody – which he associated with passivity – to a more active role, since electronic records lacked the unity of content, structure, and context that were physically evident in analog papers. Archivists

must therefore document and preserve the contexts too as metadata information (Cook 1994).

In the 2020s, digital realities are even more complex and multidimensional. Today, the postmodernist jargon of Cook and Upward may seem somewhat outdated; in particular, Cook tended to emphasize a total societal shift from analog to digital, into fluid and multidimensional new (hyper)realities. Nevertheless, their call for more proactive archivists has not lost relevance. Modern digital records are primarily abstract and contextual phenomena, while their physical forms are temporary.

Nevertheless, the underlying ethos of archivists both before and after digitalization is the same: Their task is to preserve records – evidence of occurrences that have happened or come into effect – which are interesting as proof and/or for the information that may be extracted. In fact, the term "curation" is becoming increasingly popular when dealing with, in particular, digital archives (e.g., Cunningham 2008). Digital curation is used for stressing that the necessary work is multifaceted, caring for physical storage media, administrative control, and data security.

The wider meaning of curating as the appraisal and care of archival holdings continues to be the core activity for archivists, but with enhanced meanings in the digital world. However, throughout the LAM field, there is a tension between the two senses of curatorial practice. In archives, that contradiction is fully visible, and the trends seem to go in both directions simultaneously.

Just as in museums and libraries, many archivists now aim to reach out to the public more than before. Sometimes, such endeavors are combined with a general wish to democratize and broaden archives, generally stressing the power aspects of archives as a documentary heritage. Curating in the exhibition sense – organizing displays where certain archival records are selected – may form part of such archival endeavors, but only at the particular crossroads between archives and art would individuals responsible for such exhibitions be labeled "curators" (cf. Callahan 2022; Spieker 2008). Normally, it would be regarded as a pedagogic trick: To make people reflect on archives and memory, and to entice people into archival institutions so they may dare to engage in their own research. Not least in Scandinavia, archival pedagogy has emerged as a specialty within the profession, focused on transmission of archives for the public.

While this outreach ethos emphasizes archives as resources of identity and heritage, a seemingly opposite trend aims to stress archives as evidence, mainly due to the challenges of today's almost totally born-digital archives. Archives have long been kept for different reasons: In a shorter time frame for the creators' own needs, for economic and legal matters, and for the benefit of the public; and in a longer time frame for heritage purposes and research. Since digital curation of archives must start from the very birth of records, there is a tendency to argue that we must increase the emphasis on the necessary short-term curation rather than guessing needs in the future (cf. Shepherd and Yeo 2003). As such, we partly return to the "original" function of archives that mainly developed as byproducts of the creating bodies, which simply kept what was necessary for their own interests.

Conclusion

In the introduction, we outlined two broad senses of curatorial practice, identified as *the caretaker curator* and *the exhibition curator*. Both senses are present across LAMs. But libraires, archives, and museums differ in which sense is most pronounced. The most conspicuous representations of the caretakers are archivists and staff at special libraries with responsibilities for rare books; curators of art displays exemplify the latter sense as exhibition curators. Digitalization and pressures (external and internal) to engage the public have shifted attention toward the outward-facing exhibition curator. There is thus a historical trendline that can be discerned from these two broad notions: Caretaking, preservation, and acquisition are traditionally parts of the work of professionals in LAMs, while the creation of public displays and exhibitions based on careful and qualified selection are ideals for the contemporary LAMs. Digitalization has fortified this trend.

While the participatory turn has shifted some of the power to patrons and fans (De Kosnik 2016; Hvenegaard Rasmussen 2016), LAM professionals with curation responsibilities are nonetheless distinguished because of their knowledge of, and expertise in, the collection in question. In the new world, they just cannot expect this expertise to be left unquestioned.

Because of these technosocial trends, the institutions can arguably be said to be converging, but this is far from a linear development. LAMs maintain some specific characteristics that become visible through our discussion of curation. When we state that librarians and archivists rarely go by the name of "curator," it may seem paradoxical to engage in a chapter-long discussion of this concept across all three sectors. However, curatorial *practices* clearly take place within libraries and archives – just under different names. It falls outside the scope of this chapter to deal with *why* the curation concept is used or not, but we will argue that the flexibility afforded by our curation concept can be useful for scholars and practitioners who need to conceptualize both internal processes of caretaking and activities that bring collections out to the public.

Notes

1 In the Nordic countries, one can still be appointed as a curator for children, i.e., in the Child Welfare Services with responsibilities for children and young people who live in conditions that may be detrimental to their health and development.
2 https://lyngsoesystems.com/intelligent-material-management-system/.

References

Acord, Sofia Krzys. 2018. "Learning How to Think, and Feel, About Contemporary Art: An Object Relational Aesthetic for Sociology." In *Routledge International Handbook of the Sociology of Art and Culture*, edited by Laurie Hanquinet and Mike Savage, 219–231. London: Routledge.

Altshuler, Bruce. 1994. *The Avant-Garde in Exhibition: New Art in the 20th Century*. New York: Abrams.

Andresen, Herbjørn, Isto Huvila, and Sigrid Stokstad. 2020. "Perceptions and Implications of User Participation and Engagement in Libraries, Archives and Museums." In *Libraries, Archives and Museums as Democratic Spaces in a Digital Age*, edited by Ragnar Audunson, Herbjørn Andresen, Cicilie Fagerlid, Erik Henningsen, Hans-Christoph Hobohm, Henrik Jochumsen, Håkon Larsen and Tonje Vold, 185–206. De Gruyter Saur. https://doi.org/10.1515/9783110636628-009.

Audunson, Ragnar, and Svanhild Aabø. 2013. "From Collections to Connections: Building a Revised Platform for Library and Information Science." *Information Research* 18, no. 3: paper C29.

Bäckström, Mattias. 2016. *Att bygga innehåll med utställningar: Utställningsproduktion som forskning.* Lund: Nordic Academic Press.

Bandy, Jack, and Nicholas Diakopoulos. 2021. "More Accounts, Fewer Links: How Algorithmic Curation Impacts Media Exposure in Twitter Timelines." *Proceedings of the ACM on Human-Computer Interaction* 5 (CSCW1): 78:1–28. https://doi.org/10.1145/3449152.

Bennett, Tony. 1995. *The Birth of the Museum: History, Theory, Politics.* London: Routledge.

Bhaskar, Michael. 2016. *Curation: The Power of Selection in a World of Excess.* London: Piatkus.

Callahan, Sara. 2022. *Art + Archive: Understanding the Archival Turn in Contemporary Art.* Manchester: Manchester University Press.

Cameron, Fiona R. 2021. *The Future of Digital Data, Heritage and Curation: In a More-than-Human World.* Abingdon, Oxon: Routledge.

Conn, Steven. 2010. *Do Museums Still Need Objects?* Philadelphia: University of Pennsylvania Press.

Cook, Terry. 1994. "Electronic Records, Paper Minds: The Revolution in Information Management and Archives in the Post-Custodial and Post-Modernist Era." *Archives & Manuscripts* 22, no. 2: 300–328.

Cunningham, Adrian. 2008. "Digital Curation/Digital Archiving: A View from the National Archives of Australia." *The American Archivist* 71, no. 2: 530–543. https://doi.org/10.17723/aarc.71.2.p0h0t68547385507.

Dahlkild, Nan, and Steen Bille Larsen, eds. 2021. *Dansk bibliotekshistorie. Bind 1: Biblioteker for de få - tiden før 1920. Bind 2: Biblioteker for alle - tiden efter 1920.* Aarhus: Universitetsforlag.

Davis, Jenny L. 2017. "Curation: A Theoretical Treatment." *Information, Communication & Society* 20, no. 5: 770–783. https://doi.org/10.1080/1369118X.2016.1203972.

De Kosnik, Abigail. 2016. *Rogue Archives. Digital Cultural Memory and Media Fandom.* Cambridge, MA: MIT Press.

Flügel, Katharina. 2005. *Einführung in die Museologie.* Wissenschaftliche Buchgesellschaft.

Frenander, Anders, and Jenny Lindberg. 2012. "Reflektioner Och Framåtblickande." In *Styra Eller Stödja: Svensk Folkbibliotekspolitik under Hundra År*, edited by Anders Frenander and Jenny Lindberg, 309–319. Borås: Högskolan i Borås.

Frisvold, Øivind. 2021. *Kunnskap er makt: norsk bibliotekhistorie − kultur, politikk og samfunn.* Oslo: ABM-media AS.

George, Adrian. 2015. *Curator's Handbook: Museums, Commercial Galleries, Independent Spaces.* London: Thames & Hudson, Ltd.

Ham, F. Gerald. 1981. "Archival Strategies for the Post-Custodial Era." *The American Archivist* 44, no. 3: 207–216. https://doi.org/10.17723/aarc.44.3.6228121p01m8k376.

Heesen, Anke te. 2012. *Theorien des Museums zur Einführung.* Hamburg: Junius Verlag.

Huvila, Isto. 2008. "Participatory Archive: Towards Decentralised Curation, Radical User Orientation, and Broader Contextualisation of Records Management." *Archival Science* 8, no. 1: 15–36. https://doi.org/10.1007/s10502-008-9071-0.

Hvenegaard Rasmussen, Casper. 2016. "The Participatory Public Library: The Nordic Experience." *New Library World* 117, no. 9/10: 546–556. https://doi.org/10.1108/NLW-04-2016-0031.

Johnson, Peggy. 2018. *Fundamentals of Collection Development and Management.* London: Facet.

Johnston, Jamie, Ágústa Pálsdóttir, Anna Mierzecka, Ragnar Andreas Audunson, Hans-Christoph Hobohm, Kerstin Rydbeck, Máté Tóth, et al. 2021. "Public Librarians' Perception of Their Professional Role and the Library's Role in Supporting the Public Sphere: A Multi-Country Comparison." *Journal of Documentation,* 78, no. 5: 1109–1130. https://doi.org/10.1108/JD-09-2021-0178.

Jurchen, Sarah. 2020. "Open Access and the Serials Crisis: The Role of Academic Libraries." *Technical Services Quarterly* 37, no. 2: 160–170. https://doi.org/10.1080/073 17131.2020.1728136.

Longair, Sarah. 2015. "Cultures of Curating: The Limits of Authority." *Museum History Journal* 8, no. 1: 1–7. https://doi.org/10.1179/1936981614Z.00000000043.

Mathiasson, Mia Høj, and Henrik Jochumsen. 2020. "Between Collections and Connections: Analyzing Public Library Programs in Terms of Format, Content, and Role and Function." *The Library Quarterly* 90, no. 3: 364–379. https://doi.org/10.1086/708963.

McKemmish, Sue. 2001. "Placing Records Continuum Theory and Practice." *Archival Science* 1, no. 4: 333–359. https://doi.org/10.1007/BF02438901.

Merten, Lisa. 2020. "Block, Hide or Follow: Personal News Curation Practices on Social Media." *Digital Journalism* 9 no. 8: 1018–1039. https://doi.org/10.1080/21670811.202 0.1829978.

Morris, Jeremy Wade. 2015. "Curation by Code: Infomediaries and the Data Mining of Taste." *European Journal of Cultural Studies* 18, no. 4–5: 446–463. https://doi.org/10.1177/1367549415577387.

Newell, Jennifer, Libby Robin, and Kirsten Wehner, eds. 2016. *Curating the Future: Museums, Communities and Climate Change.* London: Routledge. https://doi.org/10.4324/9781315620770.

Olsrud, Janne Werner. 2019. "Om 'Et av de viktigste arbeider ved et museum'. En studie av dokumentasjonspraksisenes gjøren av museumsgjenstander." *Tidsskrift for Kulturforskning,* 2019, no. 1: 107–112.

O'Neill, Paul. 2012. *The Culture of Curating and the Curating of Culture(S).* Cambridge, MA: MIT Press.

Oxford English Dictionary. 2021a. "† Curation, N." In *OED Online.* Oxford University Press. Accessed September 17, 2021. https://www.oed.com/view/Entry/45958.

Oxford English Dictionary. 2021b. "Curator, N." In *OED Online.* Oxford University Press. Accessed September 17, 2021. https://www.oed.com/view/Entry/45960.

Parry, Ross, ed. 2010. *Museums in a Digital Age.* Abingdon, Oxon: Routledge.

Perzanowski, Aaron, and Jason Schultz. 2016. *The End of Ownership: Personal Property in the Digital Economy.* Cambridge, MA: The MIT Press.

Pharo, Nils, and Kim Tallerås. 2015. "Formidlingsmaskiner: fra analog kunnskapsorganisasjon til digitale anbefalinger." In *Litteratur- og kulturformidling: nye analyser og perspektiver,* edited by Helge Ridderstrøm and Tonje Vold, 189–211. Oslo: Pax.

Pharo, Nils, and Kim Tallerås. 2017. "Mediation Machines: How Principles from Traditional Knowledge Organization Have Evolved into Digital Mediation Systems." *Information Research* 22, no. 1: CoLIS paper 1654.

Pierroux, Palmyre, Mattias Bäckström, Brita Brenna, Geoffrey Gowlland, and Gro Ween. 2020. "Museums as Sites of Participatory Democracy and Design." In *A History*

of Participation in Museums and Archives. Traversing Citizen Science and Citizen Humanities, edited by Per Hetland, Palmyre Pierroux and Line Esborg, 27–45. London: Routledge.

Ridderstrøm, Helge, and Tonje Vold, eds. 2015. *Litteratur- og kulturformidling: nye analyser og perspektiver.* Oslo: Pax.

Rieder, Bernhard. 2020. *Engines of Order.* Amsterdam: Amsterdam University Press.

Røssaak, Eivind. 2018. "The Emergence of the Curator in Norway: Discourse, Techniques and the Contemporary." In *Contested Qualities: Negotiating Value in Arts and Culture,* edited by Knut Ove Eliassen, Jan Fredrik Hoven and Øyvind Prytz, 127–164. Bergen: Fagbokforlaget.

Saponaro, Margaret Zarnosky, and G. Edward Evans. 2019. *Collection Management Basics.* Santa Barbara: Libraries Unlimited.

Shepherd, Elizabeth, and Geoffrey Yeo, eds. 2003. *Managing Records: A Handbook of Principles and Practice.* London: Facet Publishing.

Simon, Nina. 2010. *The Participatory Museum.* Santa Cruz, CA: Museum 2.0.

Smith, Terry. 2012. *Thinking Contemporary Curating.* New York: Independent Curators International/D.A.P.

Söderholm, Jonas, and Jan Nolin. 2015. "Collections Redux: The Public Library as a Place of Community Borrowing." *The Library Quarterly* 85, no. 3: 244–260. https://doi.org/10.1086/681608.

Solhjell, Dag. 2006. *Kuratorene kommer: kunstpolitikk 1980–2006.* Oslo: Unipub.

Spieker, Sven. 2008. *The Big Archive: Art from Bureaucracy.* Reprint edition. Cambridge, MA: MIT Press.

Suber, Peter. 2012. *Open Access.* The MIT Press Essential Knowledge Series. Cambridge, MA: MIT Press.

Tallerås, Kim, Terje Colbjørnsen, Knut Oterholm, and Håkon Larsen. 2020. "Cultural Policies, Social Missions, Algorithms and Discretion: What Should Public Service Institutions Recommend?" In *Sustainable Digital Communities,* edited by Anneli Sundqvist, Gerd Berget, Jan Nolin, and Kjell Ivar Skjerdingstad, 588–595. Lecture Notes in Computer Science. Cham: Springer International Publishing. https://doi.org/10.1007/978-3-030-43687-2_49.

Torstensson, Magnus. 1993. "Is There a Nordic Public Library Model?" *Libraries & Culture* 28, no. 1: 59–76.

Torstensson, Magnus. 2012. "Framväxten av en statlig folkbibliotekspolitik i Sverige." In *Styra eller stödja? Svensk folkbibliotekspolitik under hundra år,* edited by Anders Frenander and Jenny Lindberg, 89–134. Borås: Högskolan i Borås.

Upward, Frank. 1996. "Structuring the Records Continuum Part One. Post-Custodial Principles and Properties." *Archives & Manuscripts* 24, no. 2: 268–285.

Vårheim, Andreas, Henrik Jochumsen, Casper Hvenegaard Rasmussen, and Kerstin Rydbeck. 2020. "The Use of LAM Institutions in the Digital Age." In *Libraries, Archives and Museums as Democratic Spaces in a Digital Age,* edited by Ragnar Audunson, Herbjørn Andresen, Cicilie Fagerlid, Erik Henningsen, Hans-Christoph Hobohm, Håkon Larsen and Tonje Vold, 247–270. De Gruyter Saur. https://doi.org/10.1515/9783110636628-012.

8

KNOWLEDGE ORGANIZATION IN LAMS

Ulrika Kjellman, Hans Dam Christensen, and Johanna Rivano Eckerdal

Introduction

To be useful and retrievable, collections of publications, documents, artifacts, and specimens in libraries, archives, and museums (LAMs) need to be feasibly organized and presented. This is done in a variety of ways. Books in libraries are sorted on shelves in repositories and described in, and accessible through, catalogues and indexes; documents in archives are organized and retrievable through a variety of search protocols and tools; objects in museums are organized in storerooms and described and displayed in catalogues and various exhibitions. These doings go by the name *knowledge organization (KO)*. Due to different commissions, traditions, and material conditions, LAM institutions have developed diverse routines, techniques, and tools to work with KO.

LAM institutions' tradition of organizing collections is long, but in recent decades, tools for KO have changed enormously due to technological developments; the resources to be included in the collections – including the tools for organizing them – are increasingly digital; and their retrieval is affected by these digital technologies. Today, an unprecedented number of resources are available through a quick search online and a majority of people in Scandinavia have technological devices that offer instant access to these Internet resources.

Many of the constraints of the physical world are solved when ordering digital resources (Weinberger 2007). Even so, it is important to bear in mind that KO practices have developed out of the ordering of physical collections, hence principles from physical tools remain influential. Understanding KO tools today includes considering their historical roots.

In this text, we will trace some historical roots and some challenges and opportunities that new technologies and societal situations bring to the KO work of LAM institutions. We will follow two trajectories of development that we find

DOI: 10.4324/9781003188834-10

crucial to address, one being regulation, standardization, and rationalization and the other diversification, inclusiveness, and democratization.

When talking about LAM institutions' KO practices, we will use KO as an inclusive term, embracing, for example, information organization (Joudrey, Taylor, and Miller 2015, 3), bibliographical practice (Hansson 2012, 106), and collection management (Matassa 2011). When talking about the materials that are organized, for the most part, we use *records* within archives, *publications* within libraries, and *objects* within museums. Furthermore, the acronym LAM not only represents three different institutions but also, within them, a variety of institutional types. Libraries, for instance, can be public, private, academic, school, or special libraries. Each of these institutional types can, in different ways, affect how KO is done, but here we seek to identify general KO aspects applicable to all types of LAMs.

It is primarily within the library domain that KO has been defined and the term is closely connected to practices of classification and cataloguing. The KO concept was launched by classification researchers at the International Society for Knowledge Organization (ISKO) in the 1980s.[1] In academia, the concept has mainly been discussed within the field of library and information science (LIS). Here, Hjørland identifies two meanings of KO. The first is as something quite narrow, connected to "document description, indexing, and classification performed in libraries, bibliographical databases, archives, and other kinds of 'memory institutions'" (2008, 86). Importantly, even in this narrow definition, archives and museums can also be included as "memory institutions." Hjørland's second definition is broader and relates to how knowledge is organized in society in general, including not only how knowledge is socially organized but also how reality is organized (2008, 86). This broader view is also present in Bowker and Star's writings. In *Sorting Things Out* (1999), they show how our society is permeated by KO tools and practices in the form of categorizations, classification schemes, standards, etc. that steer our conceptions and behaviors. These tools are often so familiarized that we fail to see the advantages and power they give to some viewpoints, while neglecting others.

In this text, both the narrower and the broader view of KO will be addressed; we will look into how KO in LAMs is practiced in a concrete way, but also – in line with Bowker and Star – refer to a more broad and theoretical discussion on the consequences and power aspects of KO, not least in connection with opportunities and constraints new technology brings.

Libraries and KO

As previously mentioned, the main purpose of KO in libraries has been to provide access to publications and their knowledge content by cataloguing and classifying them, i.e., by adding bibliographical data or metadata. Even though this KO practice has a long tradition, it was the nineteenth and twentieth centuries that brought most changes to the field. Now more consistent and standardized

tools were launched, both regarding descriptive cataloguing, e.g., using systems like the joint *Anglo-American Cataloguing Rules*, and the organization of content, e.g., with classification systems such as the *Dewey Decimal Classification (DDC)* (Gnoli 2020, 17–18; Joudrey, Taylor, and Miller 2015, Chapter 2). These systems – together with the settlements of the International Federation of Library Associations (IFLA) and institutions like the Library of Congress, which took on the role of central cataloguing services – were ground pillars and parts of a general trend; sharing and standardizing bibliographical data made it possible to produce worldwide catalogues of resources in the library domain. A precondition for this sharing was, of course, that libraries organized books and serials that were published in multiple copies, but it was also facilitated by the advent of the computerized catalogue and the new ideas of standardization and "universal bibliographic control" – in a joint library domain, it is essential that libraries catalogue books in a consistent and similar way and share KO tools like cataloguing rules, metadata formats, authority control, classification schemes, etc.

Standardized KO practices enabling libraries to share resources were, as mentioned, prompted by the digital technology, but also, on a more societal level, they were closely tied to ideas and practices of modernity and rationalization (Bowker and Star 1999, 13–16). The tendency to standardize objects and routines has been influential in many sectors of the modern society (e.g., see the work of the International Organization for Standardization [ISO]), and the information domain in particular has been targeted. As we will see later on, these standardization efforts – driven by the development of digital technology and ideas of rationalization – led to similar developments in the spheres of archives and museums.

Sharing and standardization of bibliographical practices have taken different routes in Scandinavia (Hansson 2012, 121ff.) If, for example, we look at the introduction of the *DDC*, Denmark developed a national *DK (DecimalKlassifikation)* as early as 1915 (Statens Bogsamlingskomité 1915), while in Sweden, the local *SAB (Klassifikationssystem för svenska bibliotek)*, first published in 1921, started to be replaced by the *DDC* as late as 2011 (Kungl. biblioteket 2020).

Digital technique affected KO in libraries in other ways too. Since the new technology offered users the opportunity to search, from among huge databases, any favorable keywords, professional KO tools were occasionally deemed redundant. However, it soon became obvious that to obtain more accurate and precise search results, the old tools of metadata, controlled vocabularies, and thesauri were also needed in the digital environment. This need became even more obvious with the advent of network opportunities and interoperability between systems. The use of both joint metadata elements – the production of the *Dublin Core Metadata Initiative* must be seen in this context – and controlled vocabularies, especially when providing the subject element of metadata descriptions, seemed indispensable (Dextre Clarke 2008, 432–434).

This brief historical overview of KO in libraries shows that there has been a long tradition in the domain of finding economy and rationality in collaboration

and sharing KO systems, records, and standardized KO tools. It is easy to describe this development as natural, driven in a given direction by technology, rationality, and economic incentives, producing KO systems that in an objective and neutral way mediate information to the users. In recent years, however, LIS scholars have challenged this viewpoint, stating that no KO system is neutral or nontheoretical (e.g., Hjørland 2016). KO systems and tools need to be seen as culturally constructed products that reflect certain ideologies, and they need to be deconstructed and their theoretical assumptions revealed (Gnoli 2020, 24). So, it is important to recognize that when LAM institutions describe their collections and make them searchable in a standardized and systematic way, this KO work will always include a decision-making process pointing out the most pertinent aspects of the collections, i.e., this work always includes decisions about relevant sets of data.

Also, a recurrent critique is how our "universal" subject representation systems, like the *DDC*, for example, are biased by power perspectives. An important contribution to this discussion is Olson's well-cited book *The Power to Name*, where the author shows how a universal language system "marginalizes and excludes *Others* – concepts outside of a white, male, Eurocentric, Christocentric, heterosexual, able-bodied, bourgeois mainstream" (2002, 142; see also Doyle and Metoyer 2015). With a similar agenda, Beghtol criticizes the rigid standardization of bibliographical control in present global KO systems for not responding to different cultural needs. She uses the concept of *cultural warrant*[2] to stress the need to protect cultural and information diversity by "creating ethically based, globally accessible, and culturally acceptable knowledge representation and organization systems" (2002, 507), and with the concept of *cultural hospitality with user choice option*, she invites initiatives that can reframe our systems to be more inclusive and open to cultural diversity (2002, 526). This way to invite different user perspectives into the KO process foresees the possibilities to come with Web 2.0 some years later, when the users can contribute with terms they feel more comfortable with by using folksonomies, tagging, or wiki procedures. With these, more "bottom-up" processes, the positions of experts and participants are altered (Spiteri 2006, 76). In Chapter 12 (this volume), Huvila describes how, for example, Oslo's Biblo Tøyen youth-only library invited a class at a local school to develop a classification system for organizing the collection, resulting in highly unconventional subject groupings. Apart from the possibilities this brings to the indexing process in terms of democratization and inclusiveness, the disadvantages of inconsistency, including the loss of precision and control, which tend to lead to excessively high recall and "noise," have also been noted (Porter 2011, 251).

Archives and KO

The most common way to organize documents/records[3] in archives is via *the principle of provenance*, a combination of two regulating principles. The first, *respect*

des fonds, strives, as stated by the International Council on Archives (ICA), to "maintain information about the creator of the archives in order to preserve the context and ensure survival of meaningful content within the archive." The second, the principle of original order, aims to "keep the records in the arrangement which they were put by the creating body so as to retain relationships between records and thus provide evidence about how the creator carried out their activities." The archivist must therefore keep the original context and order unaltered and unmediated, as evidence would otherwise be tainted (Cook 2013, 106).

These principles occurred in the nineteenth century. During previous centuries, archives – inspired by libraries – had handled records as separate information carriers and organized them according to subject, i.e., pertinence. This practice resulted in a loss of the records' original context (Douglas 2017, 26–29), but with the nineteenth-century historical interest in archival institutions, the context of origin became appreciated as the main source for securing evidence of records.[4]

Archival collections are not only organized but also described, and the descriptions are also regulated by the principle of provenance and shall document both the context of the archive's creation and the original order; a document gets its meaning in relation to other documents in the archive and in relation to the archive as a whole with its original function, purpose, and context. Descriptions are also affected by the fact that archival documents are unique, frequently come in more than one form or medium, are usually unpublished and not available elsewhere, and are often numerous: In modern times, archives can hold millions of documents. In contrast to libraries and museums, which represent publications and objects on the edition and item level, respectively, archives need to describe collections on a higher level, i.e., the fonds level (Cook 2013, 108). This description practice involves a detailed, hierarchical analysis of the whole and its subcomponents, where all documents are included, not always targeted as items but as parts of hierarchically organized subgroups, or series. In recent decades, a shift toward a stronger focus on the record creator's structures, processes, and activities (or functions), implying a top-down rather than a bottom-up perspective, has been visible (Chaudron 2008). An example is the Swedish National Archives' instructions for public authorities to use a process-based description model instead of the traditional so-called "General archives scheme" (Riksarkivet 2012).

Even though archives handle unique material and work with organizing principles guarding the specific creating circumstances of each collection (and are restricted by national legislations), the domain has, in the past few decades, made efforts to standardize rules and codes for descriptions of archival material. (The same far-reaching standardization practice of libraries, however, has not been launched.) The possibilities, not least, that digitization might bring has triggered the development of rules, codes, and standards for descriptions of archival material, with the most renowned being *ISAD(G): General International Standard Archival Description*, *Rules for Archival Description (RAD)*, and *Encoded Archival Description (EAD)*. According to Yeo, these standards are viewed as tools

that "have facilitated systems development, data sharing, remote access, and the construction of some remarkably successful cross-institutional online services" (2017, 170). They have also met criticism, e.g., that they tend to confuse original groupings of documents, break existent narratives, and simplify a complex reality into formalized square data elements (Nesmith 2002, 36).

Descriptions mediate and contextualize records; they both steer and aid the act of interpreting the records (Yeo 2017, 164). This interpretative intervention has challenged the ideas of the neutral archivist; instead, the impact of archival intervention and power through processes of interpretation and representation (and appraisal) has been stressed: The function of archives in society is not only to secure evidence but also to create its memory (Nesmith 2002, 35). Scholars making these reflections (often from a poststructuralist perspective) notice how the constructing power of archivists is disguised behind a seemingly objective and rational practice, and they also stress the importance of archivists recognizing this act of creativity and revealing their biases (Cook and Schwartz 2002, 181–182).

In line with this too is the observation that the principles tend to preserve one *physical* order, based on *one* original creator, a practice obscuring the fact that records can have a complex history, often with several creators (Cook 2013, 109–113). To respect a complex provenance, Barr (1987–1988) suggests a more abstract way of seeing the principles, where records should be kept physically in accession units and linked to various creators through cross-references capturing the sum of relations between documents, creators, and functions. This ambition to broaden the concept of provenance has also been stressed by scholars who argue that when analyzing the provenance of an archive, societal circumstances surrounding the creation and organization of an archive, e.g., ethnicity and community belonging, must also be respected as part of the context (Douglas 2017, 35–36; Nesmith 2002, 35). People documented in the records should also be seen as part of the provenance, especially records of colonial governments where indigenous peoples are documented. In Australia and North America, there is, for example, an ongoing discussion on how to include indigenous communities as co-creators of archival descriptions (Gilliland 2012, 341). Another example is the Swedish handbook *Arkivism*, which aims to include more material about women in Swedish archives. Recognition of the power that lies in being included in an archive is shown in an analysis of a collection in the Norwegian National Archive, in particular how the choice of words to describe the material can have political implications (Qvortrup 2020).

During the past decade, scholars have argued that new digital techniques can make the KO practices of archives more inclusive and democratic; for example, digitization per se can contribute to a more inclusive treatment of provenance since the place of privilege and traditional hierarchical description of the fonds is not prompted by the new technique (Cook 2013, 110–111), and with the technologies of Web 2.0 and crowdsourcing, users themselves can contribute to descriptions by tagging the resources (Huvila 2015).

Museums and KO

KO in museums overlaps KO in libraries and archives, but also has a number of peculiarities. A brief explanation of the latter could go like this: Museums hold an abundance of unique objects, each of which is described on the item level. The wide breadth of objects within heterogeneous museums has necessitated complex and specialized KO systems growing over time. Even within one museum, different systems can be in use synchronously due to the variability of objects (Gill 2017). In comparison, this type of KO is more resource-demanding than libraries holding multiple copies of publications that can be recorded in the same way across collections, and archives holding unique documents that are recorded at the level of *fonds*.

Undoubtedly, this diversification has the strongest impact on the manifold practices of documentation in museums. However, other aspects should also be considered, whether the resource description is entered into the ledger, the card files, or the database. For example, information is rarely found on objects themselves. Unlike materials in libraries and archives, museum information requires outlying documentation sources: "knowledge creation practices are based on attribution rather than transcription" (Gill 2017; see also Bearman 2008). In addition, information usually changes over time. Updated information about, for example, location and storage, provenance, conservation analyses, loan contracts, and exhibitions and literature is added to existing records.

Today, countless computer systems are available, but no all-embracing consensus exists. An exception is the Danish Museum Act, which commands the approximately 100 state-subsidized museums to upload collection information to a common publicly managed online KO system in order to enable cross-collection searches and make all data accessible. Such an enforced compliance, seldom found in other places, is not without its issues. Interoperability is gradually being refined, but each museum has to retain its distinctive system features developed over time to document its specific kinds of objects; otherwise, this information and the collection context might be lost (Robinson 2019). Even seemingly similar KO systems can have subtle differences that challenge attempts to share information across collections.

Although comprehensive standardization has its limits within the museum domain, this does not mean that KO is not regulated, or rationalized. Early examples of efforts to standardize metadata and other information by way of structured vocabularies, thesauri, etc. include *Iconclass* (1973), *Nomenclature* (1978), the Getty's *Art and Architecture Thesaurus* (1990), and *VRA Core* (1996). Each of these and many other tools help museums in their KO practices.

Notably, online collection databases were launched from the mid-1990s onwards, as public access to museum information became an issue, both as a democratic obligation and with the purpose of employing the collections in new imaginative ways. However, nonspecialists rarely appreciated this online access. Databases were difficult to use as they often only included rudimentary

information without images or with only one low-resolution image (Bearman and Trant 2009). Traditionally, the main purpose of KO in museums has not been to provide the public access to catalogued information about objects. In-house KO systems, now becoming publicly accessible, had primarily supported professionals in their work (Gill 2017).

Today, access to information is more multifaceted. Representing information resources in museums "means not just accurately describing what one owns, but also supporting interpretive analyses and active scholarship over the long term" (Marty 2008). Thus, documentation practices run along a scale of raw, refined, and mediated information (Orna and Pettitt, 1998). This scale is reflected in traditional museum practice as both catalogues and exhibitions are ways of organizing knowledge. However, the museum's present-day exhibition does not necessarily mirror the collection catalogue. Put simply, the museum storage contains many more objects, which are identifiable by way of information in the collection catalogue. In the exhibition, objects are interpreted and put into narrative structures, often supported by technological mediation and an exhibition catalogue. In addition to all the other differences, museums' KO thus works on at least two levels: Objects are organized in collection catalogues and they are organized in exhibitions.

Historically speaking, museums have had an authoritative voice in creating records for their objects and in disseminating knowledge about their collections. The multiple systems, also assisted by the abovementioned specialist tools such as structured vocabularies, etc., support this notion. However, due to the resource-demanding practices of providing descriptive metadata, the development of digital technologies, and diverse political demands, many museums have been experimenting with not just tagging and crowdsourcing, but also gamification and machine learning.

Tagging and crowdsourcing, also addressed above, have been hailed for inviting people to engage in generating metadata in an inclusive language, e.g., keywords representing relevant minorities or communities. Such an approach might "democratize" metadata creation (Murphy and Rafferty, 2015). However, crowdsourcing is not per se inclusive. It depends, not least, on who is taking part: The tools of "participatory metadata production" are only inclusive if they are used by a variety of people (Dahlgren and Hansson 2020).

Another way of nudging people to help in the creation of metadata is gamification. Although not as widespread as crowdsourcing within the museum domain, the German ARTigo has developed a number of social games since 2008 to motivate players to provide descriptive metadata (Bry and Schefels 2016). Once more, critical questions must be raised. Players – and taggers – are, among other things, unpaid workforce, and the risk of addictiveness might create concerns (Jafarinaimi 2012). However, if varied groups of people engage in the gaming, the notion of museum professionals as the authoritative source for collection information is democratized, at least to a certain extent.

Yet another way to enrich descriptive metadata is machine learning. Because of increasingly advanced algorithms, computer vision is gradually being trained to analyze, describe, and present museum collections. Thus, computers can potentially generate data from digital images of collection objects at a very fast pace compared to the speed of producing these data manually. Moreover, through refined color and composition analysis, as well as object recognition, computer vision can find similarities and connections across digital images of collection objects (Villaespesa and Murphy 2021), possibly facilitating image retrieval for nonspecialists and opening for the information *flaneur* who does not seek precision and reliability in retrieval but has an exploratory approach (Rafferty 2019). Currently, these technologies are at an experimental level, but their potential raises pertinent questions related to KO, for example, about ethics regarding diversity and biased metadata.

Although descriptive metadata are an important way of making collections accessible, KO in museums is not limited to this. As previously mentioned, each museum has often developed its own distinctive system of documentation over time, including pertinent contextual information (and hidden ideologies), which cannot be replaced by automated processes, and, not least, *mediated* information, performed by the authoritative voice of the museum, is still the main route for making objects accessible to the public.

Conclusion

In this brief description of KO in LAMs, two lines of development have been explored: *Regulation, standardization, and rationalization* and *diversification, inclusiveness, and democratization*. Both are in many ways prompted by new digital techniques, but where the former can be seen as resulting from internal KO technological and practical rationales (connected to our narrower definition of KO, presented in the introduction), the latter is more motivated by political and societal demands (connected to power aspects and our broader definition of KO). In this last section, we will discuss these themes a bit further, but also connect them to ideas of using KO to link LAM collections.

Although we recognize a striving for more standardized KO practices in all LAM institutions, the library domain has been most affected. Libraries have long found economy and rationality in sharing and standardizing KO systems, records, and tools. This can partly be explained by the fact that many copies of books exist. Museums and archives, conversely, handle more multifaceted and unique material – even though paper or digital records/documents of archives do not show the same range of variation as objects from the museum domain – and have, accordingly, fewer opportunities to standardize their KO tools and practices.

Not only material conditions but also institutional commissions and restrictions affect standardizing practices. Since libraries' mission generally is to offer access to knowledge resources independently of where they are placed, and a

standardized global catalogue working as a surrogate to these resources seems rational. Archives, in contrast, are not only restricted by national legislation but also by the provenance principle, which states the need to be sensitive to each archive's original context and structure. Consequently, an extensive global standardization is difficult to implement. Put simply, KO work in museums is executed on two levels: First objects are organized in collections in storages and recorded in dynamic catalogues (traditionally, as an aid to professionals in the specific museum, not to provide public access), then they are organized in narratives in exhibitions. Neither of these functions encourages standardization.

Attempts to standardize and share KO tools and systems have not been limited to these institutions per se but to the LAM field as a whole. With, for example, joint metadata, crosswalks, and shared digital platforms/portals, "unified routes into their deep collective resources" have been envisioned (Dempsey 2000). These ideas have been nurtured by arguments stating that LAM collections, on some basic KO level, could be described by the same types of metadata and the notion that users do not care about institutional barriers (if objects are placed in a museum, a library, or an archive). And digital platforms and web resources connecting digital resources from different collections and domains *have* been launched; one prominent example is Europeana.eu. By using a metadata stand-ard, the *Europeana Data Model (EDM)*, a variety of collections has been mapped and integrated into one platform.

This trend has also met criticism. Some researchers have identified problems with linking metadata of different levels – the high-level descriptions of archives, and the item and edition level of museums and libraries (e.g. Yeo 2017, 182–183) – and Robinson warns that the striving for universal access to digital collections and the standardization procedure this invites put at risk the unique perspec-tives each institutional type brings. Instead, states that "an organic heterogeneous array of collecting institutions – rather than hybrid mega-repositories – could be vital to maintaining the richness and diversity of cultural knowledge" (2019, 38).

Lately, often from poststructuralist perspectives, the three domains have addressed the constructing and mediating power aspects of KO tools and systems: How, for instance, classification systems and vocabularies favor some viewpoints and neglect others.

Importantly, this bias is not limited to traditional KO tools but is also present in algorithms producing indexing and search opportunities in digital tools (Noble 2018). To address this problem, existing systems and tools have been sensitized to the needs and perspectives of different user groups by, for exam-ple, stretching standards, adding more options/codes, or changing the orders of existing systems. This work strives for the inclusion and empowerment of groups that are not normally in power to co-construct existing dominant KO tools (e.g., due to colonialism, racism, or misogyny). To produce terminologies that are more pluralistic and inclusive, digital technologies inviting users have also been seen as promising: For instance, wikis, tagging, and folksonomies. But warn-ings have been raised that these practices make some users more comfortable

about contributing than others (some groups will still be privileged) and that the reliability of records and the precision and control of the KO process might be jeopardized (Jansson 2020). In particular, this latter position is integrated in the powerful master narrative of information professionals, although serendipitous and exploratory information seeking might be more relevant in many cases (Dörk, Carpendale, and Williamson 2011).

Finally, the sharing and converging of KO practices bring benefits and drawbacks: It can be a great service to users by offering joint access to LAM materials regardless of the institutional placement of objects, and it can serve rational and economic interests. But if this converging KO practice is based on far-reaching standardization, where metadata sets and attributes are uniform and thereby reduced, the necessary diversity and polyphony that different KO practices bring might be lost and replaced by a homogenic perspective.

Notes

1 Inspired by Henry Evelyn Bliss, *The Organization of Knowledge in Libraries and the Subject-approach to Books* 1933 (Dahlberg 2008, 84).
2 The warrant concept is based on the idea that "the basis for classification is to be found in the actual published literature rather than abstract philosophical ideas or 'concepts in the universe of knowledge'" (Chan, Richmond, and Svenonius 1985, 48). But *how* the published literature shall be represented has been under debate and different warrant concepts have been proposed: user warrant, cultural warrant, gender warrant, etc. (Barité 2018).
3 A record is generally perceived as narrower than the concept of a document, and emphasizes the function of evidence.
4 The evidence approach was not new, but if earlier archives and documents were preserved to attest to rights, privileges, and obligations in juridical, economic, and political domains, now the assistance to historical disciplines became just as important (Eastwood 2017, 6).

References

Barité, Mario. 2018. "Literary warrant." *Knowledge Organization* 45, no. 6: 517–536. https://doi.org/10.5771/0943-7444-2018-6-517.
Barr, Debra. 1987–1988. "The Fonds Concept in the Working Group on Archival Descriptive Standards Report." *Archivaria* 25 (Winter): 163–170.
Bearman, David. 2008. "Representing Museum Knowledge." In *Museum Informatics: People, Information, and Technology*, edited by Paul F. Marty and Katherine Jones, 35–58. New York: Routledge. https://doi.org/10.4324/9780203939147.
Bearman, David, and Trant, Jennifer. 2009. "Museum Web Sites and Digital Collections." In *Encyclopedia of Library and Information Science*, edited by Marcia J. Bates and Mary Niles Maack, 3762–3772. 3rd edition. Boca Raton, FL: CRC Press. https://doi.org/10.1201/9780203757635.
Beghtol, Clare. 2002. "A Proposed Ethical Warrant for Global Knowledge Representation and Organization Systems." *Journal of Documentation* 58, no. 5: 507–532. https://doi.org/10.1108/00220410210441.

Bowker, Geoffrey C., and Susan Leigh Star. 1999. *Sorting Things Out: Classification and Its Consequences*. Cambridge: MIT Press. https://doi.org/10.7551/mitpress/6352. 001.0001.

Bry, Francois, and Clemens Schefels. 2016. *An Analysis of the ARTigo Gaming Ecosystem with a Purpose*, 2–10. Research report, Institute for Informatics, Ludwig-Maximillian University of Munich.

Chan, Lois Mai, Phyllis A. Richmond, and Elaine Svenonius, 1985. *Theory of Subject Analysis*. Littleton: Libraries Unlimited.

Chaudron, Gerald. 2008. "The Potential of 'Function' as an Archival Descriptor." *Journal of Archival Organization* 6, no. 4: 269–287. https://doi.org/10.1080/15332740802533313.

Cook, Terry. 2013. "Evidence, Memory, Identity, and Community: Four Shifting Archival Paradigms." *Archival Science* 13: 95–120. https://doi.org/10.1007/s10502-012-9180-7.

Cook, Terry, and Joan M. Schwartz. 2002. "Archives, Records, and Power: From (Postmodern) Theory to (Archival) Performance." *Archival Science* 2: 171–185. https://doi.org/10.1007/BF02435620.

Dahlberg, Ingetraut. 2008. "Interview with Ingetraut Dahlberg." *Knowledge Organization* 35, no. 2/3: 82–85. https://doi.org/10.5771/0943-7444-2008-2-3-82.

Dahlgren, Anna, and Karin Hansson. 2020. "The Diversity Paradox. Conflicting Demands on Metadata Production in Cultural Heritage Collections." *Digital Culture & Society* 6, no. 2: 239–256. https://doi.org/10.14361/dcs-2020-0212.

Dempsey, Lorcan. 2000. "Scientific, Industrial, and Cultural Heritage: A Shared Approach." *Ariadne: Web Magazine for Information Professionals* 22 (January).

Dextre Clarke, Stella G. 2008. "The Last 50 Years of Knowledge Organization: A Journey through my Personal Archives." *Journal of Information Science* 34, no. 4: 427–437. https://doi.org/10.29085/9781856049986.006.

Douglas, Jennifer. 2017. "Origins and Beyond: The Ongoing Evolution of Archival Ideas about Provenance". In *Currents of Archival Thinking*, edited by Heather MacNeil and Terry Eastwood, 25–52. 2nd edition. Santa Barbara: Libraries Unlimited. https://doi.org/10.1080/00049670.2010.10736034.

Doyle, Ann M., and Cheryl A. Metoyer. 2015. *Indigenous Knowledge Organization: Special Issue: Cataloging & Classification Quarterly* 53, no. 5/6: 473–715. https://doi.org/10.14288/1.0223843.

Dörk, Marian, Sheelagh Carpendale, and Carey Williamson. 2011. "The Information Flaneur: A Fresh Look at Information Seeking." *Proceedings of the SIGCHI Conference on Human Factors in Computing Systems*, 1215–1224. New York: ACM. https://doi.org/10.1145/1978942.1979124.

Eastwood, Terry. 2017. "A Contested Realm: The Nature of Archives and the Orientation of Archival Science." In *Currents of Archival Thinking,* edited by Heather MacNeil and Terry Eastwood, 3–24. 2nd edition. Santa Barbara: Libraries Unlimited. https://doi.org/10.1080/00049670.2010.10736034.

Europeana. n.d. "Europeana Data Model". Accessed December 7, 2021. https://pro.europeana.eu.

Gill, Melissa. 2017. "Knowledge Organization within the Museum Domain: Introduction." *Knowledge Organization* 44, no. 7: 469–471. https://doi.org/10.5771/0943-7444-2017-7-469.

Gilliland, Anne J. 2012. "Contemplating Co-Creator Rights in Archival Description." *Knowledge Organization* 39, no. 5: 340–346. https://doi.org/10.5771/0943-7444-2012-5-340.

Gnoli, Claudio. 2020. *Introduction to Knowledge Organization*. London: Facet Publishing. https://doi.org/10.1080/07317131.2021.1973814.

Hansson, Joacim. 2012. *Folkets bibliotek? Texter i urval 1994–2012*. Lund: BTJ förlag.

Hjørland, Birger. 2008. "What is Knowledge Organization (KO)?" *Knowledge Organization* 35, no. 2/3: 86–101. https://doi.org/10.5771/0943-7444-2008-2-3-86.

Hjørland, Birger. 2016. "The Paradox of Atheoretical Classification." *Knowledge Organization* 43, no. 5: 313–323. https://doi.org/10.5771/0943-7444-2016-5-313.

Huvila, Isto. 2015. "The Unbearable Lightness of Participating? Revisiting the Discourses of 'Participation' in Archival Literature." *Journal of Documentation* 71, no. 2: 358–386. https://doi.org/10.1108/JD-01-2014-0012.

International Council on Archives. n.d. "Who Is an Archivist?" Accessed November 1, 2021. https://www.ica.org/en/discover-archives-and-our-profession.

Jafarinaimi, Nassim. 2012. "Exploring the Character of Participation in Social Media: The Case of Google Image Labeler." *Proceedings: iConference 2012*, 72–79. Toronto: Canada. https://doi.org/10.1145/2132176.2132186.

Jansson, Ina-Maria. 2020. "Creating Value of the Past through Negotiations in the Present: Balancing Professional Authority with Influence of Participants." *Archival Science* 20: 327–345. https://doi.org/10.1007/s10502-020-09339-8.

Joudrey, Daniel N., Arlene G. Taylor, and David P. Miller. 2015. *Introduction to Cataloging and Classification*, 11th edition. Santa Barbara: Libraries Unlimited.

Kungl. biblioteket. 2020. "Dewey på svenska bibliotek". Last modified October 7, 2020. https://metadatabyran.kb.se/klassifikation/ddk/dewey-pa-svenska-bibliotek.

La Barre, Kathryn. 2017. "Interrogating Facet Theory: Decolonizing Knowledge Organization." In *Dimensions of Knowledge: Facets for Knowledge Organization*, edited by Richard P. Smiraglia and Hur-Li Lee, 7–30. Würzburg: Ergon Verlag.

Marty, Paul F. 2008. "Information Representation." In *Museum Informatics: People, Information, and Technology*, edited by Paul. F. Marty and Katherine Burton Jones, 29–34. New York: Routledge. https://doi.org/10.4324/9780203939147.

Macdonald, Sharon. 2011. *A Companion to Museum Studies*. Malden, MA: Wiley-Blackwell.

Matassa, Freda. 2011. *Museum Collections Management: A Handbook*. London: Facet Publishing. https://doi.org/10.5860/rbm.13.1.371.

Murphy, Helen, and Pauline Rafferty. 2015. "Is There Nothing Outside the Tags? Towards a Poststructuralist Analysis of Social Tagging." *Journal of Documentation* 71, no. 3: 477–502. https://doi.org/10.1108/JD-02-2013-0026.

Nesmith, Tom. 2002. "Seeing Archives: Postmodernism and the Changing Intellectual Place of Archives." *American Archivist* 65: 24–41. https://doi.org/10.17723/aarc.65.1.rr48450509r0712u.

Noble, Safiya. 2018. *Algorithms of Oppression: How Search Engines Reinforce Racism*. New York: NYU Press. https://doi.org/10.2307/j.ctt1pwt9w5.

Olson, Hope A. 2002. *The Power to Name: Locating the Limits of Subject Representation in Libraries*. Dordrecht: Kluwer Academic Publishers. https://doi.org/10.1007/978-94-017-3435-6.

Orna, Elizabeth, and Charles W. Pettitt. 1998. *Information Management in Museums*. Surrey: Gower Publishing Company.

Porter, John. 2011. "Folksonomies in the Library: Their Impact on User Experience, and Their Implications for the Work of Librarians." *The Australian Library Journal* 60, no. 3: 248–255. https://doi.org/10.1080/00049670.2011.10722621.

Pousette, Helene Larssson, and Lina Thomsgård, eds. 2021. *Arkivism: En handbok: Hitta, spara och organisera för framtidens historieskrivning*. Stockholm: Volante.

Qvortrup, Natalia. 2020. "Documenting the Armenian Genocide in Norway: The Role of a National Archive in the Social Life of a Collection." *Archives and Records* 43, no. 1: 36–55. https://doi.org/10.1080/23257962.2020.1813094.

Rafferty, Pauline. 2019. "Disrupting the Metanarrative: A Little History of Image Indexing and Retrieval." *Knowledge Organization* 46, no. 1: 4–14. https://doi.org/10.5771/0943-7444-2019-1-4.

Riksarkivet. 2012. *Redovisa verksamhetsinformation: Vägledning till Riksarkivets föreskrifter om arkivredovisning.* Stockholm: Riksarkivet.

Robinson, Helena. 2019. *Interpreting Objects in the Hybrid Museum: Convergence, Collections and Cultural Policy.* London: Routledge. https://doi.org/10.4324/9780429454400.

Spiteri, Louise F. 2006. "The Use of Folksonomies in Public Library Catalogs." *The Serials Librarian* 51, no. 2: 75–89. https://doi.org/10.1300/J123v51n02_06.

Statens Bogsamlingskomité. 1915. *Decimal-klassedeling til Brug ved Ordningen af Bogsamlinger.* København: Nielsen og Lydiche.

Villaespesa, Elena, and Oonagh Murphy. 2021. "This Is Not an Apple! Benefits and Challenges of Applying Computer Vision to Museum Collections." *Museum Management and Curatorship* 36, no. 4: 362–383. https://doi.org/10.1080/09647775.2021.1873827.

Weinberger, David. 2007. *Everything Is Miscellaneous: The Power of the New Digital Disorder.* New York: Times Books.

Yeo, Geoffrey. 2017. "Continuing Debates about Description." In *Currents of Archival Thinking,* edited by Heather MacNeil and Terry Eastwood, 163–192. 2nd edition. Santa Barbara: Libraries Unlimited. https://doi.org/10.1080/00049670.2010.10736034.

PART III

Challenges for LAMs in the 21st Century

9
THE IMPACT OF DIGITALIZATION ON LAMS

Bjarki Valtysson, Ulrika Kjellman, and Ragnar Audunson

Introduction

A good starting point when discussing the impact of digitalization is to focus on the concept of *digitalization* itself. Contrary to digitization, which is a process of converting contents into numerical data (Balbi and Magaudda 2018), digitalization takes this process further and describes the consequences of the processes of digitization. These consequences have of course been widely discussed. In a relatively early attempt, Manovich refers to "culture undergoing computerization" (2001, 27) and states that the five principles of new media are significant to this process: Numerical representation (described mathematically and subject to algorithmic manipulation), modularity, automation, variability, and transcoding. Miller (2020) applies a similar approach by referring to technical processes as being digital, networked, interactive, hypertextual/hypermediated, automated, and databased. What these writings point toward is that digitization has wide consequences in terms of the digitalization of societal, cultural, and institutional contexts. In a recent LAM study, a differentiation is made between digitization, digitalization, and digital transformation (Vårheim, Skare, and Stokstad 2020a). Here, the authors apply a definition of digitalization that perceives it as "[a] sociotechnical process of applying digitizing techniques to broader social and institutional contexts that render digital technologies infrastructural" (Tilson, Lyytinen, and Sørensen 2010, 749). This is an interesting characterization as it emphasizes social, institutional, and infrastructural contexts. Digital transformation, then, focuses more on changes in business models, organizational structures, product development, and automation. To complicate things a bit, it is not quite certain how these concepts relate to other concepts that also attempt to describe the wider consequences of digitization, such as datafication, platformization,

DOI: 10.4324/9781003188834-12

connectivity, the logics of algorithms, artificial intelligence (AI), and machine learning.

One thing is certain, however: The effects of digitalization on the LAM professions are profound, but also differ somewhat between librarians, archivists, and museum professionals. As for libraries, they have been using digital technologies for a long time, and in this particular context, digitization leads to what some authors term "disintermediation." People have direct access to the information hitherto controlled by librarians as gatekeepers. Their role as middlemen between information and those who need information changes (Nicholas 2012; Brabazon 2014). The same process also takes place in archives. We see, for example, that producers of content, e.g., bureaucrats producing reports and decision-making documents, are responsible to an increasing extent for attaching metadata to their reports and documents, not professional archivists. Furthermore, as Cook (2012) notes, the role of the archivist has changed from passive curator to active appraiser, to societal mediator, and to what he terms a "community facilitator," strongly driven by the "community requirements of the digital age" (Cook 2012, 116). As Jochumsen, Hvenegaard Rasmussen, and Skot-Hansen (2012) mention in the context of public libraries, these community requirements of the digital age have not resulted in jarring contrasts, but have rather multiplied the function and role of libraries. Finally, museums give access to their material by curating exhibitions. In on-site contexts, museum curators are therefore less affected by disintermediation than librarians and archivists. However, when arranging their collections and providing access to them in digital formats, museums are faced with processes of remediation, which essentially involve political acts of prioritization. The same goes for all LAMs, as to differing degrees they are involved in processes of digitization, in constructing databases, collections, and digital archives, and this construction involves the political acts of prioritization both on the level of construction and in providing access, search functions, metadata, and interface designs. From an occupational point of view, libraries employ professionals with other professional backgrounds than librarianship. In the public library of Oslo, no more than a third of professional man-years are now staffed by educated librarians. A similar process is detectable with larger museums where the role of curators is one amongst many others that constitute their institutional tasks. Finally, much audience research that deals with the LAM sector also indicates that the concept of *audience* is transforming, and here, the dialogic potentials of digital communication play an important role.

We have now already mentioned three contexts in which the impact of digitization is present within the LAM sector: Impact on LAM institutions, impact on LAM professionals, and impact on users of LAM institutions. To dive deeper into these and to further account for the impact of digitalization, we will start this chapter by describing in overarching terms what kind of *environment* this impact has created, and how this has led to changes in the processes of cultural production and cultural consumption. To further frame the impact of digitalization and how it affects institutions, we account for the shifting conceptualizations

of digitalization, datafication, and platformization. We will then discuss how these changes affect the working environment of LAM professionals, and lastly, how these changes affect users of LAM institutions. While the impact of digitalization certainly presents some concrete challenges on institutional, professional, and user levels, it also brings about various opportunities. The aim of this chapter is to account for both perspectives.

The institutional environment

In terms of LAMs, the distinction between the production of cultural goods on the one hand and the reproduction and diffusion of cultural goods on the other (Bourdieu 1993; Hvenegaard Rasmussen 2019) is not useful, as it is difficult to separate production from reproduction and diffusion. This has always been the case, and is increasingly so due to digitalization, as museums, archives, and libraries don't just mirror (reproduce and diffuse) knowledge, but assemble and tailor (produce and prioritize) knowledge. Cook formulates this well when he says that "archivists, with colleagues in museums, galleries, libraries, and historic sites, are the leading architects in building society's enduring memory materials" (2013, 102). Therefore, we argue in line with Larsen (2018), who maintains that LAM organizations play an important role for the infrastructure of a civil public sphere, both in terms of arts and culture and in terms of research and higher education.

From a LAM perspective, digital tools have been used to construct, organize, and provide access to collections, databases, and archives, and to communicate. The first is not recent, as LAM institutions have been using digital processes for a long time. If we take libraries as an example, constant and enthusiastic work has been going on since the 1960s to implement mechanical and digital techniques to enhance the retrieval of library collections and also connect them into joint networks (Joudrey, Taylor, and Miller 2015).

With regard to digitizing collections and databases, libraries, archives, and museums have had different approaches to digital tools depending on differences both in material and social/institutional cultures. In libraries, where the material (books) consists of many copies and the aim of the practice is to provide access and loans, there has been a long tradition of finding economy and rationality in collaborating and sharing systems, records, and standardized tools, such as cataloguing codes and controlled vocabularies, which paved the way for digitization (Dextre Clarke 2008; Joudrey, Taylor, and Miller 2015; Gnoli 2020). Archives and museums, which to a larger extent work with unique materials, have not had the same incitement to digitize their collections (see Chapter 8, this volume) – at least not until more recently.

These more "recent" times are linked to trends that have to do with the development of the technical infrastructure of the Internet, but in positions that, from the viewpoint of LAM institutions, emphasize communication with users and audience development (e.g., see: Huvila 2008; Anderson 2012; Jochumsen, Hvenegaard Rasmussen, and Skot-Hansen 2012). Concomitant with these,

there was a certain hype that foresaw great potentials in further evening out the manifold power relations in society and equipping citizens with empowering digital tools that could challenge established gatekeepers. This agency was ascribed to individuals and institutions, and their effects were meant to have genuine societal and cultural implications. On an individual level, conceptualizations like produser (Bruns 2008), proams (Leadbeater 2000), interactive audience (Jenkins 2006), and productive enthusiasts (Gauntlett 2011) signal changes in the balance between producers, consumers, and users.

While many of these writings exemplify the emancipatory potentials concomitant with digitalization, it is important to note that these are not just theoretical constructions. Indeed, as Berry (2008) remarks, the rise of the Internet was a product of similar liberal and libertarian values to open-source and free-software movements, which emphasize access, use, reuse, freedom, progress, effectiveness, and productivity. These ideas and practices are still present and exemplified in the work and projects initiated by LAM institutions. On a macro scale, the cross-institutional platform Europeana serves well to demonstrate this as it has always been a prime objective to make digital data usable, and reusable. Indeed, according to one of its core values, it intends "to support cultural heritage institutions in harnessing digital to open up their collections – to make them available to be used in new ways" (Strategy 2020–2025 Summary n.d.). This is also the case with many Scandinavian LAM institutions, which are guided by ideas of access, remix, and creative reuse when designing their digital interfaces. The phrase *sharing is caring* captures this quite well, as digitalization allows for the design of such initiatives. LAM institutions can now tailor their collections, archives, and communications on the premises of creative reuse, where users can interact with, participate, and engage in a different manner than prior to digitization. In the LAM sector, crowdsourcing and creating folksonomies, for instance, are initiatives that have been of importance (Ridge 2013).

However, there is another side to that story that goes further into infrastructures and the platformization of the web (Helmond 2015; Plantin et al. 2018). To put it simply, digitalization causes datafication. And datafication is largely driven by platformization. Datafication is the capability of networked platforms to render into data elements of the world that have not been quantified before (Mayer-Schönberger and Cukier 2013). The wider implications of this are that behavioral metadata automatically derived from different gadgets as well as every form of user interaction can now be captured as data, circulated, and commodified as data. This means that each type of content is treated as data, be it archived material, digital collections, books, files, music, videos, pictures, paintings, etc., that can now be tinkered with, circulated, and traced. Furthermore, datafication grants platforms the ability to develop predictive and real-time analytics, which is vital for their business models (Van Dijck, Poell, and de Waal 2018). Thus, alongside the voices that emphasize the impact of digitalization on the premises of creative reuse, democratization of LAM institutions, and potentials for more engaging formats for cultural participation, others flag concerns regarding

platform labor (van Doorn 2017), free labor (Terranova 2013), digital labor (Fuchs 2014), the reproduction of gendered social hierarchies (Duffy 2016), and how algorithms, platforms, and digital technologies misleadingly categorize and discriminate negligible subjects (Eubanks 2018; Noble 2018; Benjamin 2019). Others frame this on the premises of disempowerment, either as a transfer of power from citizens to the state (Braman 2007) or toward large tech companies and surveillance capitalism (Zuboff 2019).

To understand the impact of digitalization on LAM institutions, we therefore need to refer to the environment that they operate within as an environment of connected platforms, as the field of cultural production is highly affected by platformization, which, according to Poell, Nieborg, and van Dijck (2019), penetrates infrastructures, economics, and governmental platforms, and reorganizes cultural practices and imaginations. LAM institutions are central to this reorganization of cultural practices, as they hold a prominent position within the field of cultural production. Therefore, the environment of LAM institutions now increasingly converges the two approaches of *organizing* and providing *access* to collections, at the same time as using platforms to *communicate* with their users. The impact of digitalization therefore opens up new ways to preserve, store, communicate, disseminate, use, reuse, connect, engage, and participate. An important question is: How do LAM institutions take advantage of these potentials without compromising their role as established cultural institutions? Even though the gates to knowledge have multiplied, there are still gatekeepers. How do LAM institutions provide access to and legitimate knowledge and information within their field of expertise? Even though materials get digitized in great volumes, this is without much effect if these materials and collections remain hidden within the depths of digital archives, libraries, and museums. In this age of abundance, what is the future role of LAM institutions in preserving, prioritizing, presenting, and pushing information and knowledge toward their users? Connectivity is promising in terms of outreach, but this connectivity also comes at a cost. What is the cost of platformization, and what is the role of LAM institutions in reorganizing cultural practices and imaginations around platforms? How do LAM institutions maintain and develop their integrity as cultural institutions in this age of global platforms and the power of algorithms?

There is no simple answer to these questions. In the context of this chapter, it is important for us to avoid getting trapped in an either/or dichotomy, and rather discuss the potentials and challenges that digitalization has brought to the field of cultural production. The institutional environment is forever changed. Even though LAM institutions in a Scandinavian context are historically, culturally, politically, and economically anchored as powerful and prominent nodes in the network of cultural production, the advent of digital communication has made their role in preserving, developing, and facilitating our cultural heritage more complex. The professionals that work and operate at these institutions are at the heart of these institutional changes, and the next section will further address the environment in which they find themselves.

The professional environment

As was briefly implied in the previous section, libraries, archives, and museums are established institutions with roles and a remit that are relatively clear in society. This does not mean that they are "stuffy" and stagnated institutions. Quite the contrary. LAM institutions have undergone paradigm shifts in terms of outreach, audience development, societal relevance, role, dissemination, and communication. These shifts are, however, based on solid grounds that are historically, politically, culturally, and legally rooted. Structurally, these institutions are organized differently in the Scandinavian countries, as cultural policies, strategies, and implementation vary between state, regions, and municipalities. Whether the similarities between the countries justify a specific Nordic cultural policy model is up for debate, but all the same, these similarities point toward policies that promote artistic freedom, cultural diversity, cultural education, democracy, and cultural community building (Duleund 2003), with an emphasis on strong social welfare goals, relatively generous systems of subsidization, a focus on artists' welfare, corporatist relations between public authorities and cultural life, and decentralized cultural administrations and institutions (Mangset 1995). According to these writings, the Nordic field of cultural production is therefore welfare oriented, with a tradition of strong interest organizations, and with a high level of public subsidies to major cultural institutions, an egalitarian cultural life, a focus on access and participation, and a tradition of strong ministries of cultural affairs and arts councils (Mangset et al. 2008). It should be noted that such enumeration is rather crude and does not do justice to the field's finesse, but in our context, it nonetheless serves the purpose of anchoring LAM institutions and LAM occupational roles within a Scandinavian context. This is important when discussing LAMs from the viewpoint of changes in their environment, as cultural policy is amongst the factors that shape such transformations institutionally, but also at the level of LAM professionals. Here, disconnections have been detected between policies that address the digital potentials of digitalization and the challenges and practices of professionals (Valtysson 2022) who try to balance this.

As the digital gateway to these institutions is primarily guided through an interface, LAM institutions have converged in this part of their operations to similar communicative surroundings to platforms: "[A] platform is fueled by *data*, automated and organized through *algorithms* and *interfaces*, formalized through *ownership* relations driven by *business models*, and governed through *user agreements*" (Van Dijck, Poell, and de Waal 2018, 9). As LAM institutions increasingly mediate through platforms (see Chapter 10, this volume), they establish "databases," and as gatekeepers, they provide a "privileged path," or narratives, through these databases, even though they do this in different ways (Robinson 2019).

However, it is important to note that even though digitalization has converged institutional characteristics, LAM professionals still have solid knowledge and a sound educational base that construct their professional identities as librarians,

archivists, and museum professionals. How concretely the impact of digitalization affects the professions within these institutions varies, of course, depending on the institution. Larger museums, for instance, have multiple functions with many specialized staff within preservation techniques, curation, communication, and dissemination who need to work together from idea to execution. Other museums are much smaller, where the same professional is responsible for all those different functions. Small or big, all cultural institutions need to respond to digitalization. What is to be digitized and how? How do the institutions tailor the digital interface, or the app, or whichever form of digital communication they choose, and how does this tailoring refer to their on-site activities? How can an on-site text on an exhibition, a work of art, a book, or an archived document be boiled down to a tweet, a Facebook update, an Instagram story, a YouTube video, a Snap, or a video on TikTok? How much user agency should be accounted for when digitizing and designing online collections? How do LAM professionals maintain their authority and professionalism when disseminating and engaging with users online? How do LAM institutions react to issues of copyright, and how do they react to the demands of the GDPR and data protection in general?

These are questions that imply both challenges and potentials for LAM professionals. In all cases, they do need to adapt methods and strategies on how to design their own, but also interact with other, platforms. As explained in Chapter 10, platforms can be distinguished into internal, external, and cross-institutional platforms. Common to all those types is what van Dijck (2013) calls "platforms as technocultural constructs" and "platforms as socioeconomic structures." When platforms are perceived as technocultural constructs, attention is brought to the technological dimensions ([meta]data, algorithms, protocol, interface, and default settings) and how these shape usage and user agency, and which kind of content each platform's functionalities allow for. Focusing on platforms as socioeconomic structures draws attention to platforms' ownership structures, their business models, and their governance.

This approach allows for a nuanced view on some of the challenges and potentials that face LAM professionals when constructing their own platforms and engaging with external platforms, such as commercial social media. When libraries, archives, and museums make their materials available through internal platforms, there are considerations concerning the digitization process, which items to digitize, which formats are the most sustainable, and how they should be licensed. Interfaces are not neutral facilitators, but mediators. The design of the interface of LAM institutions' internal platforms is therefore political in the sense that their politics of prioritization decide which items, which knowledge, which ideas, and which cultural representation are brought to the fore, and which are forgotten. This has always been an essential part of LAM professions, and contrary to claims from digital enthusiasts, this has not changed with the advent of digitalization. The abundance and volumes of digitized items certainly have, but not the essential gatekeeping function of internal LAM platforms, and how

items are curated, presented, and pushed forward to users. When LAMs operate with internal platforms, they are usually in control regarding the platforms' characteristics as socioeconomic structures, as the ownership, business models, and governing structures are often in the hands of the institutions. Internal platforms, of course, are a part of international networks and standards (both in terms of shared data and technical solutions), but we still argue that these are structured and governed on different principles than those of external platforms, like commercial social media.

In the latter case, the curational logics are algorithmically constructed, the interfaces are not primarily designed to facilitate the needs of LAM institutions, the user-generated content is limited to the affordances of the platform in question, and the data that are produced as content and metadata feed into the business models of these platforms, which have proven to be very profitable businesses. On commercial social media, the "trending topics" are therefore algorithmically constructed, and these are driven by monetary gains, rather than the values that typically guide LAM institutions from a Scandinavian cultural policy perspective. In both cases, the internal and external platforms, this platformization has expanded the occupation role of LAM professionals. From a Scandinavian perspective, there are many successful examples of the creation and facilitation of online collections that attempt to provide access, information, engagement, and participation in a way foreseen by digital optimists. However, there are also examples of the opposite, which are typically entrapped within logics of digitizing collections, without providing searchable, creative functionalities to further engage with the collections. Importantly, in many cases, the internal platforms converge with the external platforms, as digital collections made "internally" are directly connected with external platforms like Facebook and Instagram to ensure different kinds of dialogic communications between institutions and users, and to gain increased outreach.

In any case, from the viewpoint of LAM professionals, this is an "add-on" in terms of their traditional professional identities. When these communications are moved onto commercial social media, we can say that they enter an "add-on" to the "add-on," as here, the LAM professionals need to adapt to the platform logics and affordances of services like TikTok and Instagram. Even though there are shining successful examples of this, like the literature memes of the Danish Blågårdens Library and Herlev Library's communication on Instagram, far too often these communications are generated by workers for whom this is not their primary role. LAM institutions are therefore confronted with questions such as: On which commercial social media platforms should they have an active presence? How does the institutional profile and role fit a given social media? How would they like to design their communications and who is responsible for it? The relatively brief history of social media platforms demonstrates that they change their functions over time, and that there is always a "new and upcoming" platform arising. The impact of digitization on the professional environment is therefore full of promises, but also of pitfalls. Many LAM institutions seem to

understand their outreach role as having an active presence on as many platforms as possible. The question remains as to whether TikTok's functionalities and algorithmic logics do justice to the professional communication and dissemination that LAM institutions are traditionally known for.

The user environment

We concluded the last section by questioning the strategies many LAM institutions apply when igniting communication on social media platforms. There is no question that these media provide excellent frameworks for reaching out to people and entering into dialogical communication with their users. This, of course, is also the case when they design their own internal platforms, which are more suitable for communicating these institutions' core tasks. The problem is that it is on social media where the users are already present, and therefore, these media provide convenient outlets to engage target groups that are normally hard to reach. However, in contrast to internal platforms, the external ones are not made specifically for these particular institutional purposes, and therefore LAM institutions need to tailor their communication, content creations, and user engagement toward such affordances. A tweet, for instance, provides a very different space for curators and communicators to work with than a descriptive, lengthy text that a given institution has written as part of a digital collection. This can be seen as an opportunity, as more diversified communication can potentially reach out to more people. But this can also be a challenge, as in larger institutions it is typically the communication department that is responsible for social media, rather than curators, archivists, and librarians, who often work with more open frameworks than the affordances of Twitter facilitate. Cooperation between institutional departments can be fruitful, but also challenging. This is particularly so with rooted LAM knowledge institutions with different established occupations.

Another challenge is manifested in some of the empowering conceptualizations that are meant to signal changing power dynamics between institutions and professionals, and the amateurs, users, and guests that frequent the institutions. We have already accounted for the proams, the produsers, and the like, but how do these more specifically relate to users of LAM institutions? These concepts are not developed with LAMs in mind, but other forms of digital media production, driven by other motivations. These can, for instance, be video recordings of gamers playing Counter-Strike or Fortnite and distributing on YouTube and Twitch, or influencers communicating on Instagram and TikTok. In these settings, the motivation is different from a user perspective than when users interact with LAM institutions online. LAM institutions as environments take their institutional anchoring with them to the online world and this creates a certain tension with regard to the user empowering conceptualizations, as the power balance is far from even.

To add to this, research in the Scandinavian context (Epinion and Pluss Leadership 2012; Riksantikvarieämbetet 2018) demonstrates a remarkable stability

in the demographics of frequent museum users (library numbers vary more), and these are not the same users as those that stream their gaming on YouTube and Twitch. So, users are not just users. This has, of course, been demonstrated by audience research that focuses on visitor types and visitor experiences (Falk 2009), as well as in a more recent study that demonstrates that libraries and museums are first and foremost visited physically by their users, while users of archives more often use their institutions digitally (Vårheim et al. 2020b). Our intention is not to recapitulate this in detail, but rather to point to the fact that digital media are unlikely to fundamentally change the power relations between senders and receivers, between professionals and amateurs, when the context is established knowledge institutions like libraries, archives, and museums. And even if, theoretically, these institutions can create internal platforms that facilitate active participation that adheres to the ideas associated with *sharing is caring* (such as crowdsourcing), this is not the same as somehow evening out power relations. The question also remains as to whether this is something that the majority of users want in the first place (Light et al. 2018). As already accounted for, particularly in the middle/early Internet days, much of the attention was focused on the creative, emancipatory, and empowering aspects of remix culture and creative reuse. Concomitant with the platformization of the web, dominant platforms such as Netflix, YouTube, Spotify, Instagram, and TikTok established *streaming* as the popularized format of enjoying cultural products. Technologically, we can still design platforms that allow users to download source material, ensure an open license like variations of Creative Commons, and urge users to get creative in their remixing endeavors. These kinds of projects, however, still remain niche. It takes a lot of skill, effort, and time to remix. Many users of cultural institutions don't have these capabilities and are not interested in productions of this sort. There are a lot of fan cultures that do this. LAM institutions are just not traditionally amongst them. This is partly due to the demographics that are dominant amongst their visitors, but also because LAM institutions are highly profiled, professional cultural institutions. Many users are not interested in taking control, or engaging actively in LAM institutions' productions, but would rather learn, be informed and entertained, and experience sound knowledge being communicated in an interesting way.

This is not the same as maintaining that LAM institutions should get free toils in their productions of the past, as their gatekeeping role comes with great responsibilities. Indeed, their politics of prioritization should always be subject to informed and critical deliberations driven by as many different people, institutions, and organizations as possible. Here, the impact of digitalization can provide various outlets for generating discussions with the LAM sector, either via internal or external platforms. These voices, however, take the role of traditional watchdogs, rather than produsers, proams, or productive enthusiasts. Finally, it should be noted too that digitalization can also cause digital divides in terms of skills, but also in terms of preferences of the general public, who in many cases choose the *on-site* over the *online*.

It might sound as if we are somehow downscaling the impact of digitalization on the LAM sector, as we are critical toward transformations of user positions from a fundamental power-changing perspective. But this is not the case. The impact has been enormous. A huge amount of material has been digitized and made available under the auspices of LAM institutions. This process has been scaled up during different forms of coronavirus that caused lockdowns, as the institutions could dedicate full attention to digital collections, projects, and strategies. Many institutions have therefore nuanced their gatekeeping functions by providing better search functions, metadata, descriptions, and quality of items. Digitalization has also provided LAMs with various opportunities to connect with their users. LAM institutions have initiated numerous projects and productions, podcasts, apps, tales via the telephone, Zoom events, communication on various social media platforms, etc. They are constantly becoming more skilled in these designs and outreach activities, and again, it is important to be aware of the different contexts of control between the different LAMs (Robinson 2012). The point is that in overall terms, they don't do this by primarily evening out power relations and giving their control away over their designs and narratives. There is still control. The channels have just multiplied.

References

Anderson, Gail. 2012. *Reinventing the Museum, the Evolving Conversation and the Paradigm Shift*. Lanham, MD: AltaMira Press.

Balbi, Gabriele and Magaudda, Paolo. 2018. *A History of Digital Media: An Intermedia and Global Perspective*. New York: Routledge.

Benjamin, Ruha. 2019. *Race after Technology: Abolitionist Tools for the New Jim Code*. Cambridge: Polity Press.

Berry, David M. 2008. *Copy, Rip, Burn: The Politics of Copyleft and Open Source*. London: Pluto Press.

Bourdieu, Pierre. 1993. *The Field of Cultural Production: Essays on Art and Literature*. R. Johnson ed. Cambridge: Polity Press.

Brabazon, Tara. 2014. The Disintermediated Librarian and a Reintermediated Future. *Australian Library Journal* 63, no. 3: 191–205. https://doi.org/10.1080/00049670.2014.932681.

Braman, Sandra. 2007. *Change of State: Information, Policy and Power*. Cambridge: MIT Press.

Bruns, Axel. 2008. *Blogs, Wikipedia, Second Life, and Beyond: From Production to Produsage*. New York: Peter Lang.

Cook, Terry. 2013. "Evidence, Memory, Identity, and Community: Four Shifting Archival Paradigms." *Archival Science* 13, no. 2: 95–120. https://doi.org/10.1007/s10502-012-9180-7.

Dextre Clarke, Stella G. 2008. "The Last 50 Years of Knowledge Organization: A Journey through My Personal Archives." *Journal of Information Science* 34, no. 4: 427–437. https://doi.org/10.29085/9781856049986.006.

Duffy, Erin Brooke. 2016. "The Romance of Work: Gender and Aspirational Labor in the Digital Culture Industries." *International Journal of Cultural Studies* 19, no. 4: 441–457. https://doi.org/10.1177/1367877915572186.

Epinion and Pluss Leadership. 2012. *Danskernes kulturvaner 2012*. Copenhagen: Epinion and Pluss Leadership.

Eubanks, Virginia. 2018. *Automating Inequality: How High-Tech Tools Profile, Police and Punish the Poor*. New York: St. Martin's Press.

Falk, John H. 2009. *Identity and the Museum Visitor Experience*. Walnut Creek, CA: Left Coast Press.

Fuchs, Christian. 2014. *Social Media: A Critical Introduction*. London: Sage.

Gauntlett, David. 2011. *Making Is Connecting: The Social Meaning of Creativity, from DIY and Knitting to YouTube and Web 2.0*. Cambridge: Polity Press.

Gnoli, Claudio. 2020. *Introduction to Knowledge Organization*. London: Facet Publishing. https://doi.org/10.1080/07317131.2021.1973814.

Helmond, Anne. 2015. "The Platformization of the Web: Making Web Data Platform Ready." *Social Media + Society* 1, no. 2. https://doi.org/10.1177/2056305115603080.

Huvila, Isto. 2008. "Participatory Archive: Towards Decentralised Curation, Radical User Orientation, and Broader Contextualisation of Records Management." *Archives and Museum Informatics* 8, no. 1: 15–36. https://doi.org/10.1007/s10502-008-9071-0.

Hvenegaard Rasmussen, Casper. 2019. "Is Digitalization the Only Driver of Convergence? Theorizing Relations between Libraries, Archives, and Museums." *Journal of Documentation* 75, no. 6: 1258–1273. https://doi.org/10.1108/JD-02-2019-0025.

Jenkins, Henry. 2006. *Fans, Bloggers, and Gamers: Exploring Participatory Culture*. New York & London: New York University Press.

Jochumsen, Henrik, Casper Hvenegaard Rasmussen, and Dorte Skot-Hansen. 2012. "The Four Spaces: A New Model for the Public Library." *New Library World* 113, no. 11/12: 586–597. https://doi.org/10.1108/03074801211282948.

Joudrey, Daniel N., Arlene G. Taylor, and David P. Miller. 2015. *Introduction to Cataloging and Classification,* 11th edition. Santa Barbara, CA: Libraries Unlimited.

Larsen, Håkon. 2018. "Archives, Libraries and Museums in the Nordic Model of the Public Sphere." *Journal of Documentation* 74, no. 1: 187–194. https://doi.org/10.1108/JD-12-2016-0148.

Leadbeater Charles. 2000. *Living on Thin Air*. London: Penguin.

Light, Ben, Gaynor Bagnall, Garry G. Crawford, and Victoria Gosling. 2018. "The Material Role of Digital Media in Connecting With, Within and Beyond Museums." *Convergence: The International Journal of Research into New Media Technologies* 24, no. 4: 407–423. https://doi.org/10.1177/1354856516678587.

Mangset, Per. 1995. "Kulturpolitiske modeller i Vest-Europa." In *Kulturårboka 1995*, edited by Georg Arnestad, 12–41. Oslo: Det Norske Samlaget.

Mangset, Per, Anita Kangas, Dorte Skot-Hansen, and Geir Vestheim. 2008. "Nordic Cultural Policy." *International Journal of Cultural Policy* 14, no. 1: 1–5. https://doi.org/10.1080/10286630701856435.

Manovich, Lev. 2001. *The Language of New Media*. Cambridge & London: MIT Press.

Mayer-Schönberger, Victor, and Kenneth Cukier. 2013. *Big Data: A Revolution That Will Transform How We Live, Work, and Think*. Boston, MA: Houghton Mifflin Harcourt.

Miller, Vincent. 2020. *Understanding Digital Culture*. London: Sage.

Nicholas, David. 2012. "Disintermediated, Decoupled and Down." *CLIPUPDATE*, 29–30.

Noble, Safia U. 2018. *Algorithms of Oppression: How Search Engines Reinforce Racism*. New York: NYU Press.

Plantin, Jean-Christophe, Carl Lagoze, Paul N. Edwards, and Christian Sandvig. 2018. "Infrastructure Studies Meet Platform Studies in the Age of Google and Facebook." *New Media & Society* 20, no. 1: 293–310. https://doi.org/10.1177%2F1461444816661553.

Poell, Thomas, David Nieborg, and Jose van Dijck. 2019. "Platformisation". *Internet Policy Review: Journal of Internet Regulation* 8, no. 4: 1–13. https://doi.org/10.14763/2019.4.1425.

Ridge, Mia. 2013. "From Tagging to Theorizing: Deepening Engagement with Cultural Heritage Through Crowdsourcing." *Curator: The Museum Journal* 56, no. 4: 435–440. https://doi.org/10.1111/cura.12046.

Riksantikvarieämbetet. 2018. *At vidga sin publik handlar om att vidga sig själv.* Stockholm: Riksantikvarieämbetet.

Robinson, Helena. 2012. "Remembering Things Differently: Museums, Libraries and Archives as Memory Institutions and the Implications for Convergence." *Museum Management and Curatorship* 27, no. 4: 413–429. https://doi.org/10.1080/09647775.2012.720188.

Robinson, Helena. 2019. *Interpreting Objects in the Hybrid Museums: Convergence, Collections and Cultural Policy.* London: Routledge. https://doi.org/10.4324/9780429454400.

Strategy 2020–2025 Summary Europeana. n.d. https://pro.europeana.eu/page/strategy-2020-2025-summary Accessed June 30, 2021.

Terranova, Tiziana. 2013. "Free Labor." In *Digital Labor: The Internet as Playground and Factory*, edited by Trebor Scholz, 33–57. New York: Routledge.

Tilson, David, Kalle Lyytinen, and Carsten Sørensen. 2010. "Research Commentary – Digital Infrastructures: The Missing IS Research Agenda." *Information Systems Research* 21, no. 4: 748–759. https://doi.org/10.1287/isre.1100.0318.

Valtysson, Bjarki. 2022. "Museums in the Age of Platform Giants: Disconnected Policies and Practices." *International Journal of Cultural Studies*, 1–18. https://doi.org/10.1177/13678779221079649.

Van Dijck, Jose. 2013. *The Culture of Connectivity: A Critical History of Social Media.* Oxford: Oxford University Press.

Van Dijck, Jose, Thomas Poell, and Martijn de Waal. 2018. *The Platform Society: Public Values in a Connected World.* Oxford: Oxford University Press.

Van Doorn, Niels. 2017. "Platform Labor: On the Gendered and Racialized Exploitation of Low-Income Service Work in the 'On-Demand' Economy." *Information, Communication & Society* 20, no. 6: 898–914. https://doi.org/10.1080/1369118X.2017.1294194.

Vårheim, Andreas, Roswitha Skare, and Sigrid Stokstad. 2020a. "Institutional Convergence and Divergence in Norwegian Cultural Policy: Central Government LAM Organization 1999–2019." In *Libraries, Archives and Museums as Democratic Spaces in a Digital Age*, edited by Ragnar Audunson, Herbjørn Andresen, Cicilie Fagerlid, Erik Henningsen, Hans-Christoph Hobohm, Henrik Jochumsen, Håkon Larsen, and Tonje Vold, 133–162. Berlin: De Gruyter Saur. https://doi.org/10.1515/9783110636628-007

Vårheim, Andreas, Henrik Jochumsen, Casper Hvenegaard Rasmussen, and Kerstin Rydbeck. 2020b. "The Use of LAM Institutions in the Digital Age." In *Libraries, Archives and Museums as Democratic Spaces in a Digital Age*, edited by Ragnar Audunson, Herbjørn Andresen, Cicilie Fagerlid, Erik Henningsen, Hans-Christoph Hobohm, Henrik Jochumsen, Håkon Larsen, and Tonje Vold, 247–270. Berlin: De Gruyter Saur. https://doi.org/10.1515/9783110636628-012.

Zuboff, Shoshanna. 2019. *The Age of Surveillance Capitalism: The Fight for a Human Future at the New Frontier of Power.* London: Profile Books.

10

DIGITAL COMMUNICATION IN LAMS

Henriette Roued-Cunliffe, Bjarki Valtysson, and Terje Colbjørnsen

Introduction

Digital communication has become ubiquitous for public engagement for libraries, archives, and museums (LAMs). All LAMs in Scandinavia use a variety of online platforms to communicate with users, with each other, and across institutions. But the multitude of communicative opportunities notwithstanding, digital communication also comes with potential pitfalls and challenges. The chapter will first introduce the state of digital communication as we understand it today and as we know it across and between the different LAM institutions. Exploring the notion of digital communication across the three sectors stirs up several questions about what we mean by communication in these contexts: Is it promotion, dissemination, mediation, or all three at once? Is it a one-way communication from the institution to a passive audience, or is it a dialog between equally engaged participants in areas of literature, heritage, or art? Or perhaps it is something in between?

Digital communication may vary in purpose, type, and intensity, depending on institutional aim and size, the perceived audience, and the organization's digital skills. It includes everything from the archive whose address and opening hours are available in an online directory, to the museum that makes its collection accessible through its own customized platform, to the library that engages citizens in Wiki edit-a-thons and creates TikTok videos. These various platforms each provide opportunities to connect with different audiences with varying ages and interests. However, the platforms used also come with unique challenges, not least in terms of who is able to control them and monitor their performance. By dividing the platforms used by LAMs for digital communication into (1) internal platforms, (2) external platforms, and (3) cross-institutional platforms, the chapter will explore these opportunities and challenges through the concept

DOI: 10.4324/9781003188834-13

of platformization. Finally, the chapter will discuss the most prominent challenges across platform and institution type and point towards important issues to consider for LAM institutions in their digital communication.

State of digital communication

Before we move on to the digital platforms that form the basis of digital communication across LAMs, we will specify what we mean by communication. As one of the central concepts in media and communication studies, communication can be defined as "a process of increased commonality or sharing between participants, on the basis of sending and receiving messages" (McQuail 2010, 552). In Scandinavian LAMs, this communication is often known as *formidling* or *förmedling*, which is not clearly defined and difficult to translate. While mediation and dissemination are used to describe this, consensus seems to have landed on communication as defined above (Balling 2021). When libraries, archives, and museums communicate, they do so with a purpose: It can be to promote or market an offer or an event; to inform the public on subjects like art, history, literature, and democracy; or to curate access to their collections. In some cases, the messages sent have an objective to bring people to institutional spaces both physically and online; in other cases, institutions take part in existing conversations. However, communication can also serve to sustain the institutions and their existence, autonomy, and reputation (Hardy 2011; Lammers 2011; Suddaby 2011). For instance, LAM institutions in Scandinavia communicate with stakeholders and political agencies to secure funding and show that they uphold their public mandates.

Communication can also be seen as a process; it has direction. The distinction between one-way (monological) and two-way (dialogical) communication helps us to understand the communicative practices of LAMs: Are they sending out messages, listening to feedback, or engaging in multidirectional conversations with users and across institutions?

Adding a layer of "digital" to these concepts of communication brings with it new opportunities and other challenges, as we will see in this chapter. A theoretical definition of digital communication points to the formal structures of electronic transmission of digitally encoded information. Digital communication, therefore, provides the technological means to encode culture in digital form, as Manovich (2001) formulated it. This encoding has had a huge societal, political, economic, and cultural impact, which also affects and forms modern LAM institutions. The digital format comes with certain understandings about programming and data. This creates tension in the LAM sector where few have the technical experience and confidence needed to fully understand and engage with communication and information at this level.

When discussing communication in the digital age, Castells (2009) starts by referring to similar technological transformations based on digital communication and how they affect the organizational and institutional structure of communication; how they change the definitions of senders and receivers and

their social relationships and power relations. Jenkins (2006) maintains that digital communication and digital media have provided users and consumers with tools that make them active, socially connected, noisy, and public. What he means by this is that digital communication provides the opportunity to engage in a different manner than was the case prior to this technological advancement.

Jenkins was not alone in perceiving such advancements favorably, as other, relatively early voices also looked positively upon the promise of digital communication, by emphasizing its creative, empowering, and democratic dimensions. These hopes were manifested in dynamic conceptualizations, such as prosumer (Toffler 1980), produser (Bruns 2008), users-turned-producers (Castells 2009), and productive enthusiasts (Gauntlett 2011). As these concepts indicate, they focus on the manifold potentials of tinkering with digital data, of changing consumption, production, and distribution patterns, and of the challenging power dynamics between users and organizations, agencies, companies, and institutions. According to these voices, digital communication provides citizens with tools to break the monopoly of established gatekeepers, such as LAM institutions, and facilitate communicative patterns of mass collaboration (Shirky 2008) in which more democratic, self-reflective, and participatory networked public spheres arise (Benkler 2007). Discursively, these logics described a move from a read-only culture to a read/write culture (Lessig 2009) and from a sit-back-and-be-told culture to a making-and-doing culture (Gauntlett 2011).

From a LAM perspective, these discussions bring to the foreground deep-rooted notions and struggles about authority and authenticity in communication (Drotner and Schrøder 2013). The strides that have been made in the LAM sector in the understanding of participation (see Chapter 12, this volume) have both had an influence on and been influenced by digital communication. Gathering under the banner of OpenGLAM, currently 1,200 LAMs worldwide that are providing open access to their collections have been listed (McCarthy and Wallace 2021). These activities attempt to challenge traditional ideas of authority and gatekeeping within LAMs (Roued-Cunliffe 2020). However, this is again not without its challenges and tensions, as we will see in the discussion on internal platforms.

Furthermore, as Jenkins later reflected upon, there are two sides to such participatory cultures generated by digital communication:

> Today, I am much more likely to speak about a push towards a more participatory culture, acknowledging how many people are still excluded from even the most minimal opportunities for participation within networked culture and recognizing that new grassroot tactics are confronting a range of corporate strategies which seek to contain and commodify the popular desire for participation.
>
> *(Jenkins 2014, 272)*

What Jenkins is pointing to are certain discrepancies concerning how the theoretical potentials of digital communication in terms of creativity, participation, engagement, openness, access, and empowerment have developed as major platforms and have gained in power, popularity, and in increasingly controlling the infrastructural backbone of digital communication.

According to van Dijck (2013), platforms should be understood as technocultural constructs and as socioeconomic structures:

> [P]latforms are the providers of software, (sometimes) hardware and services that help code social activities into a computational architecture; they process (meta)data through algorithms and formatted protocols before presenting their interpreted logic in the form of user-friendly interfaces with default settings that reflect the platform owner's strategic choices.
>
> *(van Dijck 2013, 29)*

When perceived as technocultural constructs, attention is focused on a given platform's technology (metadata, algorithms, protocols, default settings, and interface) and how it shapes certain usage, user agency, and specific forms for content production and consumption. Platforms as socioeconomic structures draw attention to platforms' business models, ownership, and governance.

Such a holistic view on platforms allows them to be placed in appropriate contexts with regard to LAM institutions. Importantly, it also addresses the further consequences of *platformization*, which signifies "the penetration of the infrastructures, economic processes, and governmental frameworks of platforms in different economic sectors and spheres of life" (Poell, Nieborg, and van Dijck 2019, 5–6), and as a consequence of this, "the reorganization of cultural practices and imaginations around platforms" (Poell, Nieborg, and van Dijck 2019, 6). It is this reorganization of cultural practices caused by platforms and platformization of cultural practices that LAM institutions are confronted with. In this chapter, we distinguish platforms as internal platforms, external platforms, and cross-institutional platforms. What links these approaches, however, is a certain challenge in weighing the pros and cons and the wider consequences of LAM institutions applying specific platforms. One of these challenges is directly related to powerful providers of commercial platforms as well as other external and cross-institutional platforms. All platforms have politics (Gillespie 2010), i.e., they are infiltrated by logics that are neither neutral nor coincidental. When LAM institutions decide to communicate with their users on, for example, social media platforms such as Facebook, Instagram, YouTube, and TikTok, the institutions and the users of their platforms are encapsulated within these logics. However, even if this is the case, it is important to note that users do have certain agency when communicating on these platforms, either through their own communications or by actively resisting coded instructions (van Dijck and Poell 2013). The question remains: How do LAMs navigate these consequences

of platformization? We will explore this in the discussion on external and cross-institutional platforms.

Platforms

In the following, the challenges that LAMs face in digital communication are understood through the lens of *platformization* and the various issues different types of platforms present. The platforms used by LAMs for digital communication are divided into (1) internal platforms, (2) external platforms, and (3) cross-institutional platforms. Internal platforms are those that are developed in-house or for a specific institution. This includes the institution's own website as well as custom apps and collection sites. External platforms are those that are developed for a larger audience, in which the institution can take part, often on an equal setting with all other participants. This is typically large social media sites, such as Facebook, Twitter, Instagram, TikTok, and more, as well as collaborative sites such as Flickr and Wikipedia. Cross-institutional platforms are those that are developed either for libraries, archives, or museums, or for LAM institutions collectively. An example of this is the nationwide library platform bibliotek.dk in Denmark, where users can find books in any of the country's libraries and pick them up at their own local library. Another example is the larger EU portal europeana.eu, which gathers high-level metadata from LAM institutions across Europe for the user to search and browse.

Internal, external, and cross-institutional platforms may supplement or compete for the same audiences and resources. Within and from the platforms, different types of communication take place, directed at audiences either within the institution or set apart from it, such as: intra-institutional communication, extra-institutional communication, and cross-institutional communication.

Internal platforms

The most common and best-known internal platform present among LAMs today is the institution's website. Practically, every LAM, big and small, has a presence on a website that at the very least gives basic information on opening hours and contact information (Cox 1998; Schweibenz 2019). Apart from this basic information, the institution might use their website to promote events and disseminate information about the institution's subject, content, structure, purpose, and staff. Furthermore, the institution may make all or a part of their collection available in some way to search or browse (Bolick 2006). These digital collections can vary in different ways depending on whether we are talking about libraries, archives, or museums, as well as the institution's size, geographical location, staff, etc. However, comparing the early websites of the national LAMs in Norway, Sweden, and Denmark from the late 1990s[1] to their current websites, we see that while the design has changed greatly in 20 years, the type of content has not.

Libraries typically carry comparatively homogeneous collections based around publications such as books, magazines, and video games. The concept of a published item, with an author, a date, a publisher, etc., that is distributed in many copies among libraries in a network provides a certain structure to the library collection, including in its digital form. This has been the case for many years and is also the format that libraries, relatively early, used to create their internal, but often networked, platforms. These homogeneous and standardized collections allowed for the use of the same or similar underlying digital collection systems. Thus, the development of digital communication of library collections on internal platforms has a longer history of user study and evaluation.

In this, archives differ slightly and museums considerably. Archives carry highly structured collections, which were already in heavy use and distributed in copy form, pre-digital, e.g., census records and birth, marriage, and death (BMD) registrations, which are both very popular sources amongst the ever-growing number of family historians (Evans and de Groot 2020). These collections are relatively homogeneous and contain information about our ancestors, their family connections, and major life events. The digitization and digital communication of these records are often a result of crowdsourcing, which involves the end-user in creating the service (Ridge 2014).

But apart from these collections, archival records are in general very heterogeneous and are usually only registered, if at all, with a high-level provenance and subject description. The individual records themselves vary from place to place and time to time, and thus creating an internal platform to present these collections digitally depends greatly on users, funding, and institutional skill.

Museums, as mentioned above, differ in that their collections are quite heterogeneous and include any type of item that carries a cultural or historical value. This includes everything from everyday pots and pans to esteemed artwork. Often digital museum collections are collections of metadata about items, including their provenance and, with luck, a date. However, the value and presence of other types of metadata vary according to the collection type. For example, for artwork, there is a value in knowing the artist's name and the art technique. For archeological finds, usually the context and exact geographical location are recorded. For textiles, the production methods, material, and color might be of value. But when a museum combines these items into one digital collection, it is usually only possible to communicate the highest level of metadata that they have in common.

When it comes to internal platforms, and digital collections in particular, these are often built as individual projects rather than platform products that can be sold to many users (Pries-Heje 2020). Thus, this type of platform mostly becomes an option only for the largest and wealthiest institutions. Smaller and less wealthy institutions will often not have a digital platform from which to communicate their collection but will in some cases be able to use external platforms for this purpose as we will see below.

In terms of users, there is also a difference between LAMs. Libraries, because of their long history of structured collections and inter-library collection

networks, also have a good knowledge of their online user group, but archives and museums, less so. In the field of library and information studies, user studies, of the libraries themselves and the digital platforms, have a strong foundation (Bawden and Robinson 2012). However, user studies in museums and archives have a much shorter history, and even shorter on their digital platforms.

External platform

When we talk about external platforms today, we often think of social media platforms, such as Facebook, Instagram, Twitter, YouTube, or TikTok. These are a source of digital communication for many LAMs. However, we must not forget other platforms such as Flickr, Ancestry, and Wikipedia, where LAMs can communicate their collections and content to a wider audience.

The main pull for LAM presence on these external platforms is the ideal of engagement and participation that has come to dominate the discourse in recent years (Myrczik 2020), such as the possibility of joining conversations related to culture in general, and heritage, art, and literature more specifically. Nevertheless, this can be quite difficult to achieve, and several studies indicate that interaction is limited, that users seem to focus more on seeking information than participating in any discourse, and that LAMs tend to engage in one-way communication (Aharony 2012; Fletcher and Lee 2012; Gronemann, Kristiansen, and Drotner 2015).

These external platforms are still relatively new spaces for all LAMs to navigate, just as they are for everyone else. Here their digital communication is conditioned to specific interfaces that facilitate steered and controlled forms for user engagement. Users' communications are "liked," "reeled," "filtered," "storied," and contained in specific ways that are controlled by the platforms. The institutions have agency in their communication endeavors, but this agency is still limited by the politics of platforms. Furthermore, as these are commercial entities, the costs of connection on users' behalf evoke concerns regarding free labor (Terranova 2013), digital labor (Fuchs 2014), and platform labor (van Doorn 2017).

The main disadvantage from the perspective of the LAMs is perhaps a lack of insight into where to use their limited resources for digital communication. Which platform should they focus on? How should they adapt their ideas on audience and user groups to social media algorithms and external business models? How can they understand which audiences can be reached and which conversations are possible? On the internal platforms, the institution has *the* authoritative voice, which is entirely appropriate. Visitors to the institution's website or online collection would expect the LAM to control the conversation here. But on external platforms, the conversation is controlled by other mechanisms, and, depending on the platform, the use of an authoritative voice may be less appropriate. These power imbalances can create a certain tension that defies the ideals of democratic engagement and participation on these platforms (Gronemann, Kristiansen, and

Drotner 2015). These are some of the particular concerns we have seen with LAMs attempting to engage with, and add knowledge and collections to, Wikipedia.

Wikipedia has its own form of authority and collaboration, one where LAM institutions' inherent authority exists only to a very limited degree. LAM staff may experience much frustration when they try to update a page on their subject knowledge only to find that someone has rolled it back the next day.

There have been different attempts to merge the knowledge of experienced Wikipedians with that of LAM institutions through the Wikipedian in-residence program (Roued-Cunliffe 2017). As a part of this program, an experienced Wikipedia editor either volunteers or is paid to work with an institution to add the institution's knowledge or content to Wikipedia in a way that lives up to the Wikipedia guidelines and approach. It is important to remember that it is not the institution themselves, but rather their knowledge and collections being communicated.

At the National Gallery of Denmark, they are also working to add their content to Wikipedia and the associated platforms Wikimedia and Wikidata. Because this is an art museum, their collection is relatively more homogeneous than many other museums. It is also heavily image based, which is an advantage on Wikipedia. Adding a collection of images of artwork to Wikipedia is good exposure for the museum (Pekel 2014). The main requirement from the Wikimedia Foundation is, as with textual information, that the museum can, and is willing to, publish these images using open licenses. This means that the images must be in the public domain or using an open license like those from Creative Commons.

While evaluating their experience as Wikipedians, staff from Bergen City Archive in Norway discovered that communicating on Wikipedia did require some negotiation about relevance (especially of local material), rights, sources, and trustworthiness. However, it was clear to them that the exercise was worth it in terms of both the readership of the articles they contributed to Wikipedia and the links back to the information on the archive's site (Kragseth 2016).

Cross-institutional platforms

Cross-institutional LAM platforms come in different shapes and sizes. A long-running example is the library platforms that combine information from different library collections and allow the user to enact inter-library loans on their own. In Denmark, the website bibliotek.dk has been doing this since 2000. On this platform, the user can search for any library materials in any public library in Denmark and order it to be sent to their local library through which they make the loan agreement. It means that wherever you are in Denmark, in the middle of a city or in a remote area, you have access to the same literature, whether it is commonly available at every library or only typically found in a university library.

While libraries have a long tradition of sharing their copies of literate materials with users and each other, this is not the case for archives and museums.

Archive and museum items typically do not leave the institution as they are often not produced in multiple copies like books. Rather, they are unique items, except for census and BMD records, which have been copied and shared before digitization and online publication.

The fact that books, media, and some archival records have a long history of copying also shows an existing use pattern that we are still struggling to see for many unique museum items. While libraries might lament the heavy competition with other similar content providers online, the original content that museums can provide online is in comparison near invisible and has few regular users.

This should not be taken to mean that there is no potential for use or that there are no existing users out there. Rather, there is potential for more focus on who can use these materials and what can they be used for, including when they are communicated on a digital platform.

Europeana.eu is an example of a cross-institutional platform where the idea of convergence and connection came before the use and user needs. In 2005, six European heads of state asked the EU to support the development of a European digital library. Today the Europeana platform gives access to over 50 million digital items. Many of these are digital images with various licenses and copyright statuses. About half of the items can be used freely as they have either been published with a fully open CC license or are indicated to be in the public domain. Of these, about 15 million are images. These images can potentially be used in teaching, artwork, journalism, or any other external type of physical and digital communication. Sweden is providing two million of them, Norway nearly half a million, and Denmark nearly 40,000. Most of the Swedish items come from the aggregator Swedish Open Cultural Heritage, which has been providing open access to metadata from the database of archives and museums across Sweden since 2008. Today the aggregator allows users to search in Swedish through the Kringla.nu platform, as well as using the Europeana platform to search in other European languages. However, the real value of this cross-institutional national LAM platform is its long focus on providing open data enabling any third party to build on the data set and making Sweden the second-largest provider of openly usable images in Europeana (after the United Kingdom). Norway, on the other hand, is the largest provider of metadata about openly available text material to Europeana through the National Archives of Norway.

However, despite these large numbers of items that are openly available through large aggregators and huge platforms, there is still an issue of users and use. Unlike literature in the libraries and BMD records in the archives, art and heritage items are disconnected from their natural or potential users. Research in LAM participation (see Chapter 12, this volume) tells us that there are consumers and prosumers out there for cultural and historical material. However, they are not connecting with the platforms currently used to communicate these collections, at least not in the ways the LAM community had hoped and expected.

Discussion

When discussing the challenges of platformization for LAMs, the authors came to think of several idioms that made sense in each of their ways. "If we build it, they will come"; "Jump on the bandwagon"; "Beggars can't be choosers," These were the three that stuck in our mind.

"If we build it, they will come" is a misquote from the 1989 film *Field of Dreams* often used in the field of digital humanities, sometimes to question whether *they* or the users would come and join in when we built tools and platforms in the humanities (Warwick et al. 2008). Digital Humanities and the other digital fields in play in the LAM sector are very small areas. Most of the public do not even know these fields exist. The public knows even less about the digital communication platforms and tools built in this field.

This speaks to one of the biggest challenges faced by internal platforms, namely their visibility and use for anything but one-way communication. Looking at the notions of participation and engagement, we come across issues of gatekeeping and authority. Internal platforms provide the structure for upholding an authoritarian voice. It allows LAMs to formulate the exact terms of engagement for any users of the platform. In a move from a read-only culture to a read/write culture, most internal platforms represent the former. However, this doesn't quite fit with the current LAM ideals of engagement and user participation. This can be appropriate for many types of internal platforms. Users perhaps do not come to the online library catalog looking for conversation about literature. But when we develop an internal platform that requires user input and two-way communication, this will not be sustainable if the users stay away (Westberg Gabriel and Jensen 2017).

We know that many external platforms have a huge existing user base. This, in turn, encourages LAMs to "jump on the bandwagon" and try to get some of this user base communicating with them, or at least listening to them. Some would argue that certain platforms require a watering down of knowledge, especially if it is a platform they do not have any experience with. We might ask: What purpose does a TikTok video have? Another argument might be that presence on a platform does not equate to valuable communication or connection. Does it matter that the museum is on Instagram pushing their events and collections in posts that gain no meaningful engagement with Instagram's other users? Just as physical communication during a guided tour requires a feel for the audience, so do the various platforms. Engaged communication on Facebook cannot be the same as on TikTok or the institution's web page. They reach different audiences and the platforms have been built and are continually being developed for different ways of communicating. This is the idea of platformization – that the platforms themselves end up controlling the communication rather than the strategies and aims of the LAMs. The last idiom, "beggars can't be choosers," speaks to this. On the institutional web page, LAMs can influence how the platform functions. But even here, there are templates, and every deviation from these comes at a cost. Very few LAM institutions have the funds to build their own digital collection site, and among

those who do, even fewer can promote and attract users to these. When it comes to the external platforms, all LAMs are *beggars* who must negotiate the formats and algorithms along with all other users. This will inevitably influence the modes of communication that are found in LAMs in the future.

The COVID-19 lockdowns that were implemented in various ways across Scandinavia in 2020–2021 are thought to have created a situation forcing LAMs to develop new means of communicating online. However, studies of both Norwegian libraries (Evjen et al. 2021) and Danish museums (Dam Christensen, Myrczik, and Roued-Cunliffe 2020) found that rather than transforming digital communication, there seems to have been an escalation of previous practice.

Instead of focusing on novel opportunities and technology, we suggest that LAMs shift their focus from the platforms and back to the communities that they wish to serve. Despite the issues of platformization, participatory culture is still going strong and developing. Perhaps this is the bandwagon LAMs should jump on? Maybe by finding their communities online and observing these forms of communication, this could give individual LAMs the answers they are seeking on how to develop their digital communication regardless of increasing platformization.

Conclusion

To communicate digitally – with users, with each other, and across institutions – libraries, archives, and museums are dependent on platforms. Platforms for digital communication can be developed internally by LAMs, but increasingly, and especially in the case of smaller institutions, they are reliant on external and cross-institutional platforms. The benefits of digital platforms are multiple, as they allow for extensive, multidirectional, global communication, potentially bringing in new audiences and casting a fresh light on the collections and activities of LAMs. However, the platformization of digital communication also has pitfalls and challenges: Traditional ideas of LAM communication are hard to put into practice on platforms where ideas of authority and engagement are constantly changing. As new digital communication tools and services keep cropping up, LAM professionals find it difficult to know where to turn their attention and direct their resources. Importantly, the purpose and development of external platforms does not consider the needs of the many cultural institutions seeking to communicate via them. Rather, the opportunities they provide are developed for a different purpose of user growth. Therefore, we suggest that LAMs turn their focus away from the platforms themselves. Instead, we would invite them to reflect on the communities and conversations they could take part in. Through these reflections, it may become clearer which platforms are worth spending their limited resources on and how.

Note

1 Using the Internet Archives Wayback Machine (web.archive.org).

References

Aharony, Noa. 2012. "Facebook Use in Libraries: An Exploratory Analysis." *Aslib Proceedings* 64, no. 4: 358–372. https://doi.org/10.1108/00012531211244725.

Balling, Gitte. 2021. *Kulturformidling: teoretiske begreber, historiske perspektiver og kultur-politiske rammer.* Copenhagen: Samfundslitteratur.

Bawden, David, and Lyn Robinson. 2012. *An Introduction to Information Science.* London: Facet Publishing.

Benkler, Yochai. 2007. *The Wealth of Networks: How Social Production Transforms Markets and Freedom.* New Haven, CT: Yale University Press.

Bolick, Cheryl Mason. 2006. "Digital Archives: Democratizing the Doing of History." *The International Journal of Social Education* 21, no. 1: 122.

Bruns, Axel. 2008. *Blogs, Wikipedia, Second Life, and Beyond: From Production to Produsage.* New York: Peter Lang.

Castells, Manuel. 2009. *Communication Power.* Oxford: Oxford University Press.

Cox, Richard J. 1998. "Access in the Digital Information Age and the Archival Mission: The United States." *Journal of the Society of Archivists* 19, no. 1: 25–40. https://doi.org/10.1080/00379819809514420.

Dam Christensen, Hans, Eva Pina Myrczik, and Henriette Roued-Cunliffe. 2020. "Museerne Online – Innovativt Eller Mere Af Det Samme?" *Danske Museer* 4: 22–23.

Drotner, Kirsten, and Kim Christian Schrøder. 2013. "Introduction." In *Museum Communication and Social Media, the Connected Museum*, edited by Kirsten Drotner and Kim Christian Schrøder, 1–14. New York: Routledge.

Evans, Tanya, and Jerome de Groot. 2020. "Introduction: Emerging Directions for Family History Studies." *International Public History* 2, no. 2: 1–3. https://doi.org/10.1515/iph-2019-0014.

Evjen, Sunniva, Terje Colbjørnsen, Idunn Bøyum, Kim Tallerås, and Heidi Kristin Olsen. 2021. "Samfunnsoppdrag under press: Erfaringer og vurderinger i norske bib-liotek under covid-19." *Nordic Journal of Library and Information Studies* 2, no. 1: 17–37. https://doi.org/10.7146/njlis.v2i1.125251.

Fletcher, Adrienne, and Moon J. Lee. 2012. "Current Social Media Uses and Evaluations in American Museums." *Museum Management and Curatorship* 27, no. 5: 505–521. https://doi.org/10.1080/09647775.2012.738136.

Fuchs, Christian. 2014. *Social Media: A Critical Introduction.* London: Sage.

Gauntlett, David. 2011. *Making Is Connecting: The Social Meaning of Creativity, from DIY and Knitting to YouTube and Web 2.0.* Cambridge: Polity Press.

Gillespie, Tarleton. 2010. "The Politics of 'Platforms'." *New Media & Society* 12, no. 3: 347–364. https://doi.org/10.1177/1461444809342738.

Gronemann, Sigurd Trolle, Erik Kristiansen, and Kirsten Drotner. 2015. "Mediated Co-Construction of Museums and Audiences on Facebook." *Museum Management and Curatorship* 30, no. 3: 174–190. https://doi.org/10.1080/09647775.2015.1042510.

Hardy, Cynthia. 2011. "How Institutions Communicate; Or How Does Communicating Institutionalize?" *Management Communication Quarterly* 25, no. 1: 191–199. https://doi.org/10.1177/0893318910389295.

Jenkins, Henry. 2006. *Convergence Culture: Where Old and New Media Collide*. New York: New York University Press.

Jenkins, Henry. 2014. "Rethinking 'Rethinking Convergence/Culture'." *Cultural Studies* 28, no. 2: 267–297. https://doi.org/10.1080/09502386.2013.801579.

Kragseth, Kjerstin. 2016. "Arkivar og Wikipedianer." In *#arkivdag: relevans, medvirkning, dialog*, edited by Marit Hosar, Ellen Røsjø, and Bente Jensen, 187–195. Oslo: ABM-media.

Lammers, John C. 2011. "How Institutions Communicate: Institutional Messages, Institutional Logics, and Organizational Communication." *Management Communication Quarterly* 25, no. 1: 154–182. https://doi.org/10.1177%2F0893318910389280.

Lessig, Lawrence. 2009. *Remix: Making Art and Commerce Thrive in the Hybrid Economy*. New York: Penguin Books.

McCarthy, Douglas, and Andrea Wallace. 2021. "Survey of GLAM Open Access Policy and Practice."

McQuail, Denis. 2010. *McQuail's Mass Communication Theory*. London: Sage.

Manovich, Lev. 2001. *The Language of New Media*. Cambridge: MIT Press.

Myrczik, Eva Pina. 2020. "Cultivating Digital Mediation: The Implementation of Publicly Funded Digital Museum Initiatives in Denmark." *International Journal of Cultural Policy* 26, no. 2: 239–254. https://doi.org/10.1080/10286632.2018.1495714.

Pekel, Joris. 2014. *Democratising the Rijksmuseum*. Den Haag: Europeana Foundation.

Poell, Thomas, David Nieborg, and José van Dijck. 2019. "Platformisation." *Internet Policy Review* 8, no. 4. https://doi.org/10.14763/2019.4.1425.

Pries-Heje, January 2020. *Agile projekter*. Frederiksberg: Samfundslitteratur.

Ridge, Mia. 2014. "Crowdsourcing Our Cultural Heritage: Introduction." In *Crowdsourcing Our Cultural Heritage*, edited by Mia Ridge, 1–13. Farnham, Surrey: Ashgate.

Roued-Cunliffe, Henriette. 2017. "Forgotten History on Wikipedia." In *Participatory Heritage*, edited by Henriette Roued-Cunliffe and Andrea J. Copeland, 67–76. London: Facet Publishing.

Roued-Cunliffe, Henriette. 2020. *Open Heritage Data: An Introduction to Research, Publishing and Programming with Open Data in the Heritage Sector*. London: Facet Publishing.

Schweibenz, Werner. 2019. "The Virtual Museum: An Overview of Its Origins, Concepts, and Terminology." *The Museum Review* 4, no. 1.

Shirky, Clay. 2008. *Here Comes Everybody, the Power of Organizing without Organizations*. London: Allen Lane.

Suddaby, Roy. 2011. "How Communication Institutionalizes: A Response to Lammers." *Management Communication Quarterly* 25, no. 1: 183–190. https://doi.org/10.1177%2F0893318910389265.

Terranova, Tiziana. 2013. "Free Labor." In *Digital Labor: The Internet as Playground and Factory*, edited by Trebor Scholz, 44–75. New York: Routledge.

Toffler, Alvin. 1980. *The Third Wave*. Toronto: Bantam.

van Dijck, José. 2013. *The Culture of Connectivity: A Critical History of Social Media*. Oxford: Oxford University Press.

van Dijck, José, and Thomas Poell. 2013. "Understanding Social Media Logic." *Media and Communication* 1, no. 1: 2–14. https://doi.org/10.17645/mac.v1i1.70.

van Doorn, Niels. 2017. "Platform Labor: On the Gendered and Racialized Exploitation of Low-Income Service Work in the 'On-Demand' Economy." *Information, Communication & Society* 20, no. 6: 898–914. https://doi.org/10.1080/1369118X.2017.1294194.

Warwick, C., M. Terras, P. Huntington, and N. Pappa. 2008. "If You Build It Will They Come? The LAIRAH Study: Quantifying the Use of Online Resources in the Arts and Humanities through Statistical Analysis of User Log Data." *Literary and Linguistic Computing* 23, no. 1: 85–102. https://doi.org/10.1080/10696679.2002.11501912.

Westberg Gabriel, Lýsa, and Thessa Jensen. 2017. "Who Is the Expert in Participatory Culture?" In *Participatory Heritage*, edited by Henriette Roued-Cunliffe and Andrea J. Copeland, 87–96. London: Facet Publishing.

11

LEARNING, LITERACY, AND EDUCATION IN LAMS

Johanna Rivano Eckerdal, Henriette Roued-Cunliffe, and Isto Huvila

Introduction

Even though the idea of libraries, archives, and museums (LAMs) as knowledge institutions has been problematized, LAMs are increasingly understood as vital sites for learning in society. Their societal role includes supporting democracy, but how that is done in practice is seldom specified. The Scandinavian countries differ to the extent that steering documents inscribe explicit societal missions for LAMs. In Norway and Sweden, their democratic role is stated in the Library Acts, whereas the Danish Library Act does not bestow on libraries a social mission but is characterized instead by an entrepreneurial rationale (Engström 2019). In Sweden, a social mission is also included in the Museum Act (Rydbeck and Johnston 2020). In this chapter, we will discuss the development of accentuating LAMs as sites for learning as a process in tandem with an intensified emphasis on learning – in particular lifelong learning – in society (Fejes 2006).

First, a model of three forms of lifelong learning is introduced, followed by a brief excursion into pedagogical theory and its relevance for LAM professionals. Next, we present literacy – traditionally related to libraries and in particular those within the educational sector – as a fruitful concept for LAMs as it offers potential to connect local everyday practices at LAMs with the anticipated social impacts of the institutions. After that, we describe activities at Scandinavian LAMs, with learning as the implicit or explicit goal, using both traditional and novel examples. Finally, we discuss different underpinnings to how learning is understood in society and conclude by underscoring the importance for LAMs that they remain sites for different kinds of lifelong learning in order to develop and strengthen their role in supporting democracy.

DOI: 10.4324/9781003188834-14

Three forms of lifelong learning

The shift from industrial to postindustrial society allowed people in the Scandinavian countries to engage in learning throughout their life span to an unprecedented extent. In an analysis of Swedish educational policy texts, Andreas Fejes (2006, 2017) identifies three forms of lifelong learning. *Formal learning*, occurring in dedicated educational institutions with planned learning under specific regulations, results in credits that document learning taking place. Secondly, *nonformal learning* is based on planned situations for learning but without formal teachers and with alternative types of documentation. For example, the Scandinavian tradition of adult education at study associations can be described as situations of nonformal learning. Finally, *informal learning* refers to unplanned learning taking place in situations that do not have learning as a goal (Fejes 2017, 297).

The forms of lifelong learning are not mutually exclusive – several may take place simultaneously in specific situations – neither are they easy to discern one from another. Here, we understand the three forms in the following way: Formal learning takes place within the formal educational sector either in its own or external premises and is part of regulated education that results in credits; nonformal learning comprises specific situations outside the formal educational sector that both organizers and participants construe as situations where something is learned; informal learning is unplanned learning taking place without the participants' intention to learn at all.

Understanding learning activities with the use of pedagogical theory

Three influential paradigms in the history of pedagogy have been behaviorism, constructivism, and a sociocultural perspective on learning (Säljö 2000). Even though they emerged in a chronological order, they have not replaced each other. On the contrary, they may be present simultaneously in research, pedagogical practice, and everyday speech. However, in contemporary pedagogical research, learning is predominantly understood as a social activity as proposed in the influential sociocultural perspective on learning (Insulander 2005). From this perspective, learning is perceived as activities happening within, and impossible to understand stripped from, their historical, social, and cultural context (Wertsch 1998). Learning is also considered an intrinsic part of all human activities. People will always learn from the activities they engage in (Säljö 2000), but it is difficult to pinpoint what learning is actually taking place and hence to shape learning activities targeting specific goals.

"Mediation" is a frequently used term to describe the ways in which LAMs make their collections and activities available to users. Today, attention is paid to how these activities create opportunities for learning as the focus has shifted to their pedagogical rather than merely mediating role. The increasing emphasis on pedagogy (Insulander 2005) has shaped the activities at LAMs to varying degrees.

The use of pedagogical theory and vocabulary by LAMs to describe and present their work is recent, and it is mostly museums that do it, including having museum pedagogues in their staff. Archival pedagogics does exist too (SOU 2002:78, 166), and sometimes the overarching term "cultural heritage pedagogics" is used (Riksarkivet 2019). In the realm of libraries, the term "library didactics" has been used (Laskie 2017) and library pedagogues can be found at some libraries. However, the usual approach is to understand librarianship as a profession that includes a pedagogical role.

In the LAM context, museum pedagogics is perhaps the most established academic branch of pedagogy. This is to a large extent due to the work of Eilean Hooper-Greenhill, who argues that the idea of learning as transmission (see Sfard 1998) is outdated and widely criticized, having originated from a modernist, individual-centered perception of the museum that views information as constant, immutable objects (2000, 130–135). Hooper-Greenhill proposes a "post-museum" that invites visitors to engage and participate (learning as participation; see Sfard 1998) by providing experiences that invite meaning making. She presents the post-museum as a process and an experience, not a building (Hooper-Greenhill 2000, 152). Research related to outreach activities at museums has introduced pedagogical theory to analyze and problematize activities at museums. These insights are also relevant for understanding activities at archives and libraries as situations of learning.

Democracy, literacies, and LAMs

For LAMs as educational institutions, one of the key concepts associated with their educational activities and goals is literacy. Education and learning are traditionally heavily linked to texts. The etymology of the word *literacy* exemplifies this link, as it refers to the letters that form a written text. However, how we meet texts today has changed, as people increasingly engage with them in digital form. Text is therefore understood in a broader way, including varying types of media that convey content (Säljö 2009). The concept of information literacy or, more recently, that of media and information literacy grasps this development and the new competences it demands. It is a helpful concept for describing how LAMs, as places for learning that include developing free opinions, constitute an important piece of the societal infrastructure of institutions where democracy can unfold (Rivano Eckerdal 2017).

The contemporary digital media landscape has influenced the development of many forms in which literacy is enacted. Several stakeholders state that information literacy nowadays is a vital ability needed to navigate through our society, libraries playing an important part in supporting it (ALA 1989; Wilson et al. 2011). Archives and museums increasingly hold digitized collections or digitally born collections, accessible via digital platforms (Roued-Cunliffe 2020). Therefore, not only libraries but also archives and museums make their collections

available to users both on-site and online, emphasizing the need to educate users in how to access and use the resources. Museums and archives have started to develop initiatives to foster, for instance, museum literacy (Stapp 1992), visual literacy (Lehman, Philips, and Williams 2020) and archival (Vilar and Šauperl 2014) or records (Oliver 2017) literacy with staff and the public. Without going into details about definitions of, and boundaries between, these types of literacy it suffices to conclude that literacy concepts and literacies in the plural – which is an inclusive approach to this discussion – are highly relevant to all three institutions.

Of the LAM-related literacies, information literacy has transpired as the most well-established research field, not least due to the presence of libraries in many, but not all, schools and learning institutions. Consequently, the contributions of libraries and librarians to learning are often discussed in terms of information literacy (e.g., Bruce 1997; Buschman 2019; Elmborg 2006; Hicks 2019; Limberg, Sundin, and Talja 2012; Lloyd 2006; Rivano Eckerdal 2012).

Information literacy was first introduced in the business development context and has been criticized for neoliberal aspirations of promoting economic growth. However, today a growing body of literature frames information literacy as a critical concept crucial for democratic development (Elmborg 2016). However, such critical information literacy is not practiced to a large extent, due to contested (Elmborg 2006) and vague references to what democracy entails (Rivano Eckerdal 2017). In parallel, a growing body of research problematizes the instrumental conceptualization of information literacy as a skill set and related practices. The newer research underlines information literacy as an ability shaped by the sociocultural context, involving not only reading but also understanding of content – including the conditions affecting its production and distribution – and acting on it.

Forceful rhetoric is often used when stakeholders discuss information literacy. The so-called "Alexandria Proclamation" gives a lucid example:

> Information Literacy lies at the core of lifelong learning. It empowers people in all walks of life to seek, evaluate, use and create information effectively to achieve their personal, social, occupational and educational goals. It is a basic human right in a digital world and promotes social inclusion of all nations.
>
> *(IFLA 2005)*

Both the work on information literacy and other LAM-related literacies exemplifies how LAMs contribute broadly to strengthening different kinds of literacy in society. Since the concept enables a connection to be made between everyday work at LAMs and their contribution to democracy, we find it important to raise LAM professionals' awareness of the concept. By being able to express how their work connects to different kinds of literacy, the democratic role of LAMs becomes more discernible.

Learning at LAMs

A central underpinning of the educational role of LAMs is the Scandinavian take on the welfare state constructed to offer a robust public, subsidized, social infrastructure to endorse and encourage social mobility. LAMs are important pieces of that infrastructure (Klinenberg 2018; Olsson Dahlquist 2019). By guaranteeing citizens access to well-curated collections, individuals are thought to benefit and learn from the stockpiles of this collective.

Traditionally, staff expertise has been a guarantee for the building and developing of collections to ensure that important material is preserved and curated for the future. The key expertise in this respect includes organizing collections and facilitating the retrieval of material. The different collection management and development techniques have in parallel established professional experts as key mediators between the material and the end-users (Trant 2009).

In addition to collection development, introducing people to the intended use of the institutions and their collections is part of what LAM professionals do. These activities include an aspect of learning, albeit not always explicit. Strategies for teaching users about accessing collections are therefore central to the institutions, even though not always framed as teaching. In archives and libraries, staff members typically instruct users about the access to resources: Search for a book in a library, or a record in an archive. Such instruction is offered, verbally or in writing, at the physical institution or on their website. In museums, on the other hand, activities usually explain the content of the collections. Exhibitions include texts that describe and contextualize what is displayed. Sometimes catalogues are produced to complement an exhibition. Guided tours, with some of the items presented by guides to groups – scheduled tours open for everyone present as well as tours booked in advance for dedicated groups – are common,[1] often complemented by audio guides, i.e., prerecorded tours of the collection (compare Hooper-Greenhill 2004).

Thus, traditionally mediating activities at libraries and archives are different from those at museums, influencing whether and how the activities are construed as instances of learning. Mediating activities concerning the content of the resources at museums can be easier to conceive as learning than the more indirect mediating activities at libraries and archives. While learning happening when users read books or records retrieved in collections is important for, and from a societal perspective in relation to, LAMs, the understanding of knowledge about accessing the institution and its collections is also in itself a key learning point: It adds the literacy aspect to the learning.

From the perspective of Fejes' three forms of lifelong learning, the predominant forms of learning in all three institutions have been informal and nonformal. Much of the use of public LAMs consists of people becoming informed by being there and taking part of their resources in their spare time. Something they all have in common however, is the fact that their mediating activities are increasingly integrated with formal learning. Libraries within the educational sector

have always had a relation with formal learning institutions, but there are in-
dications that the connection is becoming emphasized. One example is found
in the Swedish inquiry on school libraries (SOU 2021:3) that emphasizes the
importance of staffed school libraries for students' learning outcomes.

Examples of educational activities at LAMs

A usual activity in the first years at school is to visit a public library and to
become acquainted with its collections, activities, and staff.[2] Guided tours are
often included as well as an invitation to receive a library card. In this way,
all pupils receive information about what public libraries can offer: In a formal
learning setting, they learn about how the institution can be used for nonformal
or informal learning.

Bookstart is a method for encouraging literacy from a very early age, bearing
in mind the importance of stimulating reading in children's home environment.
It was first developed by the reading charity *BookTrust* in England, now well-
established and researched in many countries (Kulturrådet 2015, 32–34). In
Denmark, *Bogstart* was run as a project between 2009 and 2016, whereas
Bokstart in Norway and Sweden is ongoing.[3] *Bookstart* is developed to support
early literacy in families, in situations of informal learning. In collaboration
between public libraries and child health centers, book gifts are provided to
toddlers. The gifts are assumed to establish a contact between caretakers and
libraries, ensuring that the families have access to the library's resources.

Archives tend to be less known to the public even if steps have been taken
to make them better known. In Sweden, initiatives have been made to develop
material and activities for schools. Methods include thematic *Archival bags* (Arkiv-
väskor), bags filled with copies of archival records and other material to be used
in workshops in schools, but also in geriatric care, meaning that the bags can be
used both within formal and informal learning.[4] Since 1998, the second Saturday
in November has been Archives Day at Swedish archives on national, regional,
and local levels. Nowadays, it is a yearly event in all Nordic countries. During
Archives' Day people are invited to familiarize themselves with archives and the
informal learning that unfolds is described as important for democracy.[5]

Among the groups that use archives a lot, family historians are one of the most
prominent. They use and share intensively the growing digital collections avail-
able at public LAMs, private organizations, and companies (Evans and de Groot
2019). This kind of autodidactic learning related to family history can also take
place in public libraries, which usually include a section on local history. Depend-
ing on whether the focus is on learning family history as such, or on one specific
task, the autodidact can be characterized as a nonformal or informal learner.

In contrast to archives, museums have been developing specific programs to
attract schools for a long time. Visits to museums have to some extent been seen
by school classes as synonymous with a nice day out of school while the content of
the visit has perhaps been less important. Much effort has been made to develop

relevant and complementary content that matches what is taught in the classroom, that is, to establish the learning as formal. The *Danish Knowledge Centre for External Learning Environments* (Skoletjenesten) has been highly influential in providing elaborate school programs at museums. It is a national knowledge center that works to encourage and support formal learning with different guides and programs that schools can use for learning outside its premises.[6] A Swedish example is the *Working Life Museums Co-operation Council* (Arbetsam), which offers extensive information to schools about how to use working-life museums in their teaching. The material includes templates that anchor activities at museums to specific goals in the steering documents.[7]

Programs including both exhibitions and workshops where visitors continue to explore the themes and topics of the tour by drawing, painting, or playing are offered at many museums. One example is *the Children's wing* (Børnehuset) at the Louisiana Museum in Denmark, which offers such creative workshops targeted at children.[8] Children and their caretakers visiting the Children's wing in their spare time would be an example of an instance of informal learning. But the Children's wing also offers programs for school groups, which means that the same type of activity – perhaps with the same child – can also be framed as formal learning.

Novel ways of supporting learning at LAMs

The strong societal emphasis on learning apparent throughout Scandinavia together with the other societal changes described throughout this anthology affect the educational practices at LAMs. The ways in which LAMs respond to these changes do sometimes lead to developments that are at odds with their traditions. We will now present in more detail three examples that are illustrative of how they are breaking new ground in various ways in how they engage in lifelong learning.

To engage users' participation: Kolding Stadsarkiv

The city archives in Kolding, Denmark are unusual in their vision and strategy for participation and learning. The theme for their 2019–2022 strategy is summed up in the hashtag *#alleharenpladsihistorien* (the hashtag translates to #everyone-hasaplaceinhistory). This statement forms the basis of their current and future activities, from learning programs for schoolchildren to their interaction with what they call *competent users*. Many of these users have a family history interest, but some also have other more professional or theme-based interests, for example, bus or garden enthusiasts, and some have a more general, less defined historical interest. The city archives collaborate with the libraries and museums in Kolding in curating a space in the middle of the main library, a so-called "historic workshop," where all citizens can come by and engage with their town's history. It was understood that the library is more open and a more welcoming space for citizens than the traditionally hidden archives, where it is more challenging to

welcome users who do not have a specific purpose for their visit.[9] City archivist Lene Wul calls this space a hybrid-gathering place for the future, which, while being a great vision, also testifies to an experimental and agile approach, where informal learning is something that happens in the synergy between the institutions and citizens.[10]

This experimental approach is also present in the way Kolding City Archive has carved a space for archives to provide formal learning programs in local schools. Together with other city archives in Copenhagen and Esbjerg they have recently received funding to continue, but also to develop and expand, the project *The archive in the open school – meeting history* (Arkivet i den åbne skole – mødet med historien). The pilot project aims to anchor the use of historical sources in the classrooms by developing teachers' competences. The archive has an extensive catalogue of learning programs developed for children and young people. In their popular *Democracy is mine* (Demokratiet er mit) program, pupils in year 8 or 9 receive an insight into the inner workings of local government, both historically through the use of preserved sources (e.g., the minutes from the technical committee in 1989) and through arguing for their own suggestions in front of current local government politicians at the town hall.[11]

Advancing (information) literacies in collaboration: The Norwegian School Library program

Some of the pedagogical efforts at LAMs aim directly to develop specific competences and literacies. As already mentioned, the literacy concept has been explicitly seized by libraries. One of the explicit tasks of public and academic libraries in all Scandinavian countries is the advancement of (media and) information literacy (Hall 2010).

Although information literacy-oriented policy goals are broad, covering the public as a whole, much work on information literacy is related to formal learning, focused on educating students in higher education, and to a considerable extent on improving librarians' informational and digital competences. The Norwegian School Library program (2009–2013) explicitly aimed to advance information literacy in and through school libraries and public library collaborations. The program is characterizable as formal learning but is innovative in several ways: By combining reading promotion – connected to literacy in general – and information literacy; by targeting pupils in primary and lower secondary schools; and by appointing school and public libraries a joint mission to work with (information) literacy in this broad manner. Although the program was criticized for not achieving its ambitious national goals (Carlsten and Sjaastad 2014), the 210 development projects in 173 schools and 105 municipalities across the country reported positive outcomes (Carlsten and Sjaastad 2014; Ingvaldsen 2014). The program consisted of a large number of specific projects related to reading promotion and information literacy by, for example, developing means to increase the enjoyment of reading by using picture books, and by integrating

local libraries as resources in school work, explicitly to develop pupils' information literacy and learning strategies (Ingvaldsen 2012). A key challenge, as with many similar initiatives, was that at the start of the project, teachers saw just a limited pedagogical potential in working with libraries (Ingvaldsen 2017). Moreover, librarians often felt that they had inadequate pedagogical competence (e.g., Khatun, Virkus, and Rahman 2015). Therefore, a focal point in the program was to engage librarians, teachers, and school management in collaborative work (Ingvaldsen 2017).

To be and stay relevant in the local community: Sörmlands Museum

In 2018, the new regional museum for the county of Sörmland in Sweden was inaugurated. The vision of the museum is presented on its web page as "to broaden views and arouse commitment." It offers activities that "will contribute to people influencing society and their life situation."[12] An important element of the museum is the *Storytelling storehouse* (Berättande magasin). In contrast to how museums are traditionally conceived, a storehouse is at the center of the building. Visitors may enter, dressed in white protective robes, at specific times accompanied by museum staff. At other times, visitors look into the storehouse through its glass walls. The location of the storehouse invites users to actively engage with the artifacts, described as "belonging to everyone." The museum is acting to lower the threshold for users to engage with it and its collections. The *Storytelling storehouse* is open for both regular visitors and school classes. By inviting people to engage with the material held by the museum, the museum is not framing itself as the guardian of the collection. Instead, the museum is presenting itself as a guardian of the county in which everyone is included. One example is the permanent outdoor exhibition *The history in Sörmland* (Historien i Sörmland) dispersed over 13 locations across the county.[13] The museum in its design and activities has therefore established itself as an active agent and empowers social change in the local community by inviting old and new users to actively participate in the activities of formal, informal, and nonformal learning to discover and explore stories about Sörmland, past and present.[14]

The increasing emphasis on LAMs as spaces for lifelong learning

The importance of successful lifelong learning exemplified by the previous three examples is emphasized in many international LAM initiatives (ACRL 2000; ALA 1989; IFLA 2005; Wilson et al. 2011). These initiatives emphasize the importance of citizens' attitudes that motivate them to develop skills and knowledge as the demands for expertise evolve and change.

James Elmborg builds a powerful argument about the development of education in the USA during the twentieth century. Drawing on a discussion between two prominent voices within education, John Dewey and David Snedden, two rationales for education and lifelong learning are identified: "The stakes involved

boiled down to two arguments for progress and what to do with the increasingly urban citizens: Educate them to be free and autonomous thinkers, or educate them to be skilled employees" (Elmborg 2016, 544). A similar development can be identified in Scandinavia, where the idea of learning as a means to develop oneself and for personal empowerment is inherent to the concept of popular education (folkbildning) (Fejes 2017; Olsson Dahlquist 2019).

An understanding of lifelong learning as empowering stands in stark contrast to the contemporary paralleling of learning and employability and economic growth. This tension implies consequences for universities, including libraries and the education of future librarians, which can be said to be shaped by an entrepreneurial spirit (Hansson 2019).

This shift of focus signals a parallel shift from anchoring lifelong learning in informal versus formal educational sectors, which operate with different rationales (Fejes 2017). The three forms of lifelong learning – formal, nonformal, and informal – are useful for understanding activities at LAMs that include learning, and how they are related to dissimilar rationales and as a consequence differ in the role that the institutions are given in society. While LAMs traditionally have been places for informal or nonformal learning – and in Scandinavia they continue to have that role – they are also increasingly integrated into formal learning.

While two rationales may therefore be said to cross or at least be juxtaposed within LAMs, the increasing contextualization of LAMs within formal learning, as we have seen in the previous examples, does not necessarily mean that they exclusively become part of the economic rationale. The integration of activities or services from LAMs within the formal educational sector can instead be considered to be advantageous in helping them to open up to new and explorative ways of learning. Hereby they may become places for supporting their users' empowerment by offering them new opportunities to, for example, develop their literacies without losing their role as sites of informal and nonformal learning.

Conclusion

Activities involving learning and teaching are an important part of what is done at LAMs and how their missions are outlined. Not only the institutions that formally belong to the educational sector, but every LAM may fruitfully be understood as part of society's infrastructure for knowledge and learning. Given the magnitude that learning has in the contemporary societal discourse, perspectives of learning and literacies bleed into the LAMs from the formal educational sector and tint them: The learning imperative impacts society as a whole.

The critical importance of learning has been further accentuated by recent developments, including the rise of populist right-wing parties and criticism of the democratic institutions that have contributed to a decline of democracy globally (Boese et al. 2022). Democracies formerly described as stable have taken steps in reducing the political rights and civil liberties of their people, with some

leaders using the COVID-19 pandemic as an excuse to consolidate their power (Boese et al. 2022). The neologism "fake news," coined as a criticism of the free press, is but one example of how fundamental democratic institutions are currently under attack. These developments have also affected Scandinavian countries even if they are still rated, for good reason, as well-functioning liberal democracies with free elections, a free press, and an independent judicial system.[15] Measures to support people's ability to develop free opinions are therefore vital to support democracy. Knowledge not only about individual resources but also about the systems they are included in and the ways they are made public are stepping stones for learning about society as a whole.

We argue that LAMs already offer situations and sites for such learning to happen. LAMs are viewed as institutions in which knowledge about society is held in trust. For LAMs, it is vital to be able to understand both the role of the institution in society and the role of the trained LAM professionals. As their funders have a growing interest in bestowing on LAMs a mission to work with pedagogy, the expectations of their staff being knowledgeable in learning and teaching are increasing. In parallel, understanding the different forms of learning that may take place in, and be supported by, LAMs is similarly of utmost importance for LAM professionals. By offering a broad palette of educational activities, and framing the institutions themselves as sites for informal, nonformal, and formal learning alike – including discerning and discussing the diverse values underpinning the imperative of lifelong learning – LAM professionals can articulate the everyday educational activities at LAMs to align with the societal role the institutions have. Furthermore, we want to suggest that LAMs should continue to develop such activities and to frame themselves as sites for learning. To this end, establishing literacies, including their different narrower institution-specific forms, as a guiding concept of relevance for all LAMs provides a solid foundation for framing and communicating their social role as sites and facilitators of learning and education alike.

Notes

1 https://www.smk.dk/en/article/smk-art-guide/
2 https://deichman.no/vi-tilbyr/skoletjenesten_57e737c7-c943-4dd2-9972-4b86025d67cc
3 https://www.db.dk/artikel/projekt-bogstart-er-en-gevinst-de-små;Bokstart.no;Bokstart.se
4 https://www.skanearkiv.se/Skola-och-lärande/Programutbud
5 https://www.arkivensdag.nu/the-archives-day/
6 https://www.skoletjenesten.dk/om-skoletjenesten/organisation
7 https://www.arbetsam.com/pedagogik/arbetslivsmuseer-som-klassrum/
8 https://louisiana.dk/event/aabne-vaerksteder-for-boern-10-august-31-december-2021/
9 https://mitstadsarkiv.kolding.dk/projekter/kompetenceudvikling-i-arkivet/
10 Correspondence with Lene Wul.

11 https://skoletjenesten.dk/tilbud/demokratiet-er-mit-ordet-er-frit
12 https://www.sormlandsmuseum.se/om-oss/vision-och-kannetecken/ (our translation).
13 https://www.sormlandsmuseum.se/utstallningar/historien-i-sormland/
14 https://www.sormlandsmuseum.se/om-oss/nya-huset/berattande-samlingar/
15 www.freedomhouse.org

References

ACRL (The Association of College & Research Libraries). 2000. *Information Literacy Competency Standards for Higher Education.* Chicago, IL: American Library Association.
ALA (The American Library Association). 1989. *Presidential Committee on Information Literacy: Final Report.* Chicago, IL: American Library Association.
Boese, Vanessa A., Nazifa Alizada, Martin Lundstedt, Kelly Morrison, Natalia Natsika, Yuko Sato, Hugo Tai, and Staffan I. Lindberg. 2022. *Autocratization Changing Nature? Democracy Report 2022.* Varieties of Democracy Institute (V-Dem).
Bruce, Christine. 1997. *The Seven Faces of Information Literacy.* Adelaide: Auslib Press.
Buschman, John E. 2019. "Good News, Bad News, and Fake News: Going Beyond Political Literacy to Democracy and Libraries." *Journal of Documentation* 75, no. 1: 213–228. https://doi.org/10.1108/JD-05-2018-0074.
Carlsten, Tone C. and Jørgen Sjaastad. 2014. *Evaluering av Program for skolebibliotekutvikling 2009–2013.* Oslo: NIFU.
Elmborg, James. 2006. "Critical Information Literacy: Implications for Instructional Practice." *The Journal of Academic Librarianship* 32, no. 2: 192–199. https://doi.org/10.1016/j.acalib.2005.12.004.
Elmborg, James. 2016. "Tending the Garden of Learning: Life-Long Learning as Core Library Value." *Library Trends* 64, no. 3: 533–555.
Engström, Lisa. 2019. "Att skapa självstyrande individer; effektivitet och motrörelser. Styrningsrationalitet och icke-rationalitet i bibliotek med obemannade öppettider." PhD diss., University of Copenhagen.
Evans, Tanya and Jerome de Groot. 2019. "Introduction: Emerging Directions for Family History Studies." *International Public History* 2, no. 2: 20190014, https://doi.org/10.1515/iph-2019-0014.
Fejes, Andreas. 2006. "The Planetspeak Discourse of Lifelong Learning in Sweden: What Is an Educable Adult?" *Journal of Education Policy* 21, no. 6: 697–716, https://doi.org/10.1080/02680930600969266.
Fejes, Andreas. 2017. "Är du fullärd lille vän?" In *Den femte statsmakten: bibliotekens roll för demokrati, utbildning, tillgänglighet och digitalisering,* edited by Erik Fichtelius, Eva Enarson, Krister Hansson, Jesper Klein, and Christina Persson, 291–315. Stockholm: Kungliga biblioteket/Nationell biblioteksstrategi.
Hall, Rachel. 2010. "Public Praxis: A Vision for Critical Information Literacy in Public Libraries." *Public Library Quarterly* 29, no. 2: 162–175. https://doi.org/10.1080/01616841003776383.
Hansson, Joacim. 2019. *Educating Librarians in the Contemporary University: An Essay on iSchools and Emancipatory Resilience in Library and Information Science.* Sacramento: Library Juice Press.
Hicks, Alison. 2019. "Mitigating Risk: Mediating Transition through the Enactment of Information Literacy Practices." *Journal of Documentation* 75, no. 5: 1190–1210. https://doi.org/10.1108/JD-11-2018-0184.

Hooper-Greenhill, Eilean. 2000. *Museums and the Interpretation of Visual Culture*. London: Routledge.

Hooper-Greenhill, Eilean. 2004. "Measuring Learning Outcomes in Museums, Archives and Libraries: The Learning Impact Research Project (LIRP)." *International Journal of Heritage Studies* 10, no. 2: 151–174. https://doi.org/10.1080/13527250410001692877.

IFLA. 2005. "Beacons of the Information Society: The Alexandria Proclamation on Information Literacy and Lifelong Learning." Accessed May 25, 2022. https://www.ifla.org/publications/beacons-of-the-information-society-the-alexandria-proclamation-on-information-literacy-and-lifelong-learning/.

Ingvaldsen, Siri. 2012. "Joint Efforts to Improve Reading Education: Cooperative Projects between Public Libraries and Schools in the Norwegian School Library Program." In *Proceedings of IFLA 78*, Helsinki.

Ingvaldsen, Siri. 2014. "The Norwegian School Library Program: What Has Been Achieved?" In *Proceedings of IFLA 2014*, Lyon.

Ingvaldsen, Siri. 2017. "The School Library in Media and Information Literacy Education." In *Media and Information Literacy in Higher Education*, edited by Siri Ingvaldsen, and Dianne Oberg, 51–65. Oxford: Chandos. https://doi.org/10.1016/B978-0-08-100630-6.00004-7.

Insulander, Eva. 2005. *Museer & lärande – en forskningsöversikt*. Göteborg: Statens museer för världskultur.

Khatun, Momena, Virkus, Sirje, and A. I. M. Jakaria Rahman. 2015. "Digital Information Literacy: A Case Study in Oslo Public Library." In *Information Literacy: Moving Toward Sustainability*, edited by Serap Kurbanoglu, Joumana Boustany, Sonja Špiranec, Esther Grassian, Diane Mizrachi, and Loriene Roy, 121–131. Cham: Springer.

Klinenberg, Eric. 2018. *Palaces for the People: How Social Infrastructure Can Help Fight Inequality, Polarization, and the Decline of Civic Life*. New York: Broadway Books.

Kulturrådet. 2015. *Med läsning som mål: Om metoder och forskning på det läsfrämjande området*. Stockholm: Kulturrådet.

Laskie, Cecilie, ed. 2017. *Biblioteksdidaktik*. Copenhagen: Hans Reitzels forlag.

Lehman, Meredith, Sabrina Mooroogen Philips, and Ray Williams. 2020. "Beyond Visual Literacy: Listening, Speaking, Reading, and Writing in the Art Museum." In *Literacy across the Community: Research, Praxis and Trends*, edited by Laurie A. Henry and Norman A. Stahl, 171–183. New York: Routledge.

Limberg, Louise, Olof Sundin, and Sanna Talja. 2012. "Three Theoretical Perspectives on Information Literacy." *Human IT* 11, no. 2: 128–191.

Lloyd, Annemaree. 2006. "Information Literacy Landscapes: An Emerging Picture." *Journal of Documentation* 62 (5): 570–583. https://doi.org/10.1108/00220410610688723.

Oliver, Gillian. 2017. "The Records Perspective: A Neglected Aspect of Information Literacy." *Information Research* 22, no. 1: 27–29.

Olsson Dahlquist, Lisa. 2019. "Folkbildning för delaktighet: En studie om bibliotekets demokratiska uppdrag i en digital samtid." PhD diss., Lund: Lund University.

Riksarkivet. 2019. RA. 04-2017/10443. *Riksarkivets delrapport om arkiv och skolverksamhet*. https://www.raa.se/app/uploads/2020/02/Riksarkivets-rapport-arkiv-och-skola_191119.pdf.

Rivano Eckerdal, Johanna. 2012. "Information, identitet, medborgarskap: Unga kvinnor berättar om preventivmedel." PhD diss., Lund University.

Rivano Eckerdal, Johanna. 2017. "Libraries, Democracy, Information Literacy, and Citizenship: An Agonistic Reading of Central Library and Information Studies' Concepts." *Journal of Documentation* 73, no. 5: 1010–1033. https://doi.org/10.1108/JD-12-2016-0152.

Roued-Cunliffe, Henriette. 2020. *Open Heritage Data: An Introduction to Research, Publishing and Programming with Open Data in the Heritage Sector.* London: Facet Publishing.

Rydbeck, Kerstin, and Jamie Johnston. 2020. "LAM Institutions: A Cross-Country Comparison of Legislation and Statistics Services and Use." In *Libraries, Archives and Museums as Democratic Public Spaces in a Digital Age,* edited by Ragnar Audunson, Herbjørn Andresen, Cicilie Fagerlid, Erik Henningsen, Hans-Christoph Hobohm, Henrik Jochumsen, Håkon Larsen and Tonje Vold, 25–52. Berlin: De Gruyter Saur. https://doi.org/10.1515/9783110636628-002.

Sfard, Anna. 1998. "On Two Metaphors for Learning and the Dangers of Choosing Just One." *Educational Researcher* 27, no. 2: 4–13. https://doi.org/10.3102/0013189X027002004.

SOU. 2002:78. 2002. *Arkiv för alla – nu och i framtiden.* Stockholm: Kulturdepartementet.

SOU. 2021:3. 2021. *Skolbibliotek för bildning och utbildning.* Stockholm: Utbildningsdepartementet.

Stapp, Carol B. 1992. "Defining Museum Literacy". In *Patterns in Practice: Selections from the Journal of Museum Education,* edited by Susan K. Nichols, 112–117. London: Routledge.

Säljö, Roger. 2000. *Lärande i praktiken: Ett sociokulturellt perspektiv.* Stockholm: Prisma.

Säljö, Roger. 2009. "Medier och det sociala minnet: dokumentationspraktiker och lärande från lertavlor till Internet." In *Informationskompetenser: Om lärande i informationspraktiker och informationssökning i lärandepraktiker,* edited by Jenny Hedman, and Anna Lundh, 13–35. Stockholm: Carlsson.

Trant, Jennifer. 2009. "Emerging Convergence? Thoughts on Museums, Archives, Libraries, and Professional Training." *Museum Management and Curatorship* 24, no. 4: 369–387. https://doi.org/10.1080/09647770903314738.

Vilar, Polona and Alenka Šauperl. 2014. "Archival Literacy: Different Users, Different Information Needs, Behaviour and Skills." In *Information Literacy: Lifelong Learning and Digital Citizenship in the 21st Century,* edited by Serap Kurbanoğlu, Sonja Špiranec, Esther Grassian, Diane Mizrachi, and Ralph Catts, 149–159. Cham: Springer.

Wertsch, James V. 1998. *Mind as Action.* New York: Oxford University Press.

Wilson, Carolyn, Alton Grizzle, Ramon Tuazon, Kwame Akyempong, and Chi Kim Cheung. 2011. *Media and Information Literacy Curriculum for Teachers.* Paris: UNESCO.

12

LAMS AND THE PARTICIPATORY TURN

Isto Huvila, Jamie Johnston, and Henriette Roued-Cunliffe

Introduction

The entire cultural field is witnessing a participatory or "participative turn" (Bonet and Négrier 2018). Participation has been one of the most prominent buzzwords among cultural institutions for more than a decade and a central concept in strategies and policymaking. This chapter examines the concept of participation in the context of libraries, archives, and museums (LAMs) and provides an overview of the most notable forms of participation, including crowdsourcing, co-creation, and the facilitation of shared experiences of culture and art. In addition, it outlines major opportunities and challenges related to participation, how participation can be understood within the cultural sector, and what implications it has for the LAM field.

Concepts of participation

Participation is a slippery concept. It is attached to an assortment of values often relating to mutual engagement and is characterized by a miscellany of practices ranging from crowdsourcing to co-design and co-creation. As a phenomenon, it is not specific to LAMs or the cultural field, but it can be traced through the fabric of the entire society. There is no clear consensus on the origins of the "participatory turn"; however, the idea can be traced back both to the emerging policy discourse on increased civil society participation during the second half of the 1900s (Arnstein 1969; Saurugger 2010) and to the emergence of the contemporary idea of a democracy deficit in public life (Virolainen 2016). Of these, democracy and the importance of involving the civil society as a whole, particularly young people, have been powerful drivers of participation in Scandinavia. In Sweden, the Agenda Cultural Heritage (Agenda kulturarv) project and its much-debated

DOI: 10.4324/9781003188834-15

final report from 2004 advocated radical participation and dethroning of cultural heritage expertise (Agenda kulturarv 2004). The Collaborative Cultural Model (Kultursamverkansmodell) from 2011 further promoted participation, albeit in somewhat less radical terms. A more recent driver of participation has been the increasing fragmentation of mainstream societies, which has been partly catalyzed by, and has partly coincided with, the digital revolution (Deuze 2006). However, the digital revolution has also provided an apparent imaginary and a plethora of means to promote and realize many of the participatory ideals through online communities and participation. In the contemporary context, participation is construed as a norm that defines culture, such as in Jenkins' (2019) influential framing of the notion of "participatory culture," Saurugger's (2010) writing on democracy, Roued-Cunliffe and Copeland's discussion of heritage (2017) and, not least, Andresen, Huvila, and Stokstad's (2020) reflections on the rapport between LAMs and their stakeholders.

Unsurprisingly, participation has evaded a concise definition. Popular models also cited in LAM contexts include Arnstein's (1969) classic "Ladder of Citizen Participation" and Carpentier's (2016) more recent distinction of a *sociological* approach that acknowledges taking part as a form of participation and a *political* approach that entails equalization of power inequalities among participants. LAM-specific participatory concepts also exist, including the participatory museum from Simon's (2010) popular manifesto and guide book of the same name, Lankes and colleagues' concepts of the participatory library and librarianship (Lankes, Silverstein, and Nicholson 2007) and participatory systems (Lankes 2016), Library 2.0 (Holmberg et al. 2009), participatory archives (Benoit III and Eveleigh 2019; Huvila 2008), participatory appraisal (Shilton and Srinivasan 2008), and participatory heritage (Roued-Cunliffe and Copeland 2017), which have all made their appearance as participatory (re)interpretations and (re)imaginations of LAMs and LAM practices. As Benoit III and Eveleigh (2019) observe, participation and how it is conceived is pushed forward by, and realized through, specific practices such as crowdsourcing, co-design, and co-creation as well as being driven by values such as equality, empowerment, democracy, and inclusion. This also applies to the different participatory concepts. Unquestionably, one of the key reasons for the "eclecticity" of both the participatory discourse and practice is that the specific types of participation or imagined outcomes are seldom explicitly defined and incorporate elements of different, sometimes contradictory, means and ends (Huvila 2015). Amidst the diversity of views and practices, as it appears both close to impossible and meaningless to try to provide a blanket definition, a common feature of the different takes on participation is that they revolve around the question of power sharing either as its fundament or an unruly beast that is as inescapable as it is difficult to handle.

Types of participation

Participation in the LAM context comes in many forms. According to Huvila's (2015, 2020) analysis, it is possible to distinguish participation that is underpinned

by the needs and demands of the general public or specific audiences, profession-
als and their work, LAM business models and day-to-day operations, as well as
participation itself as an intrinsically valuable process. Furthermore, participation
can involve multiple stakeholder groups and multiple types of LAMs, it can be
primarily digital or nondigital, and it can be focused on the LAM or on external
actors. Typical approaches to enact participation include crowdsourcing (Bonac-
chi et al. 2019), co-design and co-creation (Kapuire, Winschiers-Theophilus,
and Blake 2015), and user-driven innovation (Hvenegaard Rasmussen 2016). In
a library context, Hvenegaard Rasmussen (2016) offers a typology for participa-
tion that includes the following forms of participation: *volunteering* as a form of
community participation; *interactive displays* as a form of user-to-user mediation;
workshops for collaborative making, learning, and exploring (e.g., makerspaces);
co-creation for engaging library users as co-creators to produce content for the
library; *user-driven innovation* for developing the library and its services with
library users; and *book clubs* for coauthoring the meaning of art. Independently
of the approach, the intensity and extent of participation varies from short-lived
casual involvement to radical and profound redistribution of responsibilities and
power, which is a notion that can be equally difficult to unfold as that of partic-
ipation. Power, which generally concerns liabilities and authority to decide, is a
relational concept and its redistribution can imply the reallocation of the man-
date and opportunities to resist and refuse participation (Prasse-Freeman 2022).
Thus, determining who the intended and expected beneficiary is in participatory
endeavors is a crucial question that must be answered as it will influence the
nature and manner of power (re)distribution.

Participation types can be categorized according to the following model
(Figure 12.1). Types of participation are characterized by varying degrees of
power sharing between participating communities and by the LAMs and/or the
communities benefiting directly or by proxy from the development of LAM
collections and services. The model serves as a starting point for discussing
participation in LAM contexts and should not be seen as a completely novel
perspective on how different types of participation can be categorized. It has
intentional and clear affinities to earlier models, including general models (incl.
Arnstein 1969; Carpentier 2016) and LAM-specific models as well as enumera-
tions of different dimensions and characteristics of participatory practices (e.g.,
Huvila 2015; Hvenegaard Rasmussen 2016; Jansson 2020). To exemplify catego-
ries in the model, four types of participatory engagement are further discussed
using four examples from Scandinavian LAM institutions placed along the axes
of the model (crowdsourcing, co-curated exhibitions, special-interest activities
and co-creation, and user-driven innovation).

Co-curated exhibitions

A co-curated exhibition refers to an exhibition developed in collaboration
between LAM professionals and community members. As a participatory

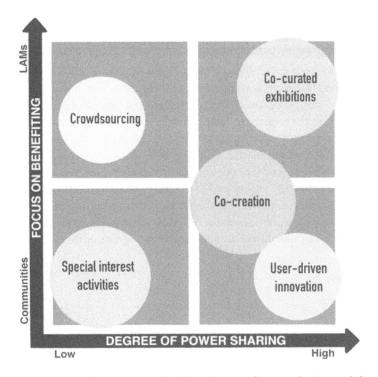

FIGURE 12.1 Types of participation based on degree of power sharing and direct or indirect benefits to communities.

activity, it focuses on broader communities benefiting from LAMs and involves a comparatively high degree of power sharing. Game museums and gaming heritage exhibition and preservation initiatives have been at the forefront of collaborating with players and game developers. Initiatives in the Scandinavian context include those at the National Swedish Museum of Science and Technology and the Finnish Museum of Games. These initiatives also demonstrate the importance of incorporating cross archive-museum perspectives in the initiatives. According to Prax and colleagues (2019), the success of such engagements often remains accidental without purposeful sharing of curatorial power, dialogue, and openness concerning each other's priorities and boundary conditions, reinterpretation and revising of policies, and the inclusion of all relevant actors, such as rogue archivists and archives, players, game makers, and the industry.

Crowdsourcing

Crowdsourcing refers to activities aimed at aggregating community input and is a more structured type of participation. The focus is often on benefiting broader communities, whereas power sharing is often limited. The Copenhagen City Archives in Denmark have been conducting crowdsourcing projects since 2010

with the aim of encouraging extensive and widespread use of their collections. The tools and platforms built for transcribing files from their collections to make them available online may seem to primarily benefit the archive; however, the collections that have been transcribed are also of great value to a vast number of family historians and academic historical researchers. The many volunteers who transcribe the files are driven by a personal genealogical interest, which attests to the value of the transcripts in the respective communities. Van Zeeland and Gronemann (2019) note the importance of allowing room for social interaction and strengthening the relations between volunteers and archival staff. A sense of responsibility and influence seems to be especially important and the most important motivating factor for the highly productive superusers. The archive gradually found that entrenching these crowdsourcing activities to become a part of the core mission was vital. This required an agile approach to both the technical and volunteer management, which was anchored with a broader and more varied team of staff members.

Co-creation

Co-creation is typically aimed at benefiting a specific community and usually involves a fairly high degree of power sharing and participation. A powerful example of co-creation was the project TID STED ROM at the Preus Museum, Norway's national photo museum, which worked to include inmates' experiences into the museum's collection. The project was part of the overarching aim of the museum and other museums in the region to include marginalized groups into museum collections in ways that ensured self-representation and ongoing community engagement. Project leaders held week-long, interactive workshops with inmates at multiple penal institutions during which they explored photography as a medium of communication and the conceptual framework of the project as well as engaging in the dynamic and reflective process of creating the material for the collection. The resulting collection was then shared with the broader community in various places of public gathering, such as town squares and libraries, and was also published in books (Preus Museum 2018).

User-driven innovation

User-driven innovation may appear similar to co-creation in that often it focuses on a specific community and involves a lot of power sharing. However, the focus of user-driven innovation is on developing the library and its services in collaboration with library users rather than involving specific communities to produce content for the library, as is done in co-creative projects. An example of user-driven innovation is Oslo's Biblo Tøyen youth-only library for young people between the ages of 10 and 15 in Norway. A reference group of local children participated in the planning process prior to the library's opening in March 2016. The staff also involved a class at a local school to develop a classification system for organizing the collection. The young people's highly unconventional

subject groupings are used in the library, and library users are able to place library materials under the subject groupings they believe fit best. A group of young programmers created their own lending and library card system with UHF RFID, a form of wireless communication that uses radio waves to identify and track objects. The library space was also designed to allow the young people to adapt the physical space according to their needs. In addition to positive feedback from its users, the success of Biblo Tøyen was acknowledged in *Time* magazine, where it was listed as one of the world's coolest places for children (Singer 2019).

Special-interest activities

Special-interest activities refer to a broad variety of participatory engagements focused on, and often led by, specific communities where LAMs engage as participants or facilitators rather than initiators or decision-makers. In the Scandinavian context, large communities in this category are amateur historians, book clubs and circles, and genealogists; however, there are many other examples of comparable groups and communities (Lepik and Pruulmann-Vengerfeldt 2014; Roued-Cunliffe 2017). More recently, practices qualifying as special-interest activities have increased noticeably in the digital sphere due to the proliferation of online history, culture, and reading groups.

The rapid evolution of the types of participation makes it difficult to suggest a definite categorization. Instead, a faceted approach of asking a series of questions can help to distinguish various types and styles of participation from each other, such as: Who is at the center of participation? Is the community participating in an activity organized by a LAM or is the LAM a participant in a community activity? Is it the LAM or the community who has the power to decide who or what benefits from participation? What is the aim of the activity and desired outcomes, and what is at stake for different participants?

Opportunities for, and demands of, participation

LAMs' participatory practices are driven by many factors. Participation can increase LAMs' popularity and vitalize their relations with their users and other stakeholders (Andresen, Huvila, and Stokstad 2020). It can also provide LAMs with access to otherwise unattainable material, improve the quality of collections and their documentation (Jansson 2018), and expand public engagement (Bonacchi et al. 2019) as well as activities and offerings, such as with gaming heritage (Prax et al. 2019). Through participatory practices, LAMs can become more relevant for their users and potential users, increase their equity and fairness, and incorporate a broader diversity of perspectives. Participation can function as a source of empowerment for the public and help LAMs to fulfill their social mission and role as arenas for public discourse (Audunson, Hobohm, and Tóth 2019). Participatory practices facilitate LAMs' ability to give voice to previously marginalized communities, including indigenous people like the Sámi people in Scandinavia (Eidheim,

Bjørklund, and Brantenberg 2012), gender and cultural minorities (Roued-Cunliffe 2017), and immigrant groups (van der Ploeg 2020). Participation is generally perceived as a pivotal way to upkeep the sustainability, longevity, and social relevance of the institutions. Contrasting with, and running parallel to, LAMs' public-spirited motivations, participatory practices can also seem like an opportunity for LAMs struggling financially to obtain cheap labor, or like a useful marketing gig, or like a new term for "use" or "visit" (Huvila 2015, 2020). Both perspectives and the breadth of the conceived benefits underline participation as an imperative in the contemporary "participatory" cultural landscape. Thus, in addition to the direct benefits of being participative, it has become equally important for LAMs to act according to the prevailing cultural imperative of being participatory.

Challenges to successful participatory practices

Contrary to the far-reaching benefits envisioned, participatory practices do not always fulfill their great expectations. Different perspectives of participation and the future of LAMs can contradict each other and be difficult to realize in practice (Huvila 2016). LAMs are not always the principal actors in participatory constellations. They might be a resource for others or a participant in a collaboration. An example of this is LAM collaborations with Wikipedia (Proffitt 2018; cf. Cook 2019). In such cases, realizing institutional goals of participation can be difficult even if the participation of LAMs would be of great value for the community. Participatory practices and their outcomes can also be demanding to integrate in and align with the professional work at LAMs (Jansson 2018); therefore, they are not always attempted. Participatory activities are generally perceived as the responsibility of individual departments within larger institutions or are written in the implicit and explicit job descriptions of only a part of the staff, which is seen in the Copenhagen City Archives example discussed above. Participation is also frequently pigeonholed in projects rather than made a part of the daily institutional routine (e.g., see: Holdgaard and Klastrup 2014; Ledinek Lozej 2019; Lucky 2017). Short projects are not necessarily what participants want. From their perspective, learning to know each other during a long-term partnership could be much more attractive (e.g., as in Kapuire, Winschiers-Theophilus, and Blake 2015). As a result, participation does not always unfold as radical (Flinn, Stevens, and Shepherd 2009; Huvila 2008) and it does not lead to as substantial outcomes (Prax et al. 2019) as potentially envisioned. Even in cases when the assumed participatory approach seeks to share power and reach out to new communities, participatory practices do not necessarily lead to an increased democratization if participants end up representing the same demography as earlier users (Bonacchi et al. 2019).

There is also a peculiar tension between participation and the contemporary Scandinavian cultural policy. The social relevance- rather than specific outputs-oriented participatory movement has been for a good reason described as a perfect match with New Public Governance and the New Public Management

ideology as a whole (Kann-Rasmussen and Hvenegaard Rasmussen 2021). In practice, however, the eclecticity of participatory practices and the diversity of ways in which social relevance and quality can be understood easily lead to a lack of consensus on whether participation contributes to them and if investing in participation is money well spent (Kann-Rasmussen and Hvenegaard Rasmussen 2021). Accordingly, even if the relevance of participatory engagements is difficult to argue against, securing funding for facilitating participation can turn out to be difficult in the absence of a consensus on its desirable outcomes.

Moreover, as all LAMs are "participatory" to some extent in their work directed toward, and in collaboration with, their stakeholders, at least in the sociological sense of Carpentier (2016), it can be difficult to weigh the immediate benefits of moving toward more radical and in-depth forms of participation (cf. Prax et al. 2019). In particular, when participation becomes an external cultural imperative, it can be difficult to balance between different forms and directions of engagement and involvement. LAM professionals' worry of losing their jobs and becoming redundant if work tasks are passed on from paid staff to volunteers is not utterly far-fetched, even if there are indications that it is not necessarily the professionals' principal concern (Andresen, Huvila, and Stokstad 2020).

Developing participatory practices

The literature offers a lot of advice on how to facilitate participation in the LAM context, but, like the concept, successful participation is slippery and difficult to attain. Only a minority of LAMs have embraced and successfully implemented the contemporary participatory ideals in practice, albeit there is a growing number of frequently cited success stories (Andresen, Huvila, and Stokstad 2020). The critical success factors tend to be specific to particular modes and configurations of participation, and, even if some generic frameworks have been proposed (e.g., as in La Barre and Richardson 2021; Sabharwal 2021), no specific recipe for how to make participatory projects successful exists.

From the already-rather-extensive literature on LAM participation, it is possible to determine a few pivotal questions that can be relevant to ask when planning participatory engagements. The following are some of the most critical ones (illustrated on the two axes of Figure 12.1):

- Who is envisioned to participate, who is expected and intended to benefit, and what is the intended degree of intensity of the participation?
- Who gets to decide the aims, forms, parameters, desired and actual outcomes, and the overall degree of power sharing between participating communities and LAMs?

None of the answers need to be discrete in a sense that there is only one party benefiting or that multiple parties could not participate at different and mixed levels of intensity (e.g., compare for the gradient of intensities of peer

production in Haythornthwaite 2009). There tends to be common challenges in participatory projects. These challenges can include:

- Fostering real reciprocal dialogue
- Developing a joint understanding of authority and decision-making procedures (e.g., if LAM professionals or community members drive the collaboration)
- Determining beneficiaries (e.g., if the collaboration aims to develop LAM collections or support community members' goals)
- Negotiating intensity (e.g., how much time and effort different parties are expected to invest in the collaboration)
- Establishing who is supposed to participate in what roles (e.g., community members as amateur historians and librarians as information specialists)

Participation changes when participants are closer to the core of a community rather than when they are on the periphery as discussed in Chapter 14 relating to communities.

Asking questions can help to elicit an understanding of the diversity of participants and possible forms of participation. Carpentier (2016) and Smith and Iversen (2014) emphasize the importance of continuous processes of mutual interaction and exchange. Flinn (2011) suggests, by quoting Harris (2011), that participants need to be invited to a project as guests by the authority of a host – whoever the host would be and however nonhierarchical the participation would be.

Successful participation does not depend on the predetermination of power relations, beneficiaries, participants, and the intensity of participation itself but rather on multiple contextual and situational factors of the field and related activities; as Carpentier (2016) reminds us, it is contingent on the actors as subjects and objects of participatory engagements. Resources – *data* in digital participation – need to be available openly enough (Roued-Cunliffe 2020), functioning infrastructures must be in place to build upon (Huvila 2012), and the needs and wants of all involved parties must align to make participation successful (Huvila 2008). Bluntly, and perhaps unfortunately, enthusiasm may be useful but on its own it is not enough.

A question relevant to participants' needs and wants is with whom and where to engage. Participatory activities are too often compartmentalized as separate engagements and not integrated as a part of the LAMs' daily routines, and frequently there is only a small number of dedicated staff members engaged in public outreach activities (van Zeeland and Gronemann 2019). Rather than trying to recruit participants to a LAM, it can be more productive as a LAM to reach out as a participant to an external community (e.g., cf. Huvila and Uotila 2018). Engaging too much with marginal interests and groups might alienate others, both those in the mainstream and other marginalized groups. Importantly, even if there is no reason to belittle the value of superficial forms of partaking as relevant for LAMs and their users, reaching out too broadly might reduce the intensity and attractiveness of participatory engagements.

In general, there is a dire need for boundary practices and the use of boundary objects, or relevant shared "things," that can help to align participants' doings and facilitate collaboration (Star 1988; Star and Griesemer 1989). These practices and objects must make sense for all participants and be hospitable concerning their epistemic beliefs (Huvila 2015). As all participation is fundamentally about creating relationships, it is crucial to take seriously and address the tension of control and freedom and apprehension of different viewpoints without falling into epistemic relativism. Key to the process is that LAMs do not lose sight of their purpose and societal legitimacy as a part of the social infrastructure (Klinenberg 2018) and, as Mars and Medak (2019) warn, completely subvert themselves to externally imposed imperatives (Huvila, 2020). However, they must also tread carefully so as not to assume a monopoly of perspectives that reduces participants to cheap labor, or, as Bowler et al. warn, frames their role as purely "decorative" (Bowler et al. 2021).

Similarly to how crucial it is to be clear with the foundational questions of power sharing and benefits of participation, a potentially useful way to approach the conundrums of participation is to break down the two broad critical questions specified at the beginning of this section to more reflective questions concerning the planned participatory engagement. A nonexhaustive list of such questions is summarized in Table 12.1 in the form of a participation matrix. The matrix takes into account both community and LAM perspectives, including:

- Who the participating bodies (e.g., genealogists and a specific LAM organization) and individuals (e.g. a local genealogy association and two archivists employed at the LAM) are
- What motivates communities and LAMs to use participatory practices (e.g., getting help and attracting more visitors)
- Who decides (e.g., community decides on priorities, LAM on what is possible) and how success should be assessed (e.g., participation does not feel meaningful for the community and for the LAM, there are too few participants)
- What infrastructures are needed (e.g., working space for community members and enough staff)
- What outcomes are anticipated and wanted (e.g., better genealogical research and increased use of collections) versus unwanted outcomes (e.g., damaged archival documents, massive workload)

Conclusion

LAMs cannot exist without participation, yet participation can mean many different things and take many different forms. The degree of power sharing between participating communities and LAMs, who benefits and how, and what participation entails in practice determine the nature of participation and its outcomes and implications. Participation risks simply being a buzzword if its aims and how it is to be realized are not made explicit; *participation* easily becomes an empty concept.

TABLE 12.1 Participation matrix with questions for reflecting on participatory practices and their premises

Participation matrix		
	Community	LAM
Participating bodies	What is/are the participating community/ communities?	What is/are the participating LAM/s?
Participating individuals	Which individuals from the community are participating?	Which individuals from the LAM are participating?
Motivations	What motivates the community to participate?	What motivates the LAM to participate (the whole organization)?
Decision-making	What does the community get to decide?	What does the LAM get to decide?
Assessment	What marks a success or failure from the community perspective?	What marks a success or failure from the LAM perspective?
Required infrastructures	What infrastructural backing for the community is needed by the community?	What infrastructural backing for the community is needed by the LAM?
Anticipated outcomes	What are the desired outcomes from participation for the community?	What are the desired outcomes from participation for the LAM?

Currently, participation could also, with some caution, be described as a paradigm. Even if participation in some sense has existed as long as LAMs, the idea of participation has become, as Barney and colleagues (2016, vii) suggest, "both environmental (a state of affairs) and normative (a binding principle of right action)" in contemporary society. As such, it is up to LAMs and participating communities together to make it meaningful and binding to positive action. In doing so, considering the questions outlined in this chapter, including who participates and reaps the benefits, what drives participation, and who gets to decide, is a crucial first step.

References

Agenda kulturarv. 2004. *Människan i Centrum: Agenda Kulturarvs Programförklaring.* Stockholm: RAÄ.
Andresen, Herbjørn, Isto Huvila, and Sigrid Stokstad. 2020. "Perceptions and Implications of User Participation and Engagement in Libraries, Archives and Museums." In

Libraries, Archives and Museums as Democratic Spaces in a Digital Age, edited by Ragnar Audunson, Herbjørn Andresen, Cicilie Fagerlid, Erik Henningsen, Hans-Christoph Hobohm, Henrik Jochumsen, Håkon Larsen, and Tonje Vold, 185–206. Berlin: De Gruyter Saur. https://doi.org/10.1515/9783110636628-009

Arnstein, Sherry R. 1969. "A Ladder of Citizen Participation." *Journal of the American Institute of Planners* 35, no. 4: 216–224. https://doi.org/10.1080/01944366908977225.

Audunson, Ragnar, Hans-Christoph Hobohm, and Máté Tóth. 2019. "ALM in the Public Sphere: How Do Archivists, Librarians and Museum Professionals Conceive the Respective Roles of Their Institutions in the Public Sphere?" *Information Research* 24, no. 4: paper colis1917.

Barney, Darin, Gabriella Coleman, Christine Ross, Jonathan Sterne, and Tamar Tembeck. 2016. "Introduction." In *The Participatory Condition in the Digital Age*, edited by Darin Barney, Gabriella Coleman, Christine Ross, Jonathan Sterne, and Tamar Tembeck, vii–xxxix. Minneapolis: University of Minnesota Press.

Benoit III, Edward, and Alexandra Eveleigh. 2019. "Defining and Framing Participatory Archives in Archival Science." In *Participatory Archives: Theory and Practice*, edited by Edward Benoit III and Alexandra Eveleigh, 1–12. London: Facet.

Bonacchi, Chiara, Andrew Bevan, Adi Keinan-Schoonbaert, Daniel Pett, and Jennifer Wexler. 2019. "Participation in Heritage Crowdsourcing." *Museum Management and Curatorship* 34, no. 2: 166–182. https://doi.org/10.1080/09647775.2018.1559080.

Bonet, Lluis, and Emmanuel Négrier. 2018. "The Participative Turn in Cultural Policy: Paradigms, Models, Contexts." *Poetics* 66 (February): 64–73. https://doi.org/10.1016/j.poetic.2018.02.006.

Bowler, Leanne, Karen Wang, Irene Lopatovska, and Mark Rosin. 2021. "The Meaning of 'Participation' in Co-Design with Children and Youth: Relationships, Roles, and Interactions." *Proceedings of the Association for Information Science and Technology* 58, no. 1: 13–24. https://doi.org/10.1002/pra2.432.

Carpentier, Nico. 2016. "Beyond the Ladder of Participation: An Analytical Toolkit for the Critical Analysis of Participatory Media Processes." *Javnost – The Public* 23, no. 1: 70–88. https://doi.org/10.1080/13183222.2016.1149760.

Cook, Stacey. 2019. "The Uses of Wikidata for Galleries, Libraries, Archives and Museums and Its Place in the Digital Humanities." *Comma* 2017, no. 2: 117–124. https://doi.org/10.3828/comma.2017.2.12.

Deuze, Mark. 2006. "Participation, Remediation, Bricolage: Considering Principal Components of a Digital Culture." *The Information Society* 22, no. 2: 63–75. https://doi.org/10.1080/01972240600567170.

Eidheim, Harald, Ivar Bjørklund, and Terje Brantenberg. 2012. "Negotiating with the Public: Ethnographic Museums and Ethnopolitics." *Museum & Society* 10, no. 2: 95–120.

Flinn, Andrew. 2011. "Archival Activism: Independent and Community-Led Archives, Radical Public History and the Heritage Professions." *InterActions* 7, no. 2. http://dx.doi.org/10.5070/D472000699 Retrieved from https://escholarship.org/uc/item/9pt2490x

Flinn, Andrew, Mary Stevens, and Elizabeth Shepherd. 2009. "Whose Memories, Whose Archives? Independent Community Archives, Autonomy and the Mainstream." *Archival Science* 9, no. 1–2: 71–86. https://doi.org/10.1007/s10502-009-9105-2.

Harris, Verne. 2011. "Jacques Derrida Meets Nelson Mandela: Archival Ethics at the Endgame." *Archival Science* 11, no. 1: 113–124.

Haythornthwaite, Caroline. 2009. "Crowds and Communities: Light and Heavyweight Models of Peer Production." *Hawaii International Conference on System Sciences*, 1–10. https://doi.org/10.1109/HICSS.2009.650.

Holdgaard, Nanna, and Lisbeth Klastrup. 2014. "Between Control and Creativity: Challenging Co-Creation and Social Media Use in a Museum Context." *Digital Creativity* 25, no. 3: 190–202. https://doi.org/10.1080/14626268.2014.904364.

Holmberg, Kim, Isto Huvila, Maria Kronqvist-Berg, and Gunilla Widén-Wulff. 2009. "What Is Library 2.0?" *Journal of Documentation* 65, no. 4: 668–681. https://doi.org/10.1108/00220410910970294.

Huvila, Isto. 2008. "Participatory Archive: Towards Decentralised Curation, Radical User Orientation and Broader Contextualisation of Records Management." *Archival Science* 8, no. 1: 15–36. https://doi.org/10.1007/s10502-008-9071-0.

Huvila, Isto. 2012. *Information Services and Digital Literacy: In Search of the Boundaries of Knowing.* Oxford: Chandos.

Huvila, Isto. 2015. "The Unbearable Lightness of Participating? Revisiting the Discourses of 'participation' in Archival Literature." *Journal of Documentation* 71, no. 2: 358–386. https://doi.org/10.1108/JD-01-2014-0012.

Huvila, Isto. 2016. "Change and Stability in Archives, Libraries and Museums: Mapping Professional Experiences in Sweden." *Information Research* 21, no. 1. http://www.informationr.net/ir/21-1/memo/memo5.html.

Huvila, Isto. 2020. "Librarians on User Participation in Five European Countries / Perspectives de bibliothécaires sur la participation des utilisateurs dans cinq pays européens." *Canadian Journal of Information and Library Science* 43, no. 2: 127–157.

Huvila, Isto, and Kari Uotila. 2018. "Taking Excavation to a Virtual World: Importing Archaeological Spatial Data to Second Life and OpenSim." Working paper. https://uu.diva-portal.org/smash/get/diva2:1192440/FULLTEXT01.pdf

Hvenegaard Rasmussen, Casper. 2016. "The Participatory Public Library: The Nordic Experience." *New Library World* 117, no. 9/10: 546–556. https://doi.org/10.1108/NLW-04-2016-0031.

Jansson, Ina-Maria. 2018. "Negotiating Participatory KO in Crowdsourcing Infrastructures." In *Challenges and Opportunities for Knowledge Organization in the Digital Age: Proceedings of the Fifteenth International ISKO Conference 9–11 July 2018 Porto, Portugal,* edited by Fernanda Ribeiro and Maria Elisa Cerveira, 863–870. Baden-Baden: Ergon-Verlag.

Jansson, Ina-Maria. 2020. "Creating Value of the Past through Negotiations in the Present: Balancing Professional Authority with Influence of Participants." *Archival Science* 20 (April): 327–345. https://doi.org/10.1007/s10502-020-09339-8.

Jenkins, Henry. 2019. *Participatory Culture: Interviews.* Cambridge: Polity.

Kann-Rasmussen, Nanna, and Casper Hvenegaard Rasmussen. 2021. "Paradoxical Autonomy in Cultural Organisations: An Analysis of Changing Relations between Cultural Organisations and Their Institutional Environment, with Examples from Libraries, Archives and Museums." *International Journal of Cultural Policy* 27, no. 5: 636–649. https://doi.org/10.1080/10286632.2020.1823976.

Kapuire, Gereon Koch, Heike Winschiers-Theophilus, and Edwin Blake. 2015. "An Insider Perspective on Community Gains: A Subjective Account of a Namibian Rural Communities' Perception of a Long-Term Participatory Design Project." *International Journal of Human-Computer Studies* 74 (February): 124–143. https://doi.org/10.1016/j.ijhcs.2014.10.004.

Klinenberg, Eric. 2018. *Palaces for the People: How Social Infrastructure Can Help Fight Inequality, Polarization, and the Decline of Civic Life.* New York: Crown.

La Barre, Kathryn, and Courtney Richardson. 2021. "Chaos and Conception in the OpenED Archive." *Library Trends* 69, no. 3: 646–671.

Lankes, R. David. 2016. *The New Librarianship Field Guide*. Cambridge, MA: The MIT Press.

Lankes, R. David, Joanne Silverstein, and Scott Nicholson. 2007. "Participatory Networks: The Library as Conversation." *Information Technology and Libraries* 26, no. 4: 17–33. https://doi.org/10.6017/ital.v26i4.3267.

Ledinek Lozej, Špela. 2019. "Collaborative Inventory–A Participatory Approach to Cultural Heritage Collections." In *Participatory Research and Planning in Practice*, edited by Janez Nared and David Bole, 121–131. Cham: Springer.

Lepik, K., and P. Pruulmann-Vengerfeldt. 2014. "Handicraft Hobbyists in an Ethnographic Museum-Negotiating Expertise and Participation." In *Democratising the Museum, Reflections on Participatory Technologies*, edited by P. Runnel, 77–87. Frankfurt am Main: Academic Research.

Lucky, Shannon. 2017. "Digital Archiving in Canadian Artist-Run Centres." In *Participatory Heritage*, edited by Henriette Roued-Cunliffe and Andrea Copeland, 163–172. London: Facet.

Mars, Marcell, and Tomislav Medak. 2019. "Against Innovation: Compromised Institutional Agency and Acts of Custodianship". *Ephemera* 19, no. 2: 345–368.

Ploeg, Jouetta van der. 2020. "The Old Town Museum: Aarhus, Denmark Special Commendation 2017." In *Revisiting Museums of Influence: Four Decades of Innovation and Public Quality in European Museums*, edited by Mark O'Neill, Jette Sandahl, and Marlen Mouliou, 205–208. London: Routledge.

Prasse-Freeman, Elliott. 2022. "Resistance/Refusal: Politics of Manoeuvre under Diffuse Regimes of Governmentality." *Anthropological Theory* 22 (1): 102–127.

Prax, Patrick, Björn Sjöblom, Lina Eklund, Niklas Nylund, and Olle Sköld. 2019. "Drawing Things Together: Understanding the Challenges and Opportunities of a Cross-Lam Approach to Digital Game Preservation and Exhibition." *Nordisk Kulturpolitisk Tidsskrift* 22, no. 2: 332–354. https://doi.org/10.18261/issn.2000-8325/-2019-02-08.

Preus Museum. 2018. *Prosjektet TID STED ROM*. https://www.preusmuseum.no/nor/Opplev-utstillingene/Formidling-og-grupper/Prosjektet-TID-STED-ROM.

Proffitt, Merrilee. 2018. *Leveraging Wikipedia: Connecting Communities of Knowledge*. Chicago, IL: ALA.

Roued-Cunliffe, Henriette. 2017. "Forgotten History on Wikipedia." In *Participatory Heritage*, edited by Henriette Roued-Cunliffe and Andrea Copeland, 67–76. London: Facet.

Roued-Cunliffe, Henriette. 2020. *Open Heritage Data: An Introduction to Research, Publishing and Programming with Open Data in the Heritage Sector*. London: Facet.

Roued-Cunliffe, Henriette, and Andrea Copeland. 2017. "Introduction: What Is Participatory Heritage?" In *Participatory Heritage*, edited by Henriette Roued-Cunliffe and Andrea Copeland, xv–xxi. London: Facet.

Sabharwal, Arjun. 2021. "Functional Frameworks for Socialized Digital Curation: Curatorial Interventions and Curation Spaces in Archives and Libraries." *Library Trends* 69, no. 3: 672–695.

Saurugger, Sabine. 2010. "The Social Construction of the Participatory Turn: The Emergence of a Norm in the European Union." *European Journal of Political Research* 49, no. 4: 471–495. https://doi.org/10.1111/j.1475-6765.2009.01905.x.

Shilton, Katie, and Ramesh Srinivasan. 2008. "Participatory Appraisal and Arrangement for Multicultural Archival Collections." *Archivaria* 63: 87–101.

Simon, Nina. 2010. *The Participatory Museum*. Santa Cruz, CA: Museum 2.0.

Singer, Allison. 2019. "Deichman Biblo Tøyen, Oslo, Norway." *Time*. https://time. com/collection/worlds-coolest-places-2019/5736017/deichman-biblo-toyen-oslo-norway/.

Smith, Rachel Charlotte, and Ole Sejer Iversen. 2014. "Participatory Heritage Innovation: Designing Dialogic Sites of Engagement." *Digital Creativity* 25, no. 3: 255–268. https://doi.org/10.1080/14626268.2014.904796.

Star, Susan Leigh. 1988. "The Structure of Ill-Structured Solutions: Heterogeneous Problem-Solving, Boundary Objects and Distributed Artificial Intelligence." In *Proceedings of the 8th AAAI Workshop on Distributed Artificial Intelligence, Technical Report, Department of Computer Science, University of Southern California*. Los Angeles, CA.

Star, Susan Leigh, and James R. Griesemer. 1989. "Institutional Ecology, 'Translations' and Boundary Objects: Amateurs and Professionals in Berkeley's Museum of Vertebrate Zoology, 1907–39." *Social Studies of Science* 19, no. 3: 387–420. https://doi. org/10.1177/030631289019003001.

van Zeeland, Nelleke, and Signe Trolle Gronemann. 2019. "Participatory transcription in Amsterdam and Copenhagen". In *Participatory Heritage*, edited by Henriette Roued-Cunliffe and Andrea Copeland, 104–113. London: Facet.

Virolainen, Jutta. 2016. "Participatory Turn in Cultural Policy? An Analysis of the Concept of Cultural Participation in Finnish Cultural Policy." *Nordisk Kulturpolitisk Tidsskrift* 19, no. 1: 59–77.

13

CONTEMPORARY SCANDINAVIAN LAMS AND LEGITIMACY

Håkon Larsen, Nanna Kann-Rasmussen, and Johanna Rivano Eckerdal

Intensification of legitimation work in LAMs

Today, arts and culture organizations are faced with increased pressure to communicate the worth of their work to a broad public (Larsen 2016; Kann-Rasmussen 2019). This helps politicians prolong their support to publicly funded organizations, such as libraries, archives, and museums (LAMs), and it leads to an intensification of organizational legitimation work. While "organizational legitimacy refers to the degree of cultural support for an organization" (Meyer and Scott 1983, 201, cited from Scott 2014, 72), organizational legitimation work concerns the work done by various actors seeking to achieve and maintain organizational legitimacy. As legitimacy is never fixed once and for all, there is a constant need to engage in legitimation work on the part of the managers of publicly funded organizations in the culture sector. They need to perform legitimacy in the public sphere (Larsen 2016, 2017b, 2017a), and show that their organizations are open (Kann-Rasmussen 2016; Kann-Rasmussen and Tank 2016; Anderson et al. 2017) and in search of collaborations (Kann-Rasmussen 2019, 2016) with community actors. They need to be perceived as worthy of public support.

That libraries, archives, and museums need to be considered legitimate to receive public support is, of course, nothing new. However, due to technological changes related to digitalization, and societal changes related to increased literacy and mass education, these institutions are constantly rethinking their societal mission to stay relevant and be worthy of public support. Professionals whose main job market is in the LAM sector are also in need of active legitimation work on the part of their professional organizations, to secure a continued outflow of graduates and a steady job market for their employment.

DOI: 10.4324/9781003188834-16

In addition to technological and social changes leading to an intensification of organizational legitimation work, these changes are also pushing for convergence between libraries, archives, and museums (see Chapter 1, this volume). Taken together, these processes lead to LAMs facing similar challenges related to legitimacy and renewal of their societal missions.

Performances of legitimacy in the culture sector

In his theoretical model for organizational legitimation work of arts and media organizations, Larsen (2016) conceptualized the audiences for the legitimation work of organizational actors to be threefold, consisting of content producers, funders, and community (see Table 13.1). His model was developed on the grounds of studies of opera houses, symphony orchestras, and public service broadcasters. The role of content producers is more obvious for these types of organizations than is the case with LAM organizations in general. However, the importance of external content producers will vary depending on the type of organization we are talking about – contemporary art museums, for example, will rely on their standing in the art world as part of their legitimacy (e.g., Solhjell and Øien 2012, Chapter 12) to a much larger degree, for example, than public archives will rely on their standing in the field of historians.

Kann-Rasmussen and Tank (2016) adapted Larsen's model in a study of libraries, where they refer to the content producers being both authors and librarians, in that dissemination of literature is a form of content production. As for the other audience groups of libraries' legitimation work, the funders, and the community, these are as important for LAM organizations as for other organizations in the culture sector. Publicly funded LAM organizations in Scandinavia receive part of their funding via the state, regional, or municipal budgets. Although the funding of these organizations is quite stable once established as part of public budgets, whether state, regional, or municipal, budget cuts do occur and may be easier to pass once the organizations are suffering from failures in their public performances of legitimacy. With regard to the community as an audience for public performances of legitimacy, it is as important for LAM organizations as it is for performing arts organizations and public service broadcasters. As is the case for other publicly funded organizations in the culture sector, LAM organizations rely on social support from their communities as part

TABLE 13.1 Audience for public performances of legitimacy

	Content producers	Funders	Community
Type of support	Artistic	Economic	Social
Societal sphere	Art	Market/State	Civil society
Type of legitimacy	Artistic credibility	Financial stability	Widespread approval

Larsen (2016, 10).

Enlightenment and playing parts in nation-building processes and democratic practices (see Chapter 1, this volume), LAMs have, of course, served communities prior to the twenty-first century. But, as the pressure to perform legitimacy increases with technological and social changes, explicating one's societal missions has become a dominant way of proving one's contribution to society (Kann-Rasmussen 2016).

The societal mission of a particular cultural institution can also be institutionalized through law, which in the Nordic countries has been quite successful. The societal mission of public libraries is institutionalized through law in Denmark, Finland, and Norway, while this has been achieved for all libraries in Iceland and Sweden (Audunson et al. 2020b, 4; Rydbeck and Johnston 2020, 26–27). The societal mission of archives is institutionalized through law in Denmark, Finland,[1] Iceland, Norway, and Sweden (Rydbeck and Johnston 2020, 37–38), and the societal missions of museums have been institutionalized through law in Denmark, Iceland, and Sweden (Rydbeck and Johnston 2020, 31–32).

These laws have been subject to change over time. In Sweden, the second Library Act, which has been in force since 2014, differs from the first Library Act, among other things, in specifying a democratic mission in its preamble (SFS 2013:801, §2). In the second version of the Act, the societal mission is more explicitly expressed, with an emphasis on the institutions' fundamental role in democratic society. Furthermore, this democratic mission is prominently included in steering documents. Contemporary LAMs are governed through an increasing number of steering documents, which reflects the significant impact of New Public Management (NPM) on all segments of the public sector (Buschman 2003; Harvey 2005; Kann-Christensen and Andersen 2009; Greene and McMenemy 2012; Goulding 2013).

Such documents exist on different levels of governance and have varying weight. The Swedish Library Act stipulates library plans on both regional and municipal levels (SFS 2013:801, §17), and there is a national requirement that public libraries governed at a municipal level develop library plans that take into account both regional and national steering documents. Extensive work is therefore required to produce such documents. Nevertheless, this activity is highly valued, especially in times of political turbulence in municipalities, as the libraries find support for their legitimation work in steering documents. The Library Act, and in particular its democratic mission, is highlighted by library staff and civil servants as significant arguments at times when library activities and priorities are questioned (Rivano Eckerdal and Carlsson 2018). Such debates are often related to the contemporary focus on the importance of the national.

In March 2019, a Swedish government-commissioned group proposed a national library strategy in response to several contemporary challenges in the library sector (Fichtelius, Persson, and Enarson 2019).[2] The strategy included one aspect of the societal mission that attracted specific attention, namely

of the process of being perceived as legitimate. As such, they ground much of their legitimacy in the civic world (Boltanski and Thévenot 2006), although they also need to relate to other common worlds (Boltanski and Thévenot 2006) in their ongoing legitimation work (Kann-Rasmussen 2016; Larsen 2016).

The LAMs in Scandinavia differ somewhat from LAMs in other parts of the world in terms of their comparatively heavy dependence on public support. Nevertheless, the issues discussed in this chapter will be of relevance for understanding LAMs in most liberal democracies, as a large part of the legitimacy of LAMs rests on them being perceived as trustworthy, open, and inclusive organizations by the community that they serve, whether the financial support comes from private or public money (Larsen 2016).

In the remainder of this chapter, we will discuss a range of issues related to ongoing legitimation work in Scandinavian LAMs. We will investigate the role societal missions play in LAM organizations' public performances of legitimacy, how worth is ascribed to LAM organizations, what role the professionals play in the legitimation of contemporary LAMs, and how notions of "the national" play into legitimation processes related to LAMs. Through this analysis we get to understand key aspects related to the legitimation work of twenty-first-century Scandinavian LAMs.

Societal missions and the legitimacy of LAMs

Since the turn of the millennium, publicly funded organizations in the culture and media sector have all defined and communicated what their societal missions are. In Norway, it is even suggested in official policy documents that culture organizations should use the notion of societal missions as part of their legitimation work (NOU 2013:4, 298–303).

The museum sector was the first part of the Norwegian culture sector where the concept of societal missions was employed in policy discussions (NOU 2013:4, 300). Other parts of the culture sector followed suit. An increased focus on societal missions does not mean that publicly funded cultural organizations in earlier times operated without such missions (e.g., Audunson 2005a). However, it does mean that societal missions during the twenty-first century have become important tools in organizational legitimation work for libraries, archives, and museums, as well as other organizations in the culture sector (Remlov 2012; Larsen 2014). Such missions are typically communicated in organizational documents like annual reports and strategy documents but may also be employed by managers performing legitimacy in mediated public spheres (e.g., see Larsen 2014).

Societal missions have become a useful concept, both for the organizations themselves and their funding bodies. Such a concept is meant to summarize the mission and worth of the organizations vis-à-vis funders and citizens, and effectively communicate the legitimacy of individual organizations to various audience groups. Being deeply rooted in values stemming from the Age of

the library sector having a crucial role in efforts related to national defense, both military and civil. It particularly emphasized that libraries are places that ensure that correct information is available to everyone. With this suggested new task, the decision of a number of municipalities to close their libraries during the coronavirus pandemic became especially problematic (Biblioteks-bladet 2020; Dahlin 2021). The proposed strategy has not yet been formalized through political processes, and the question has been raised as to whether it ever will be.

In Danish LAM legislation, the term "societal mission" is not explicitly employed, and there have as yet not been any public discussions concerning new societal roles for LAMs. As Rydbeck and Johnston (2020) state, Danish LAM legislation emphasizes "informed citizenry" (27) and "interconnectedness" (33) and is as such only indirectly focused on societal issues. However, Kann-Rasmussen (2016) has shown that managers of cultural organizations in the Scandinavian countries all point to a need for LAM organizations to be "relevant for society" as part of their quest for legitimacy. The managers interviewed in 2016 focused on two forms of societal relevance: The first was related to education and "bildung," pointing to traditional tasks of providing access to, and mediating, art and cultural heritage, a form of societal mission that is present in today's legislation. According to the managers, a second type of relevance could be achieved if LAMs sought to contribute to solving major issues in society related to climate change, health issues, or migration. However, Kann-Rasmussen also shows that the managers were unsure how to practically implement such forms of societal relevance. Nevertheless, in 2021, societal issues were present in the "framework agreements" of major national LAMs in Denmark. Framework agreements are policy documents linking the mission, vision, and objectives of publicly funded national cultural organizations. They are a certain type of contract between the organizations and the Ministry of Culture. These agreements state that, for example, the Danish National Archives (Rigsarkivet) must secure the memory of Denmark in a manner that *makes it valuable for society* (Kulturministeriet 2019 our emphasis), and that the Danish National Gallery (SMK) must be visible in Danish society and seek to improve creative and reflective abilities in Danish society (Kulturministeriet 2018). In Sweden, the National Archive is entrusted by the government to support democracy through its activities. It is even stated in the document accompanying the budget allocation from the Ministry of Culture to the Archive for 2021 that the Archive in its programming is to play a part in the national celebration of 100 years of women's suffrage (Kulturdepartementet 2020).

As can be seen from the above description of societal missions, societal issues are now integrated into organizational strategy documents, cultural policies, and framework agreements, which indicates that simply leaning on a high number of users, high quality, or excellence does not suffice as a source for legitimacy. Today, LAMs must also continuously prove their relevance and worth for society to secure widespread legitimacy.

LAMs and the concept of value

An ongoing trend in legitimating organizations in the culture sector is emphasizing the value of culture, narrowly defined. Several researchers have related the growing interest in the value and impact of culture to a legitimacy crisis in the culture sector. Crossick and Kaszynska (2016) and Phiddian et al. (2017) view demands for quantitative user surveys, research interest in the value of culture, and an increased interest in these topics from national and local cultural agencies as indicators of a legitimacy crisis. Others emphasize the lack of public discussion as a sign of declining legitimacy (Holden 2006; Hvenegaard Rasmussen 2018). A legitimacy crisis means that cultural organizations, such as LAMs, cannot maintain their legitimacy just by providing access to high-quality art and culture (Kann-Rasmussen 2019); they must do "something more," which can be related to societal missions or manifested in legitimation work striving to render their societal value more visible. In the following, we will present two theoretical contributions stemming from cultural economics and studies of public value, both of which have relevance for legitimating the public value of LAMs.

The underlying basis for cultural economics is that the value of culture and cultural institutions cannot be expressed in monetary or market value alone. Consequently, an important term is "nonmarket value." Market value is determined in the market and expressed as a price. Culture, along with most environmental goods and services, is characterized by their nonmarket value. They are not traded in markets. However, studies have shown that people are willing to pay for these nonmarket values through their taxes – even cultural activities that they never use themselves (Bille, Grønholm, and Møgelgaard 2016). LAM institutions, their collections, and practices are primarily defined by nonmarket values, such as option value, existence value, prestige value, education value, and bequest value (Frey and Pommerehne 1989). Cultural economist David Throsby (2001) furthermore introduces cultural values such as aesthetic value, spiritual value, social value, historical value, symbolic value, and authentic value. In the LAM field, it is reasonable to claim that nonmarket values are considerably higher than market values. Even so, contemporary LAM organizations need to navigate between the two sets of values in their legitimation work.

John Holden (2006) developed an influential analysis of how value is determined in different ways by different actors in the culture sector. He pinpoints three different types of values that cultural institutions represent. The first is the intrinsic value of art and culture. Here, value is created in the meeting between the user/consumer and the cultural artifact, e.g., in reading a book or contemplating a piece of art. Intrinsic value regards the individual and can be measured through personal accounts, qualitative assessments, and reviews. The second type of value in Holden's framework is institutional value. Institutional value regards the organization. We know, especially through Scandinavian research into LAMs, that the presence and activities of public cultural institutions

create value for a community and for society because they create trust and cohesion and function as public spheres (Audunson 2005b; Audunson et al. 2020a). According to Holden, institutional value is measured via feedback from users and audiences, but research on LAMs as places and public spheres shows that this value can also be measured through studies of the use and physical layout of particular LAM organizations. Institutional value is nevertheless difficult to measure. The same can be said for the third type of value, instrumental value, which regards society. This value is in focus when a cultural organization is used to achieve purposes outside of its artistic fields, e.g., for economic or social purposes. These types of values are measured in terms of output, outcome, and impact. But Holden, as well as a number of cultural policy researchers (Duelund 2003; Belfiore 2004), demonstrates that it is difficult to show a causal connection between investments in cultural institutions and economic or social improvements. Using an argument from welfare economics, Bille (2016) notes that using economic impact as a legitimating argument for investments in LAMs is flawed: Although some cultural activities have economic impact (e.g., in the form of job creation), it should not be used as an argument in itself, because all economic activity has an economic impact to varying degrees. Instead, if economic impact is to be used as an argument for cultural subsidies, the effects must be compared with the effects of alternative uses of the money. If the purpose was to create jobs, it would no doubt be better for the municipality to support something other than a library, an archive, or a museum.

The typologies of values can be regarded as languages that different actors can employ in their legitimation work. By looking into how these languages are employed by legitimation actors, we will enhance our understanding of organizational legitimation work in contemporary LAMs. As an illustration of how notions of value influence legitimation work, we discuss below two recent reports on Danish public libraries.

The first report, "The Economic Value of Public Libraries" (Folkebibliotekernes samfundsøkonomiske værdi) (Jervelund et al. 2015), was part of a project led by the Danish Library Association and supported by the Danish Agency for Culture in 2015. The authors of the report are under the impression that libraries too often are measured only in outputs (such as lending figures). Instead, the authors of the report argue that libraries should emphasize their economic value. Through an analysis of citizens' willingness to pay for libraries, they conclude that Danish libraries are worth DKK2.5 billion more than actual costs. Furthermore, the authors estimate that the "true" economic value of Danish public libraries is close to DKK2 billion of annual GDP. This economic value is primarily linked to a strengthening of children's reading skills. Upon publication, the authors of the report received heavy criticism from researchers and cultural workers. The critique focused on how such legitimation work could be counterproductive, in that the report appeared to inflate all the positive effects of the libraries.

A more recent report, "The Significance of the Public Library for the Citizens of Denmark" (Folkebibliotekets betydning for borgerne i Danmark) (Seismonaut

and Bibliotekerne 2021), focuses on the intrinsic and institutional value of public libraries. The report takes departure in citizens' first-hand, individual experience of the library, and criticizes the growing focus on the social impact of cultural institutions. The report goes on to conclude that libraries create values across four dimensions: (1) by being a space for contemplation; (2) by providing perspectives on life; (3) by stimulating creativity; and (4) by stimulating community and togetherness. The authors try to highlight the value of public libraries differently than through economic value. However, even this report might be criticized for its one-sided presentation of public libraries, along the same lines as the report using cultural economics.

This section has shown how emphasizing different types of values related to public libraries can be of benefit to library actors engaging in legitimation work. Values constitute a language to be employed in organizational legitimation work, but legitimation work is difficult, and it can result in unintended consequences if one does not strike the right balance when relating to the various audiences for the legitimation work. In the following sections, we will show how even professionals and "the national" are key elements in contemporary legitimation work.

The role of the professionals in legitimating LAMs

Over time, formal requirements for working at a library, an archive, or a museum have changed and evolved. The history of the professionals serving the three institutions differs in the timeline of changes and the emphasis on the requirements, as described in the first part of this book. However, a connection to science and university disciplines has always been important for the legitimacy of libraries, archives, and museums. Within the three institutions, a hierarchical division has often been drawn between curating and managing collections on the one hand, and serving the users on the other, with only the former requiring academic qualifications. The relevant academic training for working at LAMs has traditionally been offered in various academic disciplines such as history, archaeology, ethnology, art history, or literature. This landscape is changing due to the establishment of archival studies, library and information science (LIS), and museology as academic disciplines. Today, academic training is required for most LAM positions, even though there are differences between the library sector, the archival sector, and the museum sector when it comes to professionalization.

Recent developments related to school libraries in Sweden reveal these tensions: The Swedish Library Act (SFS 2013:801) has been criticized for not mentioning staff or their training, which has been problematized when seen in the light of the poor results of Swedish pupils in international school measures. As a consequence, the government launched an inquiry on school libraries with a view to investigating how school libraries could be strengthened to provide equal access to all pupils, and to have trained school librarians (Dir. 2019:91). The inquiry proposed the School Act to state that all school libraries be staffed,

and that staff should, as far as possible, have a degree in LIS (SOU 2021:3, 29–30). This proposition was welcomed by the professional sector (Andersson et al. 2021), including universities offering degrees in LIS. The inquiry suggested a model of supplementary training in LIS (60 ECTS) targeted at schoolteachers, who would then be qualified for working as school librarians (SOU 2021:3, Chapter 5). The suggestion relates to an ongoing debate on, and criticism of, teachers staffing school libraries. The proposition has not yet made its way through the political system, leaving open the question of whether the legislators are convinced that the proposal is a viable and fruitful development.

The Swedish Library Association has been involved in several actions directed at putting the issue of staffed school libraries on the political agenda and seeking to change the legislation for school libraries. These initiatives include supporting and hosting the interest group the National School Library Group (Nationella Skolbiblioteksgruppen) and promoting 27 October as School Library Day in Sweden.[3] In 2021, the day was celebrated by the two organizations at Linnaeus University, one of the Swedish universities with an LIS program. A short film targeting students to make them aware of the potentials in working as a school librarian was launched as well as the hashtag #skolbiblioteketsdag21.[4] These are all examples of how the professional organizations engaged in legitimation work targeted politicians and future librarians to raise awareness of the importance of trained librarians staffing school libraries.

The national and contemporary LAMs

As mentioned on several occasions in this book, notions of the national have played an increasingly important role in legitimating contemporary LAMs. In Norway, the national has gained importance since the 1990s in cultural policies (St.meld. nr. 61 (1991–92)), and it has become a tool for local and national policymakers, as well as LAM managers, when legitimating the establishment of buildings for national culture organizations in the nation's capital (Takle 2009, 183–184, 2010, 765–767). Since the turn of the millennium, a range of new buildings for art and culture have been established along the waterfront of Oslo. It all started with the construction of the opera house, which opened to the public in 2008. This was supposed to be, and became, a motor driving the city development in the harbor areas of the city (Sauge 2005, 76; Butenschøn 2013, 371, 380–381). As the opera house became a massive success, both among Norwegians and tourists, and a key element in the successful legitimation of opera and ballet in Norway (Larsen 2014), other cultural organizations, such as the National Museum of Art, Architecture, and Design (the National Museum), looked to its success as an inspiration when seeking to develop their own organization within a new building (Berg and Larsen 2020). The new National Museum, the most expensive house of culture ever built in Norway, and the largest art museum in the Nordic region, opened to the public on 11 June 2022.

In addition to the opera house and the National Museum, a range of other houses of culture have been established along the harbor in recent years: In 2021, a new Munch Museum opened for the public; in 2020, a new main building for the Deichman public library opened; a new museum building for the Astrup Fearnley Museet (contemporary art) opened in 2012; and there are discussions on building a new concert hall for the Oslo Philharmonic Orchestra as well as a photography museum in the harbor area. Even though some of these are owned by the municipality or a private foundation, they are all examples of the increased focus on houses of culture as important drivers for city harbor developments (Carlberg and Christensen 2005; Evjen 2015) and the creation of major tourist attractions in capital cities.

This increased focus on the national also demonstrates an element of state patronage in cultural policies, in terms of displaying the value of one's national culture both internally (to its own citizens) and externally (to citizens of other countries) (Abbing 2002, 240–247). This is explicit in the cultural polices of far-right political parties like the Danish People's Party, the Sweden Democrats, and the Norwegian Progress Party, which all have conservation and promotion of national culture as key parts of their cultural policies (Lindsköld 2015; Harding 2022). Since the turn of the millennium, the national has also become an important element for politicians and managers when legitimating the construction or establishment of national cultural organizations, such as national museums (Berg and Larsen 2020; Meld.St. nr. 23 (2011–2012), 163) or national libraries (Takle 2009, 2010). LAM organizations are important not only for preserving national history and culture but also for displaying for the world the worth of one's nation, its history, and artifacts (Aronsson and Elgenius 2015).

Conclusion

As seen through this chapter, societal missions, values, the professionals, and the national are important elements in the contemporary legitimation work of LAMs. Societal missions and values are important for demonstrating the worth of LAMs to society, as is the notion of the national for legitimating the construction of new buildings for national libraries, archives, or museums. The professionals, on the other hand, play an important role in demonstrating the worth of skilled staff at LAMs to politicians, universities, and managers at LAM organizations. All elements are important for maintaining and developing professional LAM organizations. As some see digitalization rendering LAM organizations less important, legitimation actors strive to prove differently. The future support of LAMs is dependent on continuous legitimation work on the part of key legitimation actors, such as professional organizations, LAM university departments, LAM managers, and cultural politicians. Despite their historical relevance and worth, LAMs cannot take their legitimacy for granted in the twenty-first century but should instead seek to actively convince society of their continued relevance and importance.

Notes

1 https://www.legislationline.org/download/id/1244/file/d79f42a78c20ace1b22935d 4971e.pdf (last accessed 22.6.2021).
2 The Government delegated to the National Library of Sweden to develop a library strategy, and the library decided to commission a group to write the report.
3 https://www.biblioteksforeningen.se/nyheter/skolbibliotekets-dag/ (last accessed 31.1.2022).
4 https://vimeo.com/623456029 (last accessed 31.1.2022).

References

Abbing, Hans. 2002. *Why Are Artists Poor? The Exceptional Economy of the Arts.* Amsterdam: Amsterdam University Press.

Anderson, Astrid, Cicilie Fagerlid, Håkon Larsen, and Ingerid S. Straume. 2017. "Åpne forskningsbibliotek. Innledende betraktninger." In *Det åpne bibliotek: Forskningsbibliotek i endring*, edited by Astrid Anderson, Cicilie Fagerlid, Håkon Larsen and Ingerid S. Straume, 11–21. Oslo: Cappelen Damm Akademisk.

Andersson, Johanna, Hanna Berg Carlsson, Liselott Drejstam, Maria Hultman Björn, Malin Holgerson, Kristina Schön, and Cecilia Välijeesiö. 2021. Yttrande från svenska skolbibliotek angående Skolbibliotek för bildning och utbildning SOU 2021:3.

Aronsson, Peter, and Gabriella Elgenius, eds. 2015. *National Museums and Nation-Building in Europe 1750–2010: Mobilization and Legitimacy, Continuity and Change.* London: Routledge.

Audunson, Ragnar. 2005a. "Norwegian Libraries: An Institution Caught between Differing Social Conflicts and Opinions." In *Knowledge and Culture: Norwegian Libraries in Perspective*, edited by Lars Egeland and Tonje Grave, 31–52. Oslo: National Library of Norway.

Audunson, Ragnar. 2005b. "The Public Library as a Meeting-place in a Multicultural and Digital Context: The Necessity of Low-intensive Meeting-places." *Journal of Documentation* 61, no. 3: 429–441. https://doi.org/10.1108/00220410510598562.

Audunson, Ragnar, Herbjørn Andresen, Cicilie Fagerlid, Erik Henningsen, Hans-Christoph Hobohm, Henrik Jochumsen, Håkon Larsen, and Tonje Vold, eds. 2020a. *Libraries, Archives and Museums as Democratic Spaces in a Digital Age.* Berlin: De Gruyter Saur. https://doi.org/10.1515/9783110636628.

Audunson, Ragnar, Herbjørn Andresen, Cicilie Fagerlid, Erik Henningsen, Hans-Christoph Hobohm, and Håkon Larsen. 2020b. "Introduction – Physical Places and Virtual Spaces. Libraries, Archives and Museums in a Digital Age." In *Libraries, Archives and Museums as Democratic Spaces in a Digital Age*, edited by Ragnar Audunson, Herbjørn Andresen, Cicilie Fagerlid, Erik Henningsen, Hans-Christoph Hobohm, Håkon Larsen and Tonje Vold, 1–22. Berlin: De Gruyter Saur. https://doi.org/10.1515/9783110636628-001.

Belfiore, Eleonora. 2004. "Auditing Culture." *International Journal of Cultural Policy* 10, no. 2: 183–202. https://doi.org/10.1080/10286630042000255808.

Berg, Ida Uppstrøm, and Håkon Larsen. 2020. "Et demokratisk flerbrukshus eller en lukket safe? Idealer for og oppfatninger av det nye Nasjonalmuseet på Vestbanen." In *Rød mix. Ragnar Audunson som forsker og nettverksbygger*, edited by Sunniva Evjen, Heidi Kristin Olsen and Åse Kristine Tveit, 213–231. Oslo: ABM-Media.

Biblioteksbladet. 2020. *Att spela roll i kris och krig.* 2020 (3). Svensk Biblioteksförening.

Bille, Trine. 2016. "Hvorfor kulturpolitik?" *Nordisk Tidsskrift for Informationsvidenskab og Kulturformidling* 5, no. 2: 5–9. https://doi.org/10.7146/ntik.v5i2.25855.

Bille, Trine, Adam Grønholm, and Jeppe Møgelgaard. 2016. "Why Are Cultural Policy Decisions Communicated in Cool Cash?" *International Journal of Cultural Policy* 22, no. 2: 238–255. https://doi.org/10.1080/10286632.2014.956667.

Boltanski, Luc, and Laurent Thévenot. 2006. *On Justification: Economies of Worth.* Princeton, NJ: Princeton University Press.

Buschman, John E. 2003. *Dismantling the Public Sphere: Situating and Sustaining Librarianship in the Age of the New Public Philosophy.* Westport, CT: Libraries Unlimited.

Butenschøn, Peter. 2013. *Oslo. Steder i byen.* Oslo: Forlaget Press.

Carlberg, Nikolai, and Søren Møller Christensen. 2005. *Byliv og havnefront.* Copenhagen: Museum Tusculanums Forlag.

Crossick, Geoffrey, and Patrycja Kaszynska. 2016. *Understanding the Value of Arts & Culture | The AHRC Cultural Value Project.* Swindon: Arts & Humanities Research Council.

Dahlin, Johanna Alm. 2021. *Bibliotek i kristid: En rapport om hur biblioteken och de anställda har påverkats av coronapandemin.* DIK 2021:4.

Dir. 2019:91. *Stärkta skolbibliotek och läromedel.* Stockholm: Utbildningsdepartementet.

Duelund, Peter, ed. 2003. *The Nordic Cultural Model.* Copenhagen: Nordic Cultural Institute.

Evjen, Sunniva. 2015. "The Image of an Institution: Politicians and the Urban Library Project." *Library and Information Science Research* 37: 28–35. https://doi.org/10.1016/j.lisr.2014.09.004.

Fichtelius, Erik, Christina Persson, and Eva Enarson. 2019. *The Treasure Trove of Democracy: Proposal for a National Strategy for Libraries.* Stockholm: National Library of Sweden.

Frey, Bruno, and Werner W. Pommerehne. 1989. *Muses and Markets: Explorations in the Economics of the Arts.* Cambridge, MA: Blackwell.

Goulding, Anne. 2013. "The Big Society and English Public Libraries: Where Are We Now?" *New Library World* 114, no. 11/12: 478–493. https://doi.org/10.1108/NLW-05-2013-0047.

Greene, Margaret, and David McMenemy. 2012. "The Emergence and Impact of Neoliberal Ideology on UK Public Library Policy, 1997–2010." In *Library and Information Science Trends and Research: Europe*, edited by Amanda Spink and Jannica Heinström, 13–41. Emerald Group Publishing Limited. https://doi.org/10.1108/S1876-0562(2012)0000006005.

Harding, Tobias. 2022. "Culture Wars? The (Re)Politicization of Swedish Cultural Policy." *Cultural Trends* 31, no. 2: 115–132. https://doi.org/10.1080/09548963.2021.1971932.

Harvey, David. 2005. *A Brief History of Neoliberalism.* Oxford: Oxford University Press.

Holden, John. 2006. *Cultural Value and the Crisis of Legitimacy: Why Culture Needs a Democratic Mandate.* London: Demos.

Hvenegaard Rasmussen, Casper 2018. "Der er ingen stemmer i kulturpolitik." *Nordisk kulturpolitisk tidsskrift* 21, no. 2: 226–245. https://doi.org/10.18261/ISSN2000-8325-2018-02-06.

Jervelund, Christian, Anders Oskar Kjøller-Hansen, Jossi Steen-Knudsen, and Johanne Jørgensen. 2015. *Folkebibliotekernes samfundsøkonomiske værdi.* Copenhagen: Tænketanken Fremtidens Biblioteker.

Kann-Rasmussen, Nanna. 2016. "For samfundets skyld – Kulturlederes forestillinger om legitimitet og omverden." *Nordisk kulturpolitisk tidsskrift* 19, no. 2: 201–221. https://doi.org/10.18261/ISSN2000-8325-2016-02-04.

Kann-Rasmussen, Nanna. 2019. "The Collaborating Cultural Organization: Legitimation through Partnerships." *Journal of Arts Management, Law, and Society* 49, no. 5: 307–323. https://doi.org/10.1080/10632921.2019.1646175.

Kann-Rasmussen, Nanna, and Elsebeth Tank. 2016. "Strategi som legitimitetsarbejde: Strategiske svar på bibliotekernes udfordringer." *Nordisk tidsskrift for Informationsvitenskab og Litteraturformidling* 5, no. 3: 5–19. https://doi.org/10.7146/ntik.v5i3.25786.

Kann-Christensen, Nanna, and Jack Andersen. 2009. "Developing the Library." *Journal of Documentation* 65, no. 2: 208–222. https://doi.org/10.1108/00220410910937589.

Kulturdepartementet. 2020. *Ku2020/02624. Regleringsbrev för budgetåret 2021 avseende Riksarkivet.* Stockholm: Kulturdepartementet.

Kulturministeriet. 2018. *Rammeaftale: Statens Museum for Kunst 2018–2021.* Copenhagen: Kulturministeriet.

Kulturministeriet. 2019. *Rammeaftale: Rigsarkivet 2019–2022.* Copenhagen: Kulturministeriet.

Larsen, Håkon. 2014. "Legitimation Work in State Cultural Organizations: The Case of Norway." *International Journal of Cultural Policy* 20, no. 4: 456–470. https://doi.org/10.1080/10286632.2013.850497

Larsen, Håkon. 2016. *Performing Legitimacy: Studies in High Culture and the Public Sphere.* Cham, Switzerland: Palgrave Macmillan. https://doi.org/10.1007/978-3-319-31047-3.

Larsen, Håkon. 2017a. "Aktivering av nasjonens hukommelse: Nasjonalbiblioteket i offentligheten." In *Det åpne bibliotek. Forskningsbibliotek i endring,* edited by Astrid Anderson, Cicilie Fagerlid, Håkon Larsen and Ingerid S. Straume, 51–70. Oslo: Cappelen Damm Akademisk.

Larsen, Håkon. 2017b. "The Public Sphere as an Arena for Legitimation Work: The Case of Cultural Organizations." In *Institutional Change in the Public Sphere: Views on the Nordic Model,* edited by Fredrik Engelstad, Håkon Larsen, Jon Rogstad and Kari Steen-Johnsen. Warzaw: De Gruyter Open. https://doi.org/10.1515/9783110546330-011.

Lindsköld, Linnéa. 2015. "Contradicting Cultural Policy: A Comparative Study of the Cultural Policy of the Scandinavian Radical Right." *Nordisk kulturpolitisk tidskrift* 18, no. 1: 8–27. https://doi.org/10.18261/ISSN2000-8325-2015-01-02.

Meld.St. nr. 23 (2011–2012). *Visuell kunst.* Oslo: Kulturdepartementet.

Meyer, John W., and W. Richard Scott. 1983. "Centralization and the Legitimacy Problems of Local Government." In *Organizational Environments: Ritual and Rationality,* edited by John W. Meyer and W. Richard Scott, 199–215. Beverly Hills, CA: Sage.

NOU. 2013:4. *Kulturutredningen 2014.* Oslo: Kulturdepartementet.

Phiddian, Robert, Julian Meyrick, Tully Barnett, and Richard Maltby. 2017. "Counting Culture to Death: An Australian Perspective on Culture Counts and Quality Metrics." *Cultural Trends* 26, no. 2: 174–180. https://doi.org/10.1080/09548963.2017.1324014.

Remlov, Tom. 2012. "Å finne sin plass. En ny tid for europeiske kulturinstitusjoner." *Samtiden* 92, no. 1: 92–99. https://doi.org/10.18261/ISSN1890-0690-2012-01-07.

Rivano Eckerdal, Johanna, and Hanna Carlsson. 2018. *Styrdokumenten i vardagen: En undersökning av kulturpolitiska styrdokuments strategiska och praktiska betydelse för folkbibliotek i fem skånska kommuner.* Lund: Lund University.

Rydbeck, Kerstin, and Jamie Johnston. 2020. "LAM Institutions: A Cross-contry Comparison of Legislation and Statistics Services and Use." In *Libraries, Archives and Museums as Democratic Public Spaces in a Digital Age,* edited by Ragnar Audunson, Herbjørn Andresen, Cicilie Fagerlid, Erik Henningsen, Hans-Christoph Hobohm, Henrik Jochumsen, Håkon Larsen and Tonje Vold, 25–52. Berlin: De Gruyter Saur. https://doi.org/10.1515/9783110636628-002.

Sauge, Birgitte. 2005. "Arv og kreativitet." In *Hundre års nasjonsbygging. Arkitektur og samfunn 1905–2005,* edited by Ulf Grønvold, 61–77. Oslo: Pax forlag.

Scott, W. Richard. 2014. *Institutions and Organizations: Ideas, Interests, and Identities.* 4th ed. Thousand Oaks, CA: Sage.

Seismonaut, and Roskilde Bibliotekerne. 2021. "Folkebibliotekets betydning for borgerne i Danmark." https://centralbibliotek.dk/sites/default/files/dokumenter/ Folkebibliotekets_betydning_for_borgerne_i_Danmark_Rapport.pdf

SFS. 2013:801. *Bibliotekslag.* Stockholm: Kulturdepartementet.

Solhjell, Dag, and Jon Øien. 2012. *Det norske kunstfeltet: en sosiologisk innføring.* Oslo: Universitetsforlaget.

SOU. 2021:3. *Skolbibliotek för bildning och utbildning.* Stockholm: Utbildningsdepartementet.

St.meld. nr. 61 (1991–92). *Kultur i tiden.* Oslo: Kulturdepartementet.

Takle, Marianne. 2009. *Det nasjonale i Nasjonalbiblioteket.* Oslo: Novus.

Takle, Marianne. 2010. "National Reproduction: Norway's New National Library." *Nations and Nationalism* 16, no. 4: 757–773. https://doi.org/10.1111/j.1469-8129.2010.00450.x.

Throsby, David. 2001. *Economics and Culture.* Cambridge: Cambridge University Press.

14

LAMS AND COMMUNITY

Deepening connections

Jamie Johnston, Henrik Jochumsen, and Samuel Edquist

Introduction

The different ways Scandinavian libraries, archives, and museums (LAMs) have related to, and supported, their respective communities have varied greatly. National museums and archives were founded for the national community and others were founded for regional or local communities. Other museums and archives have focused on particular social classes (e.g., labor movement archives and museums) or nations or ethnic groups (e.g., Sámi archives or Jewish museums). National and royal libraries were founded for the national communities, whereas public libraries have had the municipality as their legal base and have been tasked with serving the local community in its entirety. Historically, LAMs have played a central role in constructing and demarcating the community, or the community narrative. However, nowadays, LAMs are increasingly responding to the diversity in their communities and adopting more inclusive and participatory practices with the aim of strengthening and broadening community ties. This aim can be seen as a result of the institutions' increased awareness and desire to foster civic engagement and equality in the communities they serve, and thereby strengthen democracy. It can also be seen as a result of their increased need for legitimation – a need to demonstrate their relevance to the community or communities they serve. This chapter reflects on the conceptualization of community and its role within the context of the Scandinavian LAMs. A model is presented for understanding the various ways in which LAMs support deepening community connections, and typologies are given on LAM community collaborations and partnerships. Lastly, the chapter offers critical reflections on the aims of the LAMs' community engagement and their need for legitimation.

DOI: 10.4324/9781003188834-17

Community and democracy

Democracy is an open system with the ability to encompass both critical remembrance and renewal. Its distinguishing feature is that it gives the state and society at large the opportunity to discuss the rules of democracy, deliberate about their common affairs, and search together for solutions to current and future challenges (European Commission 2018). The public sphere, in the Habermasian sense, is an institutionalized arena of discursive interaction; it is the social realm in which citizens deliberate about their common affairs (Fraser 1990; Habermas 1974). Facilitating an informed and enlightened public discourse is central to the social roles, or missions, of LAMs as public sphere institutions. This is done through the provision of collections and serving as meeting places and arenas for discussion (Rydbeck and Johnston 2020). However, of great concern for our democracies and an immense challenge faced by the LAMs is the fact that the interaction between the diverse groups in our communities has been in decline.

Political scientist Robert Putnam (2001) in his groundbreaking book *Bowling Alone: The Collapse and Revival of American Community* documents the decline in civic engagement and the subsequent lack of connection amongst Americans. He cautions how the breakdown of social ties hinders the creation and maintenance of a society that is secure, vibrant, and cohesive, thereby stressing the need to foster social ties and connectedness for the revitalization of community. Another concern related to the breakdown of community is social fragmentation. Sociologist Judit Bodnár (2001) argues that social fragmentation is a recurrent theme of modernity arising from the apparent tension between the heterogeneity of citizens and their quest for unity, between the acknowledgment and support for diversity and the formation of a shared identity. However, she notes that the meaning of fragmentation has varied historically and that new forms of fragmentation have resulted from greater urban spatial transformation and digitalization. These new forms are increasingly characterized by a loss of ties, depth, and intensity of social relations. This fragmentation naturally has implications for fostering connectedness in increasingly diverse communities and, ultimately, for democracy.

This breakdown of community and the formation of communities through one's multiple affiliations raises the question: What constitutes a community? The word "community" stems from Latin *communis*, which means "shared by many". In the modern meaning, a community is a unified body of individuals or groups within the larger society. Communities can be geographically bound or dispersed. They can also be based on mutually shared beliefs, values, culture, history, or interests. Communities are essentially networks of relationships. These relationships comprise the affective dimension of a community, though they may vary in type and strength. A sense of community results from the formation of affective ties between community members; involvement in a community may help the members to achieve a sense of belonging (Sullivan 2009).

A closer investigation of the unifying aspects of a community is needed in order to understand and reflect on LAMs' relationships with their communities.

Author and consultant Charles Vogl (2016) emphasizes that community is a group of individuals who share mutual concern for one another's welfare and is distinct from groups who share ideas or interests due to proximity but lack concern for one another. He specifies groups such as medical associations, environmental organizations, and – of relevance to this chapter – members of museums as groups who share something in common but lack social connectedness. This relates to Putnam's (2001) statement that

> [these groups] root for the same team and they share some of the same interests, but they are unaware of each other's existence. Their ties, in short, are to common symbols, common leaders, and perhaps common ideals, but not to one another.
>
> *(p. 71)*

However, as will be discussed further, central to the *from collection to connection* paradigm shift occurring across LAMs, the institutions are moving away from disconnected users/members and are focusing instead on fostering connections between them (Lankes 2011).

How are community ties formed? Author and speaker Peter Block (2008) asserts that community is an interdependent human experience that is given form by conversation between citizens. He asserts that the conversations that build relatedness most often occur through associational life and that the small group is the unit of transformation. This transformation comes from shifting our attention from the problems of community to the possibility of community. It requires a focus on the gifts (e.g., knowledge, understandings, abilities, etc.) of the community members and the associated possibilities rather than on the ways in which community members may be deficient and how the community may be lacking. It develops from informed conversations that are forward-looking and shifts the power to act to the community members themselves. Block further states: "The social fabric of a community is shaped by the idea that only when we are connected and care for the well-being of the whole is a civil and democratic society created" (p. 9). Applying this to LAMs, it implies the importance of fostering meaningful engagement that can lead to the formation of affective ties as part of the LAMs' shift from being collection to connection focused.

Fostering social connectedness is, however, not unproblematic. Community change facilitator and author Paul Born (2014) notes that community as a concept is neutral – neither inherently good nor bad. He also differentiates between deep communities that are made of strong bonds based on ongoing connection and mutual caring and shallow communities that are made of weak bonds and are based on noncommittal activities that do not require ongoing connection and mutual caring. He also cautions that communities can be based on fear and othering. These communities are generally formed around community members' self-interest and an us-against-them ideology. Lastly, he emphasizes that in today's socially fragmented societies, people must choose which community or

communities they want to be their deep communities, yet also acknowledges that this "choice" may be based on external circumstances and less on people's individual choice, such as in the case of segregation or marginalization of particular social groups. These issues related to community challenge the traditional LAM ideals of neutrality and impartiality.

Although the Scandinavian welfare states are relatively homogeneous and egalitarian as compared with many other countries, they are also affected by social fragmentation and the apparent lack of depth in social relations that characterize modernity, as discussed above. The rest of this chapter will consider Scandinavian LAMs' relationships with their communities, both past and present, how the LAMs foster a deepening of social connections, the nature of the institutions' community collaborations and partnerships, and lastly, the challenges inherent in LAM community involvement.

A historical glance at LAM community relations

The histories of communities and LAM institutions are intertwined. National libraries are closely linked to the idea of the nation and their community is the nation at large; hence national libraries have the duty of collecting and preserving the nation's literature as part of the cultural heritage to pass on to future generations (Chapter 2, this volume). Locally organized book collections and associations were replaced by public libraries in the latter half of the nineteenth century and early twentieth century with the intention of supporting and promoting access to information, education, and reading in local communities. This resulted from the development of the Scandinavian welfare state that situated the local public library as a central institution for democratizing access to culture regardless of geographical location. The expansion of the welfare state subsequently led to a significant increase in the number of local libraries. While national and public libraries have been rooted in the national and local communities, university libraries are inherently linked to the emergence of universities in Europe that began in the fifteenth century and, accordingly, modern university libraries are tasked with supporting their respective universities and research communities. School libraries have developed from bookcases with edifying reading to pedagogical development centers. The school library communities are made up of students and teachers and, to some degree, the students' parents.

The establishment of national museums was often one of the many tools used in the nineteenth and twentieth centuries for fostering the imagined community of both old and new nation states. This was also the case in the Scandinavian countries. The purpose of establishing museums was to represent the glorious – or glorified – past of the respective nations (Anderson 1983; Aronsson and Elgenius 2015). Similarly, regional and local museums have historically aimed at cultivating corresponding identities. Formal national archival institutions were also established from the nineteenth century. They assumed the traditional role of keeping records for the benefit of the state along with the new purpose

of functioning as the nation's treasure house, where historians could retrieve sources for nationalist historiographies that constituted another important tool in (national) community making (Berger 2013). Archival institutions in municipalities and towns gradually developed a similar role and archival institutions based on class, ethnicity, religion, or sexual orientation were then established for the purpose of safeguarding and nurturing community and identity building. In anglophone settings, the latter type of archives is often labeled "community archives" (e.g., Bastian and Alexander 2009; Caswell 2014).

Libraries' community relations

In the twenty-first century, national libraries are increasingly opening their doors to the public and, in some cases, aiming to serve as *third places*, which are conceptualized by Ray Oldenburg (1999) as informal social arenas between home ("first" place) and work ("second" place) where people of different backgrounds gather and engage in community life. An example of this is the recent addition of a cafe and bar at Norway's National Library as well as its programming and services aimed at a broad spectrum of publicum, both in the physical library and digitally. Increasingly, university libraries are also serving as meeting places with programming and provision of social spaces (Anderson et al. 2017). Community building and development have been a central focus of public libraries' work for the past two decades. This is seen in their extended outreach to local communities and in their serving as arenas for integration for newly arrived immigrants and refugees; thus, public libraries will be the main type of library focused on in the rest of this chapter.

Within the library sphere, there has been a predominance of conceptualizing "communities" as the group or groups of users that the institutions aim at reaching out to, for example, the people living in the municipality where a public library is located. Libraries, throughout their history, have been regarded as important tools in fostering democracy and a civic culture. Nowadays, there is a general tendency for libraries to find new and creative ways of engaging with their surrounding community, which is conceptualized primarily in a civic manner rather than by such things as national origin, language(s) spoken, sexual orientation, and/or social class. However, many libraries may still focus their outreach efforts on specific groups or types of users, such as young men or immigrants, because they are often underrepresented amongst library users and regarded as needing to be drawn in or integrated into the local civic community.

The work of library science researchers Anne Goulding and David Lankes is especially relevant concerning the library's role in Scandinavian communities. Goulding (2009) emphasizes how the public library has been repositioned not just as a place to borrow or read books, or even to access digital materials, but as a critical resource and facility that can serve as a venue for community events. It also serves as a meeting place where people can connect with their local communities and wider society. Lankes (2011) stresses that the mission of librarians

is to improve their communities by being radical positive change agents and by facilitating knowledge creation within their communities. Knowledge creation, he asserts, is achieved through the facilitation of conversation.

Sociologist Eric Klinenberg's (2019) writing on US public libraries, which he refers to as "palaces for the people," is also relevant to the Scandinavian context. He argues that public libraries serve as crucial social infrastructures that support community life by fostering social cohesion amongst community members and by giving people of diverse backgrounds opportunities for civic engagement. Library science researcher Rachel Scott's (2011) investigation into the role of public libraries is also relevant. She designates five areas in which libraries contribute to community building, namely libraries serving as a conduit to access information and learn, encouraging social inclusion and equity, fostering civic engagement, creating a bridge to resources and community involvement, and promoting economic vitality with the community.

In the Scandinavian context, researchers inspired by philosopher Jürgen Habermas's (1974) concept of the public sphere and the work of sociologists such as Robert Putnam, Richard Sennett, and Ray Oldenburg, as well as critical theorist Nancy Fraser, have examined how the library as a meeting place in the community can contribute to democratic conversation, support cohesion, and help build social capital amongst citizens by serving as a bridge between different groups in society (Audunson et al. 2019, 2020).[1]

Archives and museums' community relations

The ways in which LAM institutions relate to, and are involved in, their communities differ vastly. This is because LAMs have varied aims and traditions and, even more importantly, because communities can be very diverse. Archives and museums are heritage institutions to a greater degree than libraries and have long traditions of so-called "identity politics," from the nineteenth century onward to the present day. The concept of *community* in these spheres is closely connected to communities that are represented by the collections held in archives and museums – communities that are founded on certain group characteristics such as national origin, social class, and/or gender. This type of representation generally takes one of two directions. The most common is that of archives or museums being demarcated by the community group in question, such as a national museum or an LGBTQ archive, and the other one is that of external users using the institutions' collections for their community-building activities, which are also often based on the same types of demarcations.

In recent years, however, there has been an observable development in which museums are increasingly turning to the local community to ensure their continued relevance. This development can be seen as part of the so-called "new museology," which, amongst other things, involves a redefinition of the relationship between museums, citizens, and communities. The trend-setting museum director Nina Simon (2016) argues that by increasing the understanding of the

circumstances, desires, and needs that characterize the surrounding local community, a museum can change its own significance and relevance to the local community's citizens. However, according to Simon, this requires an understanding, responsiveness, and acceptance of the local community's input, which necessitates the museum's involvement in the community and willingness to assume a degree of risk.

In recent decades, the dominant discourses on heritage both in academia and public policy have come to acknowledge and address the historicity and contingency of all communities and the power aspects that have accompanied community building – not least those kinds of dominant community categories that archives, and particularly museums, have been instrumental in constructing and reproducing. In museum studies, the concept of "authorized heritage discourses" (Smith 2010) – largely coinciding with a postcolonial cultural critique – has become widely used to analyze museums' activities. For example, this is seen in the subfield of critical heritage studies and is also increasingly used by professionals in the institutions. Accordingly, publicly funded museums, and to some degree archives, in Scandinavia critically reflect on their own past and their roles in establishing nationalist master narratives that have resulted in the marginalization of particular groups, including women, workers, and minorities (Goodnow and Akman 2008; cf. Maliniemi 2009). Museums and archives have responded in varying degrees by reaching out to their actual or potential users in these communities. This has led them to increasingly involve community members rather than internal "experts," since it was the specialized and often academically trained experts within the institutions who contributed to, and ultimately shaped, the narrow and elitist nationalist community (Golding and Modest 2016).

Progression to connection

Born (2014), building upon Peter Block's (2008) statement that communities are human systems given form by conversations that build relatedness, asserts that the deepening of community starts with the sharing of stories as a way to open up to one another and enter into conversations that build relatedness. We might ask how, in concrete terms, LAMs can facilitate conversations that foster connection, relatedness, and ultimately belonging. Since the early 2000s, as previously noted, LAMs have been undergoing a paradigm shift from *collection to connection*. They are moving away from focusing solely on providing experiences and towards creating opportunities for ongoing, meaningful engagement, thus shifting from communities of card-holding members who have no relation with each other to fostering connections between members and nurturing deeper community connections. In the broadest sense, LAMs are increasingly aiming to foster the conversations and meetings needed for people and social groups to share their stories with one another and create new ones (e.g., Johnston 2018; Ulvik 2010).

The way the Scandinavian LAMs are making this shift from collection to connection can be seen in their ability to support varying levels of

community involvement and progression from noncommittal experiences to deeper community involvement in ways that allow individuals to share their gifts (knowledge, understandings, etc.) with each other and the broader community. This can be related to Charles Vogl's Inner Rings Principle (2016). He asserts that strong communities are made up of different levels of inner rings that community members can take part in. Each level offers benefits to the members' development or formation, such as new learning or knowledge-sharing opportunities, acknowledgment, or authority. Members may choose to stay at a particular level or journey into the successive inner rings. Strong or deep communities generally offer a way for members to progress, and thereby grow and develop. Interestingly, these paths of progression result in members' focus on self diminishing and the concern for others growing. The smaller and more exclusive the ring, the broader the concern for others.

The authors of this chapter have adapted the Inner Rings principle to the various ways LAMs engage with their communities to illustrate how the respective institutions support users', volunteers', and groups' involvement in the community and how the LAMs facilitate community members' and groups' ability to meet, converse, and exchange their stories and thereby deepen their community connections.

Inner Rings principle adapted to LAMs

Users (passive) seek novelty or fun experiences. Focus is primarily on self. LAM use is based on noncommittal experiences, such as attending a program or exhibition, enjoying the cafe or using the premises (e.g., as a plaza for social interaction).

Users (active) seek personal achievement, connection, or validation. LAM use includes active participation in programs (e.g., book group, makerspace, and children's programming) and/or the use of information and knowledge sources in pursuit of interests or research.

Volunteers are primarily concerned for their neighbors and the immediate local environment as well as connecting with others in the community. They generally dedicate time to promoting learning and may mentor others, such as providing homework help, teaching ICT skills, volunteering at a language café, and so on.

Collaborators (local community) work to improve conditions or develop initiatives in the local community. Collaborators may be other community organizations or communities with which a LAM collaborates. Examples might be groups of heritage or local history groups, coordinators for community archives, cultural or ethnic groups, and so on.

Collaborators (broader community) work to improve conditions or develop initiatives for the broader community. They may do this by connecting the local community with other similar communities nationally or internationally. Collaborators can be other community organizations or source communities with which the LAM collaborates.

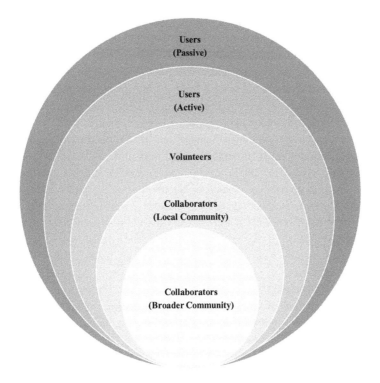

FIGURE 14.1 LAM inner community rings.

There is naturally some overlap between the different rings and people may enter into the multiple levels depending on their interest in the various subjects, activities, and/or areas of focus across the institutions. For example, a visitor may be a member of a particular cultural group, but not interested in anything more than experiencing the representation of their culture. However, that experience may inspire them to progress through the rings and contribute more actively to the community, to share their story and knowledge with others. Importantly, the rings represent the way LAMs facilitate conversations that address the possibility of community and engender the formation of affective ties between community members, all of which is essential for the formation of the public sphere and fostering of democracy.

Collaboration and partnerships

Scandinavian public libraries have a long tradition of collaborating with different partners in the local community. However, they have primarily been collaborators closely related to the libraries, such as educational institutions and local cultural offerings. In recent years, libraries have appeared to be focusing on new and more untraditional partners, including the private business community and civil

society. These new partnerships are generally aimed at strengthening libraries' relations with the local community and/or developing new library services and programs. There can be many reasons driving this development. Firstly, there appears to be a new willingness and desire amongst library professionals to enter into more dynamic relationships with their communities. Secondly, the development might also be due to external changes that affect libraries, such as new technologies that reduce libraries' dependency on physical collections and changes in user expectations. Thus, the legitimacy of the library becomes more dependent on what the library can contribute to the users and the surrounding society. However, due to reduced public resources for libraries to draw upon, they are forced to focus primarily on what is of the greatest relevance to citizens, users, and potential partners (Hvenegaard Rasmussen, Jochumsen, and Skot-Hansen 2011; Chapter 13, this volume). The following is a typology of the collaborations and partnerships that libraries are increasingly entering into:

Libraries and private sector: Collaboration between public libraries and local trade associations to create more attractive town centers.

Libraries and volunteers: Collaboration between the library and volunteers to present different types of work and career opportunities to young people or to help foster tolerance and understanding by facilitating meetings between people with different backgrounds.

Libraries and the public sector: Collaborations between public libraries, universities, and schools of architecture to bridge the virtual and physical space of the library.

Libraries and NGOs: Collaboration between libraries and various "green" NGOs to support and promote sustainability and the Sustainable Development Goals of the UN (Chapter 16, this volume).

Archives and museums engage in similar types of collaborations and partnerships, but also in unique types of their own. Since the 1970s, there has been a general upsurge of grassroots amateur historian movements in the Scandinavian countries. Archivists have been active in assisting people with researching the history of their immediate context, such as their workplace or the immediate geographical area.

Archives, museums, and user participation: Collaboration with users to expand or refine collections through user-contributed texts, photos, and other records or artifacts, or through larger crowdsourcing projects that invite users to contribute to their knowledge and/or other holdings to the institutions.

Archives and local history groups: Promotion of public participation in historical research, especially labor history, through emancipatory local history endeavors. In Sweden, this phenomenon is often referred to as the *dig-where-you-stand* movement.

Archives and businesses: Utilization of a business's archival records to develop its public image through the dissemination of its history.

Archives, museums, and educational institutions: Collaboration with educational institutions in the public sector to promote learning and informal education.

Partnerships and collaborations in various forms with the surrounding local community are a way to strengthen the societal relevance and legitimacy of Scandinavian LAMs. At the same time, such relationships can support the institutions' current objectives of incorporating more inclusive and participatory practices (Chapter 12, this volume). Against this background, it will undoubtedly be an area that LAMs will develop significantly in the coming years.

Challenges of community relationships

Collaborations and partnerships are important for sharing the stories of diverse community groups and ensuring that relevant conversations take place. Writing from a participatory heritage perspective, Henriette Roued-Cunliffe and Andrea Copeland (2017) emphasize that heritage institutions (LAM institutions) increase their capacity for building more inclusive and culturally relevant collections by forming relationships with various groups. It is through these partnerships that the institutions become exposed to a broader scope of heritage topics and thereby are better positioned to help those communities that are not as capable of telling their own stories.

The nature of the relationships that LAMs establish with various community groups will vary. Generally, the institutions' involvement in their communities has two dominant aspects. One aspect is LAMs' support for the empowerment of individuals and groups in their communities. This is seen in the LAMs' activities aimed at fostering a sense of belonging and providing the tools needed for improving community members' situation or for gaining recognition from the surrounding society. This largely coincides with the broader aims of community building and strengthening democracy. The other aspect is the institutions' aim to elicit justification or a legitimation of the interests or social position of the community or a particular group. In many cases, empowerment and justification have been combined, not least in the case of institutions that are demarcated by identity-based communities.

Nowadays, LAM institutions are reaching out to segments of their communities that seldom visit these institutions. Public museums and archives are also increasingly acknowledging the ways that their own institutions were shaped by dominant community ideologies as well as how particular communities were marginalized or excluded in the process. In Scandinavia, this includes communities and groups such as the Sámi, the working class, women, and immigrants. Additionally, there is an increasing number of private museums and archives connected to marginalized communities. An example of this is the Archives and Library of the Queer Movement (in Swedish: Queerrörelsens Arkiv och Bibliotek [QRAB]) that "collects, organizes, preserves, and makes accessible documentation and information related to queer movements and people."[2]

Outreach to marginalized groups, however, often challenges institutional neutrality. Communities are never uniform and are usually subject to internal differences and power relations; marginalized communities are no exception.

Furthermore, conflicts and tensions not only exist between the traditional dominant nation state institutions vis-à-vis the marginalized but also within and between marginalized communities. Navigating these complex social dynamics can be a challenge for LAM institutions because they exist within the webs of power relations in question. It becomes problematic for a library, archive, or museum run by the state or a municipality, and as such part of the apparatus that still represents a dominating nation state, to intervene in questions of internal divisions of marginalized communities. An example of this is the Sámi Archives in Kautokeino, which is a formal part of the National Archives of Norway.[3] This inclusion in the national archives can be regarded as state recognition, but also as a form of embedding, as a potential threat to Sámi autonomy.

Summary

The ability of Scandinavian LAM institutions to fulfill their democratic missions lies in their ability to support varying levels of community involvement and the progression from noncommittal experiences to deeper community involvement. It also rests on the institutions' ability to incorporate forgotten and marginalized voices into the public discourse and thereby create inclusive arenas for critical reflection and dismantling of hegemonic master narratives that they – the institutions – have historically played a role in constructing. Collaborations and partnerships with various community organizations and stakeholders are crucial for ensuring that community-relevant conversations take place – conversations that shift the focus from the problems of community to the possibility of community, that make possible critical remembrance and renewal, and that facilitate knowledge sharing and creation.

Notes

1 See also works published as part of the research project PLACE: Public Libraries – Arenas for Citizenship: https://app.cristin.no/projects/show.jsf?id=288092 (last accessed 22.02.2022).
2 Archives and Library of the Queer Movement: http://qrab.org (last accessed 31.01.2022).
3 Sámi Archives: https://www.arkivverket.no/om-oss/samisk-arkiv (last accessed 31.01.2022).

References

Anderson, Astrid, Cicilie Fagerlid, Håkon Larsen, and Ingerid Straume, eds. 2017. *Det åpne bibliotek: Forskningsbibliotek i endring*. Oslo: Cappelen Damm Akademisk.
Anderson, Benedict. 1983. *Imagined Communities: Reflections on The Origin and Spread of Nationalism*. London: Verso.
Aronsson, Peter, and Gabriella Elgenius, eds. 2015. *National Museums and Nation-Building in Europe, 1750–2010: Mobilization and Legitimacy, Continuity and Change*. Abingdon, Oxon: Routledge.

Audunson, Ragnar, Svanhild Aabø, Roger Blomgren, Sunniva Evjen, Henrik Jochumsen, Håkon Larsen, Casper Hvenegaard Rasmussen, Andreas Vårheim, Jamie Johnston, and Masanori Koizumi. 2019. "Public Libraries as an Infrastructure for a Sustainable Public Sphere a Comprehensive Review of Research." *Journal of Documentation* 75, no. 4: 773–790. https://doi.org/10.1108/JD-10-2018-0157

Audunson, Ragnar, Herbjørn Andresen, Cicilie Fagerlid, Erik Henningsen, Hans-Christoph Hobohm, Henrik Jochumsen, Håkon Larsen, and Tonje Vold, eds. 2020. *Libraries, Archives and Museums as Democratic Spaces in a Digital Age*. Berlin: De Gruyter Saur. https://doi.org/10.1515/9783110636628.

Bastian, Jeannette A., and Ben Alexander, eds. 2009. *Community Archives: The Shaping of Memory*. London: Facet Publishing.

Berger, Stefan. 2013. "The Role of National Archives in Constructing National Master Narratives in Europe." *International Journal of Recorded Information* 13, no. 1: 1–22.

Block, Peter. 2008. *Community: The Structure of Belonging*. San Francisco, CA: Berrett-Koehler.

Bodnár, Judit. 2001. "On Fragmentation, Urban and Social." In *Critical Perspectives on Urban Redevelopment (Research in Urban Sociology, Vol. 6)*, edited by Kevin Fox Gotham, 173–193. Emerald Group Publishing Limited. https://doi.org/10.1016/S1047-0042(01)80008-8.

Born, Paul. 2014. *Deepening Community: Finding Joy Together in Chaotic Times*. San Francisco, CA: Barrett-Koehler.

Caswell, Michelle. 2014. "Inventing New Archival Imaginaries: Theoretical Foundations for Identity-Based Community Archives." In *Identity Palimpsests: Archiving Ethnicity in the U.S. and Canada*, edited by Daniel Dominique and Amalia Levi, 35–55. Sacramento, CA: Litwin Books.

European Commission. Directorate General for Education, Youth, Sport and Culture. 2018. *Participatory Governance of Cultural Heritage: Report of THE OMC (Open Method of Coordination) Working Group of Member States' Experts: Executive Summary*. LU: Publications Office.

Fraser, Nancy. 1990. "Rethinking the Public Sphere: A Contribution to the Critique of Actually Existing Democracy." *Social Text*, no. 25/26: 56–80. https://doi.org/10.2307/466240.

Golding, Viv, and Wayne Modest. 2016. *Museums and Communities: Curators, Collections, and Collaboration*. London: Bloomsbury.

Goodnow, Katherine, and Haci Akman, eds. 2008. *Scandinavian Museums and Cultural Diversity*. New York: Berghahn.

Goulding, Anne. 2009. "Engaging with Community Engagement: Public Libraries and Citizen Involvement." *New Library World* 110, no. 1/2: 37–51.

Habermas, Jürgen. 1974. "The Public Sphere: An Encyclopedia Article (1964)." *New German Critique* no. 3: 49–55. https://doi.org/10.2307/487737.

Hvenegaard Rasmussen, Casper, Henrik Jochumsen, and Dorte Skot-Hansen. 2011. *Biblioteket i Byudviklingen: Oplevelse, Kreativitet og Innovation*. Copenhagen: Danmarks Biblioteksforening/Det Informationsvidenskabelige Akademi.

Johnston, Jamie. 2018. "The Use of Conversation-Based Programming in Public Libraries to Support Integration in Increasingly Multiethnic Societies." *Journal of Librarianship and Information Science* 50, no. 2: 130–140. https://doi.org/10.1177/0961000616631613.

Klinenberg, Eric. 2019. *Palaces for the People: How Social Infrastructure Can Help Fight Inequality, Polarization, and the Decline of Civic Life*. New York: Broadway Books.

Lankes, R. David. 2011. *The Atlas of New Librarianship*. Cambridge: Massachusetts Institute of Technology.

Maliniemi, Kaisa. 2009. "Public Records and Minorities: Problems and Possibilities for Sámi and Kven." *International Journal on Recorded Information* 9, no. 1–2: 15–27.

Oldenburg, Ray. 1999. *The Great Good Place: Cafés, Coffee Shops, Bookstores, Bars, Hair Salons, and Other Hangouts at the Heart of a Community.* New York: Marlowe.

Putnam, Robert D. 2001. *Bowling Alone: The Collapse and Revival of American Community.* New York: Touchstone.

Roued-Cunliffe, Henriette, and Andrea Copeland, eds. 2017. *Participatory Heritage.* London: Facet Publishing.

Rydbeck, Kerstin, and Jamie Johnston. 2020. "LAM Institutions: a Cross-country Comparison of Legislation and Statistics on Services and Use." In *Libraries, Archives and Museums as Democratic Spaces in a Digital Age,* edited by Ragnar Audunson, Herb-jørn Andresen, Cicilie Fagerlid, Erik Henningsen, Hans-Christoph Hobohm, Henrik Jochumsen, Håkon Larsen, and Tonje Vold, 25–52. De Gruyter Saur. https://doi.org/10.1515/9783110636628-002.

Scott, Rachel. 2011. "The Role of Public Libraries in Community Building." *Public Library Quarterly* 30, no. 3: 191–227.

Simon, Nina. 2016. *The Art of Relevance.* Santa Cruz, CA: Museum 2.0.

Smith, Laurajane. 2010. *Uses of Heritage.* London: Routledge.

Sullivan, Larry E. 2009. "Community." In *The SAGE Glossary of the Social and Behavioral Sciences,* edited by Larry E. Sullivan, 91. Thousand Oaks, CA: Sage. https://doi.org/10.4135/9781412972024.n448.

Ulvik, Synnøve. 2010. "Why Should the Library Collect Immigrants' Memories?" *New Library World* 111, no. 3/4: 154–160. https://doi.org/10.1108/03074801011027655.

Vogl, Charles. 2016. *The Art of Community: Seven Principles for Belonging.* San Francisco, CA: Berrett-Koehler.

15

LAMS AS ACTIVISTS? DILEMMAS BETWEEN NEUTRALITY AND TAKING A STAND

Nanna Kann-Rasmussen, Casper Hvenegaard Rasmussen, and Roger Blomgren

Introduction

Activism is a specific type of political participation that is typically associated with collective efforts to promote, hinder, or intervene in social or environmental change to create a better society (Norris 2002; Della Porta and Diani 2020). Activism today takes place in both physical and online environments, ranging from traditional political activities, such as debating or agitation, to more active and visible collective action, such as demonstrations, hunger strikes, protests, consumer boycotts, and occupation of buildings. In this sense, publicly funded cultural institutions, which are instruments of government and part of the welfare state, cannot be activists. However, the term "activism" and a perceived need for archive, library, and museum (LAM) professionals to engage themselves in society's pressing problems is on the agenda in research and practice.

Activism in LAM institutions is a complex phenomenon for three main reasons. First, researchers and LAM professionals use the term "activism" in diverse ways. For some LAM professionals, working for social justice is activism; for others, it is an integrated part of outreach activities. Furthermore, much of the work described in literature on activism in libraries, archives, and museums is done in LAMs without any label of activism in practice. Second, much of the literature cited below relates to an American context, where research is more normative and positive toward LAM activism. In contrast, the scarce Scandinavian research literature on the topic is typically more distanced from the field. Third, and maybe most importantly, Scandinavian cultural policy has been an instrument of social and political change as well as for improvement in terms of equality and social justice for decades. Since the 1960s and 1970s, Scandinavian cultural policy strategies have continuously focused on the democratization of culture by

DOI: 10.4324/9781003188834-18

removing or lowering socioeconomic barriers to participation in, and access to, LAMs and promoting diversity in terms of cultural democracy (Duelund 2003; Mangset and Hylland 2017). For this reason, it is fair to argue that much of the work concerning the inclusion of marginalized groups in society is a continuation of mainstream cultural policy. In a Swedish context, librarians from the socialist association of progressive librarians even reject the notion that their work should be labeled as activist (Atlestam 2020; Persson et al. 2021) because both the Swedish constitution and cultural policy explicitly support diversity and anti-discrimination. Consequently, it is possible to argue that while some designate certain activities in libraries as "activism," others would describe them as "business as usual." For this reason, this chapter develops a definition of Scandinavian LAM activism and discusses a few contemporary examples according to the definition.

In archival studies, the Society of American Archivists defines an activist archivist as someone who "strives to document the under-documented aspects of society and to support political and social causes through that work" or "seeks to move the archives profession, archives workplaces, and society in general toward social justice" (Society of American Archivists 2020). In two articles, both named "Archival activism", Flinn (2011) and Findlay (2016) both address the need for archivists to either build or facilitate the building of alternative community archives for oppressed groups in society, such as black and LGBT+ persons, and immigrants. An important detail regarding community archives is the collaboration between the professional archivists in the public archive and the community members in question. Flinn states: "[T]he community should play a significant, even dominant, role" (Flinn 2011, 8). Furthermore, activist archival research stress the need to engage in radical or counterhegemonic public history-making activities, which entails an increased consciousness of the archive and archival work as a politically loaded and far-from-neutral practice. A good example of this is research and practice in colonial archives (Agostinho, Dirckinck-Holmfeld, and Søilen 2019). The notion that archives are sites of power and politics also explains how activist archival practice focuses on whistleblowing and openness. The first appearance of the term "activist archivist" refers, among other issues, to the need for archivists to "campaign to open all government documents to the public" (Quinn 1977).

Activist librarianship has been described as "progressive" or "critical" librarianship, especially in an American context. The Progressive Librarians Guild's statement of purpose reads:

> [...] libraries are sites where structures of injustice, exploitation, control, and oppression are nourished, normalized, and perpetuated. The Progressive Librarians Guild exists to expose and call out librarianship's active and passive complicity and acceptance of those systems, to offer and practice alternatives to those systems, to empower the voices of those excluded from

positions of power and/or the historical record and to develop a praxis that contributes to ongoing pursuits of human rights and dignity.

(Progressive Librarians Guild 2017)

Contemporary library activism is primarily concerned with library services for underrepresented groups. In a recent anthology called *Social Justice and Activism in Libraries* (Epstein, Smallwood, and Gubnitskaia 2019), the authors emphasize the library's role "as a place of safety and inclusion" and address the problem that certain groups in society, such as black, disabled, and LGBT+ persons, are both oppressed in society and underrepresented in libraries. With the addition of non-Western immigrants, these groups are also in focus in a Swedish context, where discussions center on how librarians respond to these groups and how library services can contribute to empowering them (Sundeen and Blomgren 2020). In a European context, library activists have also actively worked against New Public Management (NPM), outsourcing, and budget cuts (Kagan 2015; Sundeen and Blomgren 2020). Furthermore, there is a growing focus on sustainability, climate change, and the UN 2030 Agenda (Antonelli 2008; Meschede and Henkel 2019; Mathiasson and Jochumsen 2021).

Museum activism is also discussed under the heading of museum ethics. Activism has been described by Janes and Sandell (2019, 1) as "museum practice shaped out of ethically informed values that is intended to bring about political, social, and environmental change." Museum activism and museum ethics emphasize the museum as a powerful and influential institution in society and thereby the inherent responsibility that museums have to work for the "good" (Janes and Sandell 2019; Madoff 2019). Museum activism is influenced by postcolonial and feminist theory, and according to the *Routledge Companion to Museum Ethics*, it concerns: (1) social responsibility, including working with new modes of participation, democratic pluralism, and underrepresented groups; (2) radical transparency – museums should not just convey knowledge, but also analyze and expose power relations in society; and (3) shared guardianship of heritage, which includes the will to question and renegotiate ownership (Marstine 2011). Museum activism also includes sustainable development. This entails educating the public about global warming and ecological crisis (Newell, Robin, and Wehner 2017) but also involving the museum in artistic handling of the crisis by curating and collaborating with activist artists (Madoff 2019), and collaborating with local schools, companies, and other community actors about activities outside the museums that highlight problem (Rathjen 2020).

As part of the large ALMPUB project, the Norwegian professor Ragnar Audunson and colleagues have investigated how professionals in LAM institutions have perceived the changing roles of libraries, archives, and museums in society. The authors distinguish between their traditional roles (of preserving and promoting the cultural heritage and being arenas for learning) and their roles as meeting places and arenas underpinning the public sphere, with the mission of

sustaining democratic values in societies (Audunson, Hobohm, and Tóth 2020, 165). As part of the new roles, the authors asked professionals at Scandinavian archives and museums about their attitudes to neutrality and activism. The results show that among archivists, those who define their professional role

> as being neutral guardians of the material submitted to the archives are in a clear minority (only 10% of the Danish archivists answered 'yes' to this question). In all the countries, except Norway, the largest group consisted of those maintaining that the archivists should actively strive to document easily marginalized histories.
>
> *(Ibid., 179)*

Museum professionals answered a question that counterposed neutrality versus creating involvement, and "if necessary by provoking and taking a stand." However, a majority of the respondents (although not an overwhelming one) answered for engagement, even by taking a stand. The most activist group was the Norwegian museum professionals (30% of whom answered for neutrality and 70% for engagement) (*Ibid.*, 180). Unfortunately, the survey did not include questions regarding activism and neutrality for library professionals.

In the following, we discuss the notion of neutrality and argue that there is a close connection between "the myth of neutrality" and LAM activism. After this, we argue how activism differs from cultural policy and the concept of cultural democracy and suggest a definition of LAM activism. We then discuss examples of how, and to what extent, LAMs act as activists focusing on collections- and connections-oriented activism.

Questioning neutrality

The inspiration for challenging "the myth of neutrality" mainly came from the youth revolt, progressive movements in the late 1960s, and research that can be labeled as different kinds of social constructivism that flourished in the 1990s (Bennett 1995; Vukliš and Gilliland 2016; Sundeen and Blomgren 2020). Before the late 1960s, policymakers and professionals perceived neutrality as an achievable ideal within LAM institutions. For professionals in libraries and museums, the guiding light for neutrality was science. In libraries, the selection of books was primarily dependent on the quality of the content of the book, which the professionals decided. These would be literary experts for fiction or a wide range of experts for nonfiction. In art museums, curators typically had a background in art history, while museum professionals in culture-historical museums normally had an educational background in history, ethnology, or archeology. The educational backgrounds of LAM professionals are not so different today. However, the way science was perceived compared to now is notably different. Previously, science was seen as a synonym for truth. The quality of art or literature was seen as universal and embedded in the work of art.

Furthermore, curators were invisible in the classical exhibition because they mediated the correct objects in the right way (Roppola 2012). In the same way, archives have been associated with truth because they have been perceived as neutral repositories of facts (Schwartz and Cook 2002). As mentioned above, the confidence in neutrality has been challenged since the late 1960s. An example is a young and rebellious librarian from Denmark writing about the public library as an integrated part of structural oppression.

> The public libraries have neatly found their role in a system of cultural oppression. When libraries approve the culture that belongs to the intellectual upper class, (it is almost equivalent to the political and economic upper class) and devalue the popular culture, libraries support a sense of inferiority, which is necessary to maintain the existing power structure.
>
> *(Agger 1969, 5 our translation)*

Almost at the same time, the American radical historian Howard Zinn questioned the "impartiality" and "objectivity" of archival practice when he coined the term *activist archivist* at the annual meeting of the Society of American Archivists in 1970. According to Zinn, archivists should not see their job as a technical job free from a world of political interests. According to Zinn, neutrality was a fiction in a nonneutral world. Consequently, archivists would probably support the hegemony or status quo if they went about their ordinary business. Instead, Zinn argued that the archivist should embrace an activist rather than a passive mindset in striving for social justice (Zinn 1977). This argument is repeated many times in more recent LAM literature, supporting more activist activities in the LAMs (Gibson et al. 2017; Winn 2017; Prescha 2021). In addition to arguing that neutrality is an implicit support for the ruling power, the research on LAM institutions based on cultural theory has industriously disclosed hidden power structures and meanings. Libraries' classification systems are normally seen as neutral tools for retrieval. However, according to Olson (1998), classification is constructed by dominant cultural discourses reflecting a specific "take" on the world, where some knowledge is accepted, and other knowledge is marginalized or excluded. Collections of archives and museums have been discussed in the same way. According to Cook (1997), LAMs are arenas for an ongoing controversy on what is worth remembering and what should be forgotten. Thus, the LAMs represent a considerable power over memory and identity.

The ongoing questioning of neutrality since the 1960s has challenged the image of LAMs as "impartial" or "objective." Today, most professionals within LAMs would probably agree that it is difficult to be neutral, if not impossible. It is common knowledge that literary quality is neither universal nor embedded in the artwork in libraries. In the same way, curators are aware that an exhibition is one take among others on the world, while archivists not only perceive the archive as a passive storehouse for dusty documents, but it is also a battleground for memory politics. Although many LAM professionals agree that neutrality is

problematic, the unity is broken when discussing the response to problematic neutrality. One way of dealing with the problem of neutrality is to evade controversial issues. At first sight, this strategy could ensure support for LAMs from all parts of society. However, burying the controversial problems has been criticized for hollowing out relevance (Williams 2017), for disengaging from society (Gibson et al. 2017), and for lacking accountability (Evans et al. 2020). Another way of dealing with the problem of impossible neutrality is taking a stand. How this strategy may unfold, we discuss in the following section.

When are LAMs activist?

Olson and Hysing (2012) have described a certain figure in public institutions, namely the "inside activist." Their classification of the inside activist as a civil servant is based on specific criteria, which differ from other civil servants such as bureaucrats and entrepreneurs. Their classification does not focus on what kind of ideas characterize the inside activist's mission. They can be based on political thoughts emanating from both the left and the right. Olson and Hysing define an inside activist as someone who is an activist in civil society, holds a formal position in the public sector, and uses this position to influence public decision-making regarding the agenda they are engaged in (Olsson and Hysing 2012, 259). In the following, we focus on LAM organizations rather than individual inside activists. However, we acknowledge that it is probably inside activists that drive the climate agenda, LGBT+ work, and anti-racism forward in LAMs. Sundeen and Blomgren's (2020) article about activism in Swedish public libraries suggests that this is the case.

Merklen (2016) claims that LAMs are both political and democratic institutions. Publicly funded LAMs are the results of political priorities. In this way, they are tools for governments, regardless of the political aims. If LAMs are perceived as such, it follows that the employees should ideally be loyal public servants fulfilling the wishes of the political leaders. However, LAMs can also be perceived as political institutions when they take an independent political stance. A quick Google search on "museums taking a stand" reveals a broad spectrum of different museums taking a stand against systematic racism, or climate change. If museums take a stand independently of the political system, we argue that such activities could be seen as activist. In particular, if museums or other LAMs connect to existing activist activities and use the language and slogans of these, their activities are activist.

LAMs are also democratic institutions, and activism can also take place in this understanding. When we claim that LAMs are democratic institutions, we note that a traditional cornerstone in Scandinavian cultural policies is the democratization of culture – that all citizens should have access to art and culture. Furthermore, LAMs have a strong tradition for supporting users with special needs, such as persons with disabilities. This policy has been supplemented with a cultural democracy – that the publicly funded institutions' cultural

offerings should reflect the diversity of the population. In addition to supporting democracy by giving access to diverse collections, LAMs can be arenas for participation and public debate (Andresen, Huvila, and Stokstad 2020). These ways of supporting democracy are on a par with most of the basic principles of social justice: access, equity, diversity, participation, and human rights (Sandell and Nightingale 2012; Pateman and Vincent 2016). Thus, the boundaries between social justice, democracy, and activism are blurred. On the one hand, LAMs can work for social justice without anybody using the concept of activism. Nearly all Scandinavian public libraries do that every day in a noncontroversial way: They are aligned with human rights, they give access to diverse collections, they promote equity by taking care of special needs, and they counteract the established grounds for discrimination.[1] Furthermore, participation has been a buzzword for more than a decade. On the other hand, social justice activities within LAMs can be perceived as activism in several ways. For this reason, we will now suggest a definition of Scandinavian LAM activism.

The first part of the definition regards what we discussed above, i.e., that LAMs are activist if they take a political stand. Second, an obvious way for LAMs to be associated with activism is to connect explicitly to activist agendas. Certain social movements, such as the LGBT+ movement, Black Lives Matter, and the climate movement, are by nature activist. However, if a LAM institution creates special activities for black community members, it is not necessarily activism. However, if the institution connects explicitly with the Black Lives Matter movement, for example, by using rhetoric, symbols, or methods of this social movement, it is more likely to be defined as activism. Third, as stated above, it is a traditional part of LAMs' work to include minorities. We argue that when LAMs add active endeavors to *expose* inequality they are more likely to be seen as acting in an activist manner. Many activists and social movements have a strong emphasis on making structural inequalities more visible by actively exposing hierarchies and powers in society. The same goes for sustainability activists, whose endeavors typically focus on pushing, for example, the climate agenda forward by making it visible. Fourth, we argue that pointing out one's own privileged status is also a sign of activism. This is normally followed by a wish for the institutions and their professionals to change themselves to promote social justice. Much literature on activism in LAMs calls for professionals to observe and take heed of their own privilege and thus interpret traditional values such as "equal access" in new ways (Caswell 2017; Hudson 2017).

We argue that it is meaningful to talk about LAM activism if they:

- Take a political stand
- Couple themselves openly to activist agendas (e.g., by using language, slogans, or symbols related to these agendas)
- Persistently expose structural inequalities (as opposed to just trying to include nonprivileged user groups), or
- Work actively with their own privileged status

Different ways LAMs are activist

As noted above, the ALMPUB survey (Audunson, Hobohm, and Tóth 2020) distinguished between "traditional" and "new" roles for LAM professionals. In the following, we will present and discuss some examples of different ways in which LAMs are activists using the phrase *from collection to connection* (see Chapter 2, this volume). This means that we categorize different examples of LAM activism from Scandinavia by distinguishing between "collection-oriented" and "connection-oriented" approaches to present an overview of the ways in which activism manifests itself in Scandinavian LAMs.

Collection-related work

One way for LAMs to be activist is through the handling of their collections. Promoting certain parts of the collection is a way to make an agenda more visible in both libraries and museums. There has been a large-scale introduction of so-called "rainbow shelves" in Swedish libraries, which makes books about LGBT+ visible both in the physical space and on libraries' websites. However, they also exist in Denmark and Norway on a much smaller scale. On the one hand, these shelves can be perceived as attempts at equity on the same terms as other services for special groups in the library. On the other hand, the rainbow shelves can be seen as activist activities if they are combined with LGBT+ agendas or if the shelves are an integrated part of the library professionals' ongoing work with their own privileged status. Libraries can also purchase or refuse to purchase certain books. As noted above, this is not necessarily activism since a core activity for libraries is maintaining their collections, which entails choosing and discarding books. However, refusing to lend out certain books can be seen as activist, because it involves taking a political stand. There have been several cases of politically motivated censorship from Swedish public libraries, where the Swedish Parliamentary Ombudsman has criticized public libraries for letting (anti-racist) political opinions stand in the way of free access to information and formation of opinions (Helgason 2020; Sundeen and Blomgren 2020).

In museums, collection-oriented activism concerns exhibitions. American artist and commentator Emma Thorne-Christy (2020) distinguishes between different types of exhibitions museums can engage in: (1) the sanitized exhibition – intentionally avoids challenging (including political) topics to prevent risking their visitors feeling uncomfortable or alienating their funding sources; (2) the both-sides-of-the-coin exhibition – encourages political engagement by displaying multiple perspectives on a topic while not privileging one side; (3) the inconvenient-truth exhibition – lays out the facts, even if it makes some visitors uncomfortable or they deem it "too political"; (4) the advocacy exhibition – as the name suggests, advocates certain political stances; (5) the propaganda exhibition – these exhibitions blatantly refuse to acknowledge their prejudices while disseminating highly biased information and narratives. We argue that the

last three types of exhibitions can be categorized as activist in some cases. No examples of the "propaganda exhibition" have been identified, but exhibitions such as *Kirchner & Nolde – Up for discussion* at the National Gallery of Denmark (which was on display in 2020) would be an example of an exhibition that focuses on "the inconvenient truth." The exhibition website invites a discussion on the following questions: *What worldview do the works of art express? Can we hold the artists accountable? Shall we? And does the story of Nolde and Kirchner have relevance in today's racism debate?* (SMK 2021). It can be discussed whether this exhibition can be called an "activist exhibition." It exposes structural inequalities and uses language related to the anti-racist movement in descriptions of the works of art and the artists. However, it does not couple itself openly to any anti-racist movement, nor does the exhibition take a stand.

Connection-related work

Activism that relates to "connections" typically regards participatory practices, either where LAMs play a role in relation to particular (activist) communities or to so-called "radical democracy" (Mouffe 2005).

With regard to the former, community archival work can serve as an example. A dominant way of seeing activist archival work regards the institutions' collaboration with communities. Archival researchers such as Flinn, Stevens, and Shepherd (2009) emphasize the importance of giving the power to communities in establishing new archives to preserve and tell the history of marginalized groups in society. As mentioned above, ideas of increased democratization, participation, and activism have challenged the understanding of archives as neutral guardians of evidence. The literature on Scandinavian community archives is scarce, but an interesting example to discuss is the Norwegian "Skeivt Arkiv" (queer/skewed archive). Skeivt Arkiv collects "anything that relates to queer history, particularly Norwegian and Scandinavian history, whether it's a button from an event, three volumes of a queer journal, four gay love letters, or 14 boxes of organizational history" (Skeivt Arkiv 2015). But can this be meaningfully described as activism? According to our definition, it is not a case of taking a clear political stand. However, it does couple itself to the LGBT+ movement because it is dependent on the (moral, not financial) support from the LGBT+ community in order to be able to obtain archival matter. On the other hand, Tone Hellesund, one of its founders, states that queer history should be part of general history and not seen as belonging to any particular group (Hellesund 2016, 118). Notably, Skeivt Arkiv is established and maintained by a public institution, the University of Bergen, and not by the queer community. Hellesund (2016) describes this as an anomaly if viewed from an international perspective (e.g., see: Flinn, Stevens, and Shepherd 2009; Flinn 2011; Edward and Eveleigh 2019) but argues that in Scandinavian countries, the established public institutions are better suited for the task of housing a queer archive because they have

the infrastructure, stability, and governmental support that is needed. Hellesund even states that potential owners of relevant material would have more trust in a project embedded in a public institution than in an activist/NGO initiative (Hellesund 2016, 118).

One can argue that a queer archive is needed and the fact that it does not appear until 2013 is due to structural inequalities. However, neither their homepage nor Hellesund's (2016) article emphasizes this in any way. Likewise, there is no evidence of archivists or librarians displaying active work with their status. Thus, Skeivt Arkiv is not an example of clear LAM activism, but rather shows how projects that closely relate themselves to social movements can live in public LAMs.

Activism and legitimacy

As suggested above, LAM legitimacy has been closely connected to the notion of neutrality, meaning that institutions and their employees should not favor any specific ideologies or political ideas of their own in their daily work. The close relation with science and the professional expertise of the LAM staff conditioned the legitimacy of the professionals and the institutions. If society at large agrees that LAM collections reflect "the truth" and that employees of these institutions are guardians and promoters of this truth, it follows that legitimacy, among both funders and the public, is unquestioned. When this changes, legitimacy also changes. How this legitimacy changes is, however, not entirely certain.

One possible answer could be that taking a stand against neutrality and coupling the institutions to contemporary social movements or agendas would benefit the legitimacy of LAMs. Larsen (2014) and Kann-Rasmussen (2016) argue that cultural organizations today legitimize themselves based on their contribution to society, and activism can be seen as a(n) (albeit radical) way of doing this. When LAMs, for example, commit themselves to contributing to fighting climate change or working for LGBT+ rights, it can broaden the scope of their legitimacy (Reinecke, Bommel, and Spicer 2017; Kann-Rasmussen 2022).

On the other hand, activism can challenge the legitimacy of the LAM sector among politicians and citizens if the activist ideas implemented have low acceptance (Kann-Rasmussen 2022). In Sweden, there have been debates about several cases where libraries have denied library users the right to borrow books, with these libraries being characterized as xenophobic (Helgason 2020; Sundeen and Blomgren 2020). In these cases, librarians faced criticism for acting as gatekeepers instead of promoters of free access to information. The Swedish Parliamentary Ombudsman criticized these libraries for violating the intentions of the Swedish Library Act, 2§, which states: "The libraries in the public library system shall promote the development of a democratic society by contributing to the transfer of knowledge and the free formation of opinions" (SFS 2013:801). It poses an obvious legitimacy problem for libraries if the legislation passed by the parliament is not interpreted in the way that the legislators intended.

Conclusion

LAM activism is what discourse analysists would call a "floating signifier," as it is used in different ways. Scandinavian cultural policies also overlap with many of the objectives of international LAM activism. In this chapter, we have therefore offered a definition of Scandinavian LAM activism and suggested that LAM activism is characterized by LAM institutions that either (1) take a political stand, (2) couple themselves openly to activist agendas, (3) persistently expose structural inequalities, or (4) work actively with their own privileged status. The chapter shows how activism has been made possible by the decline of the notion of neutrality in the wake of social constructivism and the youth revolt in the late 1960s. The idea of neutrality has also been an essential part of the legitimacy of LAMs. Consequently, activism can be seen both as a threat to traditional LAM legitimacy and as a search for legitimacy on new grounds by contributing to the solution of significant problems in society.

Note

1 With small differences, Scandinavian law states that discrimination reasons are age, disability, ethnic origin, sex, sexual orientation, gender identity, religion, and political views.

References

Agger, J.P. 1969. "Folkebibliotek eller elitebibliotek (Public Library or Elitist Library)." *Biblioteksdebat* 1.

Agostinho, Daniela, Katrine Dirckinck-Holmfeld, and Karen Louise Grova Søilen. 2019. "Archives that Matter." *Nordisk Tidsskrift for Informationsvidenskab Og Kulturformidling* 8, no. 2: 1–18. https://doi.org/10.7146/ntik.v7i2.118472.

Andresen, Herbjørn, Huvila Isto, and Sigrid Stokstad. 2020. "Perceptions and Implications of User Participation and Engagement in Libraries, Archives and Museums" In *Libraries, Archives and Museums as Democratic Spaces in a Digital Age*, edited by Ragnar Audunson, Herbjørn Andresen, Cicilie Fagerlid, Erik Henningsen, Hans-Christoph Hobohm, Henrik Jochumsen, Håkon Larsen and Tonje Vold, 185–206. Berlin: De Gruyter Saur. https://doi.org/10.1515/9783110636628-009

Antonelli, Monika. 2008. "The Green Library Movement: An Overview and Beyond." *Electronic Green Journal* 1, no. 27. https://doi.org/10.5070/G312710757.

Atlestam, Ingrid. 2020. "Vem Är Egentligen Aktivist?" *bis: Bibliotek i Samhälle*, no. 1: 14–16.

Audunson, Ragnar, Hans-Christoph Hobohm, and Máté Tóth. 2020. "LAM Professionals and the Public Sphere." In *Libraries, Archives and Museums as Democratic Spaces in a Digital Age*, edited by Ragnar Audunson, Herbjørn Andresen, Cicilie Fagerlid, Erik Henningsen, Hans-Christoph Hobohm, Henrik Jochumsen, Håkon Larsen and Tonje Vold, 165–183. Berlin: De Gruyter Saur. https://doi.org/10.1515/9783110636628-008

Bennett, Tony. 1995. *The Birth of the Museum: History, Theory, Politics*. London: Routledge.

Caswell, Michelle. 2017. "Teaching to Dismantle White Supremacy in Archives." *The Library Quarterly* 87, no. 3: 222–235. https://doi.org/10.1086/692299.

Cook, Terry. 1997. "What is Past is Prologue: A History of Archival Ideas Since 1898, and the Future Paradigm Shift." *Archivaria* 43: 17–63.

Della Porta, Donatella, and Mario Diani. 2020. *Social Movements: An Introduction.* Third edition. Hoboken, NJ: Wiley-Blackwell.

Duelund, Peter. 2003. *The Nordic Cultural Model.* Copenhagen: Nordic Cultural Institute.

Edward, Benoit III, and Alexandra Eveleigh. 2019. *Participatory Archives.* London: Facet Publishing.

Epstein, Su, Carol Smallwood, and Vera Gubnitskaia. 2019. *Social Justice and Activism in Libraries: Essays on Diversity and Change.* Jefferson, NC: McFarland.

Evans, Henry James, Line Nicolaisen, Sara Tougaard, and Marianne Achiam. 2020. "Perspective. Museums beyond Neutrality." *Nordisk Museologi* 29, no. 2: 19–25. https://doi.org/10.5617/nm.8436.

Findlay, Cassie. 2016. "Archival Activism." *Archives and Manuscripts* 44, no. 3: 155–159. https://doi.org/10.1080/01576895.2016.1263964.

Flinn, Andrew. 2011. "Archival Activism: Independent and Community-Led Archives, Radical Public History and the Heritage Professions." *InterActions: UCLA Journal of Education and Information Studies* 7, no. 2. https://doi.org/10.5070/D472000699.

Flinn, Andrew, Mary Stevens, and Elizabeth Shepherd. 2009. "Whose Memories, Whose Archives? Independent Community Archives, Autonomy and the Mainstream." *Archival Science* 9, no. 1: 71. https://doi.org/10.1007/s10502-009-9105-2.

Gibson, Amelia N., Renate L. Chancellor, Nicole A. Cooke, Sarah Park Dahlen, Shari A. Lee, and Yasmeen L. Shorish. 2017. "Libraries on the Frontlines: Neutrality and Social Justice." *Equality, Diversity and Inclusion: An International Journal* 36, no. 8: 751–766. https://doi.org/10.1108/EDI-11-2016-0100.

Helgason, Jon. 2020. "Truth, Knowledge, and Power. Censorship and Censoring Policies in the Swedish Public Library System." In *Forbidden Literature: Case Studies on Censorship,* edited by Erik Erlanson, Jon Helgason, Peter Henning, and Linnéa Lindsköld, 227–243. Lund: Nordic Academic Press.

Hellesund, Tone. 2016. "Skeivt Arkiv." *Lambda Nordica* 21, no. 3–4: 111–134.

Hudson, David James. 2017. "On 'Diversity' as Anti-Racism in Library and Information Studies: A Critique." *Journal of Critical Library and Information Studies* 1, no. 1. https://doi.org/10.24242/jclis.v1i1.6.

Janes, Robert R., and Richard Sandell. 2019. *Museum Activism.* Museum Meanings. Taylor and Francis. https://doi.org/10.4324/9781351251044.

Kagan, Alfred. 2015. *Progressive Library Organizations: A Worldwide History.* Jefferson, NC: McFarland & Company, Inc., Publishers.

Kann-Rasmussen, Nanna. 2016. "For samfundets skyld – Kulturlederes forestillinger om legitimitet og omverden." *Nordisk kulturpolitisk tidsskrift* 19, no. 2: 201–221.

Kann-Rasmussen, Nanna. 2022. "When Librarians Speak Up: Justifications for and Legitimacy Implications of Librarians' Engagement in Social Movements." *Journal of Documentation,* ahead of print. https://doi.org/10.1108/JD-02-2022-0042.

Larsen, Håkon. 2014. "Legitimation Work in State Cultural Organizations: The Case of Norway." *International Journal of Cultural Policy* 20, no. 4: 456–470. https://doi.org/10.1080/10286632.2013.850497.

Madoff, Steven Henry. 2019. *What about Activism?* London: Sternberg Press.

Mangset, Per, and Ole Marius Hylland. 2017. *Kulturpolitikk: Organisering, legitimering og praksis.* Oslo: Universitetsforlaget.

Marstine, Janet. 2011. *The Routledge Companion to Museum Ethics: Redefining Ethics for the Twenty-First Century Museum.* Florence, KY: Taylor & Francis Group.

Mathiasson, Mia, and Henrik Jochumsen. 2021. "Working for a Better World: The Librarian as a Change Agent, an Activist and a Social Entrepreneur." In *New Librarianship Symposia* Series. Fall 2021

Merklen, Denis. 2016. "Is the Library a Political Institution?: French Libraries Today and the Social Conflict between Démocratie and République." *Library Trends* 65, no. 2: 143–153. https://doi.org/10.1353/lib.2016.0027.

Meschede, Christine, and Maria Henkel. 2019. "Library and Information Science and Sustainable Development: A Structured Literature Review." *Journal of Documentation* 75, no. 6: 1356–1369. https://doi.org/10.1108/JD-02-2019-0021.

Mouffe, Chantal. 2005. *The Democratic Paradox*. London: Verso.

Newell, Jennifer, Libby Robin, and Kirsten Wehner. 2017. *Curating the Future: Museums, Communities and Climate Change*. Milton Park, Abingdon, Oxon: Taylor & Francis.

Norris, Pippa. 2002. *Democratic Phoenix: Reinventing Political Activism*. Cambridge: Cambridge University Press.

Olson, Hope A. 1998. "Mapping beyond Dewey's Boundaries: Constructing Classificatory Space for Marginalized Knowledge Domains." *Library Trends* 47, no. 2: 233–254.

Olsson, Jan, and Erik Hysing. 2012. "Theorizing Inside Activism: Understanding Policymaking and Policy Change from Below." *Planning Theory & Practice* 13, no. 2: 257–273. https://doi.org/10.1080/14649357.2012.677123.

Pateman, John, and John Vincent. 2016. *Public Libraries and Social Justice*. London: Routledge.

Persson, Martin, Tobias Willstedt, Lena Lundgren, Sofia Berg, Christian Forsell, and Annelien van der Tang. 2021. "Felaktig bild av BiS och en förenklad syn på biblioteks-spolitik i forskningsartikel." *BiS* (blog). April 26, 2021.

Prescha, Livia. 2021. "Myth of Neutrality and Non-Performativity of Antiracism." *Museum Management and Curatorship* 36, no. 2: 109–124. https://doi.org/10.1080/096 47775.2021.1891559.

Progressive Librarians Guild. 2017. "Statement of Purpose." What Progressive Librarians Believe. http://www.progressivelibrariansguild.org/content/purpose.shtml.

Quinn, Patrick M. 1977. "The Archivist as Activist." *Georgia Archive* 5, no. 1: 25–35.

Rathjen, Kasper Thissenius Haunstrup. 2020. "Museet i tidens tegn. Et tidsligt blik på museumsaktivismen." *Nordisk Museologi* 29, no. 2: 4–18. https://doi.org/10.5617/ nm.8435.

Reinecke, Juliane, Koen Bommel, and Andre Spicer. 2017. "When Orders of Worth Clash: Negotiating Legitimacy in Situations of Moral Multiplexity: Contributions from French Pragmatist Sociology." In *Research in the Sociology of Organizations*, edited by Charlotte Cloutier et al., 52:33–72. https://doi.org/10.1108/ S0733-558X20170000052002.

Roppola, Tiina. 2012. *Designing for the Museum Visitor Experience*. New York: Routledge.

Sandell, Richard, and Eithne Nightingale. 2012 "Introduction" In *Museums, Equality and Social Justice*, edited by Richard Sandell and Eithne Nightingale, 1–10. London: Routledge.

Schwartz, Joan M., and Terry Cook. 2002. "Archives, Records, and Power: The Making of Modern Memory." *Archival Science* 2, no. 1–2: 1–19. https://doi.org/10.1007/ BF02435628.

SFS 2013:801 *Bibliotekslag*.

Skeivt Arkiv. 2015. "Contribute." Skeivt Arkiv. March 11, 2015. https://skeivtarkiv.no/ en/contribute.

SMK. 2021. "Kirchner og Nolde til diskussion." SMK – Statens Museum for Kunst. March 3, 2021. https://www.smk.dk/exhibition/kirchner-nolde/.

Society of American Archivists. 2020. "Activist Archivist." In *Dictionary of Archives Terminology*. Society of American Archivists. https://dictionary.archivists.org/entry/ activist-archivist.html.

Sundeen, Johan, and Roger Blomgren. 2020. "Offentliga bibliotek som arena för aktivism." *Nordisk kulturpolitisk tidsskrift* 23, no. 02: 159–179. https://doi.org/10.18261/issn.2000-8325/2020-02-06.

Thorne-Christy, Emma. 2020. "Musings." Exhibits of Humanity. https://exhibitsofhumanity.com/musings. Accessed 7 October 2022.

Vukliš, Vlada, and Anne J. Gilliland. 2016. "Archival Activism: Emerging Forms, Local Applications." In *Archives in the Service of People – People in The Service of Archives*, edited by B. Filej, 14–25. Maribor: Alma Mater Europea.

Williams, Mary Elizabeth. 2017. "A Noble Balancing Act: Museums, Political Activism and Protest Art." *Museum International* 69, no. 3–4: 66–75. https://doi.org/10.1111/muse.12173.

Winn, S. 2017. "The Hubris of Neutrality in Archives." Paper presented at MARAC Newark 2017. https://vtechworks.lib.vt.edu/handle/10919/77572.

Zinn, Howard. 1977. "Secrecy, Archives, and the Public Interest." *The Midwestern Archivist* 2, no. 2: 14–26.

16

PURSUING SUSTAINABLE FUTURES THROUGH LAMS

Henrik Jochumsen, Jamie Johnston, and Andreas Vårheim

Introduction

The ideals of *sustainability* have become the twenty-first-century beacon for securing our common yet increasingly uncertain future. Sustainable practices are widely adopted amongst citizens, corporations, political parties, and governments in Scandinavia and throughout the world. The adoption of these practices has resulted from greater societal awareness of global interdependence as well as the climate crisis that drives the international agenda. Sustainability researcher Leslie Thiele emphasizes the gravity of the situation by stating that the consequences of our actions, and inactions, will cross borders and generations, span the globe, and cast long shadows into the future (Thiele 2016).

Sustainability is a broad concept that refers to the present and future generations' environmental, economic, and social well-being. According to sustainability researchers Tom Kuhlman and John Farrington (2010), the concept was coined in German forestry in the early 1700s as *Nachhaltigkeit*, which means never harvesting more than what the forest yields in new growth. Sustainability as an area of study was later taken up by economists, including the classic and influential economist Thomas Malthus (1766–1834), who developed a theory connecting the scarcity of resources with population growth.

The widespread attention to sustainability can be attributed to the report "Limits to Growth" by the Club of Rome that was published in 1972. The report pessimistically predicted that many resources crucial to our survival would be exhausted in one or two generations. This was followed by the so-called "Brundtland Report" that was published in 1987. The report, named after the former prime minister of Norway, Gro Harlem Brundtland, was more moderate in tone and described sustainability as a worthy goal to be pursued through sustainable development, which was envisioned as the sum of natural and man-made

DOI: 10.4324/9781003188834-19

resources remaining constant so that the well-being of future generations would not decline (The World Commission on Environment and Development 1987). Sustainability, as defined in the report, was understood broadly as encompassing a complexity of economic, environmental, and social conditions, which are referred to as sustainability's three dimensions, often known as the "pillars of sustainability."

Integrating the three pillars of sustainable development, the 2030 "Agenda for Sustainable Development Goals" (SDGs) was unanimously adopted by the United Nations member states in 2015. The 2030 Agenda serves as a universal call to action to end poverty, protect the environment, and achieve peace and prosperity for all. It recognizes that ending poverty and other deprivations must coincide with environmental and climate-friendly strategies that can also sustain economic growth and development. The Agenda's 17 sustainable development goals (SDGs), known as the "Global Goals," "provide a shared blueprint for peace and prosperity for people and the planet, now and into the future."[1]

The Nordic region is ambitiously pursuing the 2030 Agenda. The Nordic Council of Ministers baseline report "The NORDICS – A Sustainable and Integrated Region? Baseline Report for Our Vision 2030" (2021) designates three areas of strategic priority for the region: A green Nordic region, a competitive Nordic region, and a socially sustainable Nordic region. The report indicates that the Nordic region is starting from a solid base but reveals challenges and room for improvement in all three areas, especially concerning the *green Nordic region*. Specific areas of concern related to the environment are greenhouse gas emissions and the protection of nature and biodiversity. The region is competitive and innovative; however, school dropout rates and a widening education gap between men and women are major challenges, with men generally obtaining fewer qualifications and being at higher risk of dropping out. Social sustainability is challenged by the persistent gender segregation in the labor market and by integrating non-EU citizens into the workforce, especially women.

This chapter considers the ways libraries, archives, and museums (LAMs) are meeting the challenges that the Scandinavian societies face in the twenty-first century and the roles the institutions play in pursuing sustainable futures. The following two sections illuminate how the Scandinavian LAM institutions respond and contribute to central parts of the sustainability agenda. The focus in the first section is on how the institutions are advancing environmental responsibility, and the second section looks at how they promote social equity related to diversity and equality. The two sections offer typologies that broadly group LAMs' activities in the related areas. A final section on the LAM institutions as part of the Nordic model provides a reflective perspective on the institutions as agents working on supporting sustainable futures. This chapter does not address economic sustainability directly. This is because the education-, innovation-, and inclusion-related activities and work being done associated with environmental and social sustainability provide support for economic sustainability and are more central to the role of the LAMs.

Sustainability and the sustainable development goals

Until the adoption of the 2030 Agenda, sustainable practices within LAMs were primarily connected to the attention given to the *greening* of LAM buildings, practices, and services. This was seen in the advent of what is commonly referred to as "the Green Library Movement" in North America in the 1990s. Nowadays, the universal imperative for action and goals for achieving sustainable development are prioritized in LAM strategy documents. For example, this is seen in the International Federation of Library Associations and Institutions' (IFLA) strategy "Global Vision" that calls upon libraries and librarians to act and "initiate the change that is urgently needed confronting climate change, poverty, hunger, gender equality, etc." (Hauke 2018, 1). This call for action is central in the 2021 IFLA World Library and Information Congress theme: "Let's work together for the future."

The call or readiness to act can be seen in the context of broader developments in the library field. The first development is the increased focus over the past two decades on the users, the role of the library, and the value it brings to the citizens, community, and society. As stated by researcher Anne Goulding, the public library has been repositioned not just as a place to borrow or read books or access digital materials, but as a key resource and facility that can act as a venue for community events and an access point connecting individuals with one another, their local communities, and the wider society (Goulding 2009). The second development is the increasing focus on librarians as proactive change agents and drivers of change. Being a driver of change is not new to librarians. Librarians have always worked to make the world a better place by improving the lives of individuals and communities by supporting enlightenment, literacy, democracy, and social mobility, and by giving free and equal access to information and services. This has been based on a widespread understanding of librarians as being neutral, whereas nowadays there appears to be a growing recognition that librarians should be proactive change agents working for a better world, thus moving away from a tradition as neutral guardians of public sphere ideals.

The library researcher David Lankes has been one of the more forthright promoters of librarians shifting from a position of neutrality to one of advancing social equity and the well-being of their communities (Lankes 2016, 2020). In his influential book on "new librarianship," Lankes poses the compelling argument that "librarians are agents for radical positive change who choose to make a difference" (Lankes 2016, 1). Thus, according to Lankes, to be a librarian is not to be neutral or passive but to be a radical positive change agent within one's community (Lankes 2020). Libraries' and librarians' engagement in sustainability and the SDGs clearly fits within this development.

In museums, there has been a similar move toward an increased focus on the users, the institution's role in the (local) community, and the value it creates for citizens, the community, and society. The changes underway in understanding the role of the museums are reflected in the work to update the International

Council of Museums' (ICOM) definition of museums. The proposed definition states that museums " are aiming to contribute to human dignity and social justice, global equality, and planetary well-being."[2] Although not accepted in the presented full form, it signals a shift in the way the relationship between museums and the surrounding world is understood.

These changes in the role of museums are seen in the writings of the American museum director Nina Simon. Simon's two influential books (2010, 2016) concerning user participation in museums and the museum's relevance in a community context advocate a shift from an authoritative and one-way communicative museum toward a more dialogue-oriented, inclusive, and less collection-centered museum. This shift began around the turn of the century and has been termed "new museology" (Vergo 1989). As with libraries, there is a movement away from an understanding of the museum as being neutral. The British museologists Robert Janes and Richard Sandel observe that "[p]osterity has arrived – the necessary emergence of museum activism" and argue for a more normative and ideologically driven museum practice that works for change. Accordingly, museum activism is seen as a "practice, shaped out of ethically-informed values, that is intended to bring about political, social, and environmental change" (Janes and Sandell 2019, 1).

Similar developments have been witnessed in archives to those seen in libraries and museums. Archives have an increased focus on their societal value as collections and institutions as well as on how they can strengthen their relationship with society and their social relevance in general. Their increased social role has largely resulted from technological developments that have facilitated archives' increased interaction with their users, such as through crowdsourcing and metadata creation initiatives. *Participation* has become a central concept to archives (Jensen and Røsjø 2016), as well as the adoption of a more activist approach (see Chapter 16, this volume) to being inclusive and open to all, increasing the visibility of marginalized groups and creating opportunities for community members to be represented on their own terms (Sjögren Zipsane 2016). In particular, there has been an increased focus on the relationship between archives and social justice and on how archival work can serve social justice goals (Duff et al. 2013).

The international adoption of the SDGs, the national and local governmental focus on the goals, and the widespread interest from civic society and NGOs have prompted LAMs, especially libraries and museums, in the Scandinavian countries to pursue sustainability and sustainable development. The Danish Museum Association (ODM) proclaims it will lead the Museum 2030 initiative, building on the SDGs, to advance a shared vision of sustainable museums.[3] Similarly, the Norwegian Museum Association states that it is actively engaged in increasing museums' focus on sustainability in the future.[4] In Sweden, Formas – a government research council for sustainable development – has provided considerable funding to several museums to disseminate knowledge and research regarding the SDGs.[5] The Danish Library Association created the DB2030 network for

libraries working with SDGs to ensure that the public library sector can serve as an anchor for this work. Furthermore, the Danish Agency of Culture and Palaces made supporting the SDGs a central criterion for libraries to receive funding for projects. Currently, the Scandinavian archival sector does not seem to have made a commitment to sustainability and the SDGs at the associational level like the library and museum sectors have.

Museums and libraries in Scandinavia have taken different approaches toward sustainability and the SDGs. In Denmark, the Danish Museum Association has spearheaded a process with the aforementioned Museum 2030 initiative to create a shared vision of sustainable museums. The focus is largely on how to make museums sustainable by using sustainable energy, supporting research in sustainable solutions, preserving biological diversity, and creating equal opportunities for all citizens. Additionally, several goals aim to support the development of a sustainable society in a broader sense. A similar focus on sustainability has been adopted by the Swedish National Museum, which states that sustainable practices are incorporated in all the museum's activities and operations. Furthermore, the museum reduces traveling with the help of digital couriers and works with sustainability in its shops and cafés.[6]

Libraries appear to take a more practical approach to sustainability. Arguably, the modern public library is the quintessence of the sharing economy. The library was one of the first sustainable infrastructures in our present-day society to support a circular economy and collaborative consumption. Many libraries in Scandinavia have further promoted these practices by lending such things as tools, fishing gear, bicycles, laptops, knitting kits, and seeds. Some libraries provide sewing machines that can be used to repair or upcycle clothing and other textiles, and some libraries provide repair stations to fix one's bicycle. Several libraries have followed with activities such as repair cafés or upcycling workshops, and some libraries aim to be local hubs for citizen-generated ideas and activities related to sustainability by providing space and facilities. Other examples from Scandinavian libraries include programs focused on sustainability such as reading clubs about the Global Goals and specific issues related to sustainability. A major Scandinavian research project entitled UPSCALE is underway that investigates how public libraries can be used for upscaling collaborative consumption by organizing the lending of things such as tools from the local hardware store via the library system.[7]

The following typology encapsulates the broad range of LAM activities, practices, services, and programs related to sustainability:

Buildings and operational solutions: LAM institutions incorporating sustainable goals in their own buildings, activities, and services, or when they optimize existing resources.

Advocacy and promotion: LAM institutions advocating sustainability or acting as change agents in the local communities.

Discovery and dialogue: LAM institutions creating space for the public to learn or debate about sustainability and sustainable solutions.

Experimentation and development: LAM institutions using their facilities as laboratories to develop and explore new types of services to support the circular economy and sustainable consumption or providing space for new activities for the user and citizens connected to sustainability.

The activities within these areas will develop in the coming years as there will be continual political pressure on LAM institutions to incorporate, promote, and develop sustainable solutions. Working with sustainability also offers the LAM institutions an important way to legitimize their activities in their communities and to various stakeholders.

Diversity, unity, and equality

Scandinavian societies have undergone dramatic sociocultural changes due to greater cultural and ethnic diversification resulting from immigration, greater awareness and acknowledgement of ethnic minorities, and inclusion and empowerment of gender and identity-based groups. This is happening within the context of an increasingly interconnected and globalized world that brings with it new and varied cultural influences from beyond the region. Social anthropologist Thomas Hylland Eriksen (2019) observes that, as with other liberal states, the Nordic countries are striving to find a balance between similarity and difference and between equal rights and the right to one's own cultural identity. LAMs adopt this approach in responding to the challenges related to diversity. Increasing the visibility and equality of different groups can have far-reaching implications for how societies balance the various, and sometimes conflicting, societal ideals related to sustainability, as well as for their own institutional legitimacy.

Historically, the Scandinavian countries have appeared to be relatively homogeneous based on the dominant national narratives and the cultural representations that they have presented within and beyond their political borders. However, these narratives and images of the nations have been selective and have generally not acknowledged the cultural heterogeneity and diverse identities that have existed in the countries. The national museums and libraries that emerged in the context of the nation-building period of the 1800s played a central role in the creation of the national narratives. The narratives of the respective nations that were formed at that time largely favored the dominant ethnic groups (Danes, Norwegians, and Swedes), thereby excluding the narratives of the diverse groups inhabiting the region (Newby 2019).

These national narratives were challenged in the last half of the twentieth century when various groups began developing and institutionalizing themselves in new and independent cultural forms of expression. This occurred during the cultural upheaval and subsequent emancipation of the late 1960s, when groups from the upcoming generation questioned the existence of a monoculture and championed the acceptance and acknowledgment of greater cultural diversity and lifestyle choices. Labor migration in the 1960s and 1970s, much of which came

from non-Western cultures, accelerated this process and gave it new direction and depth (Audunson 2005).

Since the 1980s, the awareness and acknowledgment of ethnic minorities and their histories have increased worldwide, including in the Scandinavian countries. Groups within Scandinavia who have national minority status include the Jews, Finns (*Kvæner, Forest Finns, Tornedalians*), Roma and Romani (*tatere/tattare*), as well as Germans in southern Denmark. The indigenous peoples of Sámi and Greenlandic Inuit also inhabit the region. Many Sámi live in their traditional territories in the north of Norway, Sweden, Finland, and Russia. They are a separate nation that spans the political borders of the countries.

There are also many other ethnic groups that do not have the legal status of being a national minority but who are considered minorities as they constitute less than half the population in their respective countries. These include groups that came to the region in the 1970s and 1990s, such as the Turks in Denmark and Sweden, Pakistanis in Norway, and Yugoslavs in Sweden (Eriksen 2019). However, in the period 1990–2018, most migrants to the Nordic countries, which include Iceland and Finland, came from Poland, the United States, Germany, and the United Kingdom. Migration from countries such as the United States is likely characterized by return migration, Nordic citizens returning home, and therefore may not contribute significantly to the ethnic or cultural diversity of the region. The largest refugee groups coming to the region during this time have come from Syria and Iraq. These groups are followed, in descending order, by migrants from China, Turkey, Thailand, Somalia, France, Romania, India, and Iran. Documentation of migration from countries formerly part of Yugoslavia or the Soviet Union has been varied and inconsistent, thus resulting in some ambiguity over the exact number of migrants who have come from these countries (Østby and Aalandslid 2020, 23–26).

Overall, the largest number of migrants to the region have gone to Sweden, except for during the latter part of the 1990s when most of the migration was to Denmark. Since 1990, Sweden has consistently been the main Scandinavian country of destination for those coming from Africa, Asia, and Latin America. Migration from the new EU countries has been most significant for Norway, and migration from western Europe and the United States has been most significant for Denmark (Østby and Aalandslid 2020, 51).

The struggle for equality and visibility, particularly for women and people identifying as part of the queer community, has paralleled the developments and trends related to cultural and ethnic diversity. The support for gender equality gained momentum in the Scandinavian countries at the end of the nineteenth century. Women progressively obtained equal rights in terms of education, government posts, voting, and political positions in the years leading up to 1920. By 1929, equality within the institution of marriage had also been obtained in each of the countries (Melby, Wetterberg, and Ravn 2008). Yet, while the countries are moving closer to gender equality and greater gender diversity in the workforce, some of the underlying societal attitudes are slow to change, and,

as touched upon in the introduction, there persist gaps in social and economic life, especially concerning pay and representation in management positions (OECD 2018).

For most of the twentieth century, the Scandinavian countries were not generally tolerant nor accepting of queer identities, though there were known pockets of tolerance in the larger urban areas, most notably in Stockholm and Copenhagen. However, a dramatic shift has taken place, especially in the past couple of decades with the legalization and increased acceptance of same-sex marriages, and now the region is regarded as exceptionally tolerant, even being referred to as a *queer utopia*. However, there is still discrimination and unequal representation, especially for the trans community (Benediktsdóttir et al. 2020; Del Mar 2021). The numerous identities within the queer community overlap with other cultural and ethnic identities; thus, recognition of, and support for, diversity in the Scandinavian countries has many different and overlapping aspects.

The new wave of refugees arriving in the region in 2015 again brought cultural diversity to the forefront of social and political debates. This has resulted in recent policy initiatives in the three countries that have aimed to tackle segregation and growing social inequalities; however, these initiatives have taken different approaches. The Danish strategy has emphasized measures related to housing and the settlement patterns, while Norway has had a stronger emphasis on the labor market and education, especially policies targeting children. The Swedish strategy has designated five areas of intervention, namely housing, the labor market, education, crime, and democratic participation (Balke Staver, Brekke, and Søholt 2019). These policies and the issues they target all have implications for the work and activities of LAMs, especially those around education and democratic participation (see Johnston and Audunson 2019).

Against this backdrop, the library researcher Ragnar Audunson (2005) stated that one of the significant challenges for public libraries in late modern society is to contribute to creating a shared understanding and societal coherence and, at the same time, stimulate diversity and tolerance. This challenge is not solely related to public libraries. Museums and archives also face challenges connected to diversity and its significance for development in the Scandinavian societies. Audunson aligns the LAMs' roles to the sociocultural aspects underpinning Eriksen's observation concerning the countries' strivings to find the balance between similarity and difference. Accordingly, the LAMs in Scandinavia are engaging to varying degrees with minority groups who historically have been marginalized and oppressed, immigrants and their descendants, and other groups who seek greater visibility and equality. Recent examples include the Danish Women's Museum's name change to Gender Museum Denmark and the MultiAalborg project by the Department of Sociology and Social Work at Aalborg University and Aalborg's City Archives in Denmark that aims to explore the different lived realities of being an Aalborg resident by including the life stories of immigrants and refugees in the archive's holdings.

The idea that culture should be considered an additional component or pillar within sustainable development agendas has recently gained more widespread recognition. With reference to UNESCO (2013), the researchers Loach, Rowley, and Griffiths (2017) argue that protecting cultural heritage is crucial for cultural sustainability and that sustaining culture has an impact beyond social, economic, and environmental concerns. The four components of sustainability are shown in Figure 16.1, which is a diagram inspired by Loach, Rowley, and Griffiths and developed by Danish library science researchers Høj Mathiasson and Jochumsen (2022).

Expanding upon the social and cultural pillars of the diagram, and with emphasis on the institutions' role in fostering an inclusive cultural heritage, the following is a typology of LAMs' core activities related to diversity and social sustainability:

Inclusion: Activities include those related to LAM professionals selecting and mediating materials, documents, or objects that represent and reflect diverse cultures, perspectives, and lifestyles. These activities fall under the banners of inclusive collection development and promotion of diversity. Archive and museum-related examples include the proactive collection of materials connected to underrepresented communities or around particular events.

Connection: Activities include those related to organizations creating arenas for people and groups of diverse backgrounds to meet, engage in dialogue, and

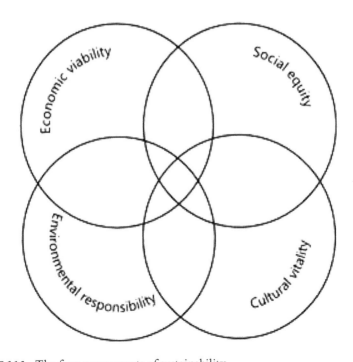

FIGURE 16.1 The four components of sustainability.

exchange knowledge. Relevant examples include *human libraries* (aka borrow a person), *conversation-based programs* (e.g., language cafés, story sharing, etc.), *makerspaces* and *themed workshops*, as well as *artist- or scholar-in-residence* programs (see Chapter 15, this volume).

Participation: Activities include those related to institutions incorporating diverse experiences, perspectives, understandings, and knowledge through such things as *crowdsourcing, co-creation, co-curation,* and *user innovation* (see Chapter 13, this volume).

Representation: Activities include those related to *community-based collections* and/or *institutions* (e.g., community-based libraries, archives, or museums). These types of collections or institutions make communities' autonomous representation and narrative (re)construction possible.

The activities within these areas are, and will continue to be, central in determining the LAM institutions' success in meeting the challenges of their increasingly diverse and fragmented societies, including their ability to support the formation of an inclusive and sustainable public sphere.

LAMs in the Nordic model: Challenges, communities, and empowerment

Increased migration since the 1970s, and especially since the millennium, has made immigration and integration policies contentious issues in Scandinavia. Large parts of the population in Europe and the Scandinavian countries see climate policy as a top-down strategy negatively affecting ordinary people's daily lives (Otto and Gugushvili 2020). Especially in rural areas, populist counter-movements, such as France's yellow vests and the electoral success of the farmers' party (the Centre Party) in Norway, have gained traction. Even in the progressive Scandinavian countries, holding a favorable view toward both welfare state policies and climate change policies is only attractive to about a third of the population (Otto and Gugushvili 2020). Considering the strict government immigration policies and climate populism, it might appear fruitless for LAM institutions to engage in programs directed at immigrants and socioecological sustainability-related activities. However, in the LAMs' roles as universal welfare state institutions and community hubs, Scandinavian LAM institutions meet the challenges of migration and climate change by supporting community activities and local organizing. What is the rationale behind this persistence? What are the mechanisms supporting the notion that LAMs matter in creating a sustainable society and the inclusion and integration of migrants?

Cleavages regarding immigration and sustainability have neither eroded trust in government nor interpersonal trust. In the Scandinavian countries, trust levels are still amongst the highest worldwide (worldvaluessurvey.org[8]). Breidahl and Fersch (2018) developed a theoretical model for explaining how welfare state institutions influence migrant integration processes through influencing migrant values and attitudes. Several studies have found that fair and impartial

public institutions that treat all people equally positively impact institutional and interpersonal trust (Kumlin and Rothstein 2005, 2010). Kumlin and Rothstein (2010) discovered that the effect is especially strong for immigrants. Trust in the welfare state institutions can even counter negative experiences with individual welfare state officers (Fersch 2016; Fersch and Breidahl 2018). As regards public libraries, they are consistently ranked among the most highly trusted public institutions (Höglund and Wahlström 2009; Vårheim 2014a; Söderholm, Ögland, and Gunnarsson Lorentzen 2021). A handful of studies find that libraries positively influence institutional and interpersonal trust in the general population and amongst immigrants (Vårheim, Steinmo, and Ide 2008; Vårheim 2014a, 2014b).

Like the general population, migrants meet with the welfare state at street level. They are in contact with a variety of trusted welfare state institutions, ranging from social services to public schools and libraries. These institutions are important in people's daily lives and contribute to forming values and preferences. The general positive attitudes toward LAM institutions are important, but even more important might be the migrants' everyday experience with LAMs. Not only libraries but also museums are frequently visited. As frequently visited and highly trusted community organizations, Scandinavian LAMs are important informal points of contact and places for meeting other local people. This includes attending and participating in museum exhibitions and activities, and library programs for the public or specially targeted groups, such as language cafés for newcomers (Johnston 2018) or programs for sharing tools, bikes, or skis. LAMs alone or in cooperation with voluntary community organizations create initiatives for integration and socioecological sustainability from below, thereby empowering individuals and communities.

Seen from an inside perspective of the LAM institutions, incorporation of the diverse groups' experiences and perspectives is not a straightforward process. It requires navigating in the larger political and social debates, both current and past. Ultimately, LAM institutions must decide which groups or communities are to be included in their collections and activities, and how the groups are to be represented (Gabriel and Jensen 2017). The institutions must decide how and to what degree they involve various groups in developing the collections and activities, the nature of the groups' participation, and how much power is shared. SDGs, on the other hand, do not require quite the same navigation for the LAMs. SDGs are adopted by all the UN member states and working for sustainable development has extensive and worldwide political support, at least rhetorically. Moreover, many organizations representing civic society are engaged in sustainability activities, and large parts of the business community are involved in creating a more sustainable production. Nevertheless, major concerns related to sustainable development such as individual freedom, private consumption, economic growth, national wealth, the rural population decline, and the time frames of CO_2 emission reduction objectives await solutions.

An essential role for Scandinavian LAMs going forward will be to initiate a community-based debate and make space for democratic discussion concerning challenges. As Thiele (2016) warns, sustainability does not just refer to the long-term survival of a specific practice, relationship, or institution; it entails an expanded scope that requires management of the scale and speed of change and the use of imagination, innovation, and creativity. The ways LAMs navigate toward sustainability in their communities will contribute to the long-term development of the Scandinavian region.

Notes

1 https://sdgs.un.org/goals. Accessed 2 February 2022.
2 https://icom.museum/en/news/icom-announces-the-alternative-museum-definition-that-will-be-subject-to-a-vote/. Accessed 2 February 2022.
3 https://www.dkmuseer.dk/nyhed/odm-med-i-projekt-om-b%C3%A6redygtighed. Accessed 2 February 2022.
4 https://museumsforbundet.no/emne/baerekraft/. Accessed 2 February 2022.
5 https://formas.se/en/start-page/archive/calls/2019-02-01-the-museums-and-the-sustainable-development-goals.html. Accessed 2 February 2022.
6 https://www.nationalmuseum.se/om-nationalmuseum/n%C3%A5gra-rader-fr%C3%A5n-%C3%B6verintendenten/kultur-och-ett-h%C3%A5llbart-samh%C3%A4lle. Accessed 2 February 2022.
7 https://cicero.oslo.no/en/posts/projects/upscale-oppskalering-av-baerekraftig-deling-ved-hjelp-av-offentlige-biblioteker. Accessed 2 February 2022.
8 https://www.worldvaluessurvey.org/wvs.jsp. Accessed 2 February 2022.

References

Audunson, Ragnar. 2005. "The Public Library as a Meeting-place in a Multicultural and Digital Context: The Necessity of Low-intensive Meeting-places." *Journal of Documentation* 61, no. 3: 429–441. https://doi.org/10.1108/00220410510598562.
Balke Staver, Anne, Jan-Poul Brekke, and Susanne Søholt. 2019. *Scandinavia's Segregated Cities – Policies, Strategies and Ideals*. Oslo: Norwegian Institute for Urban and Regional Research.
Benediktsdóttir, Ásta Kristín et al. 2020. "Uncovering Intra-Nordic Queer Migration in the 20th Century". *nordics.info*. https://nordics.info/show/artikel/uncovering-intra-nordic-queer-migration-in-the-20th-century-1/. Accessed 2 February 2022.
Breidahl, Karen N., and Barbara Fersch. 2018. "Bringing Different States In: How Welfare State Institutions Can Possibly Influence Sociocultural Dimensions of Migrant Incorporation." *Nordic Journal of Migration Research* 8, no. 2: 99–106. https://doi.org/10.1515/njmr-2018-0011.
Del Mar, Kira M. 2021 (February 9). "How Can We Plan Trans-Inclusive Harry Potter Events at Public Libraries?" *Medium.com*. https://bibliotekforalle.medium.com/how-can-we-plan-trans-inclusive-harry-potter-events-at-public-libraries-e7ac3d272241. Accessed 2 February 2022.
Duff, Wendy M., Andrew Flinn, Karen Emily Suurtamm and David A. Wallace. 2013. "Social Impact Justice of Archives: A Preliminary Investigation." *Archival Science*, 13: 317–348. https://doi.org/10.1007/s10502-012-9198-x.
Eriksen, Thomas Hylland. 2019. "Ethnic Minorities in the Nordic Countries." *nordics.info*. https://nordics.info/show/artikel/ethnic-minorities. Accessed 7 October 2022.

Fersch, Barbara. 2016. "Welfare Service Professionals, Migrants, and the Question of Trust. A Danish Case." *Professions and Professionalism* 6, no. 2: e1567. https://doi.org/10/gnxbt8.

Fersch, Barbara, and Karen N. Breidahl. 2018. "Building, Breaking, Overriding...? Migrants and Institutional Trust in the Danish Welfare State." *International Journal of Sociology and Social Policy* 38, no. 7–8: 592–605. https://doi.org/10.1108/IJSSP-12-2017-0177.

Gabriel, Lýsa Westberg, and Thessa Jensen. 2017. "Who Is the Expert in Participatory Culture?" In *Participatory Heritage*, edited by Henriette Roued-Cunliffe and Andrea Copeland, 87–96. Facet. https://doi.org/10.29085/9781783301256.010.

Goulding, Anne. 2009. "Engaging with Community Engagement: Public Libraries and Citizen Involvement." *New Library World* 110, no. 1/2: 37–51. https://doi.org/10.1108/03074800910928577.

Hauke, Petra. 2018. "From Information Literacy to Green Literacy: Training Librarians as Trainers for Sustainability Literacy." http://library.ifla.org/id/eprint/2147/1/116-hauke-en.pdf. Accessed 2 February 2022.

Höglund, Lars, and Eva Wahlström. 2009. *Användningen och attityderna. En rapport om allmänhetens användning av och syn på folkbibliotek baserad på SOM-Undersökningen 2007.* Stockholm: Svensk Biblioteksförening.

Høj Mathiasson, Mia, and Henrik Jochumsen. 2022. "Libraries, Sustainability and Sustainable Development: A Review of the Research Literature," *Journal of Documentation*, ahead-of-print. https://doi.org/10.1108/JD-11-2021-0226

Janes, Robert R., and Richard Sandell. 2019. "Posterity Has Arrived: The Necessary Emergence of Museum Activism." In *Museum Activism*, edited by Robert R. Janes and Richard Sandell, 1–22. London: Routledge.

Jensen, Bente, and Ellen Røsjø. 2016. "Introduction: Archives and Outreach in the Nordic Countries – History, Status and the Road Ahead." In *#arkivdag – relevans, medvirkning, dialog*, edited by Marit Hosar, Ellen Røsjø, Bente Jensen, Charlotte S.H. Jensen, Anna Ketola, og Maria Larson Östergren, 9–21. ABM-media as.

Johnston, Jamie. 2018. "The Use of Conversation-based Programming in Public Libraries to Support Integration in Increasingly Multiethnic Societies." *Journal of Librarianship and Information Science* 50, no. 2: 130–140. https://doi.org/10.1177/0961000616631613.

Johnston, Jamie, and Ragnar Audunson. 2019. "Supporting Immigrants' Political Integration through Discussion and Debate in Public Libraries." *Journal of Librarianship and Information Science* 51, no. 1: 28–242. https://doi.org/10.1177/0961000617709056.

Kuhlman, Tom, and John Farrington. 2010. "What is Sustainability?" *Sustainability* 2, no. 11: 3436–3448. https://doi.org/10.3390/su2113436.

Kumlin, Staffan, and Bo Rothstein. 2005. "Making and Breaking Social Capital: The Impact of Welfare-State Institutions." *Comparative Political Studies* 38, no. 4: 339–365. https://doi.org/10.1177/0010414004273203.

Kumlin, Staffan and Bo Rothstein. 2010. "Questioning the New Liberal Dilemma: Immigrants, Social Networks, and Institutional Fairness." *Comparative Politics* 43, no. 1: 63–80. https://doi.org/10.5129/001041510X12911363510394.

Lankes, R. David. 2016. *The New Librarianship Field Guide*. Cambridge, MA: The MIT Press.

Lankes, R. David. 2020. "Never Neutral, Never Alone." *Journal of Education for Library and Information Science* 61, no. 3: 383–388. https://doi.org/10.3138/jelis.61.3.2020-0007.

Loach, Kirsten, Jennifer Rowley, and Jillian Griffiths. 2017. "Cultural Sustainability as a Strategy for the Survival of Museums and Libraries." *International Journal of Cultural Policy* 23, no. 2: 186–198. https://doi.org/10.1080/10286632.2016.1184657.

Melby, Kari, Christina Wetterberg, and Anne-Birte Ravn, 2008. "Introduction: A Nordic Model of Gender Equality?" In *Gender Equality and Welfare Politics in Scandinavia: The Limits of Political Ambition?*, edited by Kari Melby, Chistina Wetterberg, and Anne-Birte Ravn, 3–24. Bristol: Policy Press.

Newby, Andrew G. 2019. "Nordic Museums and their History." *nordics.info.* https://nordics.info/show/artikel/museums-and-their-history/. Accessed 2 February 2022.

Nordic Council of Ministers. 2021. *The NORDICS – A Sustainable and Integrated Region? Baseline Report for Our Vision 2030. Norden.org.* https://www.norden.org/en/publication/nordics-sustainable-and-integrated-region-baseline-report-our-vision-2030. Accessed 2 February 2022.

OECD. 2018. *Is the Last Mile the Longest? Economic Gains from Gender Equality in Nordic Countries.* Paris: OECD Publishing. https://doi.org/10.1787/9789264300040-en.

Østby, Lars og Aalandslid, Vebjørn. 2020. *Innvandring og innvandrere i Norden en komparativ analyse.* Oslo: Statistisk sentralbyrå. https://nordicwelfare.org/integration-norden/fakta/innvandring-og-innvandrere-i-norden-en-komparativ-analyse/. Accessed 2 February 2022.

Otto, Adeline and Demitri Gugushvili. 2020. "Eco-Social Divides in Europe: Public Attitudes towards Welfare and Climate Change Policies." *Sustainability* 12, no. 1: 404. https://doi.org/10/gns49z.

Simon, Nina. 2010. *The Participatory Museum.* Santa Cruz, CA: Museum 2.0.

Simon, Nina. 2016. *The Art of Relevance.* Santa Cruz, CA: Museum 2.0.

Sjögren Zipsane, Eva. 2016. "Arkivet som samhällsaktör för demokrati, social rättvisa och andre nyttor." In *#arkivdag - relevans, medvirkning, dialog*, edited by Marit Hosar, Ellen Røsjø, Bente Jensen, Charlotte S.H. Jensen, Anna Ketola, and Maria Larson Östergren, 23–35. Oslo: ABM-media.

Söderholm, Jonas, Malin Ögland, and David Gunnarsson Lorentzen. 2021. "Biblioteken fortsatt starka trots kristid." In *Ingen anledning till oro (?)*, edited by Ulrika Andersson, Anders Carlander, Marie Grussel, and Patrick Öhberg, 165–177. Gothenburg: University of Gothenburg.

The World Commission on Environment and Development. 1987. *Our Common Future.* United Nations. https://sustainabledevelopment.un.org/content/documents/5987our-common-future.pdf. Accessed 2 February 2022.

Thiele, Leslie Paul. 2016. *Sustainability.* Second edition. Cambridge: Polity.

UNESCO 2013. *Introducing Cultural Heritage into the Sustainable Development Agenda.* United Nations Educational, Scientific and Cultural Organization. http://www.unesco.org/new/fileadmin/MULTIMEDIA/HQ/CLT/images/HeritageENG.pdf. Accessed 2 February 2022.

Vårheim, Andreas. 2014a. "Trust in Libraries and Trust in Most People: Social Capital Creation in the Public Library." *The Library Quarterly* 84, no. 3: 258–277. https://doi.org/10.1086/676487.

Vårheim, Andreas. 2014b. "Trust and the Role of the Public Library in the Integration of Refugees: The Case of a Northern Norwegian City." *Journal of Librarianship and Information Science* 46, no. 1: 62–69. https://doi.org/10.1177/0961000614523636.

Vårheim, Andreas, Sven Steinmo, and Eisaku Ide. 2008. "Do Libraries Matter? Public Libraries and the Creation of Social Capital." *Journal of Documentation* 64, no. 6: 877–892. https://doi.org/10.1108/00220410810912433.

Vergo, Peter, ed. 1989. *New Museology.* London: Reaktion Books.

PART IV

Conclusion

17

DIFFERENCES AND SIMILARITIES BETWEEN LAMS, AND THEIR PURSUIT OF COMMONS CHALLENGES

Kerstin Rydbeck, Håkon Larsen, and
Casper Hvenegaard Rasmussen

As mentioned in Chapter 1, the conditions for libraries, archives, and museums (LAMs) have changed constantly throughout history in relation to wider societal changes. During the late 1900s and early 2000s, LAMs faced new, quick, and quite similar challenges, often linked to global trends and changes. In some instances, this also created incentives for new LAM collaborations. In this volume, we have discussed this development from different perspectives and highlighted differences and similarities among LAMs, using examples from Scandinavia. Furthermore, we have also discussed some of the important challenges that LAMs are facing today.

The historical section of the book (Chapters 2–4) shows that large national LAM institutions in Denmark, Norway, and Sweden started to form during the seventeenth century. As in other Western countries, the development intensified in the centuries that followed under the influence of the Enlightenment, the development of science, the rise of the bourgeois public sphere, and industrialization, which started in the Scandinavian countries in the late nineteenth century. The modern regional and local LAM institutions also emerged at the end of the nineteenth century. The development of LAMs was closely connected to the modern project and the demand for public enlightenment, as well as to nation building and the construction of national identities. In Scandinavia, the development of LAMs during the twentieth century was also connected to the creation of the modern welfare state, with cultural policies focusing on democratic and equal access to culture and cultural heritage, and on the right of citizens to free and reliable information (see Chapter 5).

The acronym LAM was used from the late 1990s as a collective term for libraries, archives, and museums. However, it also had an ideological dimension, implying that it was partly a common practice field with opportunities for

DOI: 10.4324/9781003188834-21

increased collaboration across institutional borders. As mentioned in Chapter 5, attempts around the turn of the millennium to create national LAM authorities in Scandinavia failed, although a national LAM authority existed in Norway for some years. Often, the collaboration has grown from the bottom up, in various regional and local projects, and through co-localization of different LAM institutions.

Similarities and differences

Perceiving LAMs as a partially common practice field presupposes some overlapping between libraries, archives, and museums. Based on Scandinavian conditions, it can be summarized in the following four points.

1 *LAMs are all engaged in the acquisition, organization, curation, preservation, mediation, and dissemination of material, carrying different types of information.* Although there have been examples, especially in ancient and older history, of true LAM institutions, there are differences in the practices of libraries, archives, and museums, as shown throughout this book. As discussed in Chapters 1–4, throughout history, libraries, archives, and museums have been given diverse societal tasks connected to different user groups and to different types of materials. This required distinct principles and tools, and thereby distinct competences among the professionals. Thus, it resulted in a divergent development of the LAM field, where separate institution-related discourses were constituted – one for libraries, one for archives, and one for museums. This did, however, complicate broader LAM collaborations. Today, separate laws define the missions and aims of libraries, archives, and museums, and no Scandinavian country has a common law for the entire LAM field. Nevertheless, in spite of the divergence, the borders between libraries, archives, and museums have always been blurred. Many archival institutions have libraries and collections of artifacts, many libraries have archives and collections of artifacts, and many museums have libraries and archives. Some materials – for example, image material – have traditionally been handled by all LAMs, but in various ways, depending on the different tools and practices (see Chapter 8; Kjellman 2006).

2 *LAMs are often referred to as our (society's) collective memory or "memory institutions,"* and their collections form part of what we call our "common cultural heritage" (Dempsey 1999). However, LAMs handle different types of materials. The archival records and the library documents are relatively uniform – traditionally mostly paperbound and fairly easy to handle. Museum collections, on the other hand, include almost anything from microscopically small insects to large works of art or machines. This material is often fragile or difficult to move from storerooms, which explains why users mostly do not have

access to the collections in museums, like they have in archives and libraries. Nevertheless, as discussed in Chapter 7, curated exhibitions built on material from the collections are a central activity in museums, something that libraries and archives rarely have. The interpretation of objects in these exhibitions is an important task for the museums, and many large museums also have staff employed to research the collections. Generally, the staff at archives and libraries do not engage in interpreting the contents of the collections.

The focus on cultural heritage is most prominent in museums. Libraries and archives also have other important missions: Public archives provide the juridical system and the public administration with information, and handle the extensive material they continuously produce, while libraries are expected to promote information literacy. But there are also important differences *within* the three LAM sectors. For example, some research libraries, typically national libraries, have an archival function and are expected to save everything that is printed in the country for future generations. The public libraries, on the other hand, provide collections that are considered relevant based on contemporary needs and interests, and materials are withdrawn when they become obsolete or no longer considered relevant. As mentioned in Chapter 6, there are LAMs without collections.

The concept of cultural heritage also has an ideological dimension that is reflected in the building of the collections. Who defines what is considered a cultural heritage? The national discourse has been, and still is, important in that context. LAMs have had a nation-building function since the middle of the nineteenth century, but what that means has changed over time, and LAMs have gradually become more inclusive from a social and ethnic perspective.

3 *LAMs produce different kinds of documents and meta-information connected to the organizing, searching, and retrieving of information.* All three LAM sectors have knowledge-organizing systems (KO systems). As discussed in Chapter 8, both archives and libraries attach great importance to having public catalogs of their collections and fonds. Museums, on the other hand, rarely have public catalogs covering their complete collections. The difference is partly explained by the varying degrees of standardization. It has the greatest significance in the library sector, as the same publications are usually found in many different libraries. There has thus been a lot to gain from collaborating across the institutions and in creating common solutions, which can be illustrated by the fact that the Dewey Decimal Classification system is a national standard in many countries across the world. Standardization saves time and effort. Sometimes the archives developed standardized solutions too, albeit on a national basis. However, the diversity of materials in the museum collections may help explain why standardization is less common in the museum sector. It is difficult to build comprehensive KO systems

covering all kinds of material in museums. Yet, museums have an extensive production of printed exhibition catalogs, especially the art museums.

Even before the turn of the millennium, there were ideas of creating comprehensive KO systems for LAMs – digital catalogs that would enable users to simultaneously search for materials, such as photos or letters, in different LAM institutions. In general, the user perspective was often emphasized in the arguments for increased collaboration – the use of digital technology should enable new solutions for the benefit of users. As pointed out in Chapter 8, digitalization fundamentally changed the routines for KO. In the past few years, however, the focus has mainly been on full text digitization of material from the collections, which is especially important for museums in their effort to make the collections accessible to users.

4 *LAMs are considered important for an open and democratic society, and their work is largely determined by cultural and educational policy decisions.* There is great public support for LAMs in the Scandinavian countries. As stated in Chapter 5, most LAM organizations have been publicly funded for a long time, either because they are owned by the state or a municipality, or because they receive public support for their activities. LAMs are important components of a cultural policy that aims to offer equal access to culture. This unites Denmark, Norway, and Sweden and contributes to what can be considered a Scandinavian model for LAMs.

However, there are many policy decisions that affect LAMs in various ways. One example previously mentioned is the Public Lending Right, which has existed since the middle of the twentieth century in all three countries. This is a financial compensation given to domestic authors – writing both in the majority languages and in languages spoken by different minority groups – for their books being lent at public libraries. All the languages in Scandinavia are spoken by a small number of people, which makes the book markets small and book production costly. It is difficult for authors to make a living from their writing if their readers borrow the books from libraries instead of purchasing them. The purpose of the Public Lending Right is to promote domestic literary production, but it also contributes to the public library's nation-building function by supporting domestic literature.

Traditionally, public archives and libraries are free to visit and use, while museums have entrance fees. However, in some countries – including the Scandinavian ones – some publicly owned museums are obliged to be admission free, due to political decisions. Just over a third of the Swedish museums were completely free of entrance fees by 2020, according to official statistics (Myndigheten for kulturanalys 2021, 19).

The notion of what LAMs should contribute to society has changed over time. Recently, both libraries and museums have broadened their work and become cultural institutions offering different activities, focusing on community

building and user participation. Archives have not been affected in the same way, although they are now also expected to focus on mediation and on becoming user oriented. As discussed in Chapter 11, education policy affects LAMs – especially libraries – in relation to the promotion of reading, information literacy, and lifelong learning.

Challenges

The impact of digitalization

Digitalization has fundamentally changed the whole of society and is still a central issue for LAMs in various ways (Chapter 9). The change has meant both opportunities and challenges for organizations, staff, and users, but much of the utopian attitude that prevailed a decade or two ago has today been replaced by a somewhat more dystopian attitude when faced with difficulties connected to digitalization.

All LAMs use online platforms for communication. As discussed in Chapter 10, different kinds of platforms present different challenges. Internal platforms are expensive and require competence to maintain, which is not always available at small LAM institutions. Many users, or potential users, are active on social media, but global commercial companies with their own agendas run the social media platforms, and external platforms can be difficult to adapt to the missions and work of LAMs. Cross-institutional platforms maintained by many collaborating LAMs are a solution, but there still seem to be problems in communicating with users.

The technical development is very fast and it is important to ensure that today's solutions for digital storage will also work in the future. This poses a challenge, not least for archives, where more and more of the material is born and saved digitally. Today, LAMs have to recruit competences outside the traditional LAM professions to deal with issues related to digitalization. As mentioned in Chapter 3, the archivist profession was almost split into two different professions because of digitalization – one focusing on digital archives and the other on traditional paperbound archives.

When the Swedish Royal Library presented a proposal for a national library strategy in 2019, it emphasized the importance of making cultural heritage accessible to a broader public through digitization (Fichtelius, Persson, and Enarson 2019). This suggestion was partly a consequence of discussions about copyright and copyright costs, which is another challenge LAMs have to face in connection to digitization. There is still a lot of ambiguity about how the legislation should be applied to digitized material, which sometimes means difficulties for LAMs in making digitized material accessible. Paradoxically, digitization sometimes results in a situation where material is more difficult to access for users, as it is now hidden behind licenses with high fees. One example is the digitized twentieth-century Swedish news press. Difficulties may also arise for

LAMs attempting to arrange social activities, such as lectures, discussions, and public readings, in digital media if copyrighted material is to be used. However, in 2019, the European Union adopted the *Directive on Copyright in the Digital Single Market*, which aims to update and harmonize copyright law in the member states, in order to better meet the challenges of digitalization and the Internet. *The General Data Protection Regulation (GDPR)*, which came into force in 2016 with the aim of protecting people's personal privacy and preventing personal data from misuse, also affects LAMs' digitization of materials.

LAMs' acquisition of digitally published material is more complicated than the acquisition of paperbound material. Ebooks and audiobooks are accessed through license agreements, where fees are mostly linked to the number of downloads. This has resulted in difficulties for public libraries in predicting their costs for digital material, costs that have often become very high. In order to handle the situation, limitations are introduced at many libraries for the number of ebooks a user can download during a certain period – a new and uncomfortable situation for an institution whose basic mission is to increase the reading of literature in society. The situation became especially problematic during the COVID-19 pandemic in 2020–2021, when LAMs were forced to switch from physical to digital activities. In some Swedish municipalities, there was a dramatic increase in the number of downloads, leading to a complete stop in lending of ebooks due to runaway costs (SOU 2021:77).

Despite digitalization, the ever-growing amount of material to be documented is difficult and expensive for LAMs to handle and store. This is especially noticeable for archives. As mentioned in Chapter 3, decisions have been made to use different kinds of sampling in order to keep the volumes down. Since the new Swedish Museums Act was introduced in 2017, museums have been able to withdraw objects from their collections, something that was not common practice previously. The large and old research libraries used to save nearly all the printed material they received through the Legal Deposit Act, but today they continually withdraw items and create collection strategies. Swap agreements between research libraries used to be important, but they hardly exist anymore. How to curate the collections in a sustainable way for both contemporary and future users is a difficult challenge, as discussed in Chapter 7.

Legitimacy and democracy

As pointed out in Chapters 13 and 16, there is an increasing external demand on LAMs to show relevance and to legitimize their work. This is partly a consequence of digitalization, but also a result of the efforts by the state and the municipalities to coordinate resources in a cost-effective and sustainable way. The competition for public resources among different societal institutions is increasing. This has sometimes affected LAMs negatively. For example, there has been a considerable decrease in the number of libraries in the Scandinavian countries

in recent decades, as the municipalities have tried to reduce their library costs by closing local public library branches.

Consequently, LAMs put a lot of energy into explaining the value of, and need for, what they do, and into adapting to changing needs, expectations, and opportunities. The way in which LAMs support democracy has been important, and traditionally they have supported democracy by giving access. However, LAMs seek to broaden the understanding of what democracy means (Kranich 2020). For instance, their social and community-building roles have been strongly emphasized in recent years, which is described by researchers as "the social turn" (Söderholm and Nolin 2015). As discussed in Chapters 6, 14 and 16, LAMs' opportunities to fulfill their democratic role lie today largely in how well they succeed in community involvement at different levels, i.e., national, regional, and local, and vis-à-vis different social, ethnic, and age groups. This is also an important challenge, and inclusion and diversity play a central role. LAMs serve as meeting places and arenas for public debate, and offer a wide spectrum of activities and programs, both on-site and digitally (Audunson et al. 2020). User participation is part of the community involvement. User participation, as pointed out in Chapter 12, has developed in various forms in LAMs during the past few decades, something that is illustrated by the concept of "the participatory turn," reflecting a changed view of the user. The importance of LAMs for both informal and formal learning has also increased. As discussed in Chapter 11, literacy could be a concept connecting local everyday practices with social significance for LAM institutions.

LAMs and activism

As pointed out in Chapter 15, activism has not been as prominent in Scandinavian LAMs as in some other countries. This is due to the fact that the politicizing of LAM institutions and LAM professions has not been as strong here, which, in turn, is explained by the countries' educational and cultural policies. Legislation is important in ensuring LAMs' independence, and the so-called "arm's length principle" determines the relation between politicians and LAM professionals, both at the municipal and state levels. It means that politicians set the frames through cultural policy and public grants but leave it to LAM professionals to transform this into concrete activities. This principle is central to the Nordic cultural model (Duelund 2003, 505) and has thus served as a counterweight to the politicizing of LAMs that is observed in other parts of the world (Koizumi and Larsen 2022).

However, although internal activism is not very prominent, discussions and opinions in society sometimes lead to activist demands and actions, putting external pressure on staff, collections, and activities at LAMs. A current Scandinavian example concerns the photos of Sámi people in a photo collection created by the State Institute for Racial Biology that existed in Sweden between 1922 and 1958 (Kjellman and Eld 2019). The archive from the institute is held

in the university library in Uppsala, but in recent years there have been demands from the Sámi minority to take over the responsibility for the Sámi photos. The library, on the other hand, claims, based on the provenance principle prescribed by the Archival Act, that the photos must not be viewed out of context (SVT Nyheter/Sápmi 2022a, 2022b). The question is whether material collected for research almost 100 years ago, in a way that today appears ethically indefensible, should still be publicly accessible as documentation of a dark part of history. Or, if the integrity of the depicted individuals is more important, and justifies a relocation of the material to the minority they were a part of. Is it up to them to decide what should happen to it?

Many LAMs face similar challenging discussions today. The discussions cover all types of material, from human remains, and art and cultural artifacts, to documents and photos, but also printed books that are regarded as controversial, for example due to minority offensive language. "Banned books" are nothing new, but today the discussion about this phenomenon has broadened and includes new groups that question the content of collections and fonds in new ways. Power is important from the postcolonial perspective: Who owns the cultural heritage, and whose interests are reflected in legislation? This is important for the community-building work and understanding of democracy at LAMs, especially in relation to the ongoing digitization of old artifacts and documents, making this material publicly accessible to a completely new extent.

LAMs and societal crises

Crises related to natural disasters such as fires, hurricanes, and floods are potential threats to the collections and premises of LAMs. At the same time, institutions like public libraries can take on important roles in rebuilding communities after such a crisis (Dickerson 2008; Jaeger et al. 2008). In Scandinavia, the COVID-19 pandemic also drew attention to the importance of LAMs mediating public information and cultural experiences digitally, as local public meeting places had to be closed due to infectious disease restrictions.

LAMs have been destroyed in war many times throughout history. The Swedish army looted libraries in central Europe during the Thirty Years' War in the seventeenth century and brought the books home as booty. The Nazis engaged in systematic looting of LAMs, both in Germany and in occupied territories (Pettegree and der Weduwen 2021, 173–174, 323–349; Rydell 2014). As mentioned in Chapter 2, about 50 libraries were destroyed in Norway during the German occupation. Often looters had economic motives, but the lootings were also expressions of *identicide* – a deliberate, systematic, and targeted destruction of artifacts, books, and other symbols and property representing the cultural heritage and identity of a people (Meharg 2011). Identicide occurred in the Balkan wars during the 1990s and in the Middle East when ISIS destroyed cultural

heritage – for example, when a museum and several libraries were looted and destroyed in Mosul, Iraq, in 2015 (Turku 2017, 42). With the Russian invasion of Ukraine in February 2022, Europe is facing a new war, and all Ukrainian LAMs are trying to protect their collections from bombing and looting – sometimes with support from LAMs in other countries. Simultaneously, they are working to maintain a digital service to provide residents with official information about the current situation, and helping refugees. This, of course, is extremely challenging work, and it emphasizes both nation building and an activist role for contemporary LAMs in times of war.

Final remarks

In this book, we have described the development of LAMs throughout history as a diverging process. However, the various rapid and global changes in recent decades have presented LAMs with new and common challenges, which must be addressed, and where LAM collaborations sometimes have been the solution, a converging development. There is still much that differentiates LAMs in terms of missions, traditions, and working methods. But for LAMs as a whole, the changes from the past few decades have meant a changed view of the collections, of digitization, and of participants in LAM activities.

We have discussed the development and challenges of LAMs based on the situation in the three Scandinavian countries of Denmark, Norway, and Sweden. Our conclusion is that a Scandinavian model for LAMs can be distinguished, based primarily on the perception of publicly funded LAMs as an important part of the welfare state. In the Nordic region, both culture (Duelund 2003) and media (Syvertsen et al. 2014) policy is seen as an extension of the welfare state, with free and democratic access to culture and information as important values. As demonstrated throughout this book, LAMs play important parts in supporting open and democratic societies. Legislation and the arm's length principle provide independence to LAMs, while simultaneously protecting them from a politization of their activities.

"Legitimation," "sustainability," and "democracy" are keywords when defining contemporary challenges for LAMs. In order to preserve the trust LAMs have gained from politicians and the general public, LAMs must be able to explain and defend the worth of what they do, and they must adapt to the sustainability agenda – not only in relation to cultural heritage and climate, but also in relation to a sustainable social and economic development. The nation-building function has become more inclusive from a social and ethnic perspective and has taken a somewhat new direction, in that LAMs are considered important in different types of societal crisis. Their role in emergency management and civil defense has been emphasized during the COVID-19 pandemic and is being brought up again with the invasion of Ukraine.

References

Audunson, Ragnar, Herbjørn Andresen, Cicilie Fagerlid, Erik Henningsen, Hans-Christoph Hobohm, and Håkon Larsen. 2020. "Introduction – Physical Places and Virtual Spaces. Libraries, Archives and Museums in a Digital Age." In *Libraries, Archives and Museums as Democratic Spaces in a Digital Age*, edited by Ragnar Audunson, Herbjørn Andresen, Cicilie Fagerlid, Erik Henningsen, Hans-Christoph Hobohm, Håkon Larsen and Tonje Vold, 1–22. Berlin: De Gruyter Saur. https://doi. org/10.1515/9783110636628-001

Dempsey, Lorcan. 1999. "Scientific, Industrial, and Cultural Heritage: A Shared Approach." *Ariadne: Web Magazine for Information Professionals*, no. 22.

Dickerson, Lon. 2008. "Capitalizing on a Disaster to Create Quality Services: Some Lessons from Hurricane Katrina." *Public Library Quarterly* 26, no. 1–2: 101–115. https://doi.org/10.1300/J118v26n01_06

Duelund, Peter. 2003. "The Nordic Cultural Model: Summary." In *The Nordic Cultural Model*, edited by Peter Duelund, 479–581. Copenhagen: Nordic Cultural Institute.

European Union. 2016. *The General Data Protection Regulation (GDPR)*. Regulation 216/679.

European Union. 2019. *Directive on Copyright in the Digital Single Market*. Directive 2019/790.

Fichtelius, Erik, Christina Persson, and Eva Enarson. 2019. *The Treasure Trove of Democracy: Proposal for a National Strategy for Libraries*. Stockholm: Kungliga biblioteket.

Jaeger, Paul T., Lesley A. Langa, Charles R. McClure, and John Carlo Bertot. 2008. "The 2004 and 2005 Gulf Coast Hurricanes: Evolving Roles and Lessons Learned for Public Libraries in Disaster Preparedness and Community Services." *Public Library Quarterly* 25, no. 3–4: 199–214. https://doi.org/10.1300/J118v25n03_17

Kjellman Ulrika. 2006. "Från kungaporträtt till läsketikett: en domänanalytisk studie över Kungl. bibliotekets bildsamling med särskild inriktning mot katalogiserings- och indexeringsfrågor." PhD Diss. Uppsala: Uppsala University.

Kjellman, Ulrika and Christer Eld. 2019. "The Construction of Whiteness in the Work of the Swedish State Institute for Race Biology." In *Shades of Whiteness*, edited by Ewan Kirkland, 53–63. Leiden: Brill Academic Publishers.

Koizumi, Masanori and Håkon Larsen. 2022. "Democratic Librarianship in the Nordic Model." *Journal of Librarianship and Information Science*. Ahead of print. https://doi. org/10.1177/09610006211069673

Kranich, Nancy. 2020. "Libraries and Democracy Revisited." *The Library Quarterly* 90, no. 2: 121–153. https://doi.org/10.1086/707670

Meharg, Sara Jane. 2011. "Identicide in Sarajevo: The Destruction of the National and University Library of Bosnia and Herzegovina." In *Modern Military Geography*, edited by Francis Galgano and Eugene J. Palka, 341–357. New York: Routledge. https://doi. org/10.4324/9780203844397

Myndigheten för kulturanalys. 2021. *Museer 2020. Kulturfakta 2021:1*. Stockholm: Myndigheten för kulturanalys.

Pettegree, Andrew and Arthur der Weduwen. 2021. *The Library: A Fragile History*. New York: Basic Books.

Rydell, Anders. 2014. *Plundrarna: hur nazisterna stal Europas konstskatter*. Stockholm: Ordfront.

Söderholm, Jonas and Jan Nolin. 2015. "Collections Redux: The Public Library as a Place of Community Borrowing." *The Library Quarterly* 85, no. 3: 244–260. https:// doi.org/10.1086/681608

SOU 2021:77. *Från kris till kraft: återstart för kulturen*. Stockholm: Ministry of Culture.

SVT Nyheter/Sápmi. 2022a. "På plats i rasbiologiska arkivet: det är tungt att se bilderna på min aahka och aajja." 2022-02-08.

SVT Nyheter/Sápmi. 2022b. "Universitetet har inga planer på att lämna ifrån sig bilderna." 2022-02-08.

Syvertsen, Trine, Gunn Enli, Ole J. Mjøs, and Hallvard Moe. 2014. *The Media Welfare State. Nordic Media in the Digital Era*. Ann Arbor: The University of Michigan Press.

Turku, Helga. 2017. *The Destruction of Cultural Property as a Weapon of War: ISIS in Syria and Iraq*. Cham: Palgrave Macmillan. https://doi.org/10.1007/978-3-319-57282-6

INDEX